JUERGEN TELLER
PLUMTREE COURT

STEIDL

My interest in architecture is based on direct experience. David Adjaye, who built the auditorium at Plumtree Court, also built my home about fifteen years ago. I then worked with 6a architects to build my studio in west London, which was completed in 2016. I love both buildings and it feels incredible to have created something new from scratch.

I was in Beirut for the opening of Tony Salamé's new cultural foundation and luxury shopping centre designed by Adjaye Associates in 2015. Whilst I was there, Jeffrey Deitch asked me if I would be interested in an architecture project for Goldman Sachs, after seeing the catalogue I had produced for the Aïshti Foundation, which featured photographs of the site development.

He was one of the highly regarded curators in the art world who were helping Goldman Sachs commission art for their new headquarters in Europe. I got very excited and said yes. However, within about a year into the project Brexit happened and sadly all the planned art commissions got deferred. I felt like a man left alone in that vast space.

The building took about five years to build in the end. I liked the diggers, cranes, cables, concrete and dirt. Not in a macho or childish way, but appreciating how all this construction work produces such a beautiful mess. By photographing the site or detailed sections of it, I was able to create some truly harmonious pictures.

I really enjoyed shooting this building as it gradually evolved over several seasons – in the sunshine, with grey skies or rain and in heavy snowfall. I have many memories of how the building was fitting into its surrounding cityscape from my repeat visits, such as photographing a hawk in the springtime, up high on the roof, protecting the seeds from the seagulls.

Once I had finished photographing the site, the process of editing the images and working on the layout of this book was very pleasurable, finding ways to contrast past and present through visual juxtaposition and collage.

This time spent reflecting upon the photographs reminded me of the freedom that I had whilst I was there. It also made me admire all the wonderful facilities that have been built for the employees as well as the environmental sensitivity of the project and the beauty of architectural details themselves. All my life I thought I would never work for a bank. And here I am.

Juergen Teller

Sustainably printed by Steidl, Göttingen

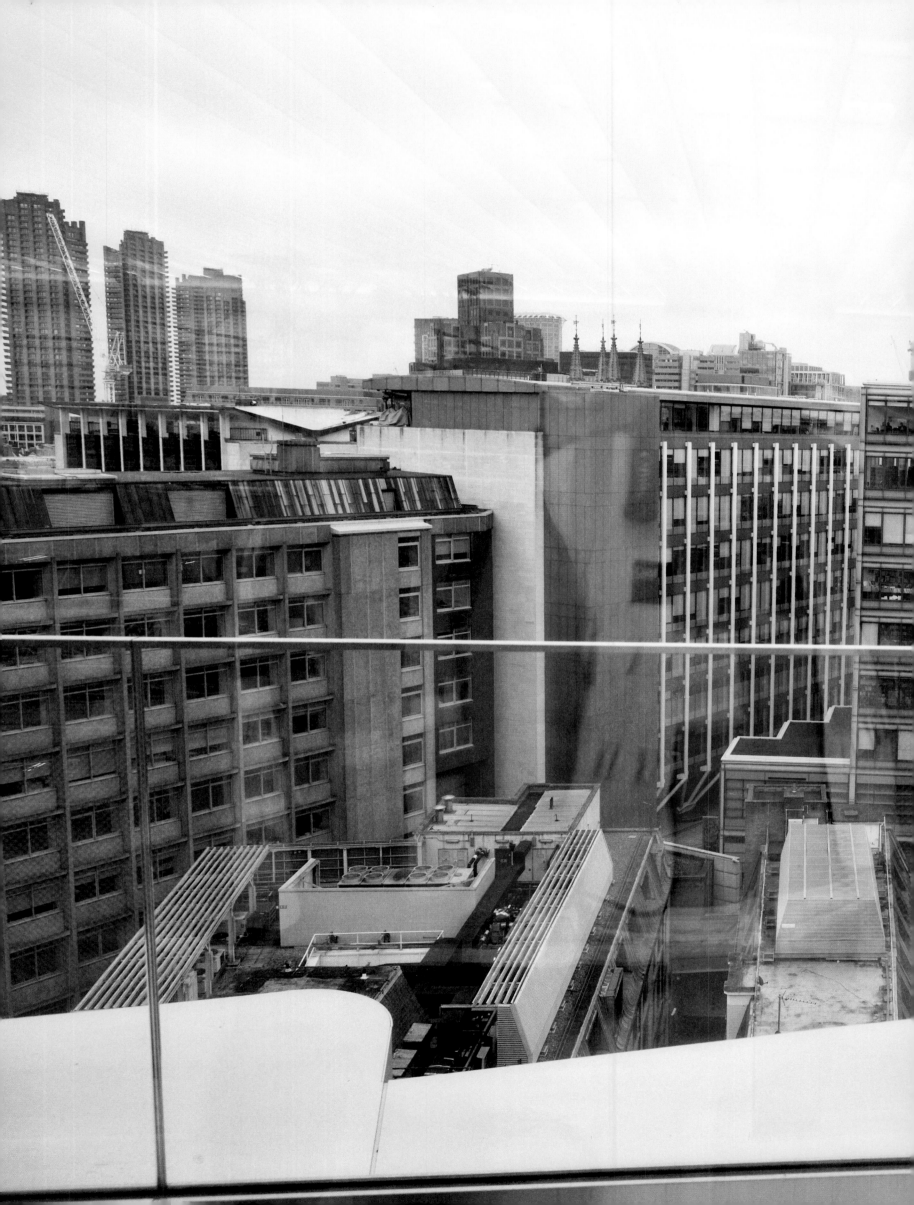

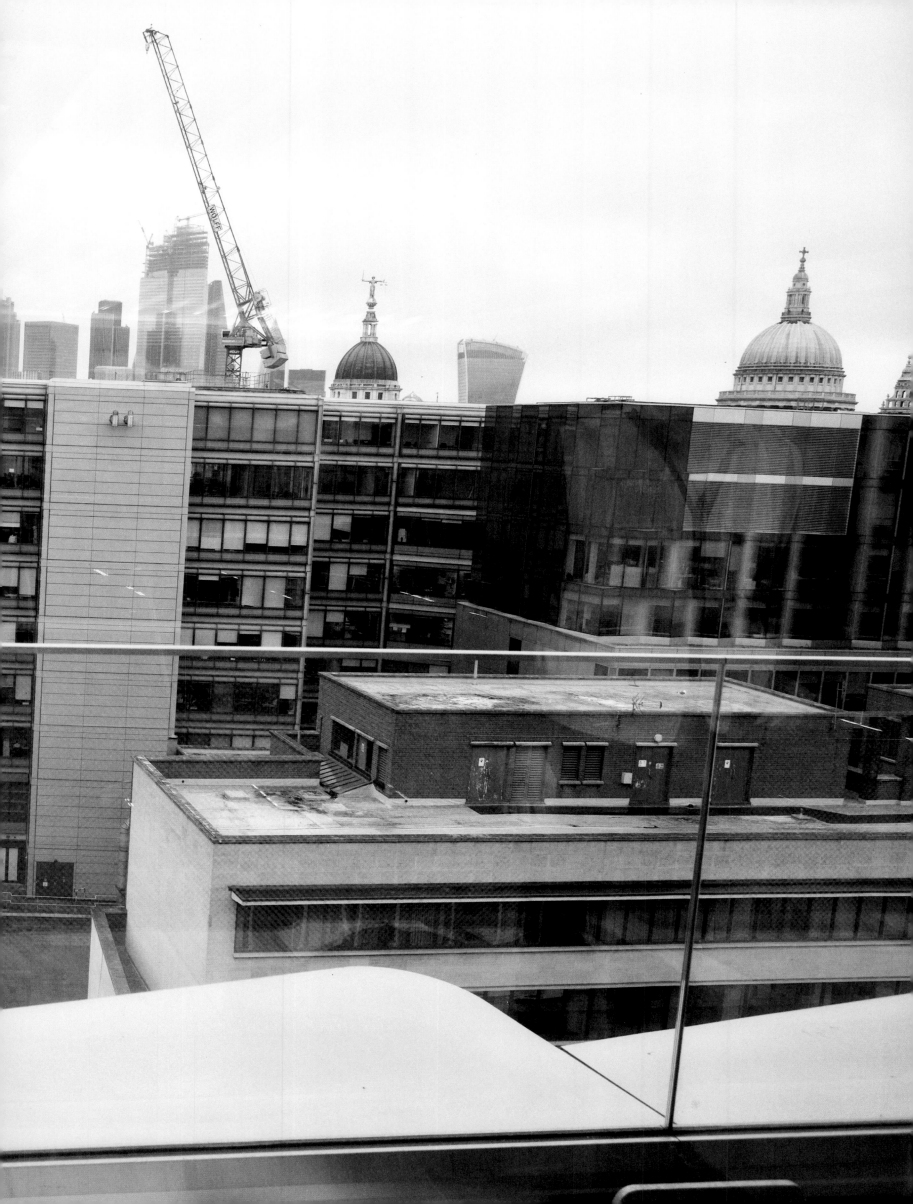

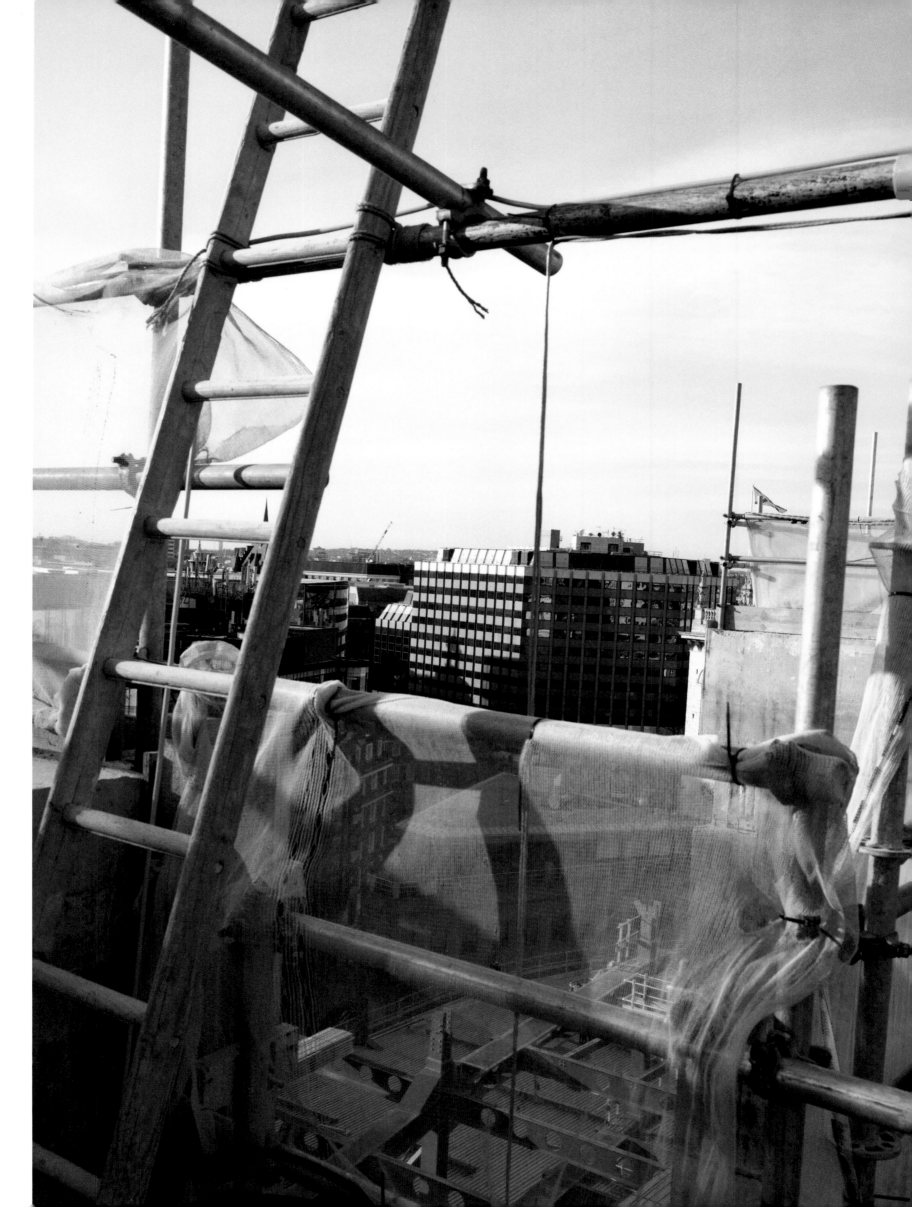

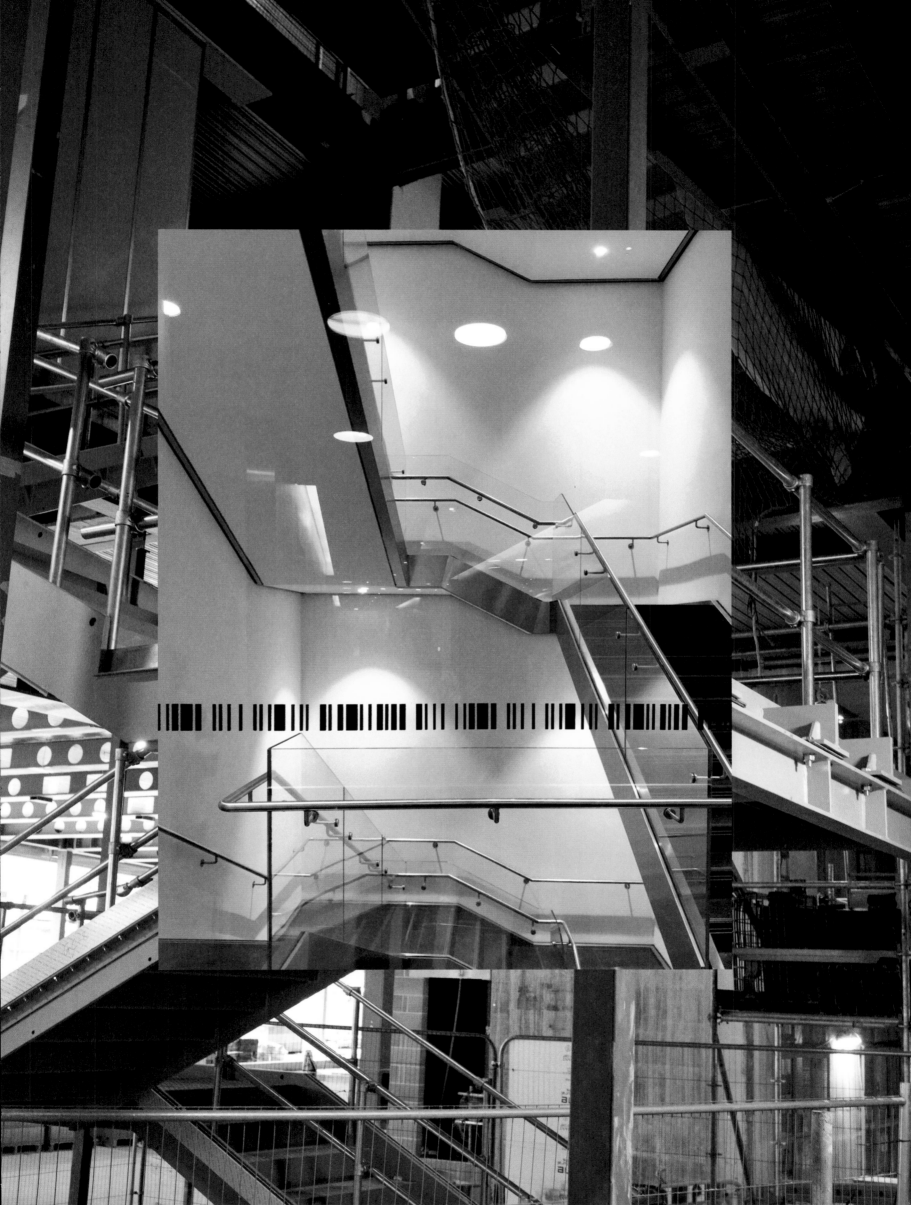

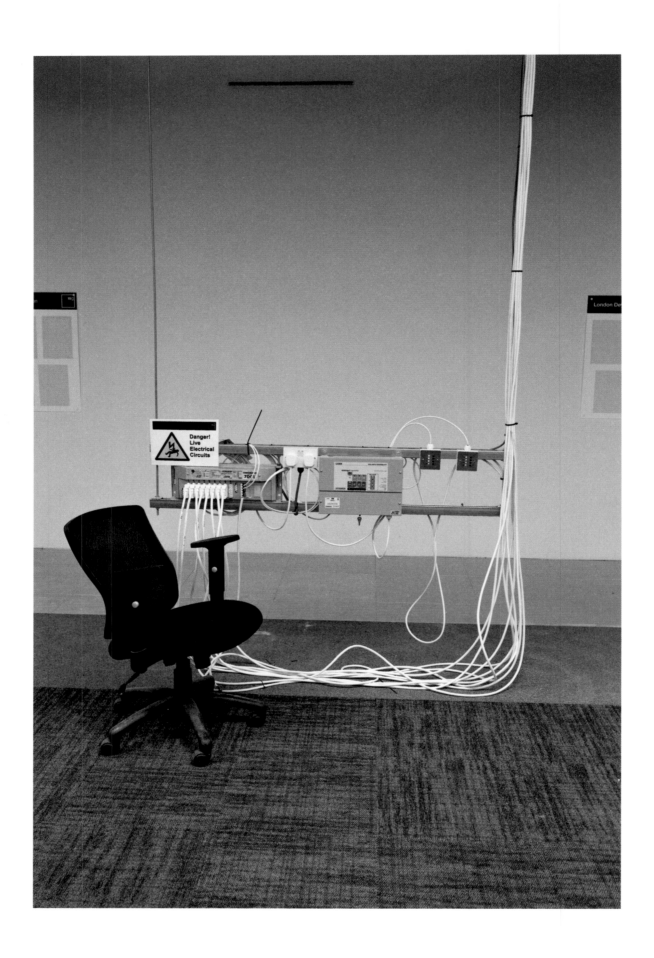

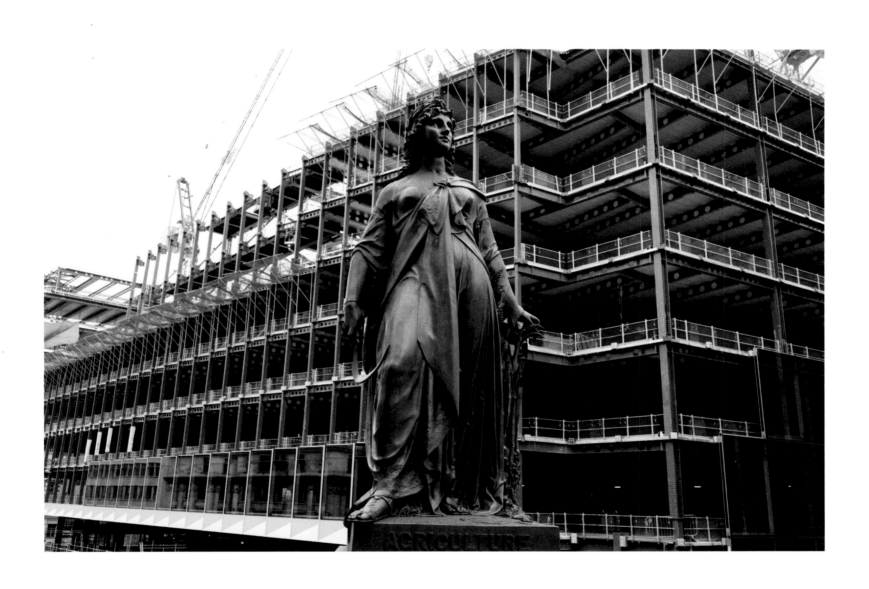

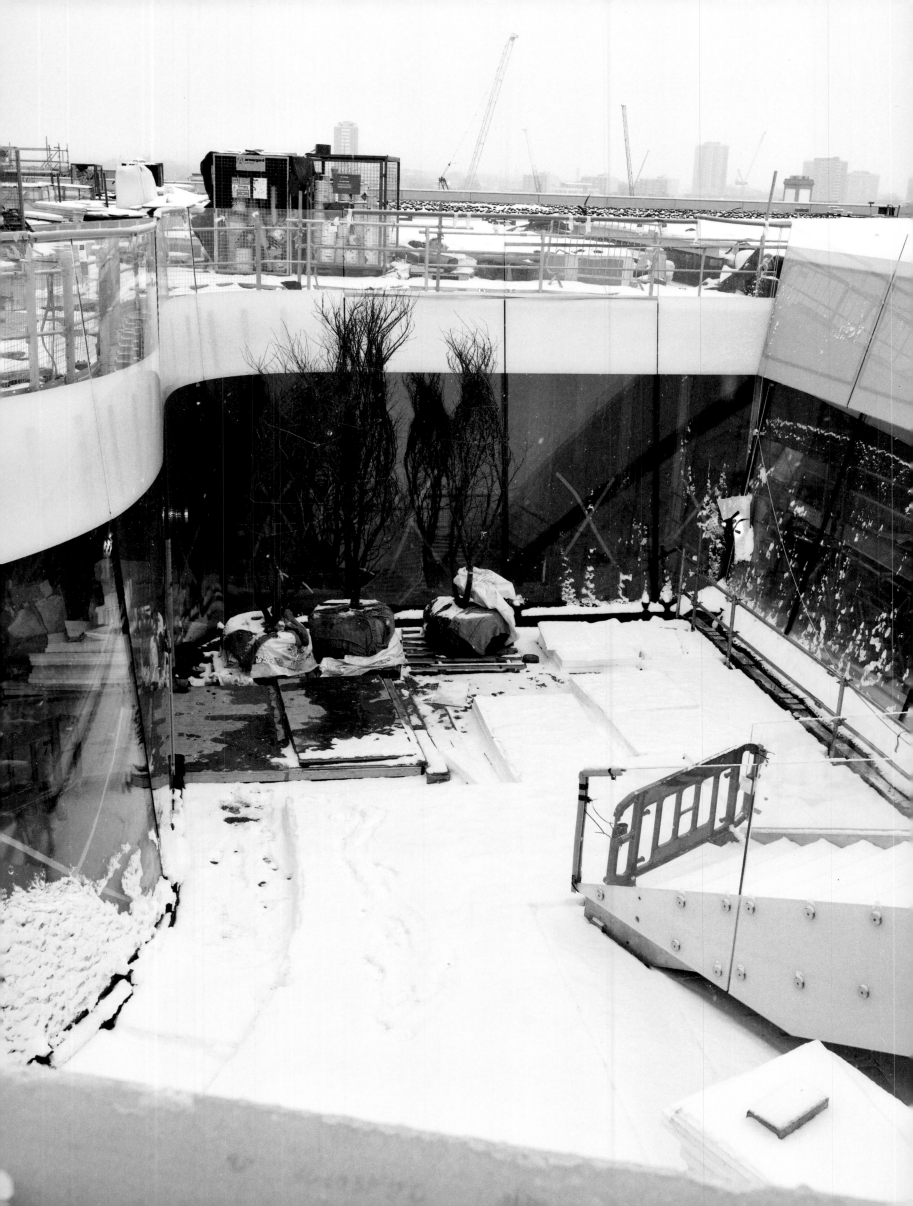

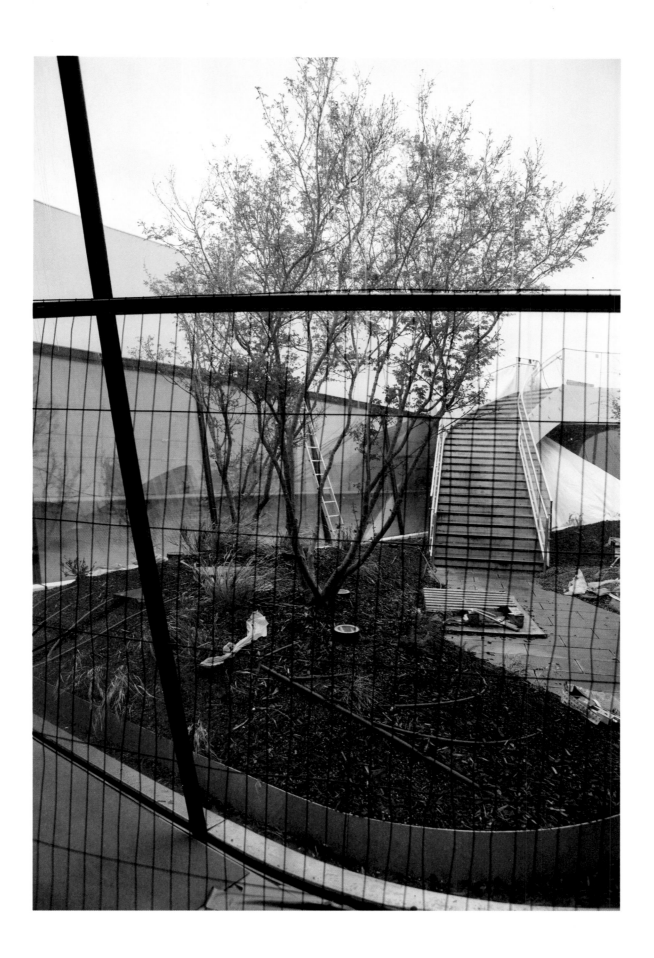

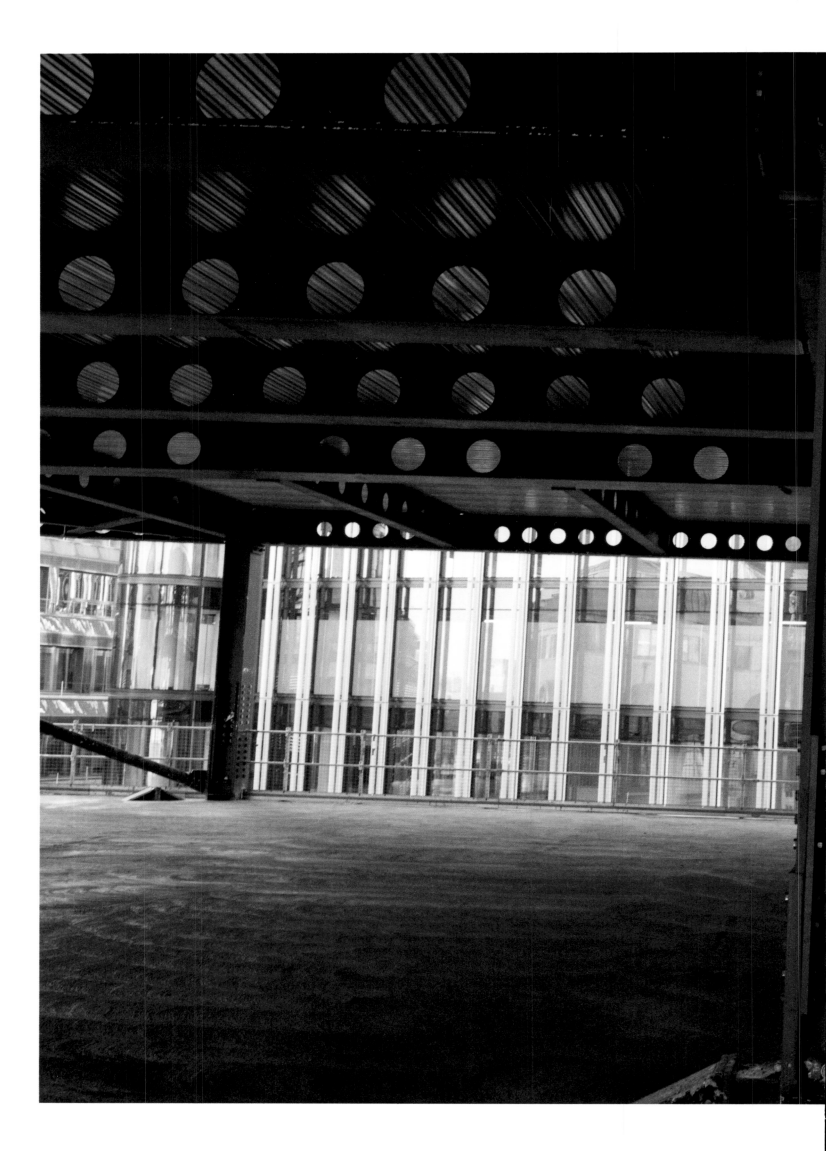

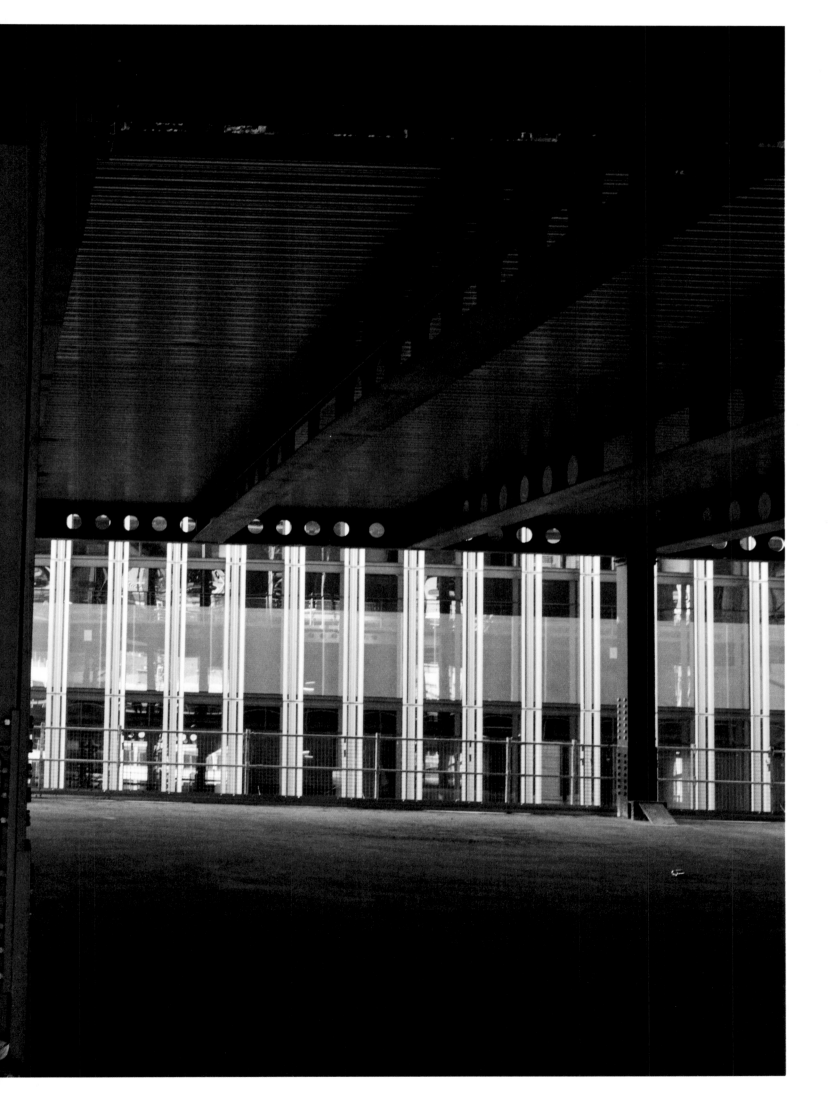

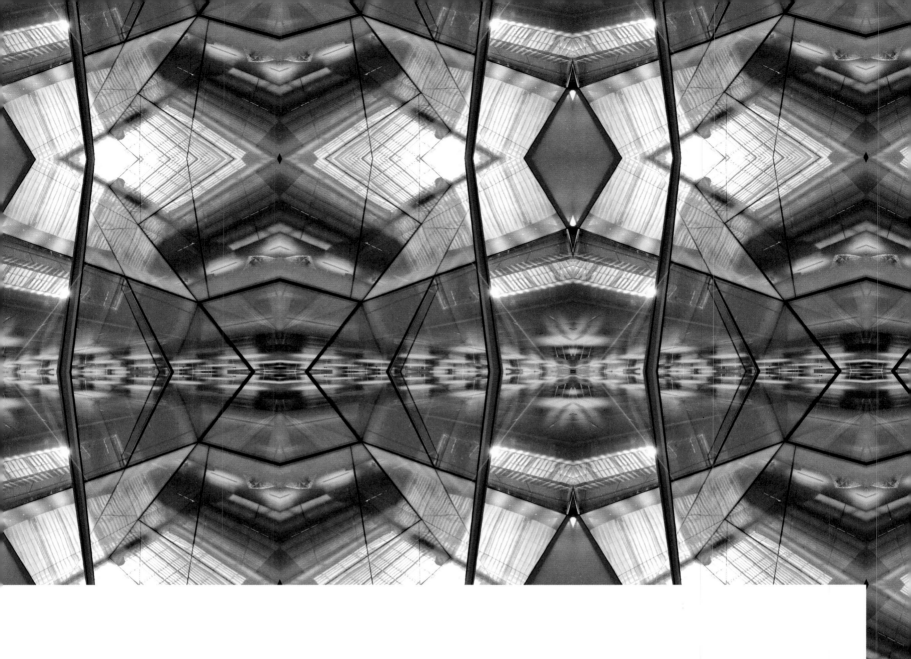

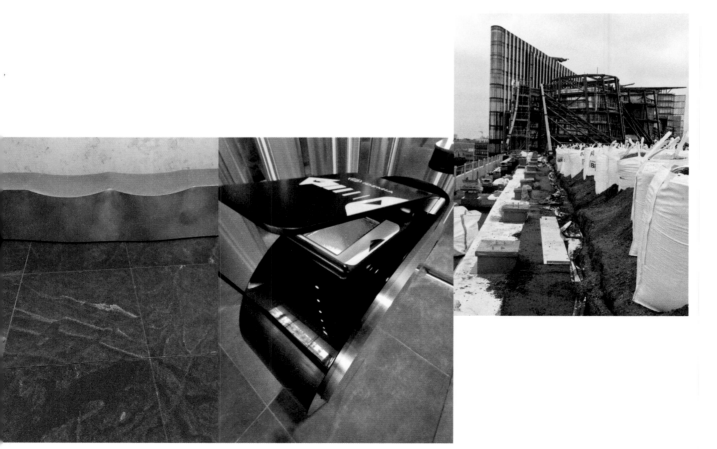

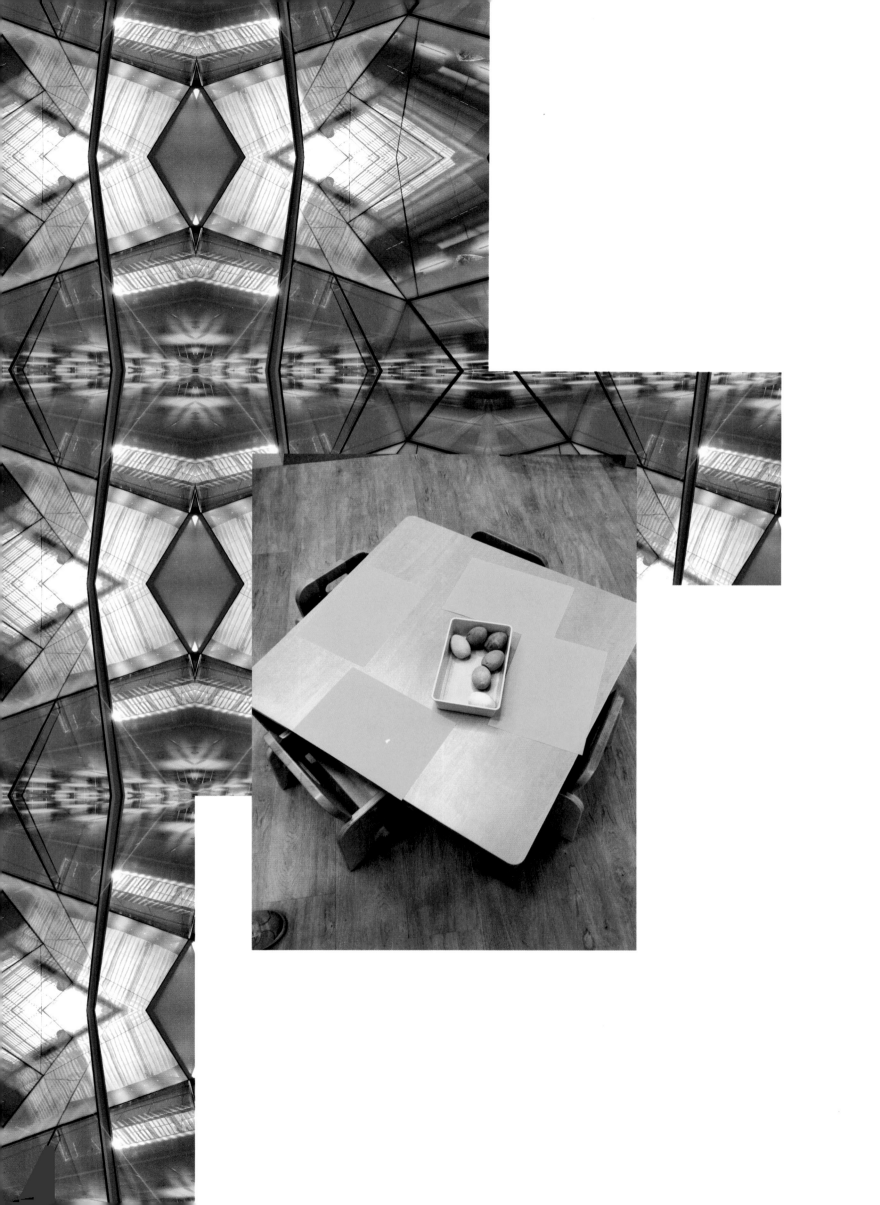

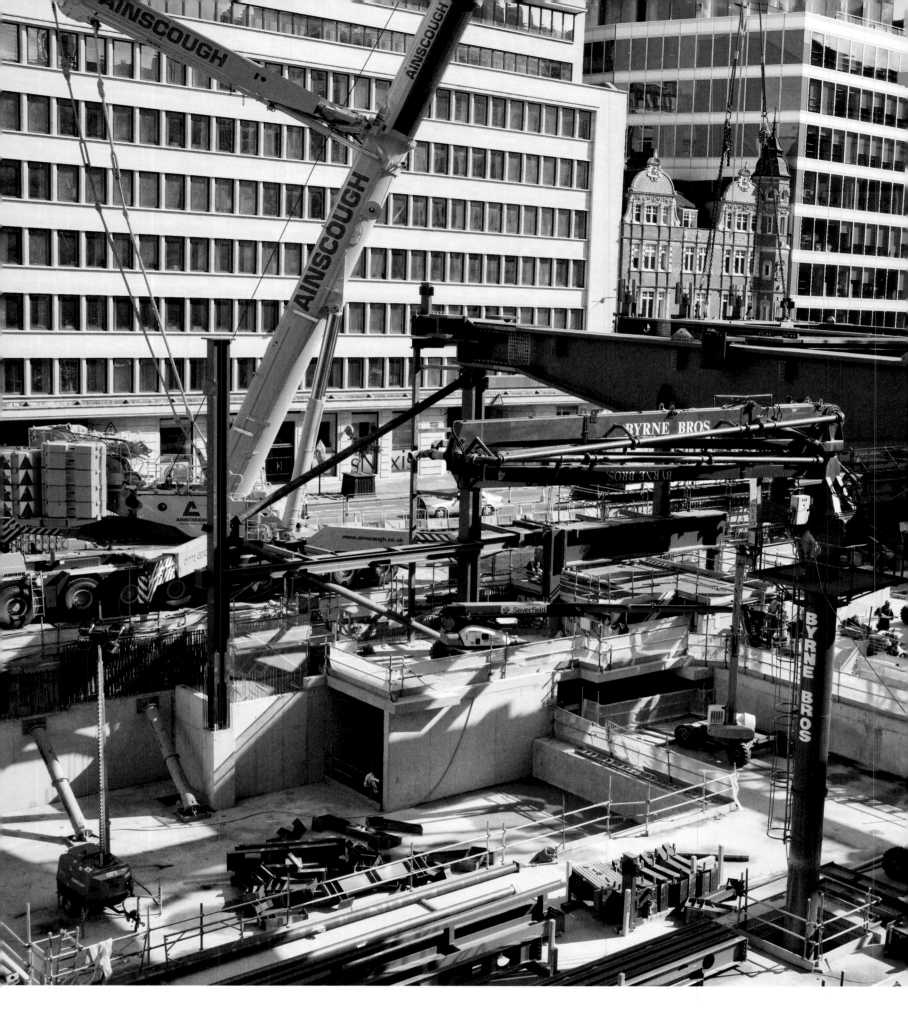

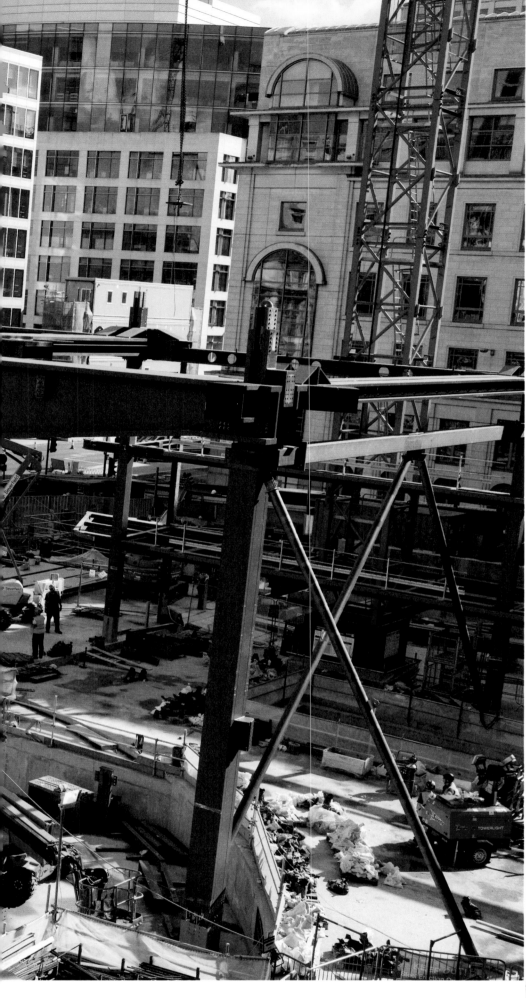

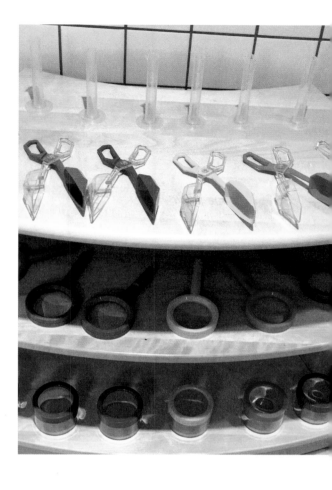

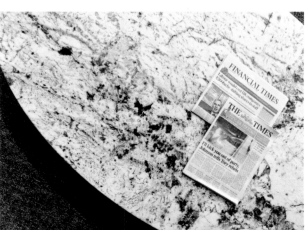

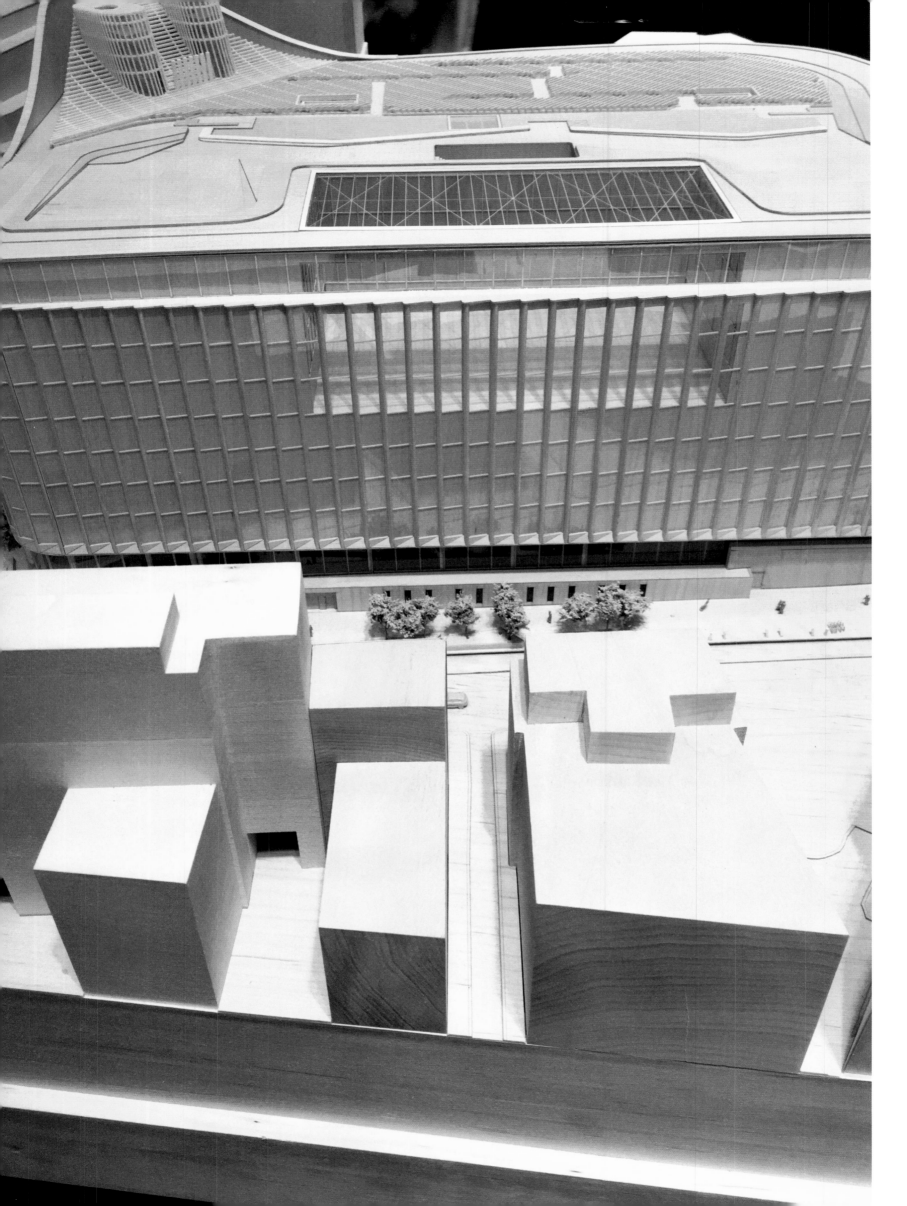

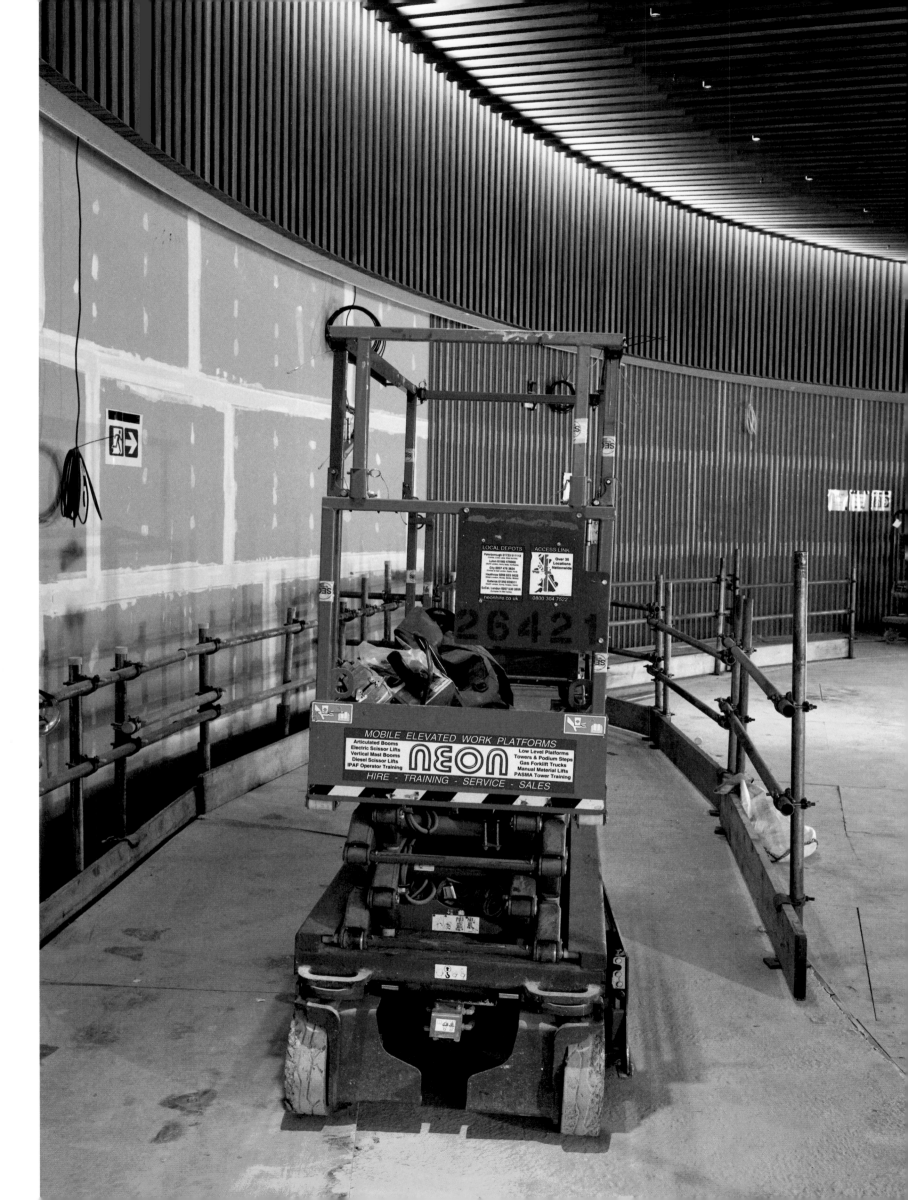

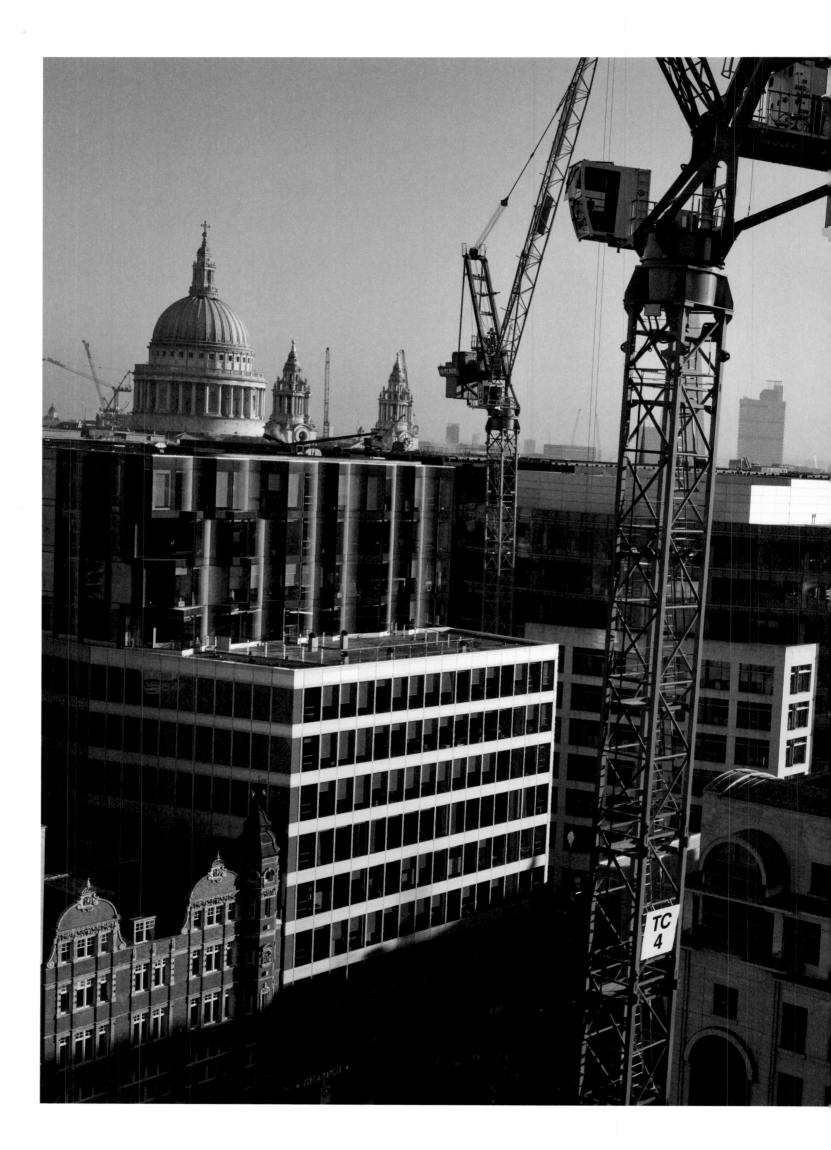

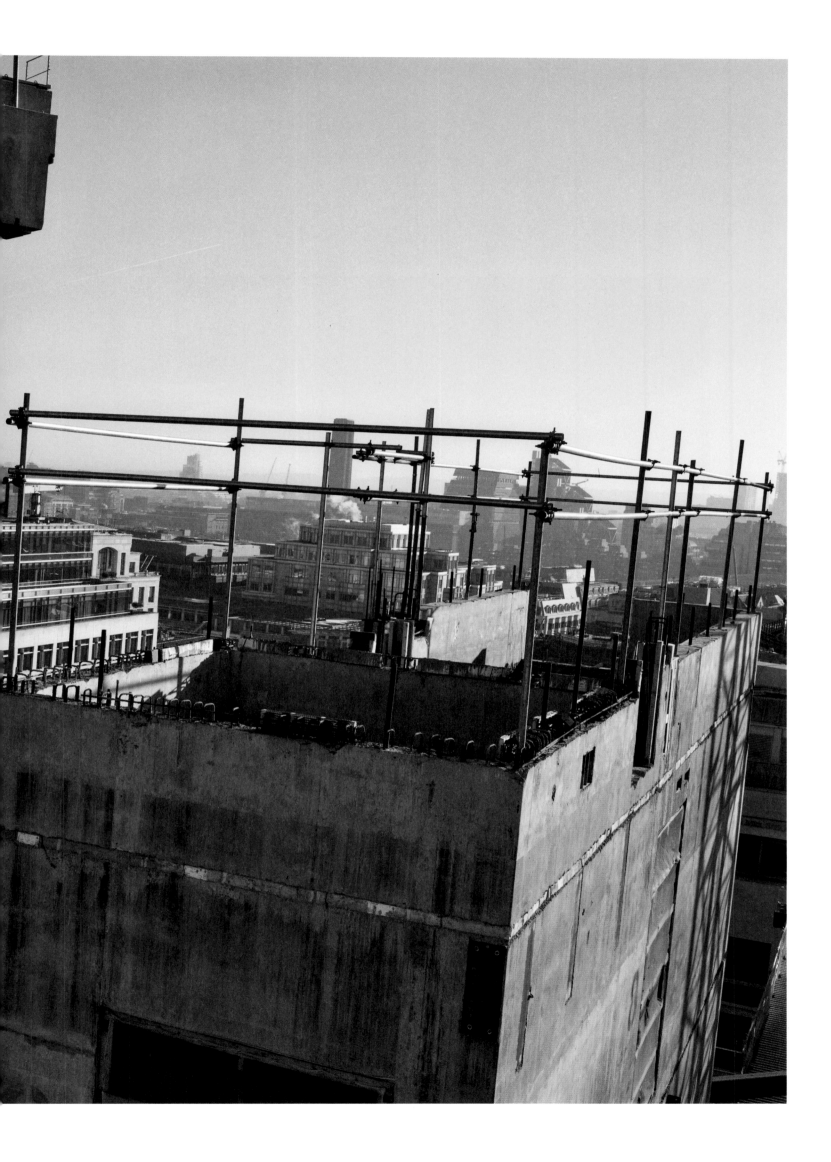

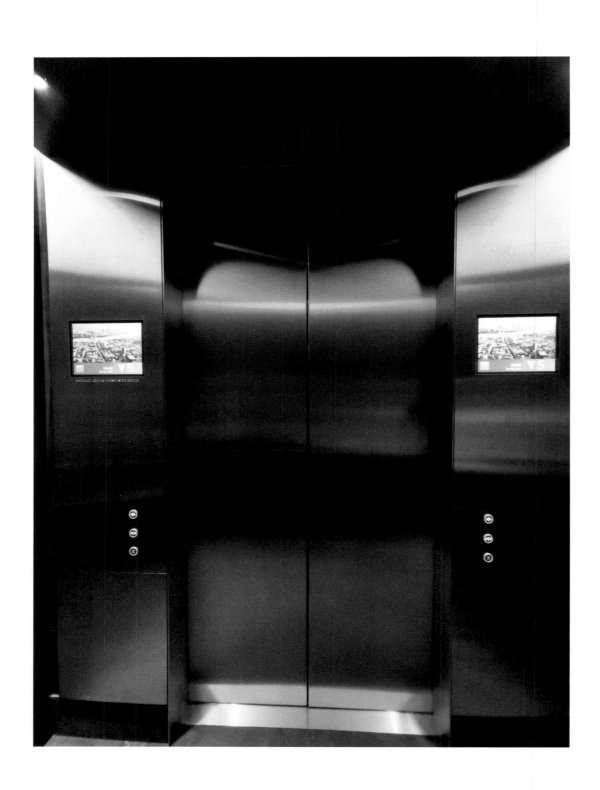

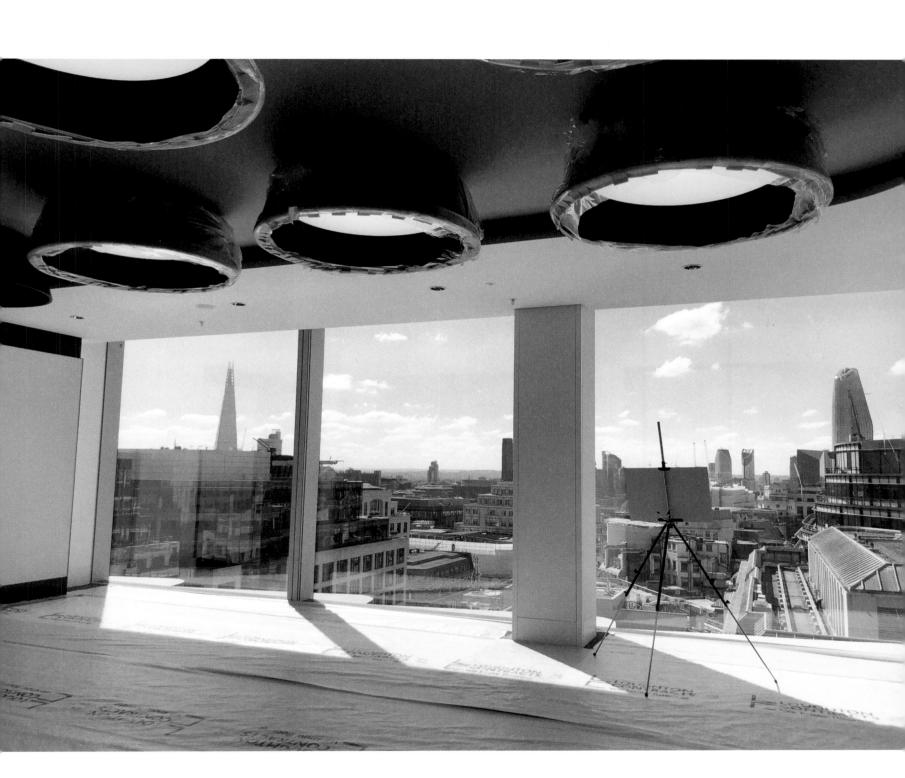

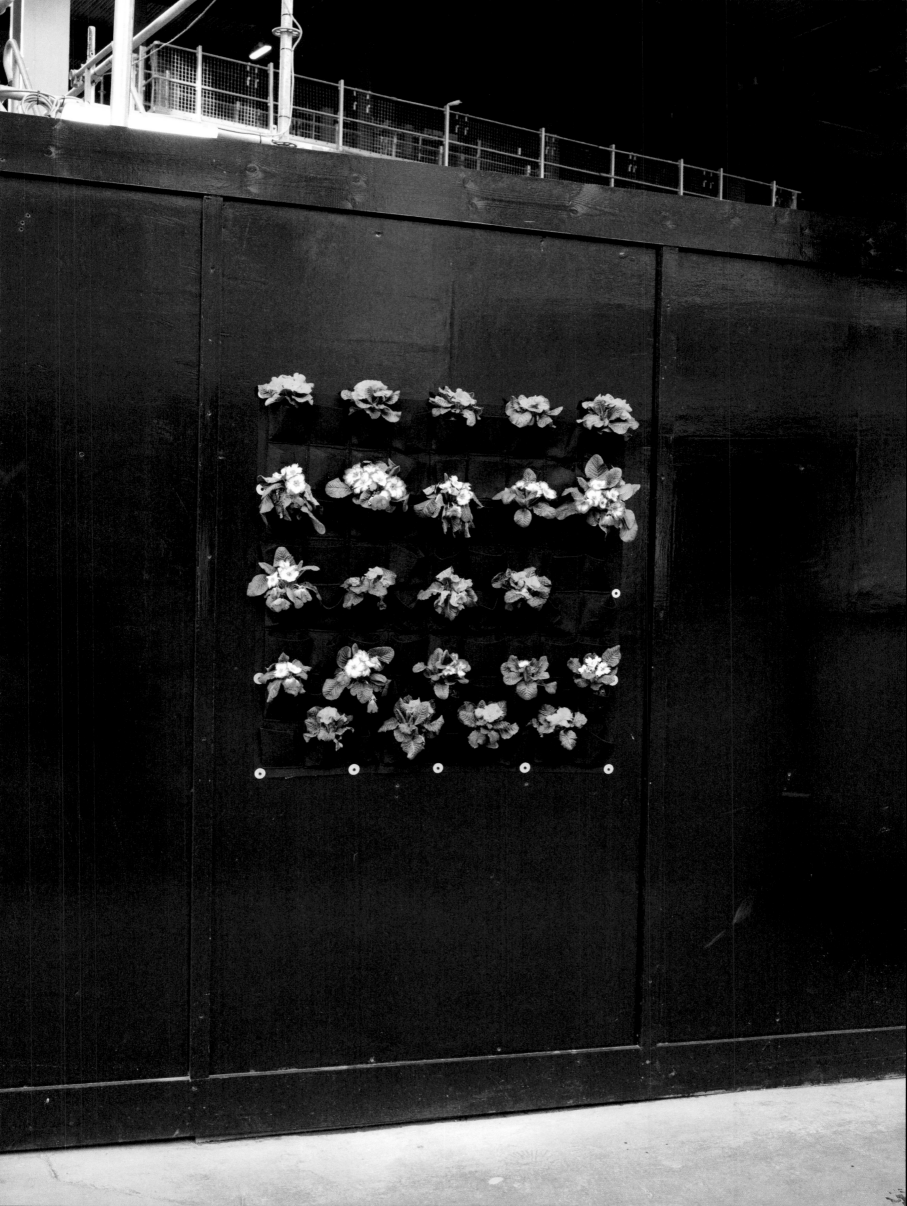

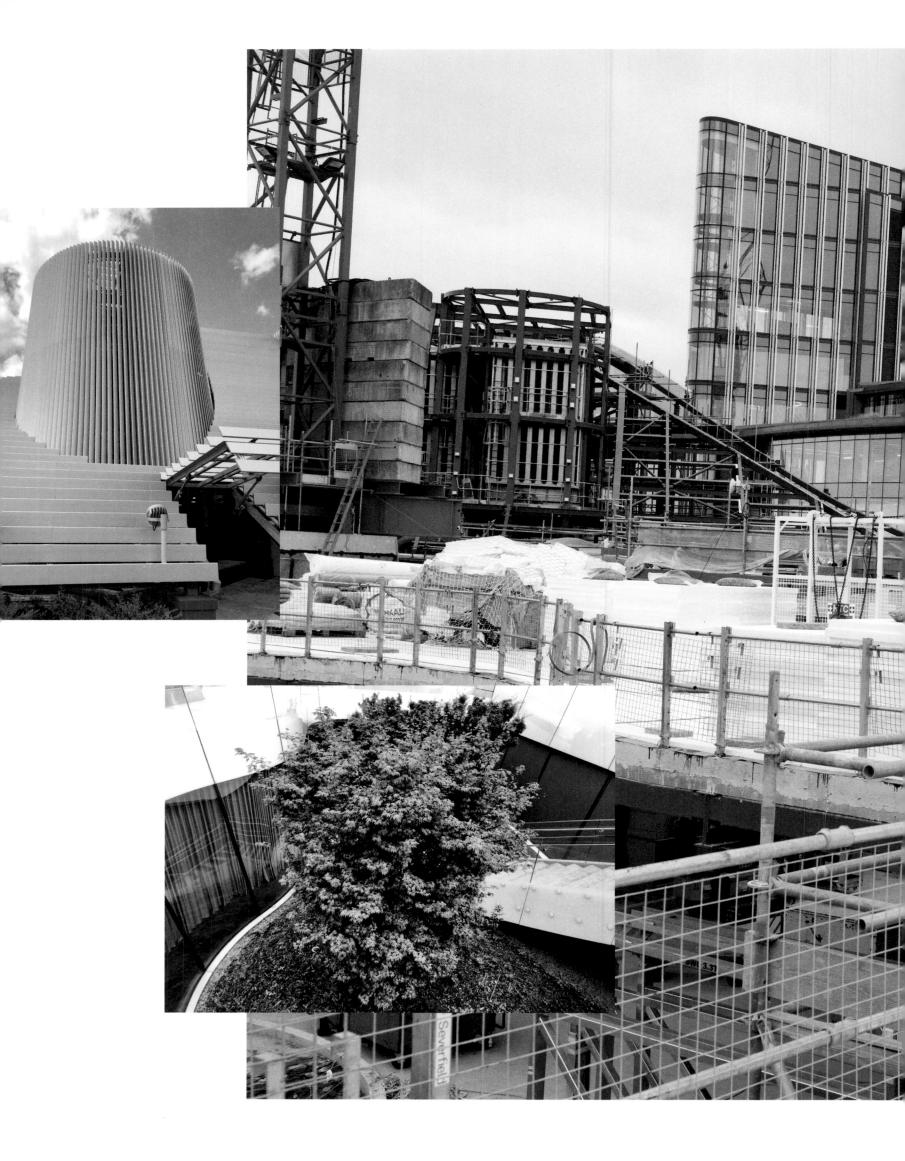

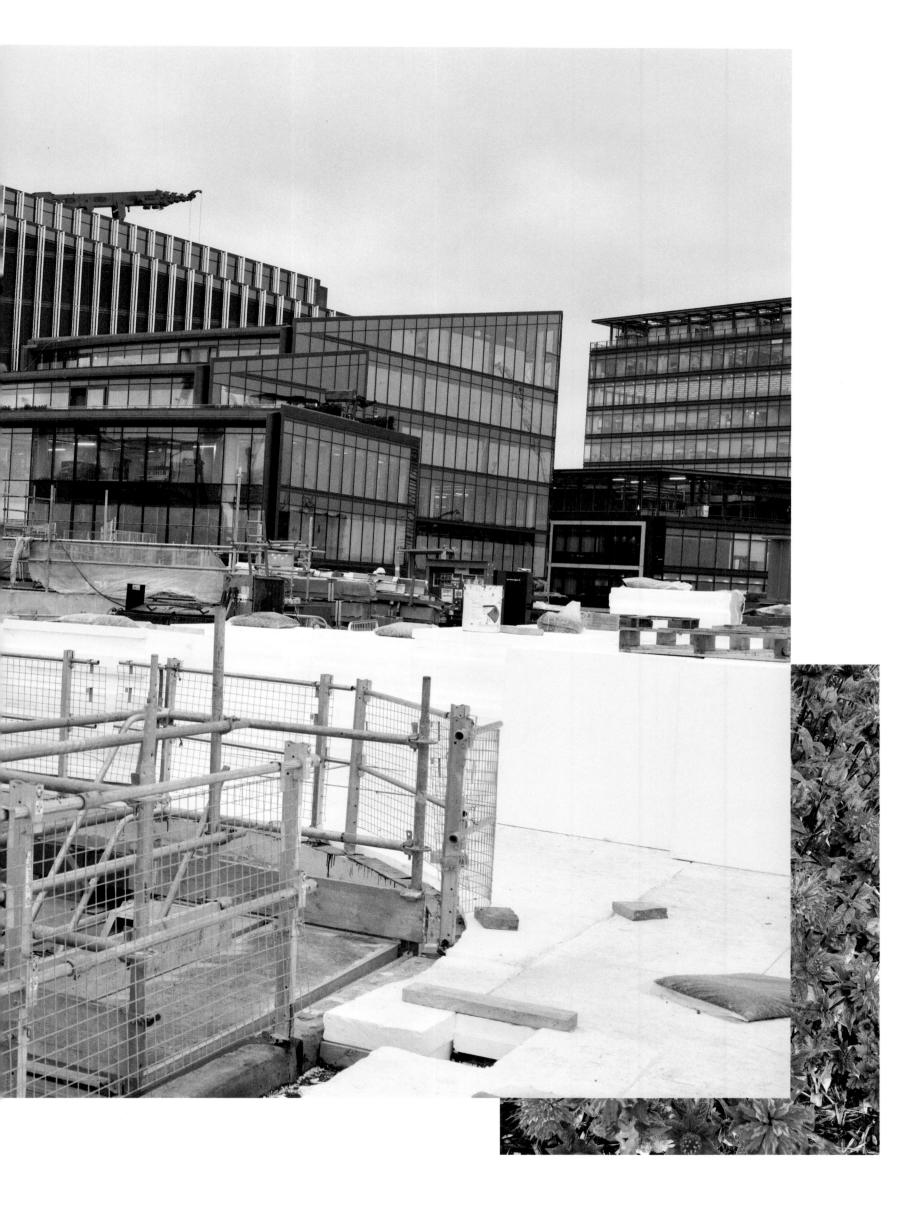

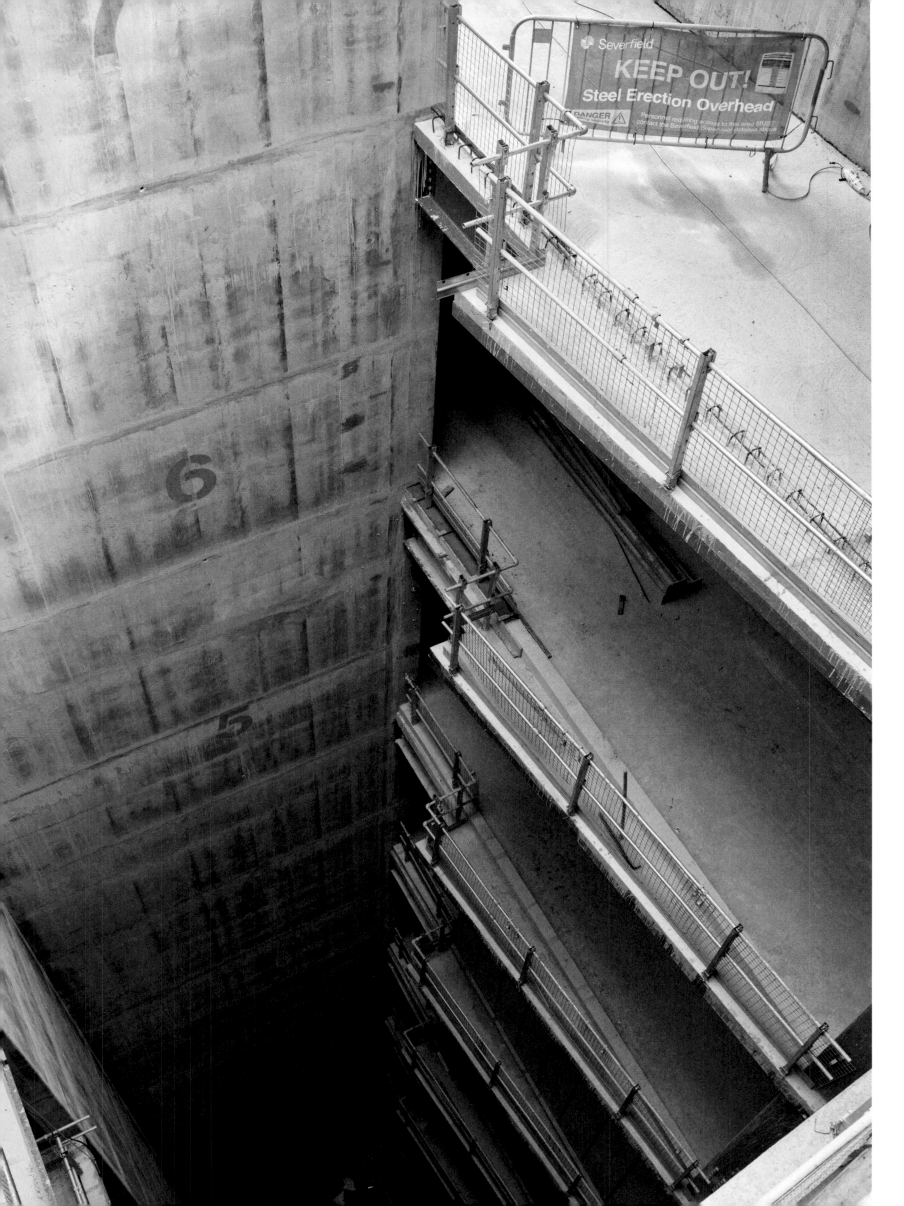

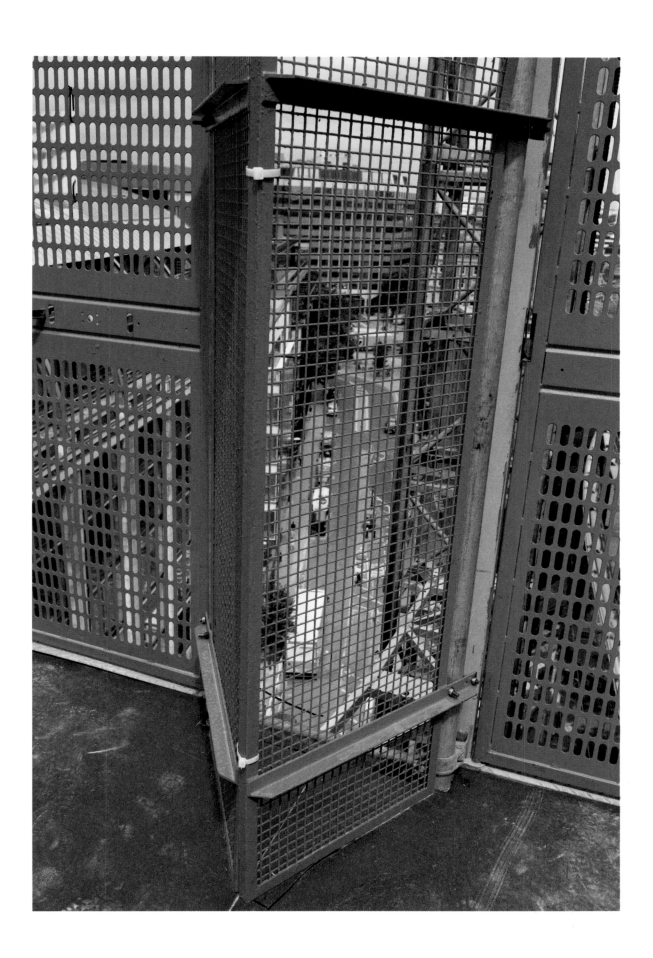

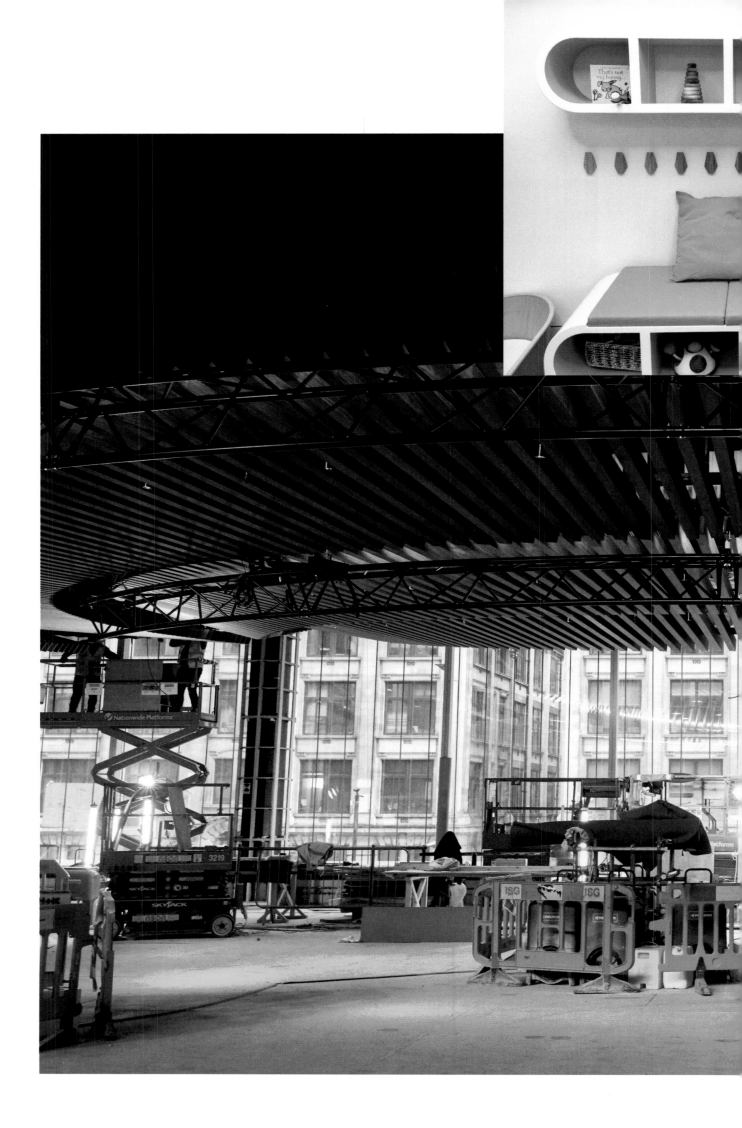

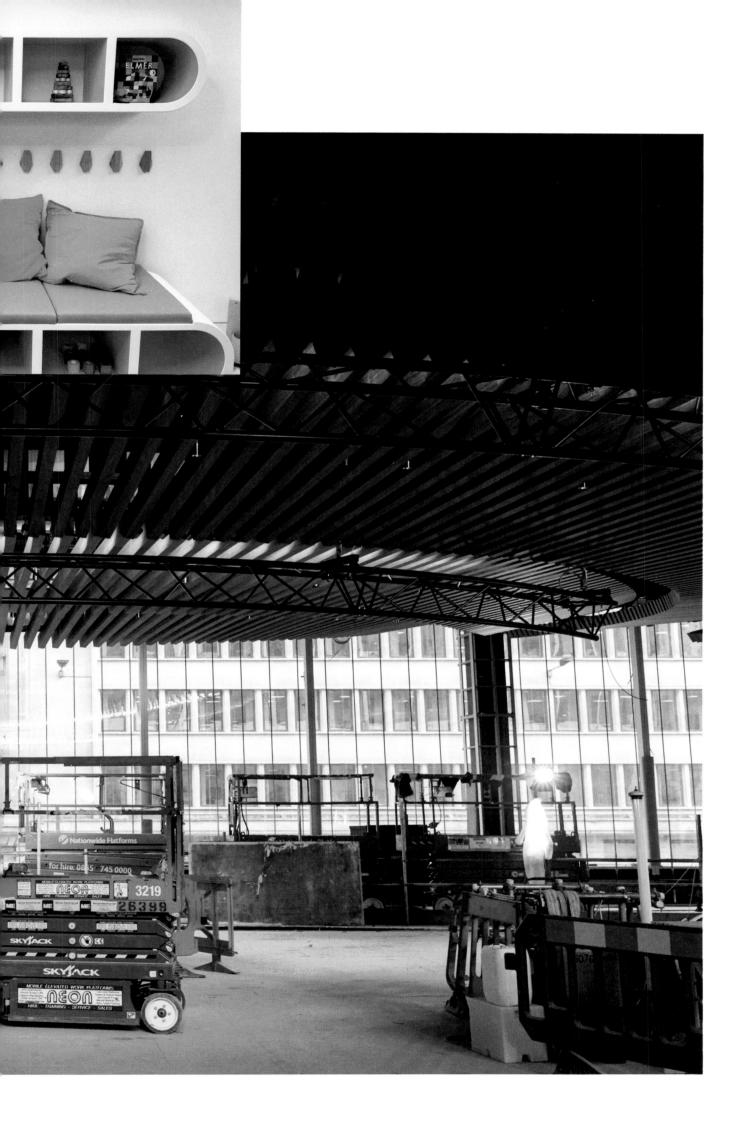

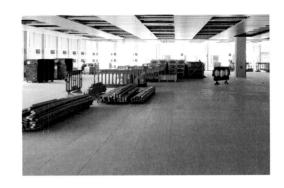 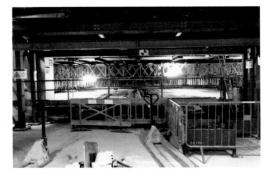

 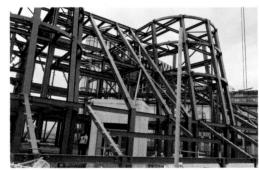 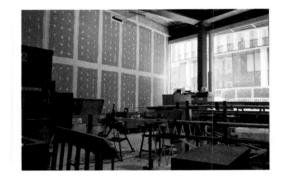

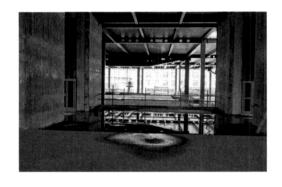 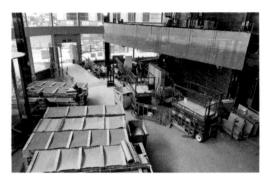 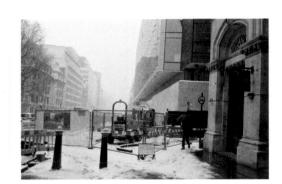

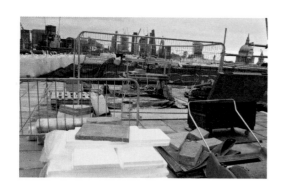
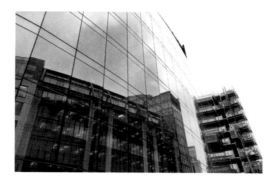
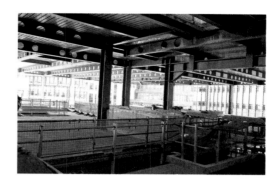
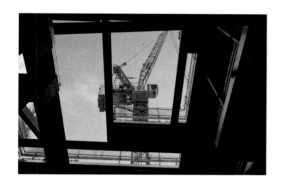
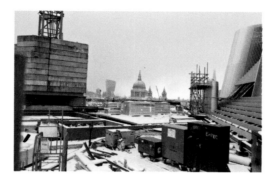
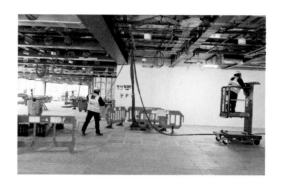
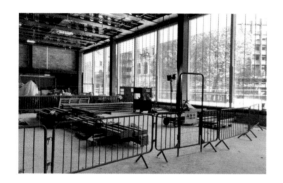
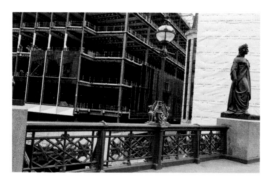
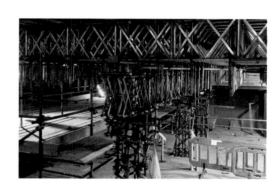

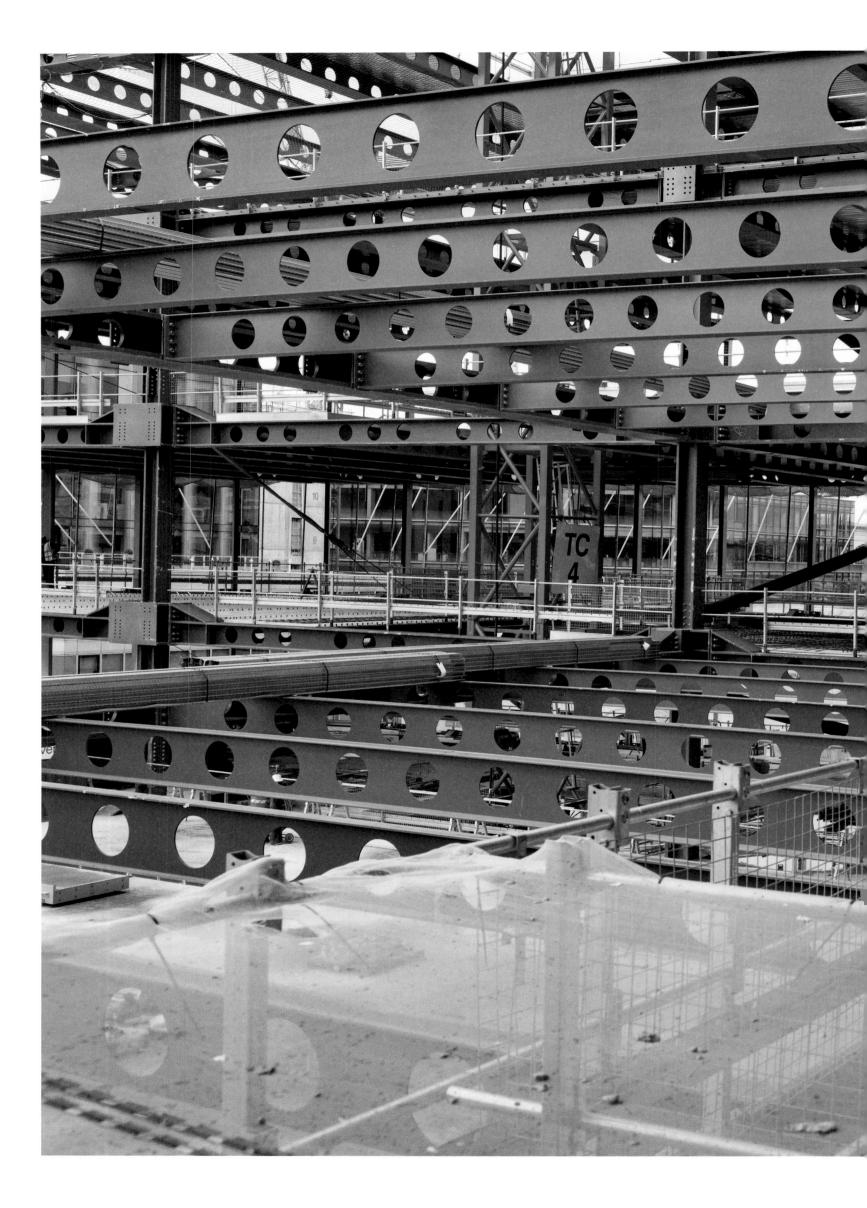

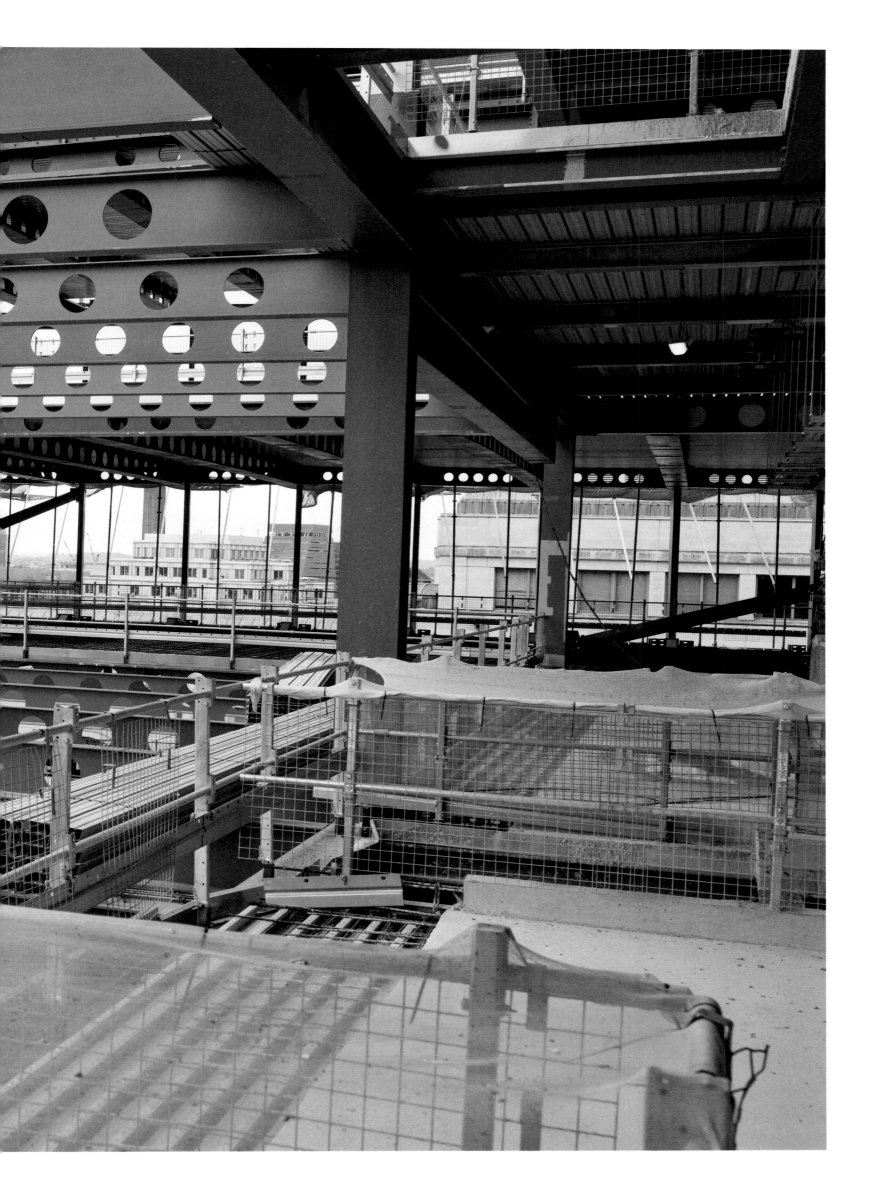

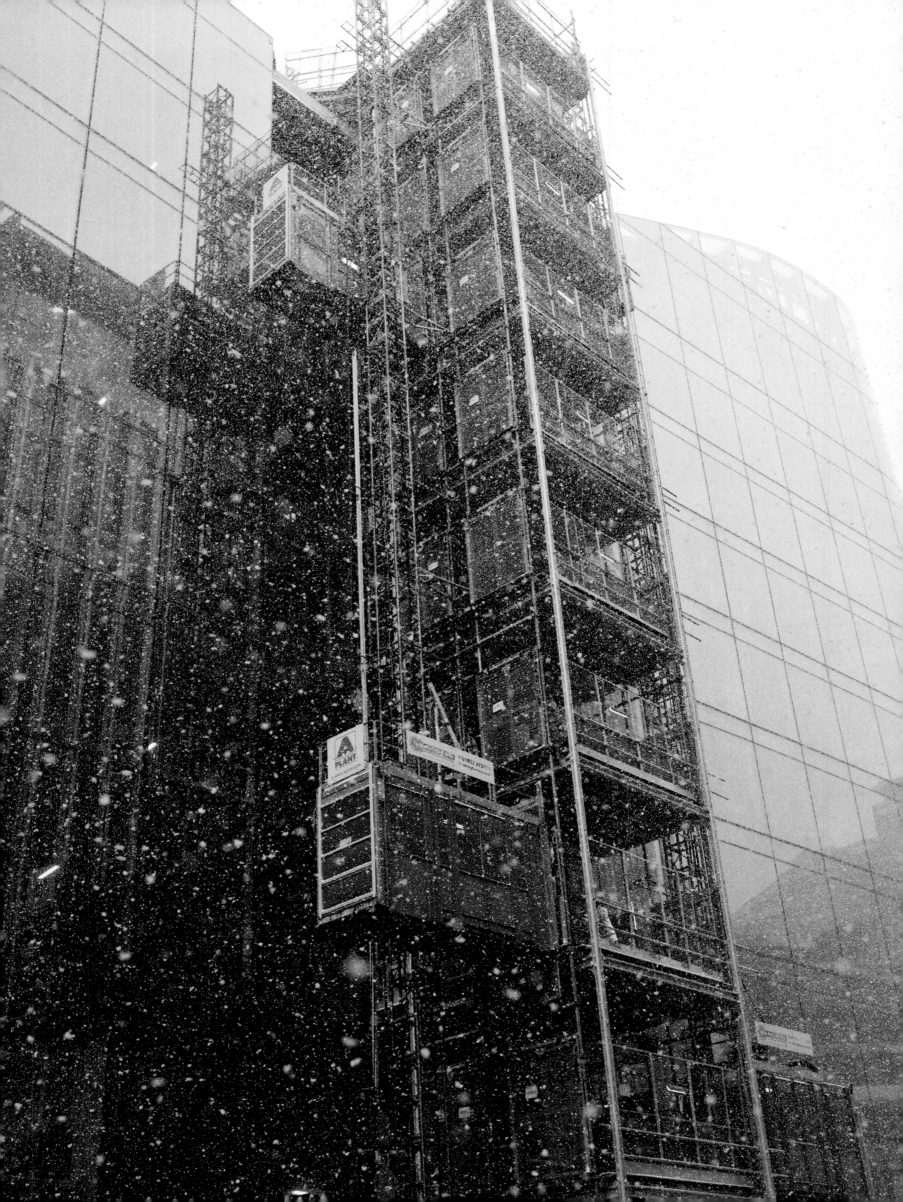

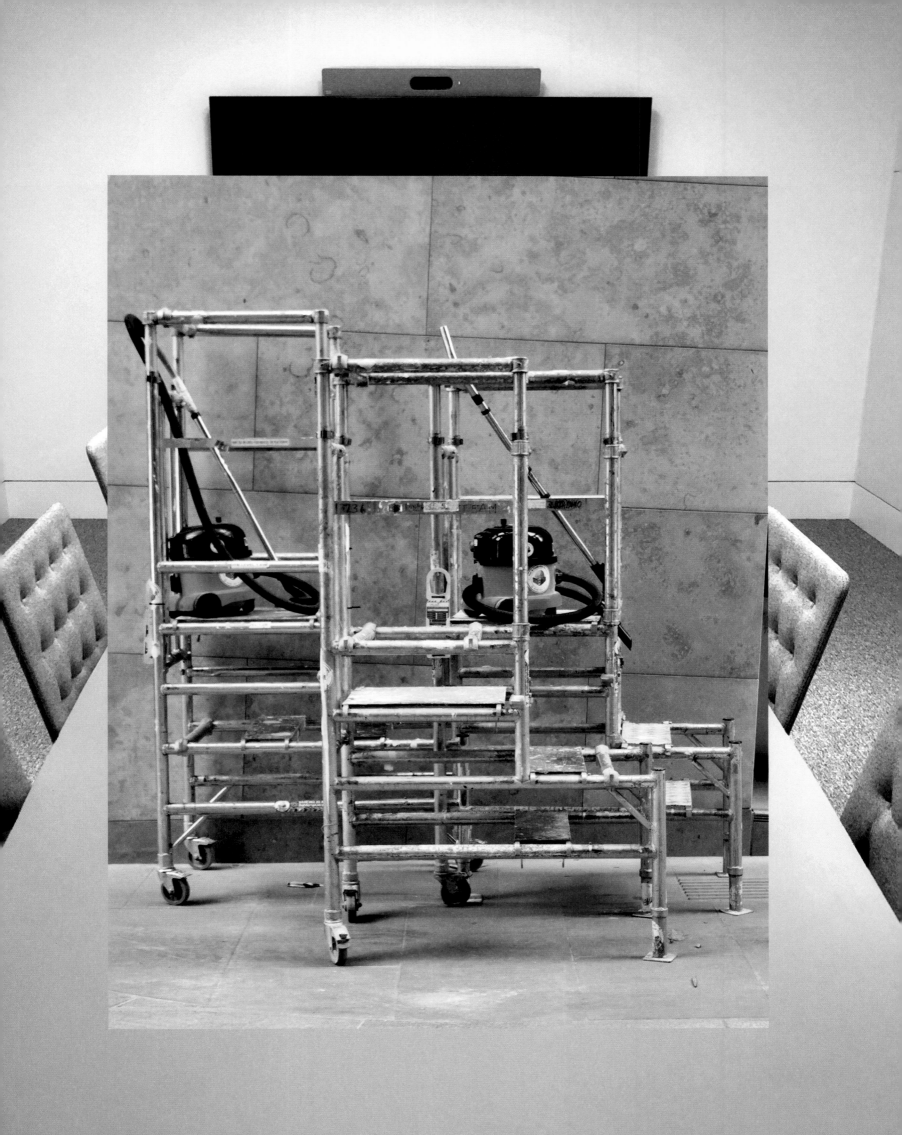

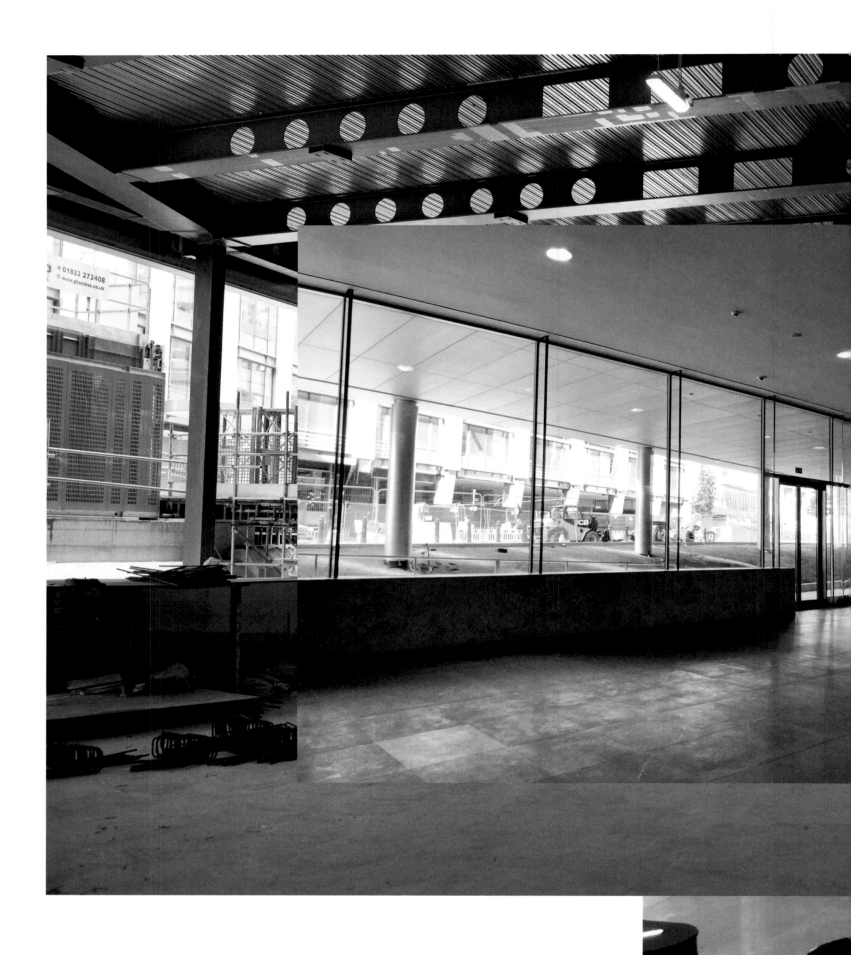

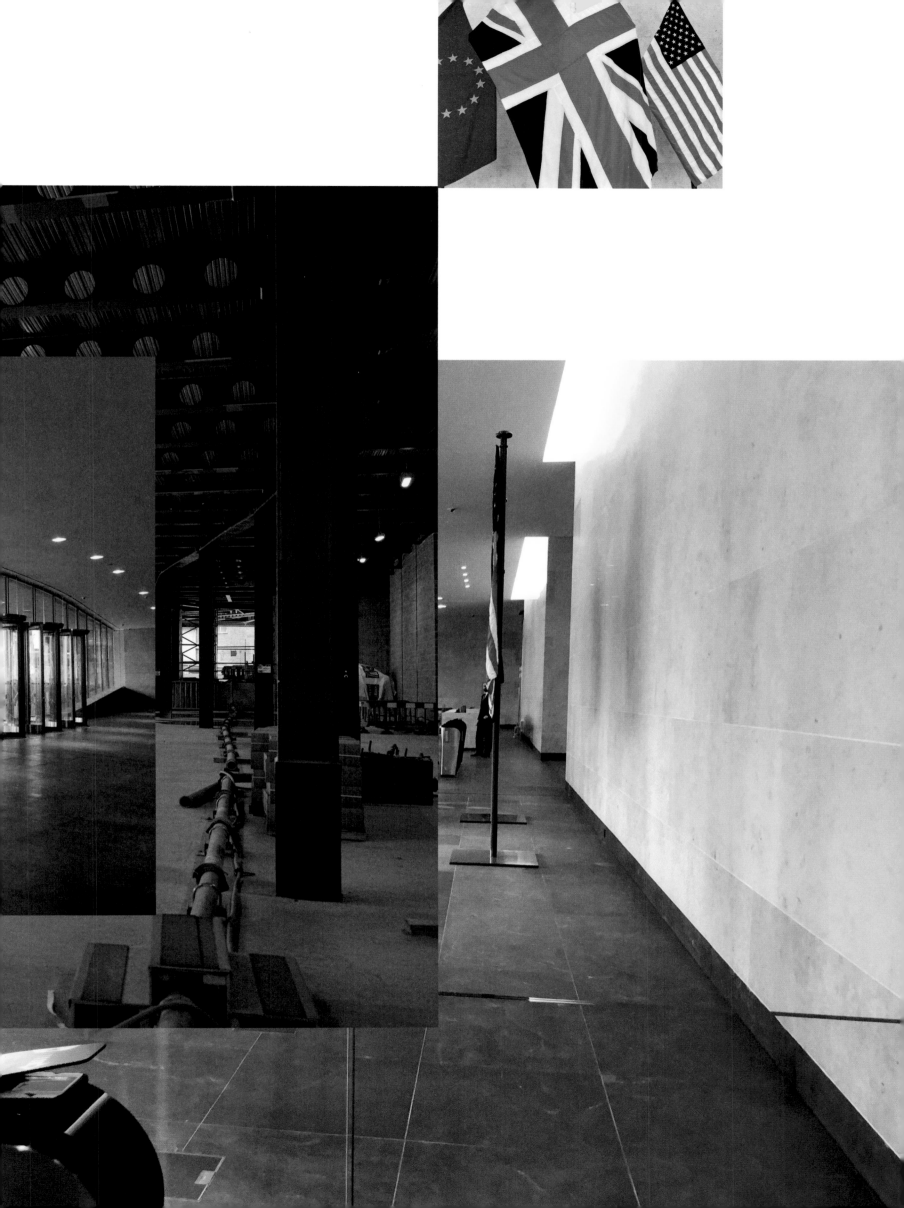

DEMOLITION AND ENABLING WORKS

SPIDERS WEB OF TEMPORARY WORKS

BASEMENT CONSTRUCTION

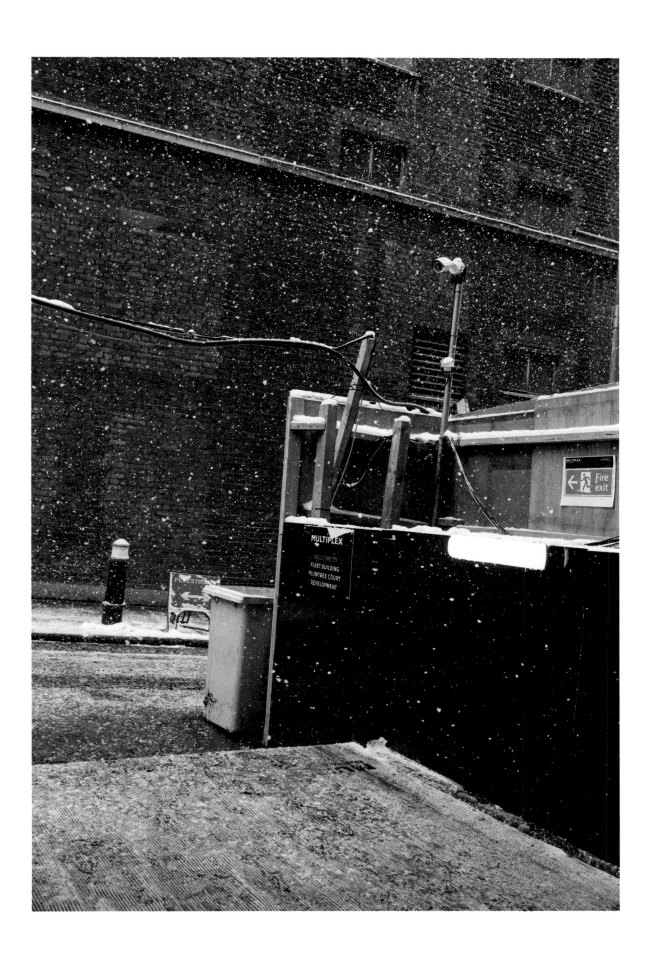

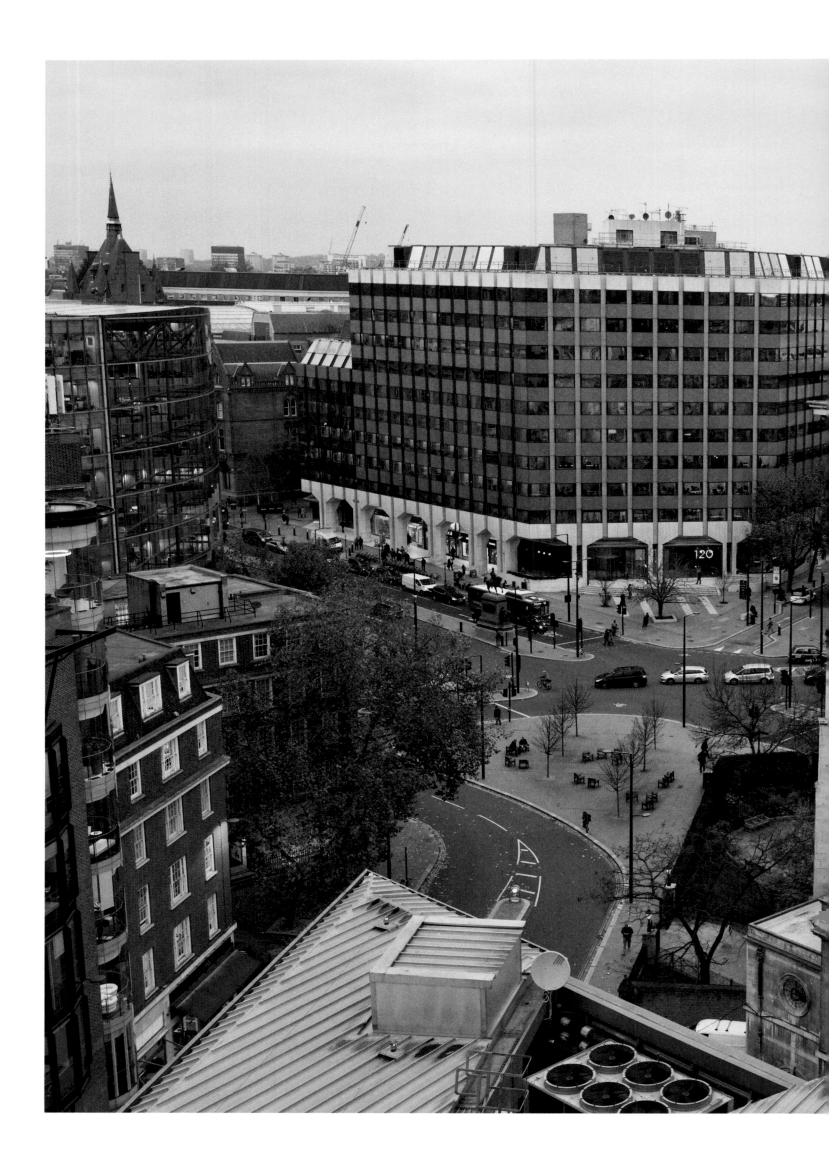

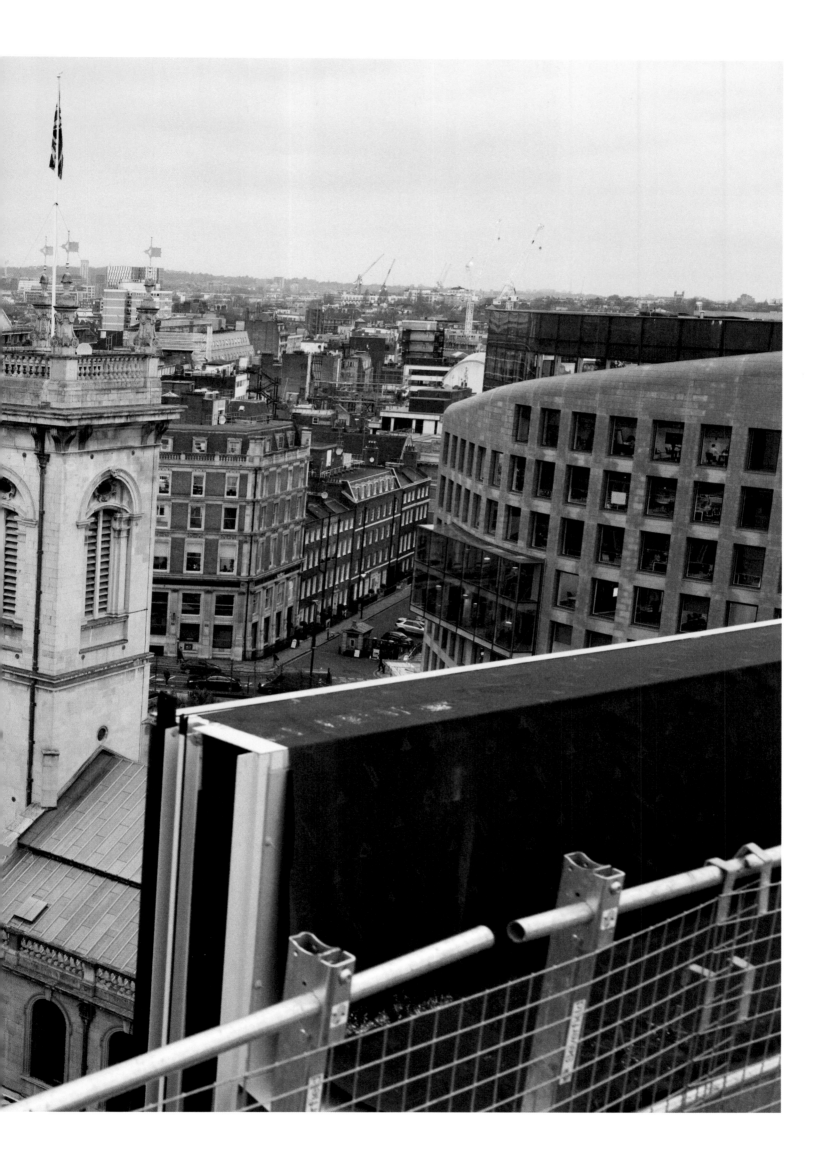

 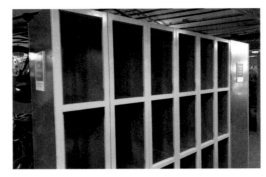 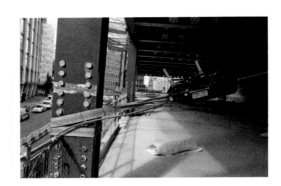

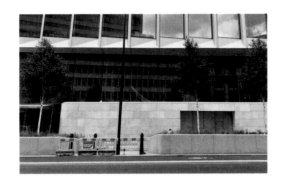 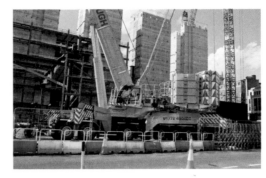 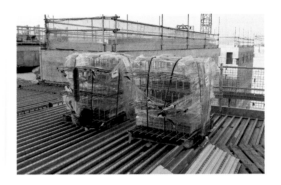

 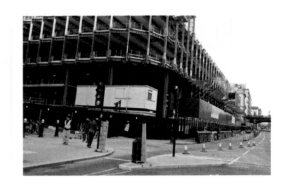

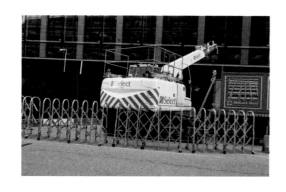 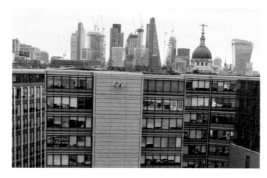 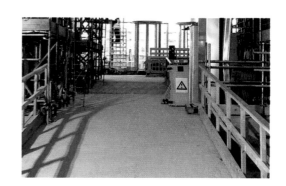

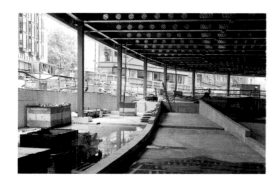 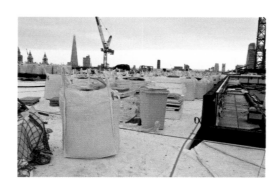 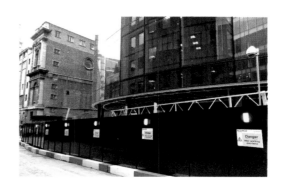

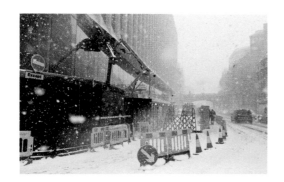 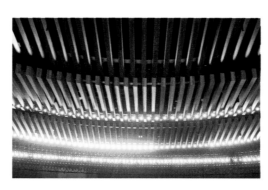 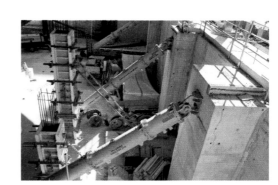

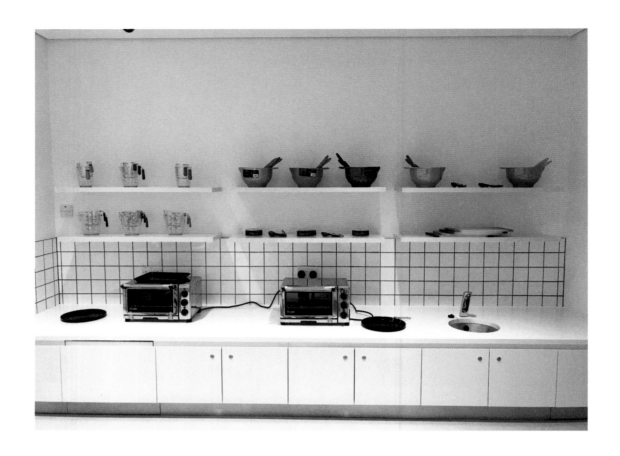

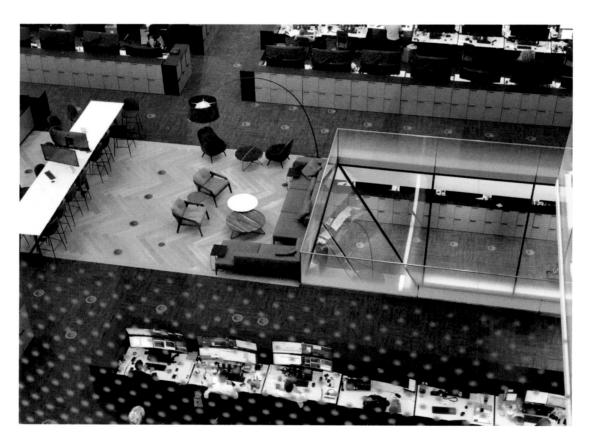

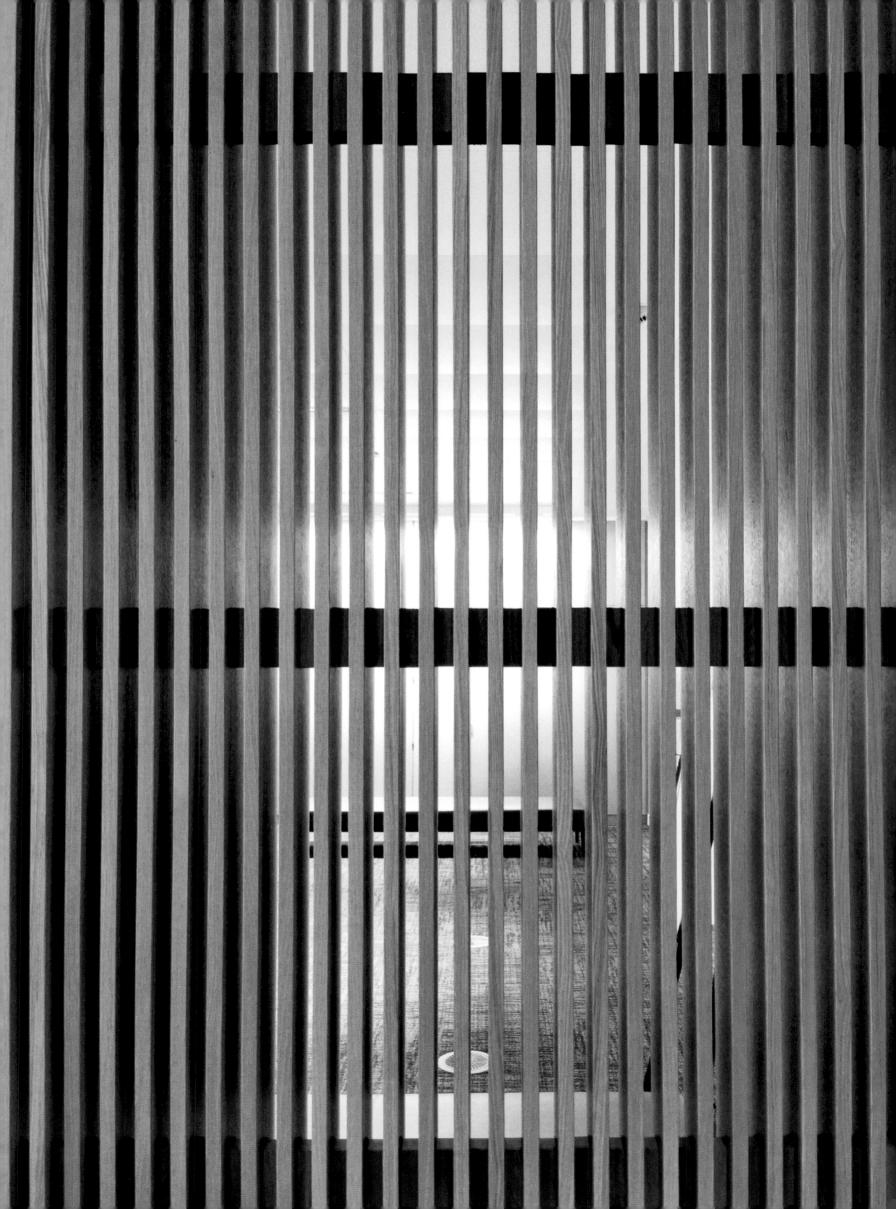

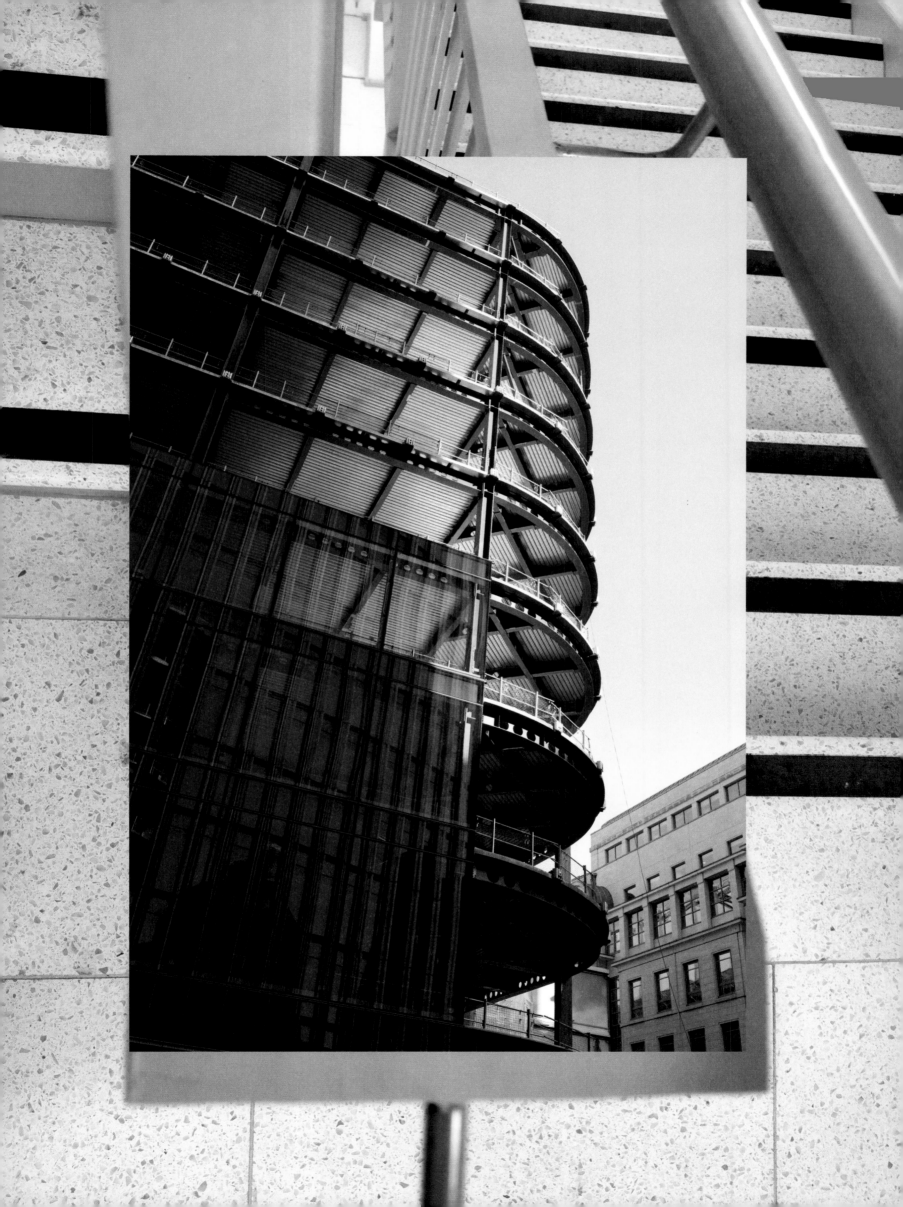

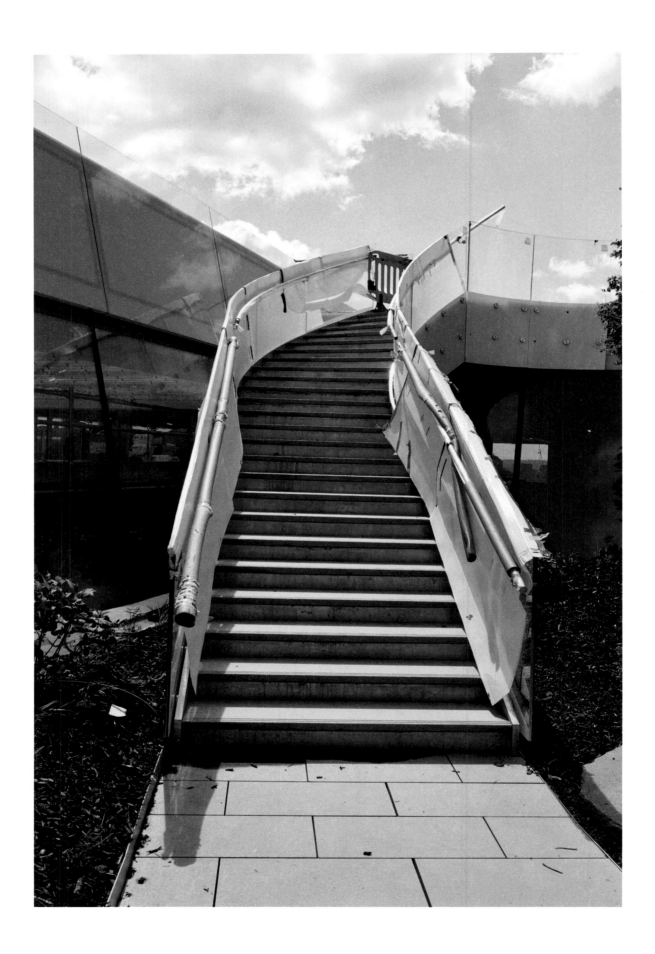

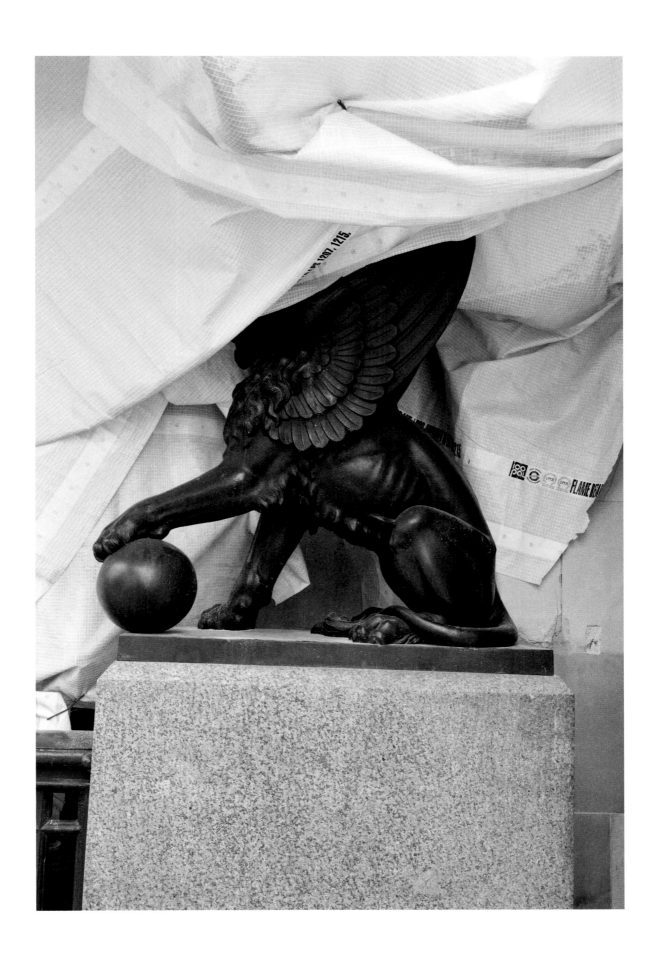

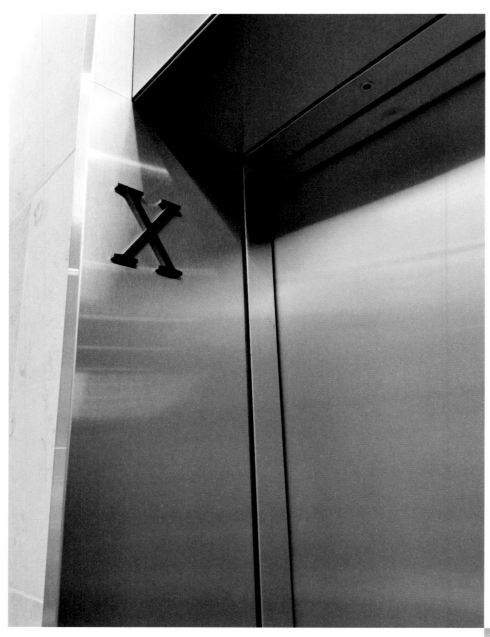
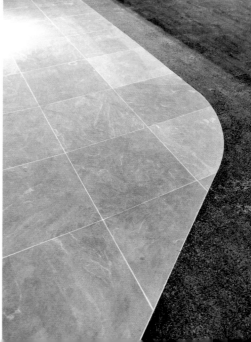

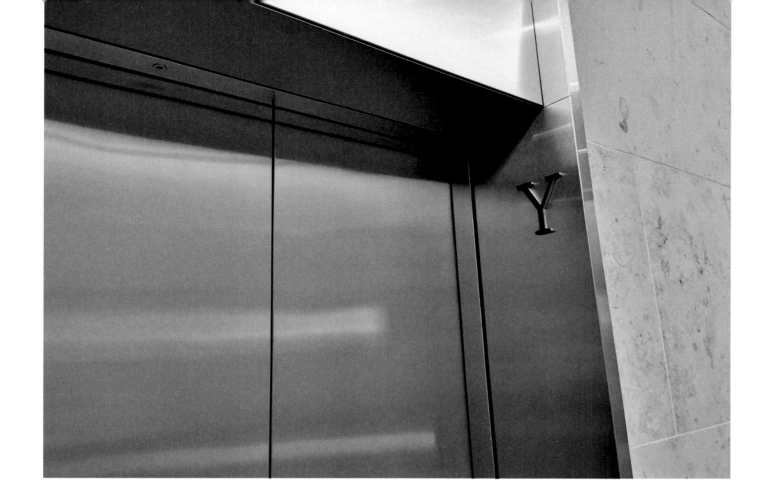

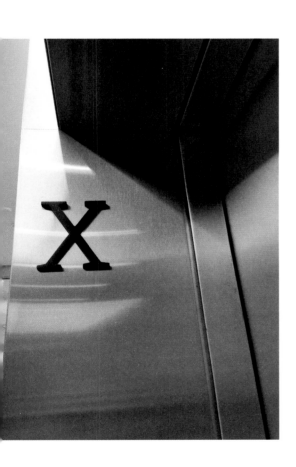

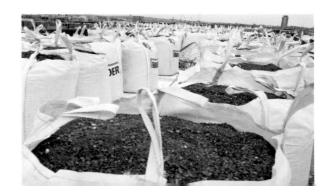

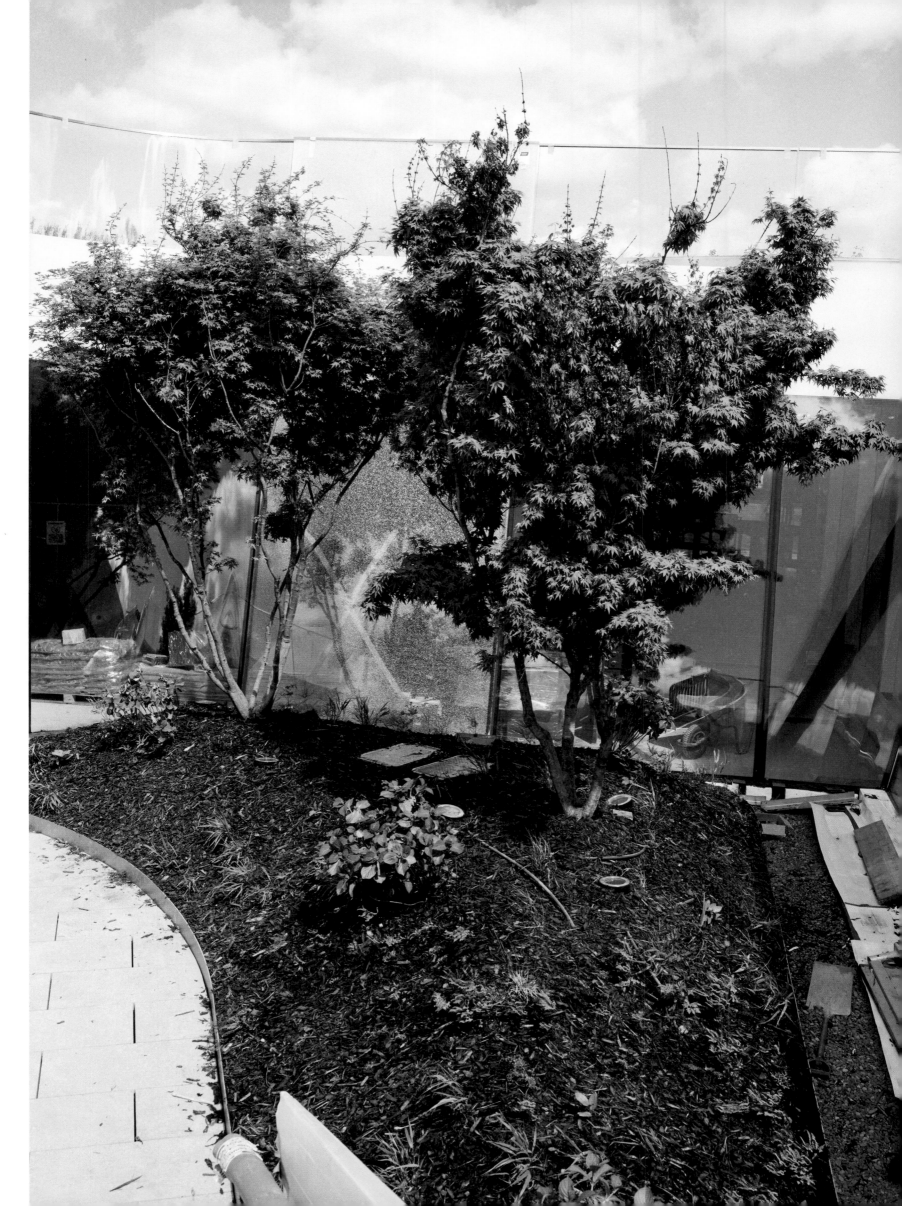

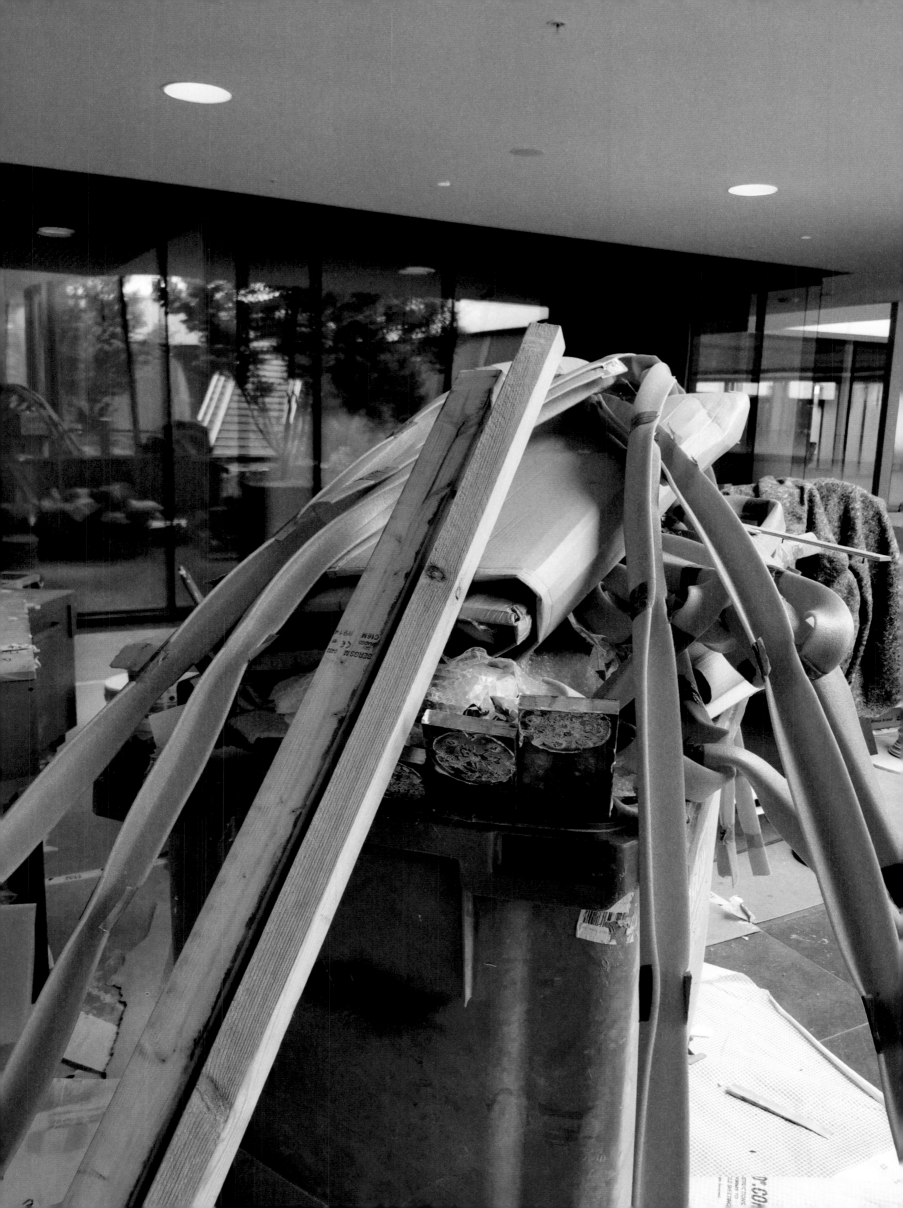

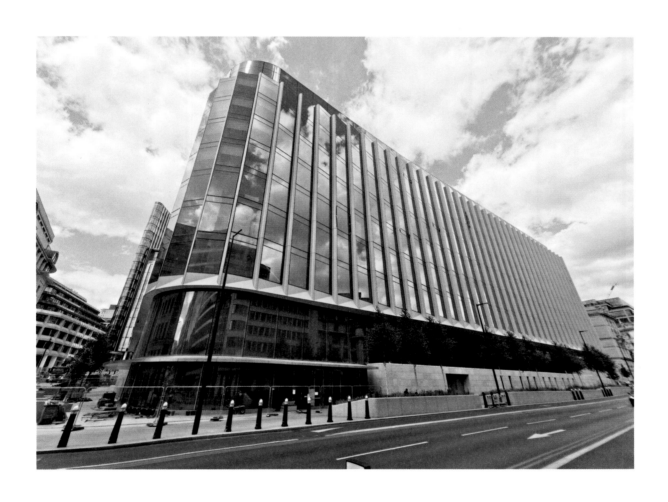

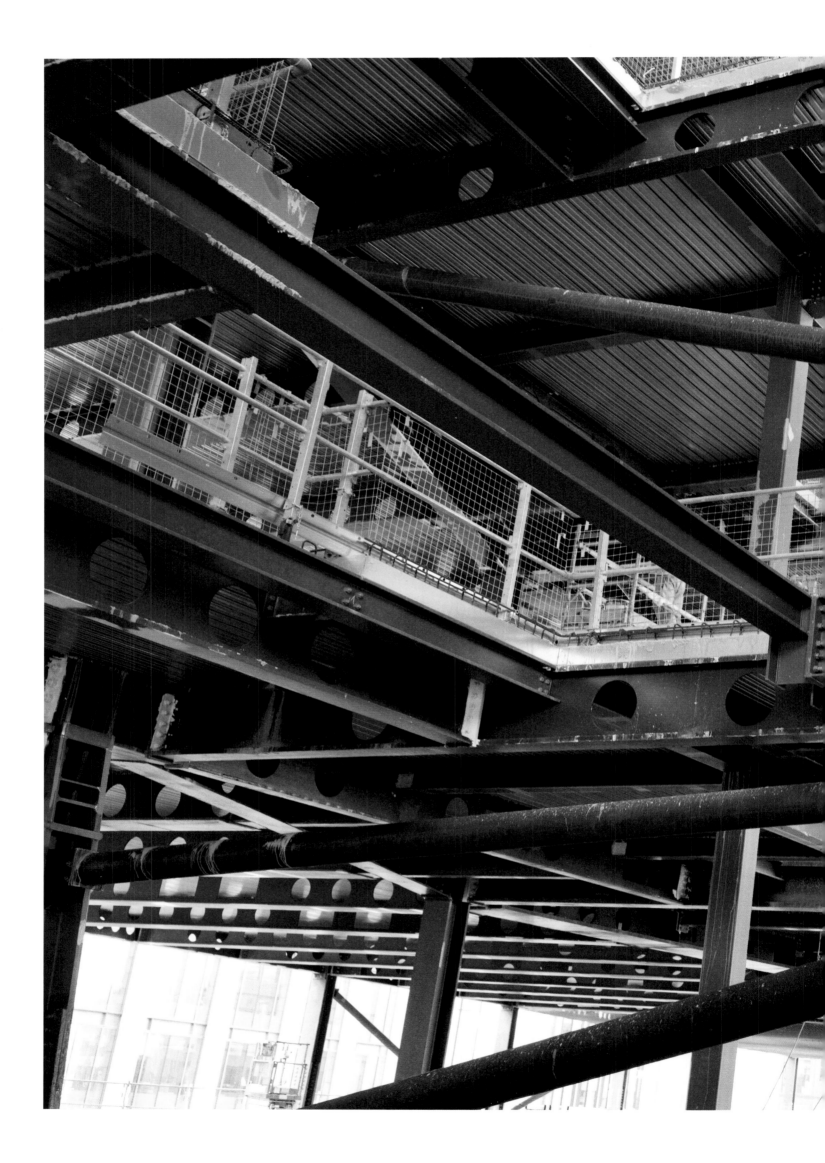

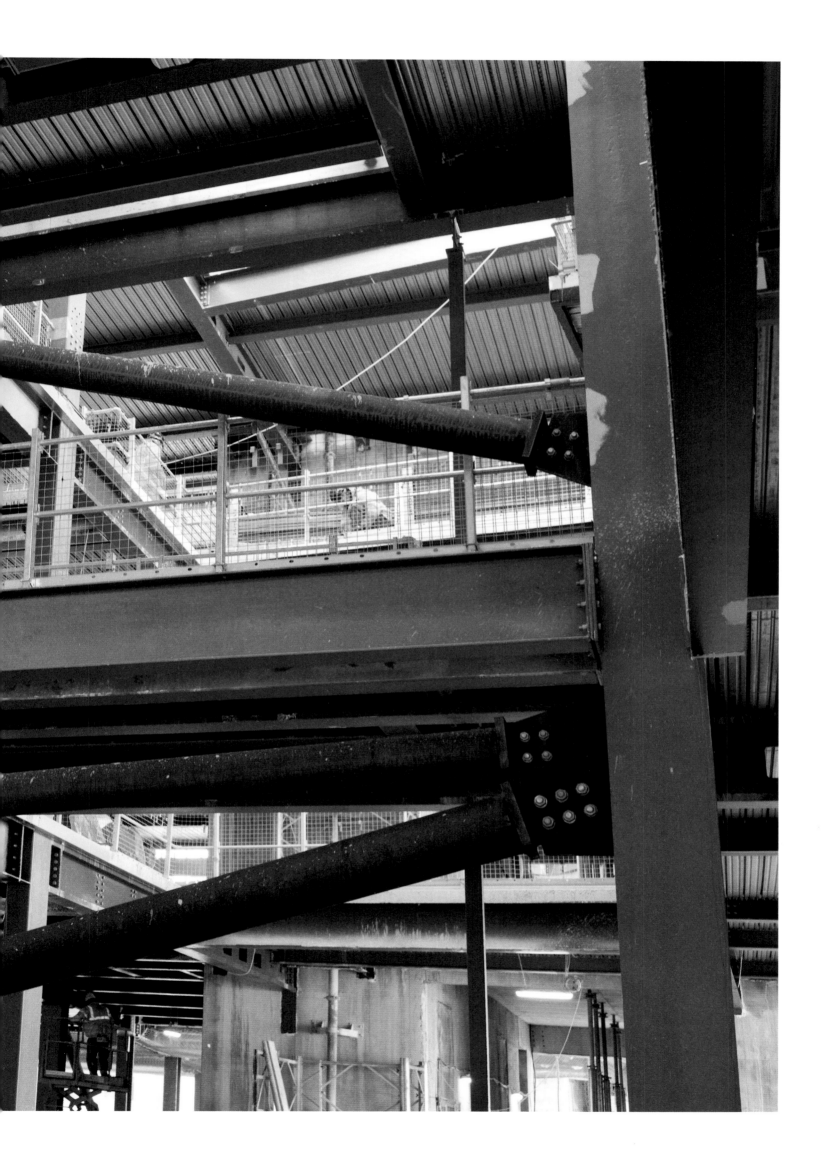

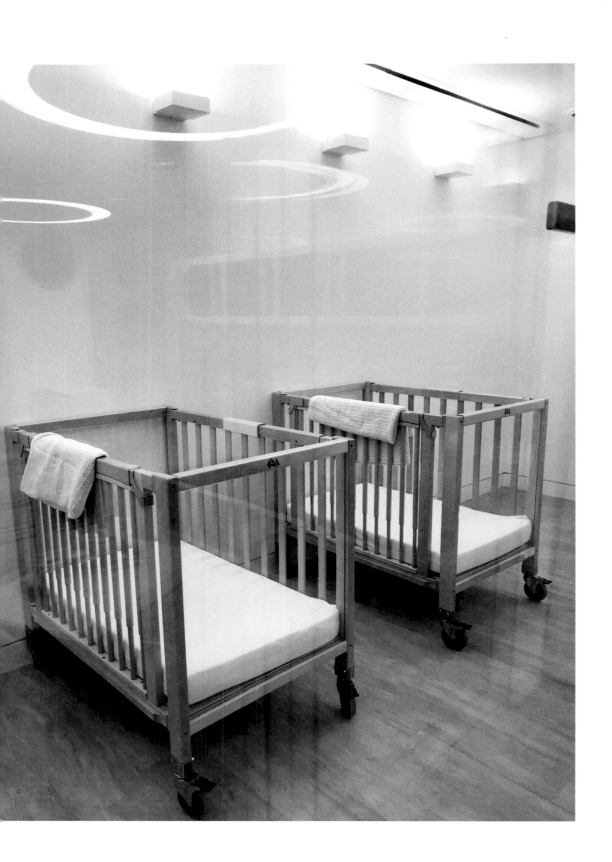

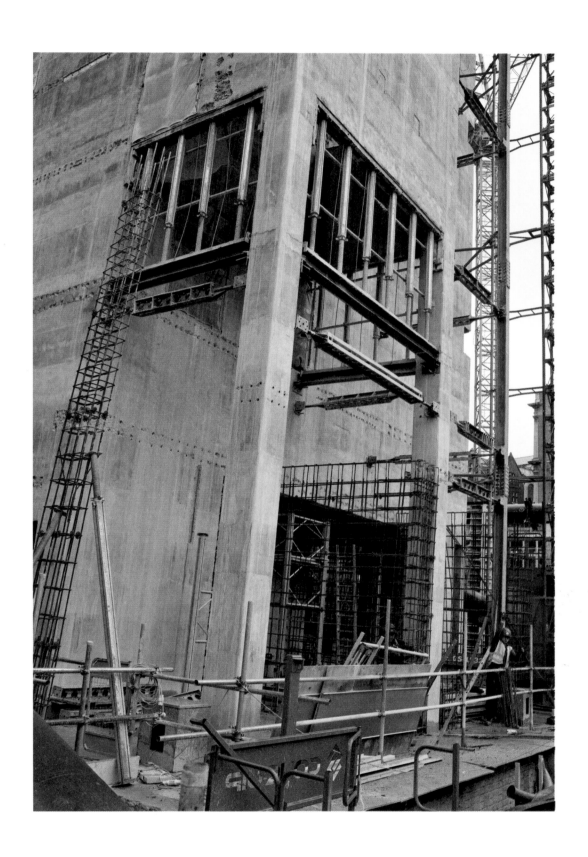

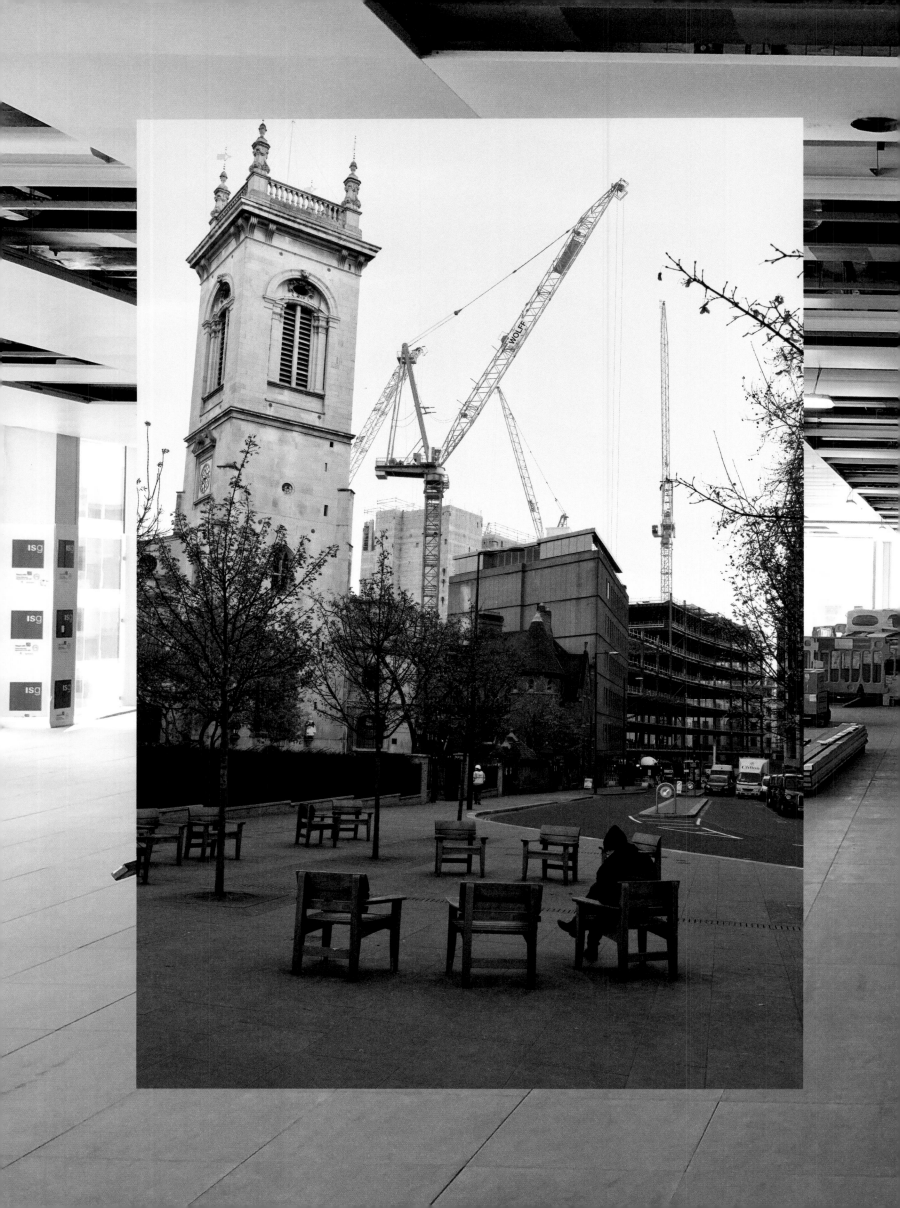

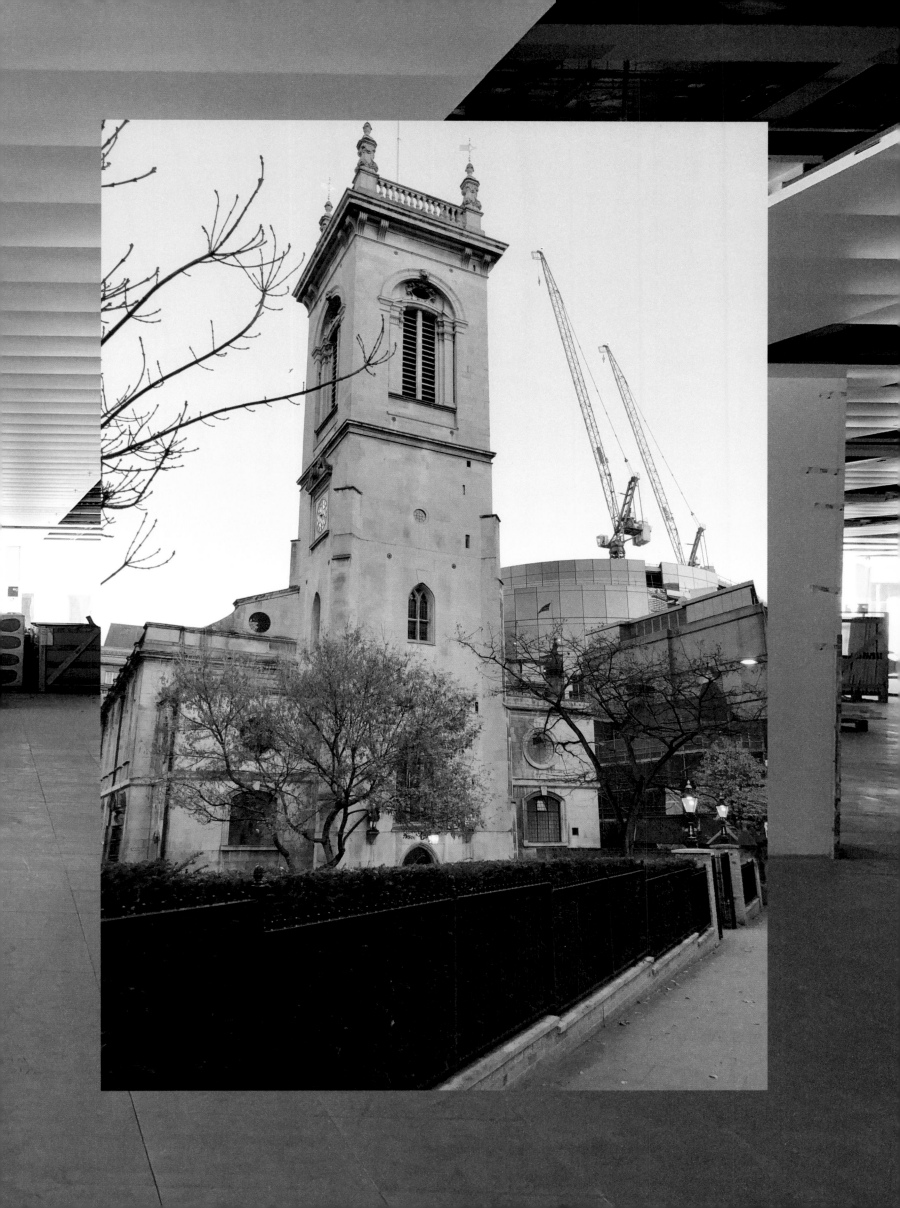

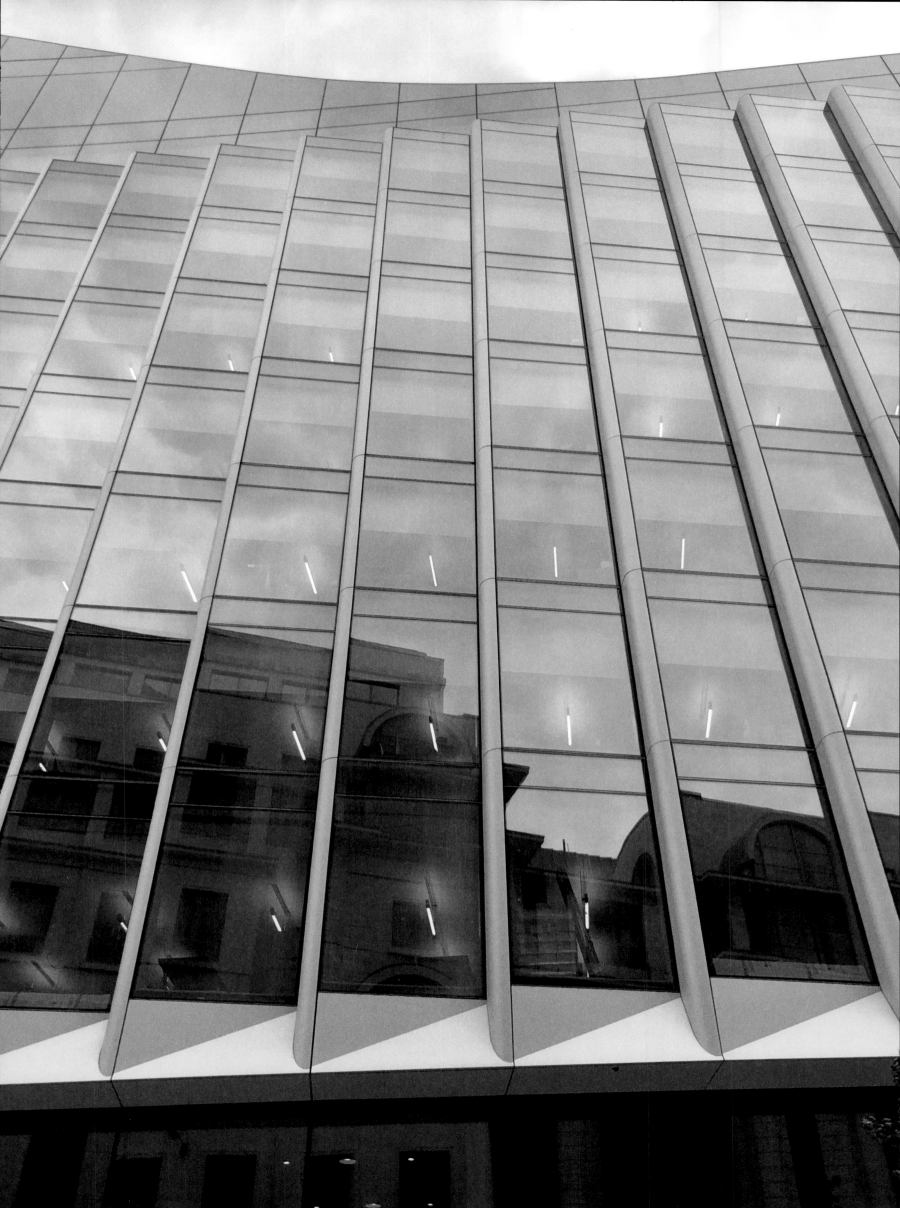

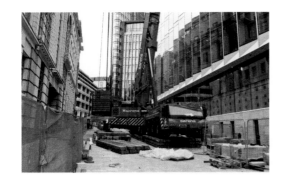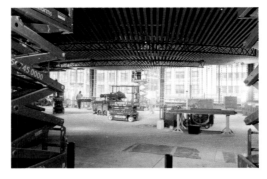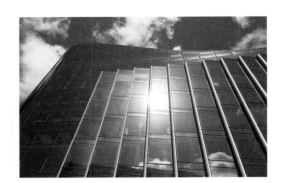
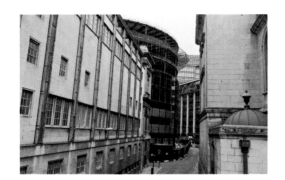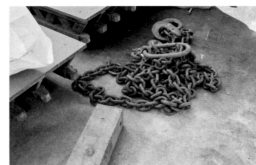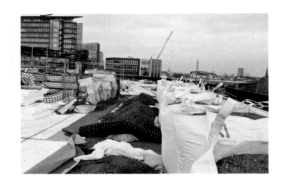
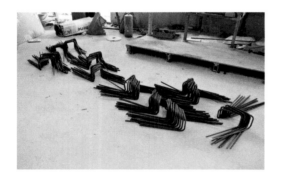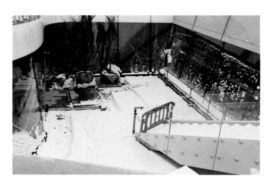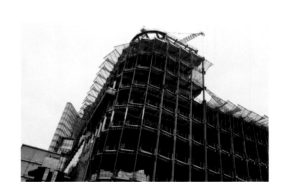

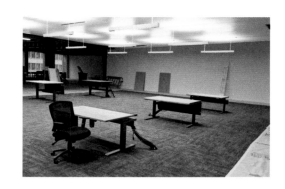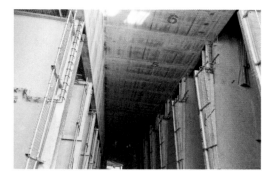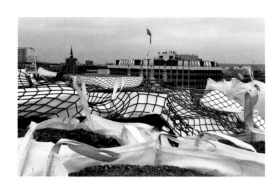

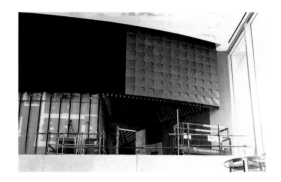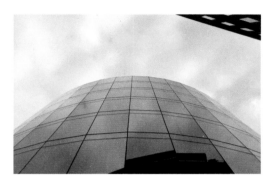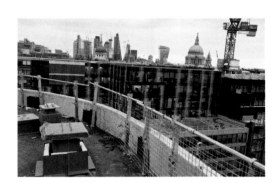

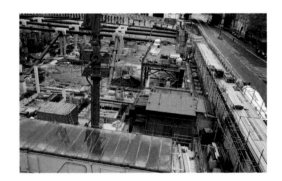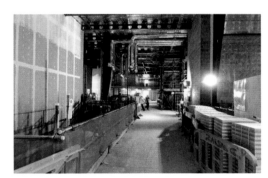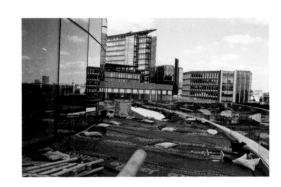

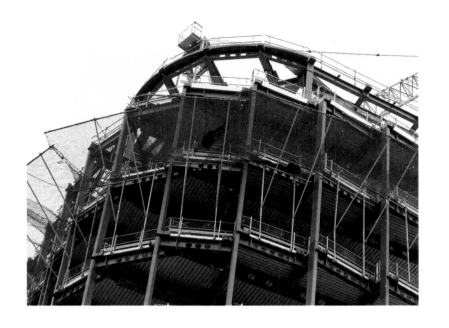

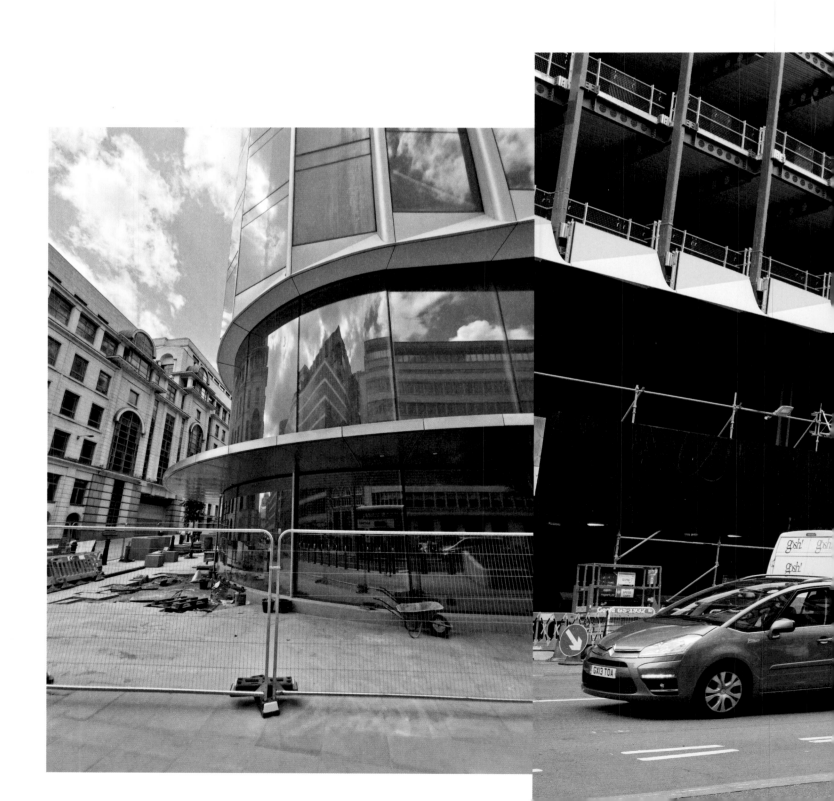

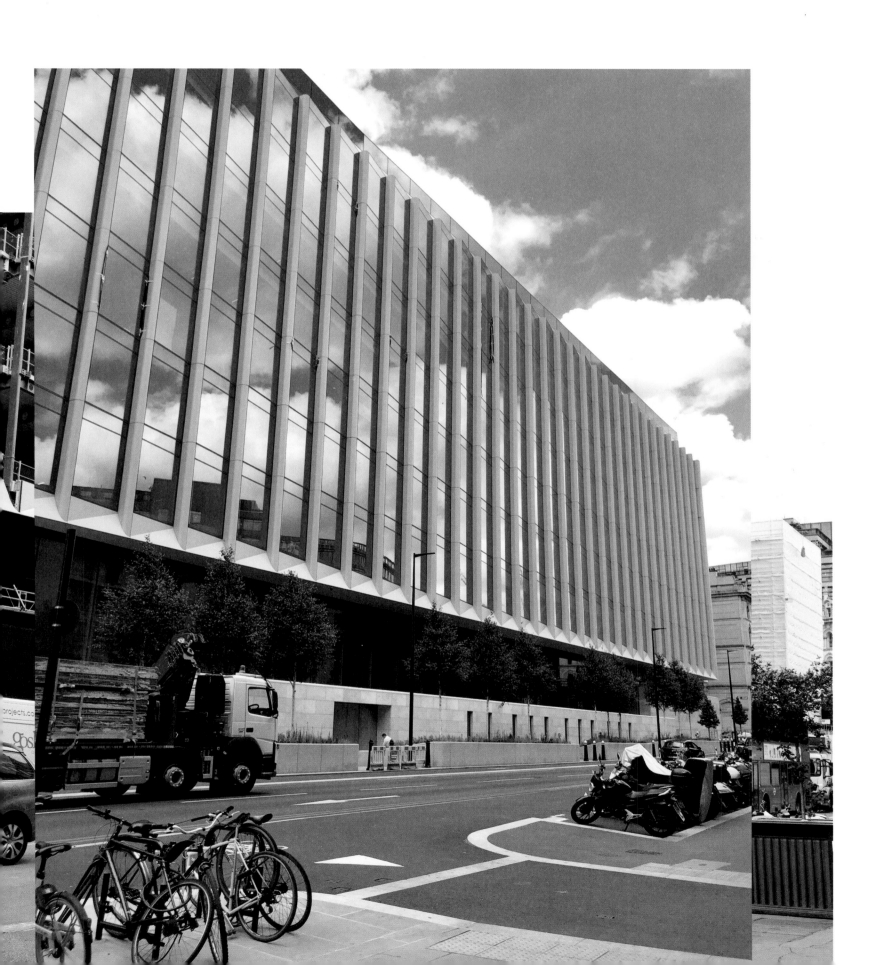

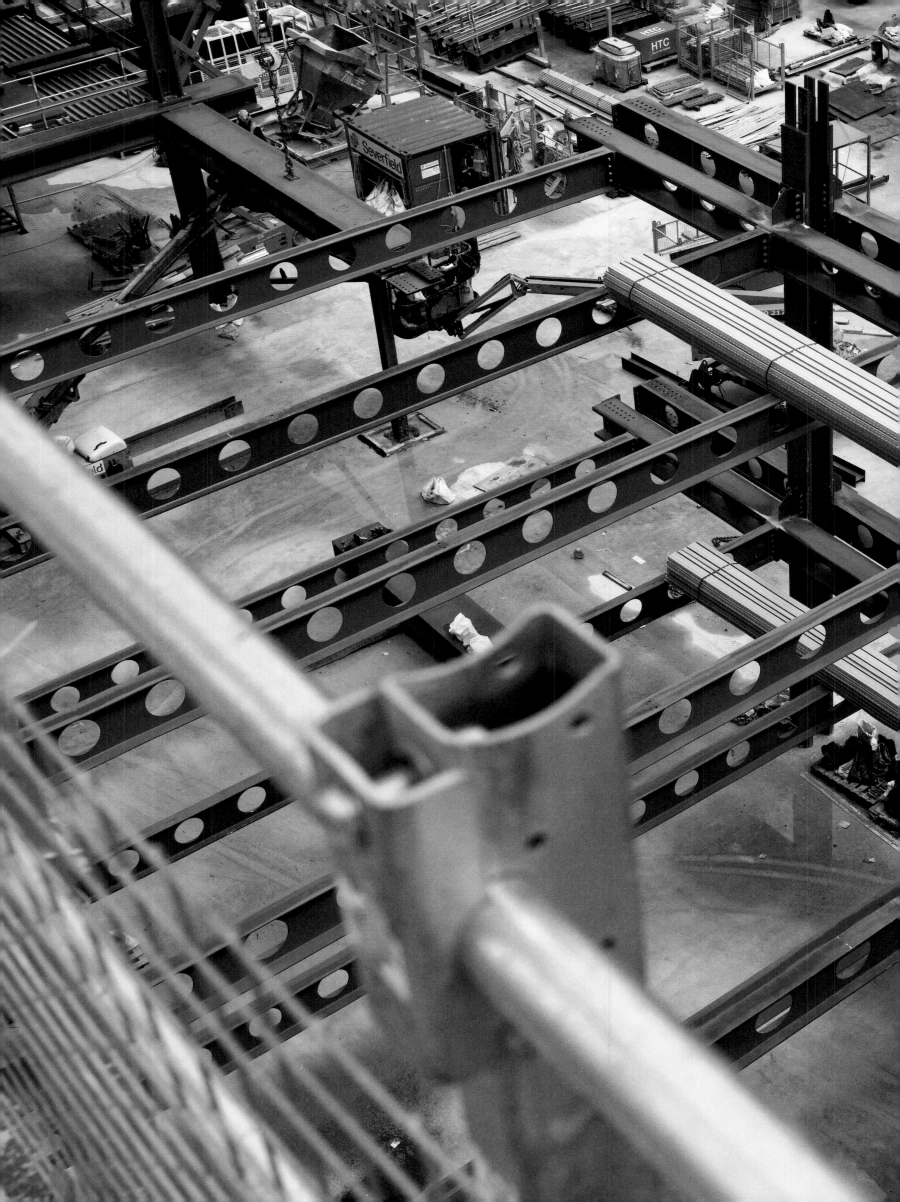

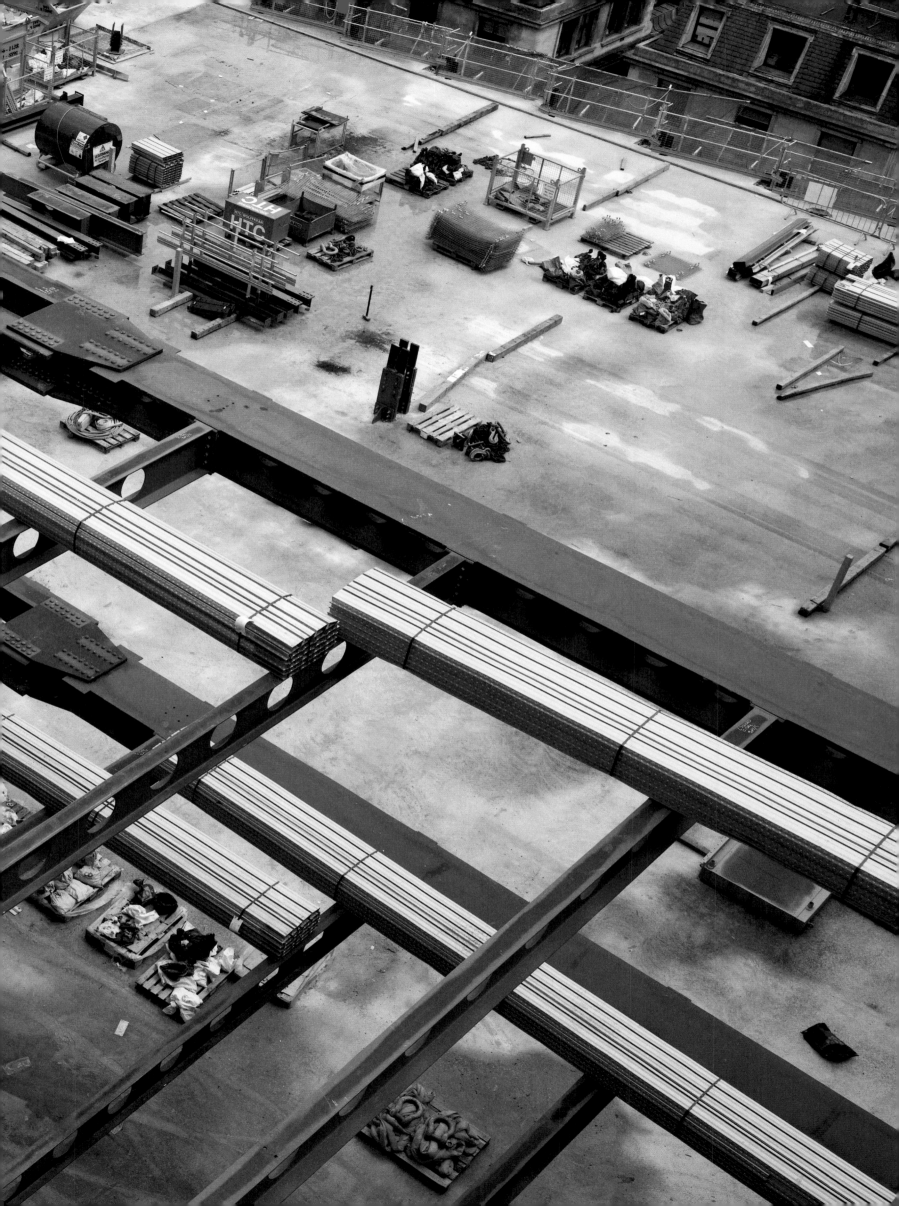

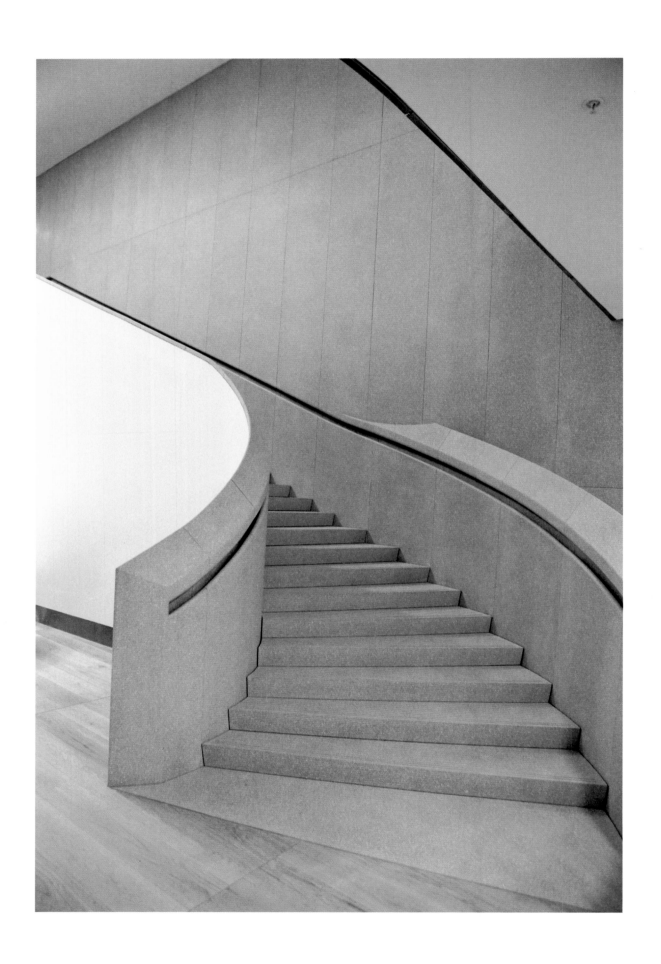

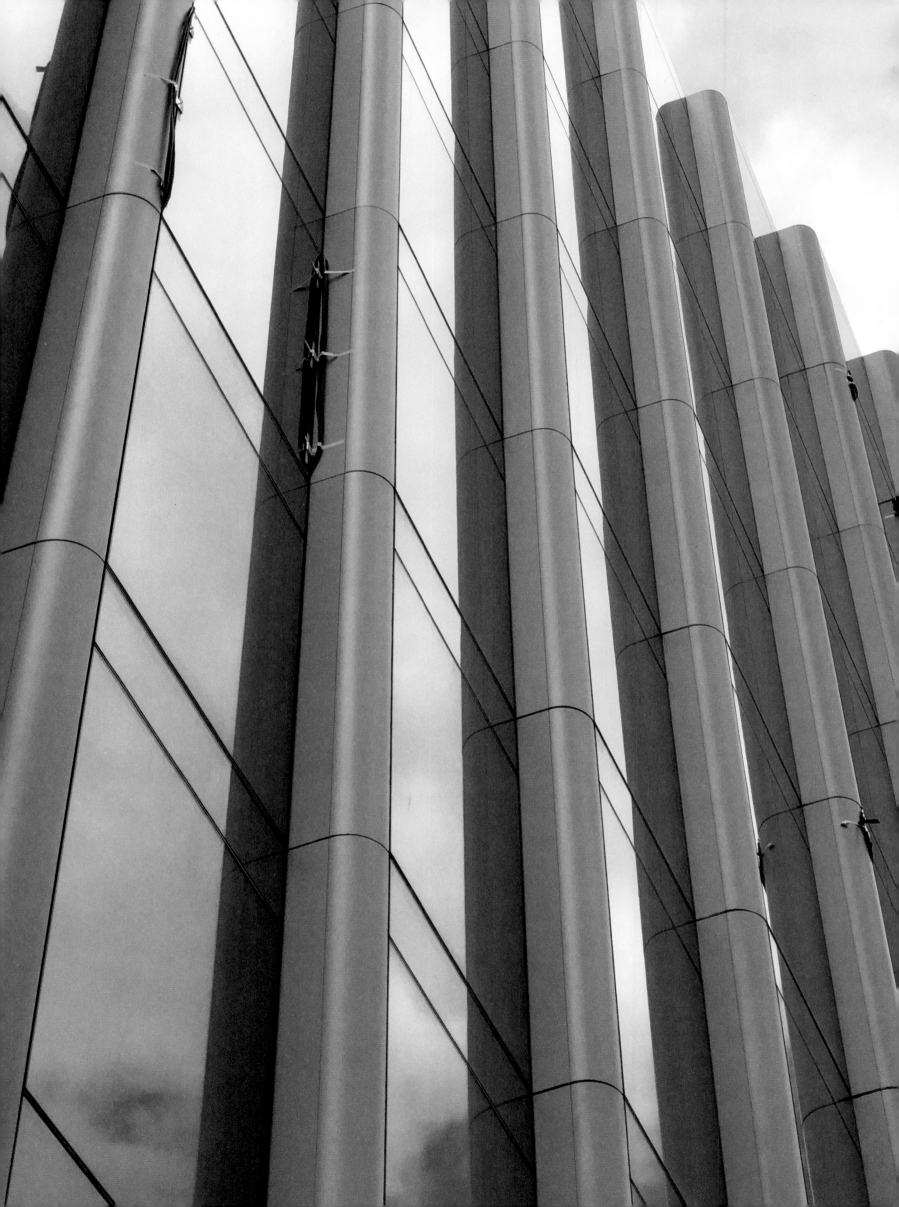

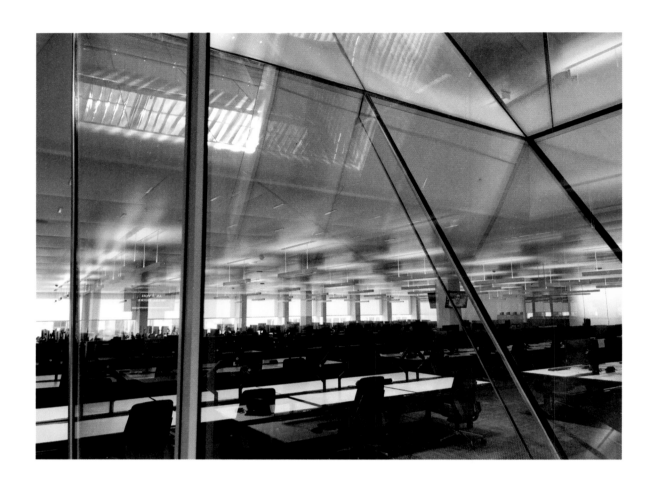

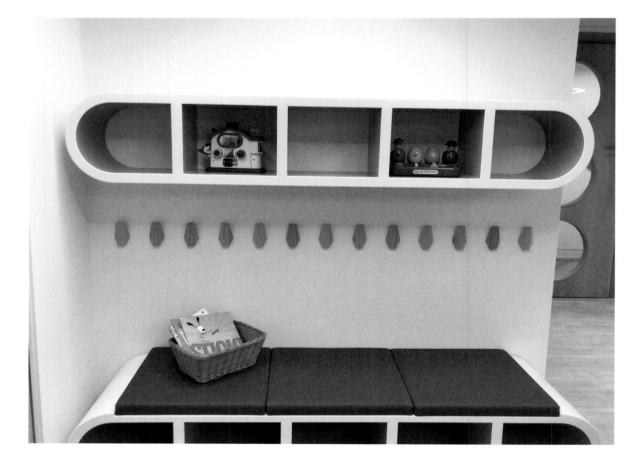

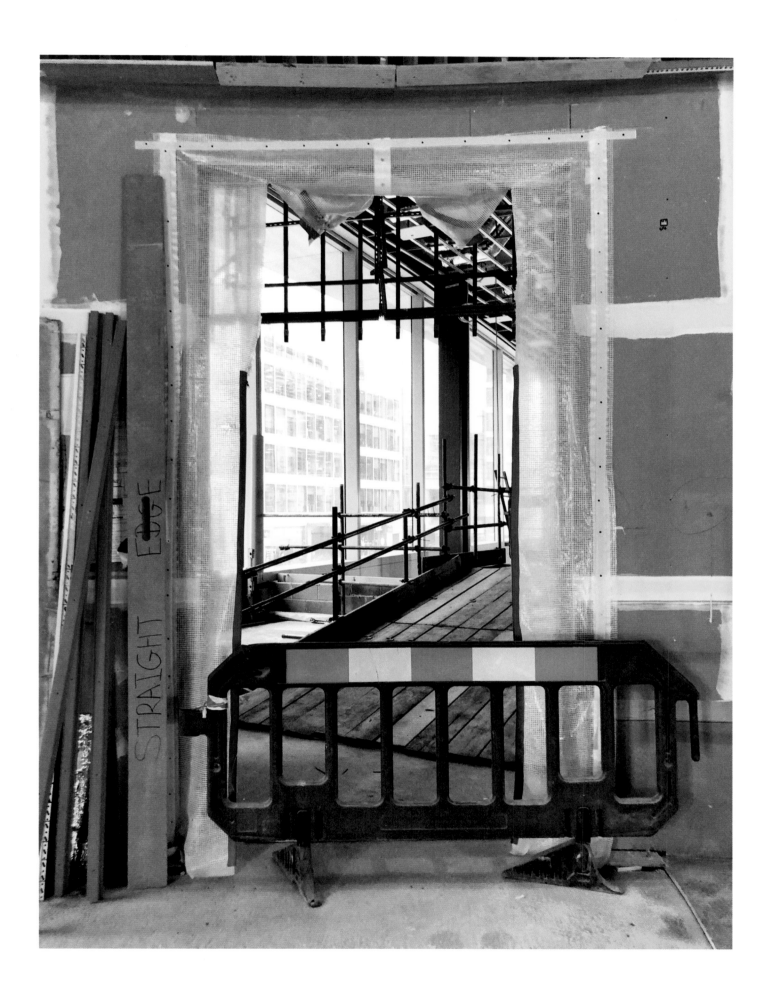

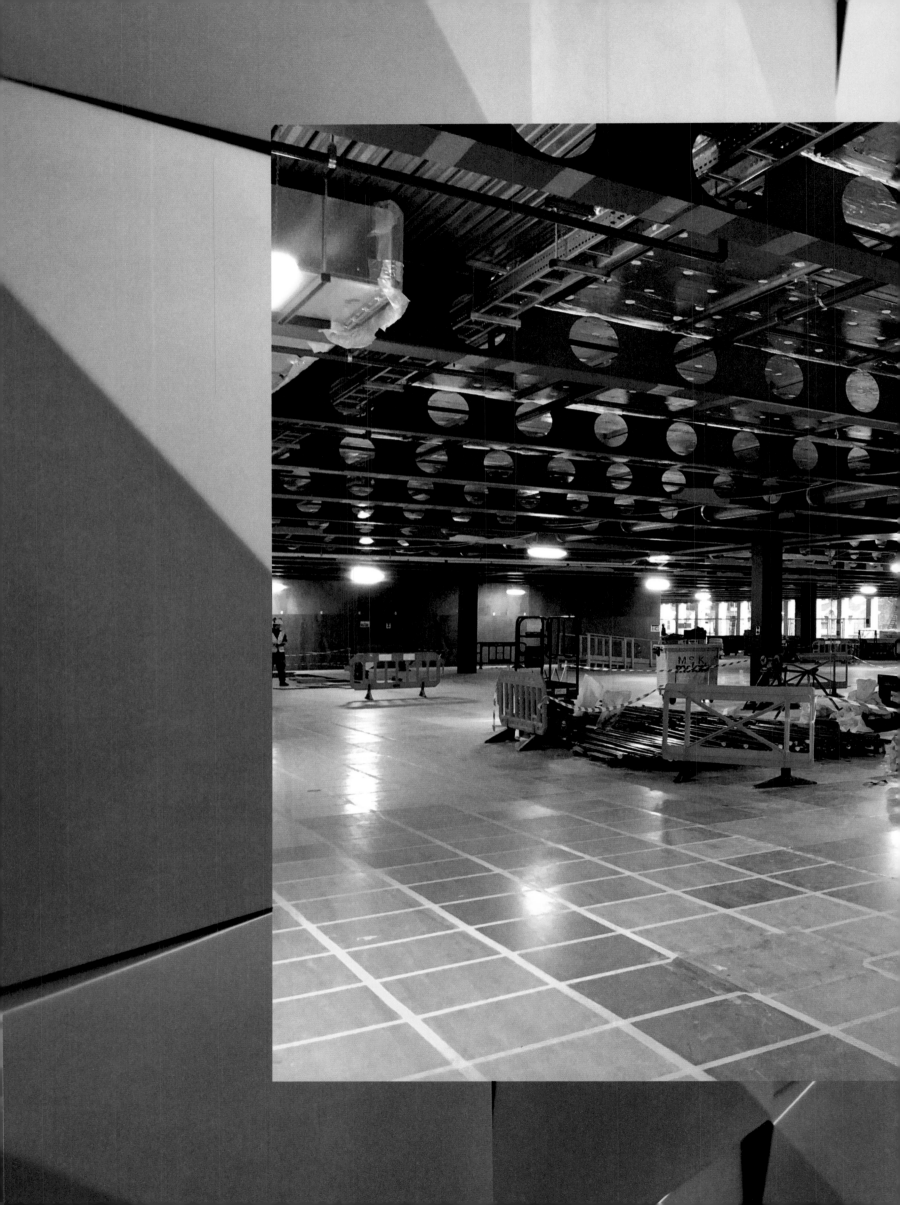

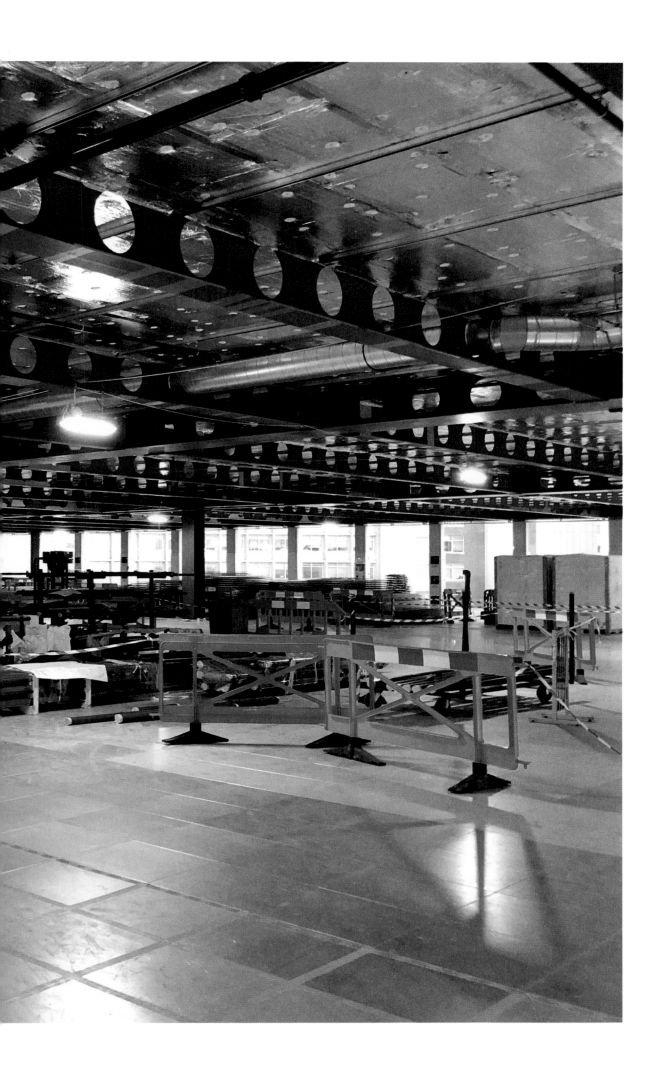

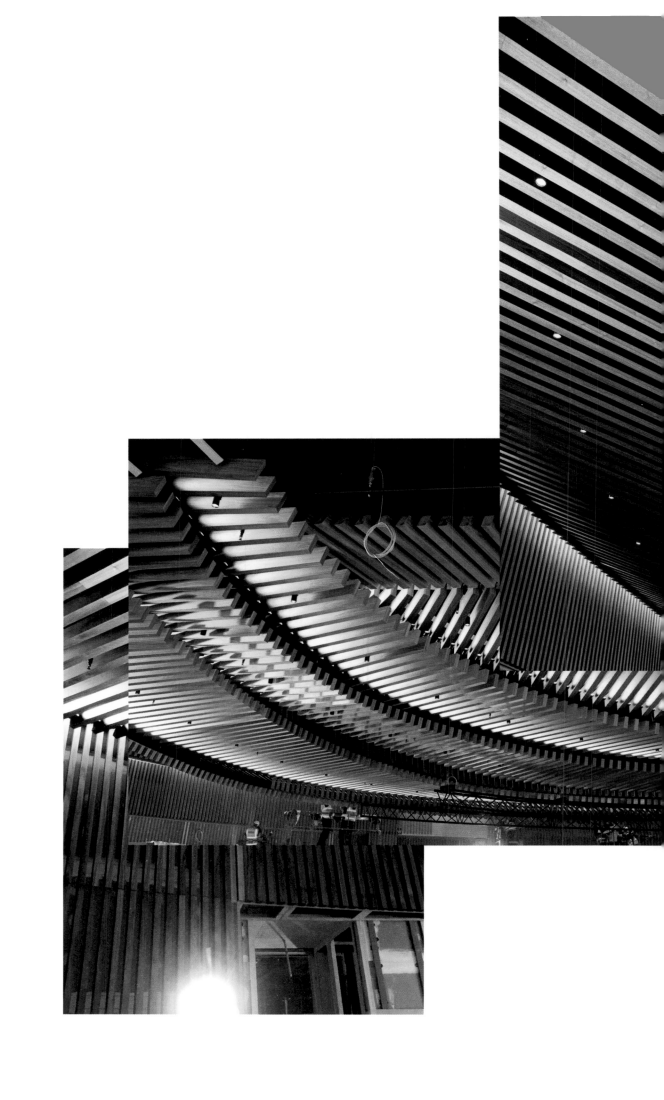

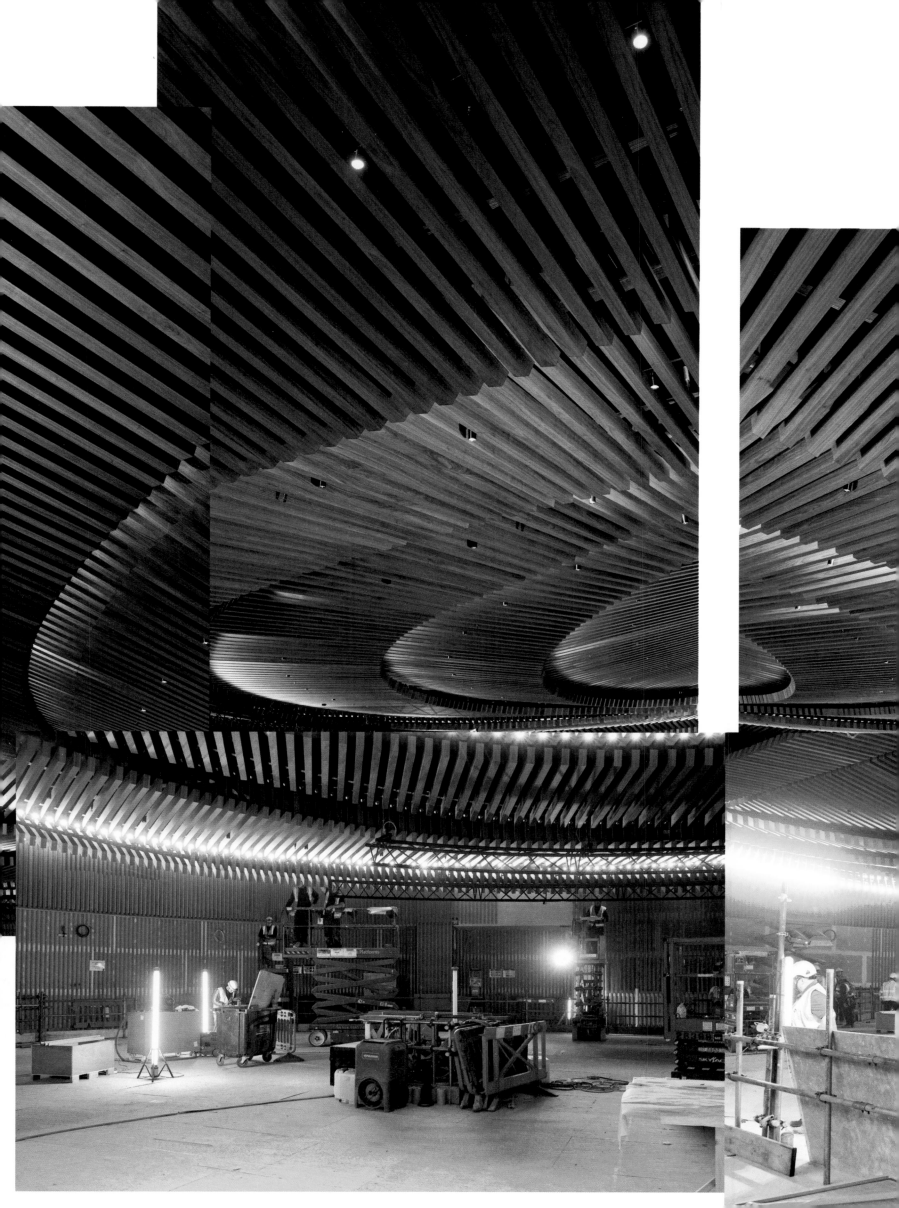

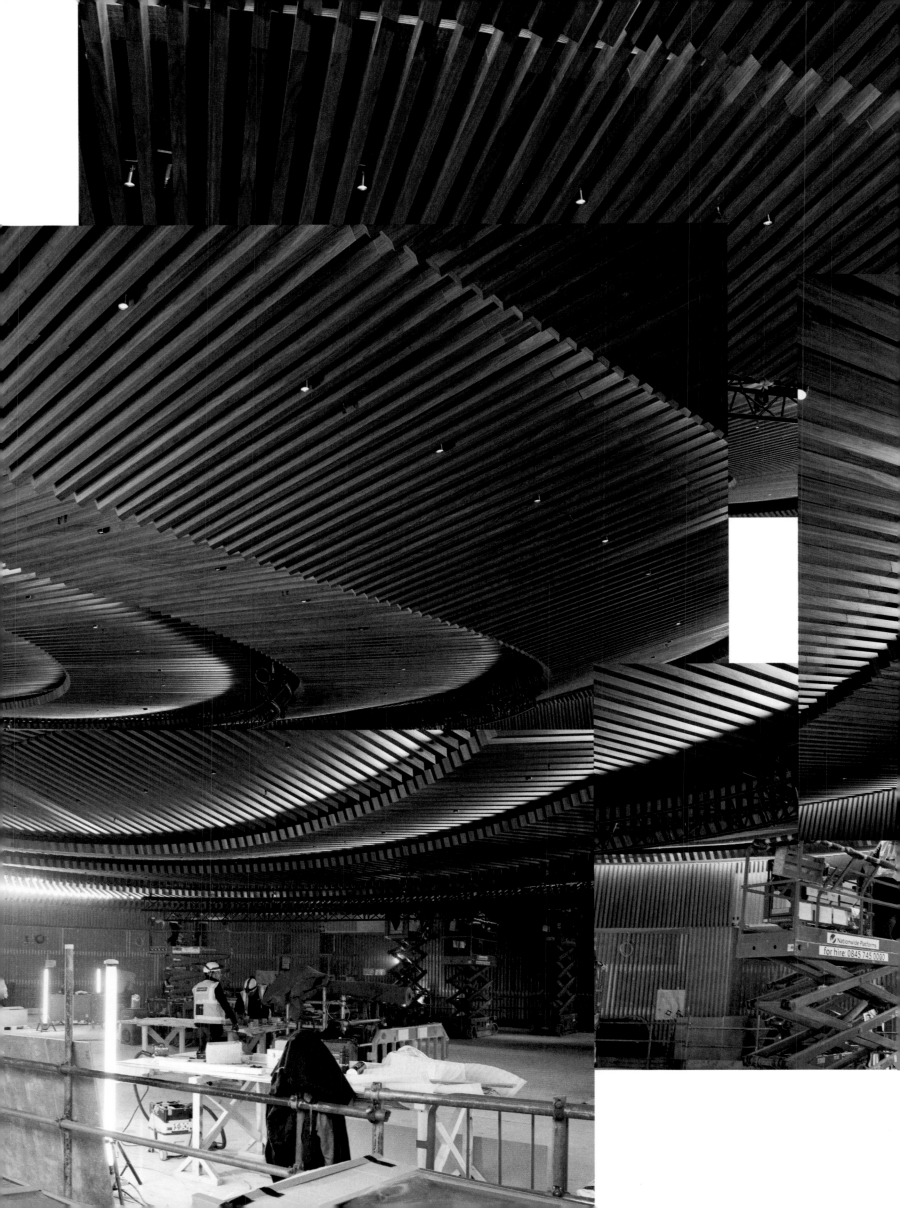

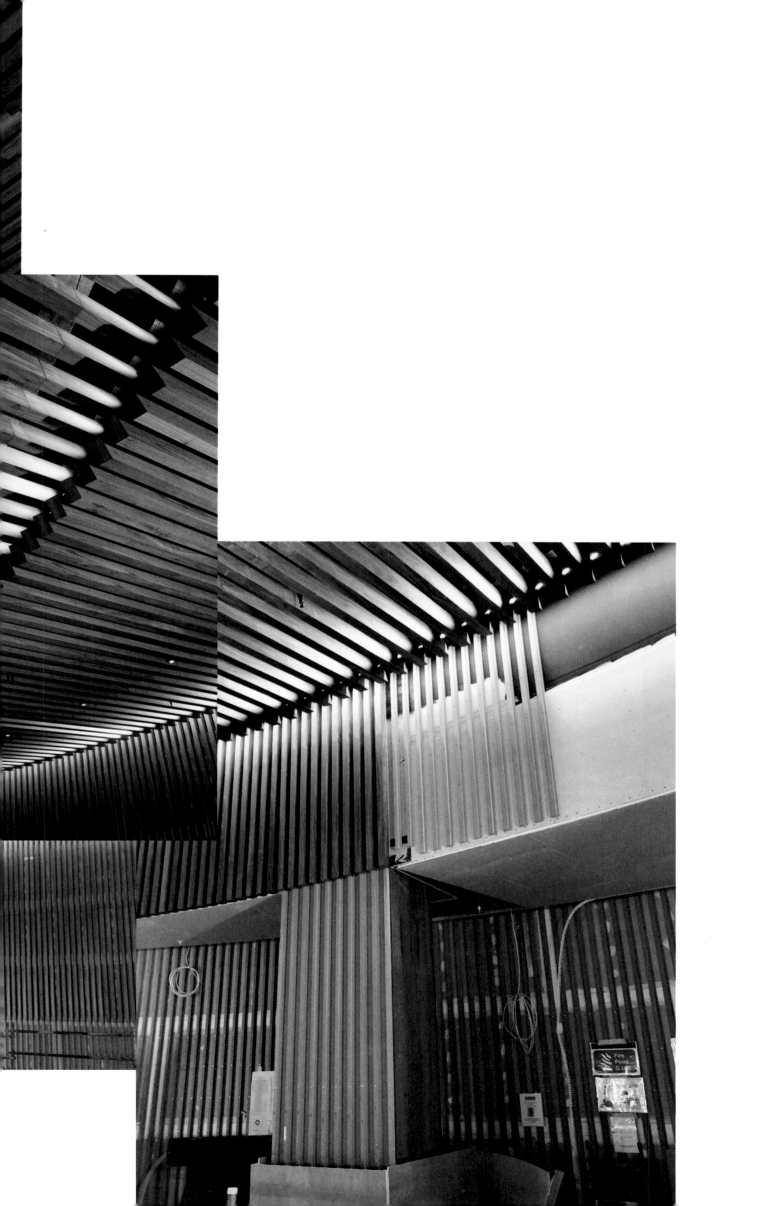

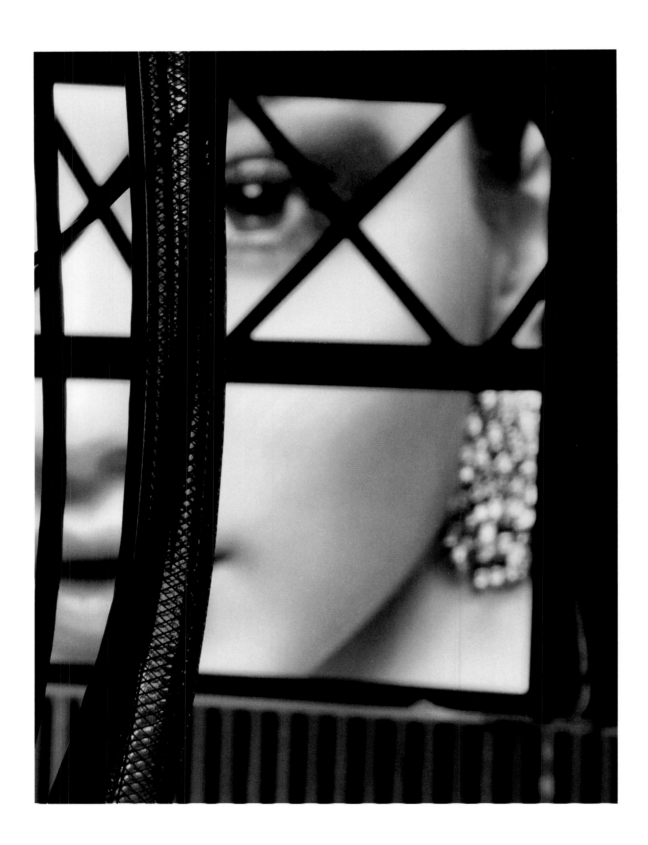

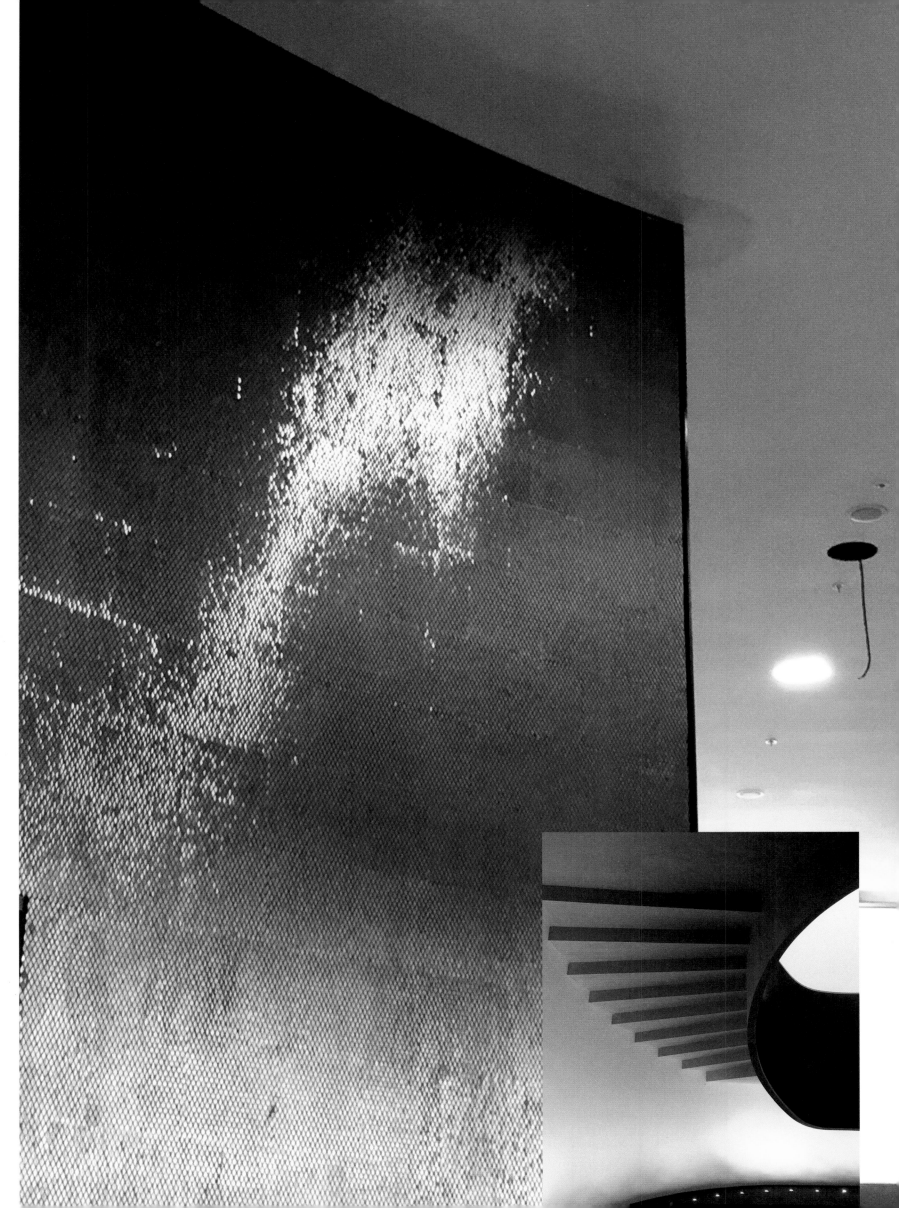

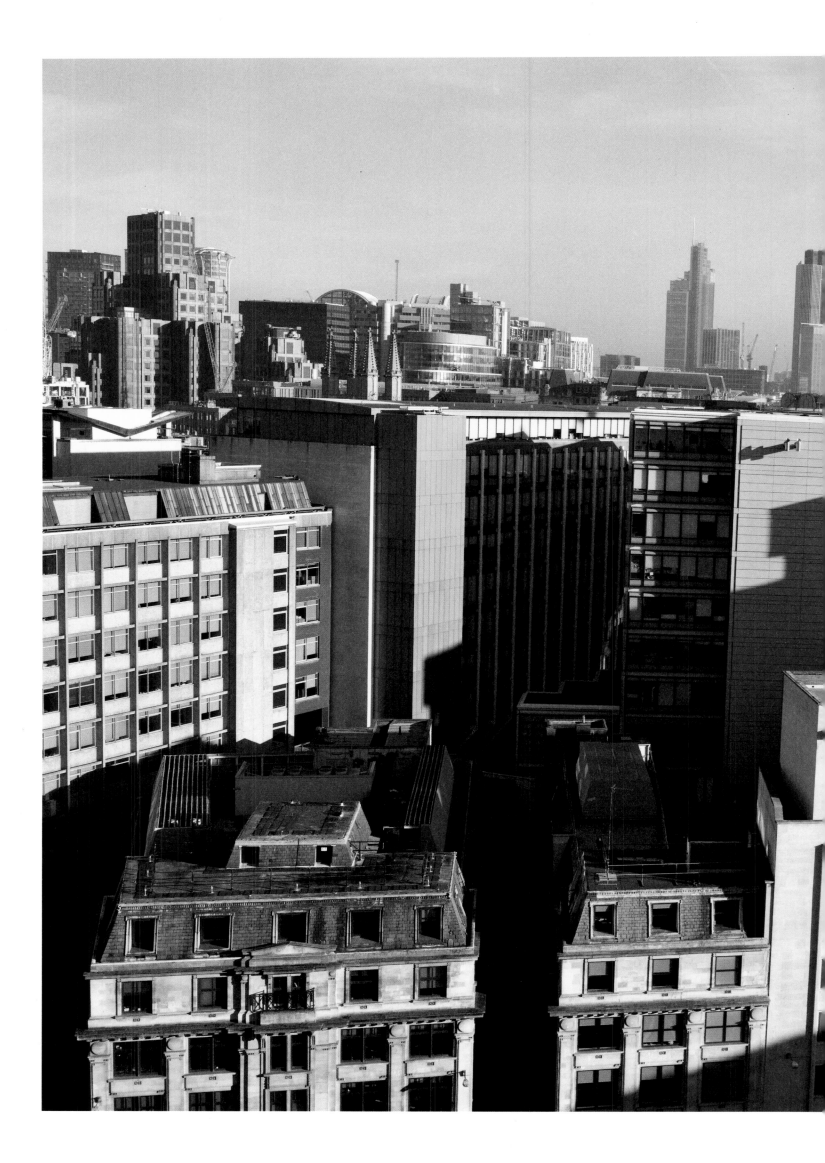

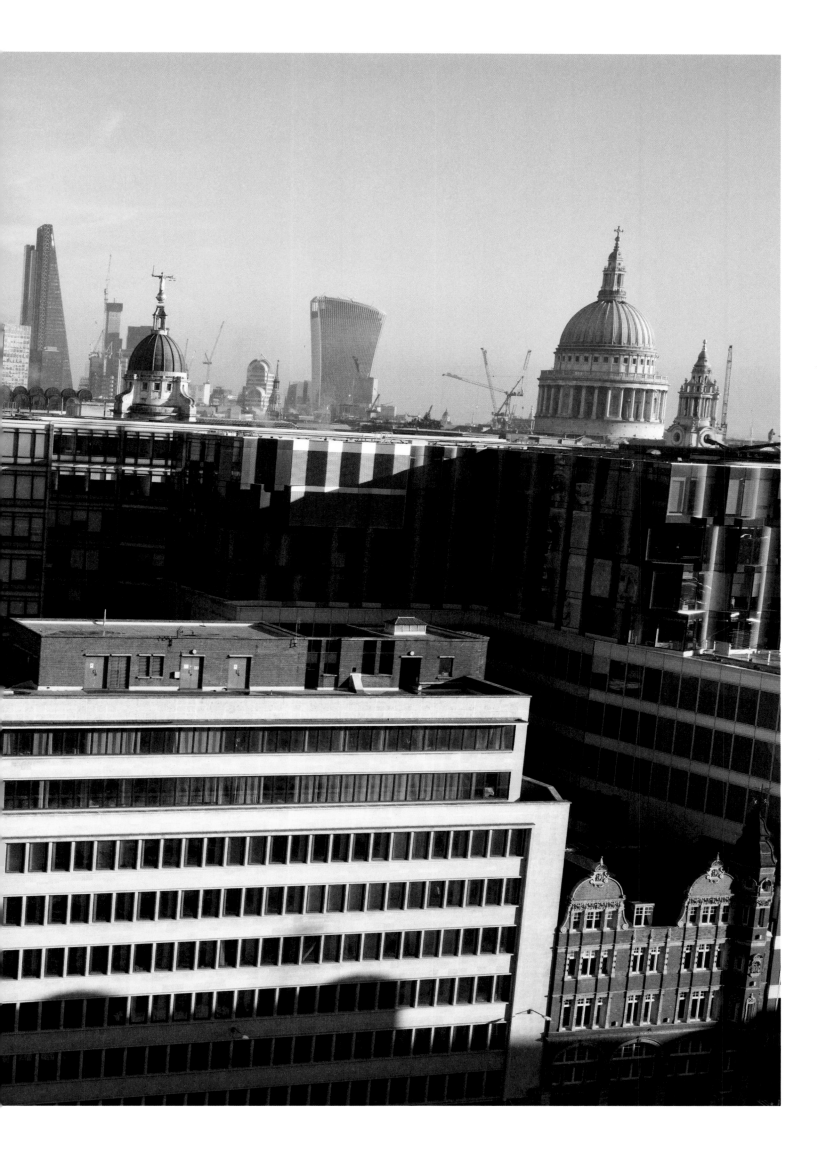

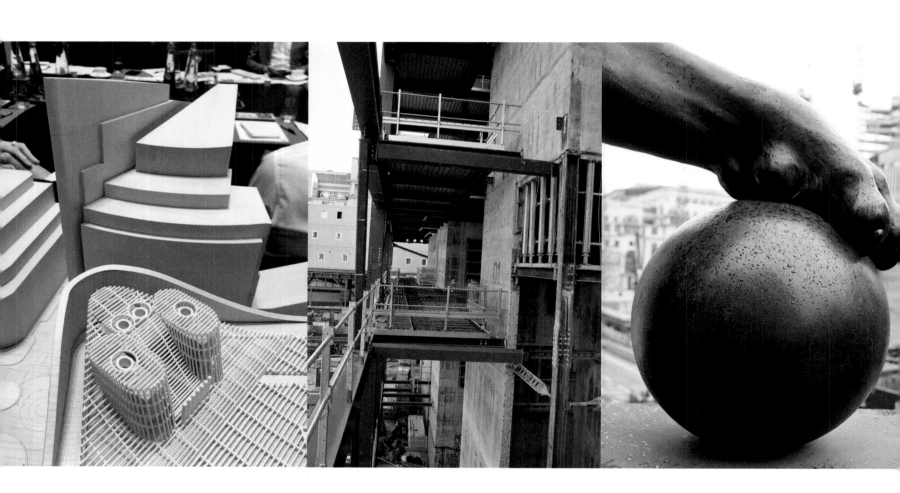

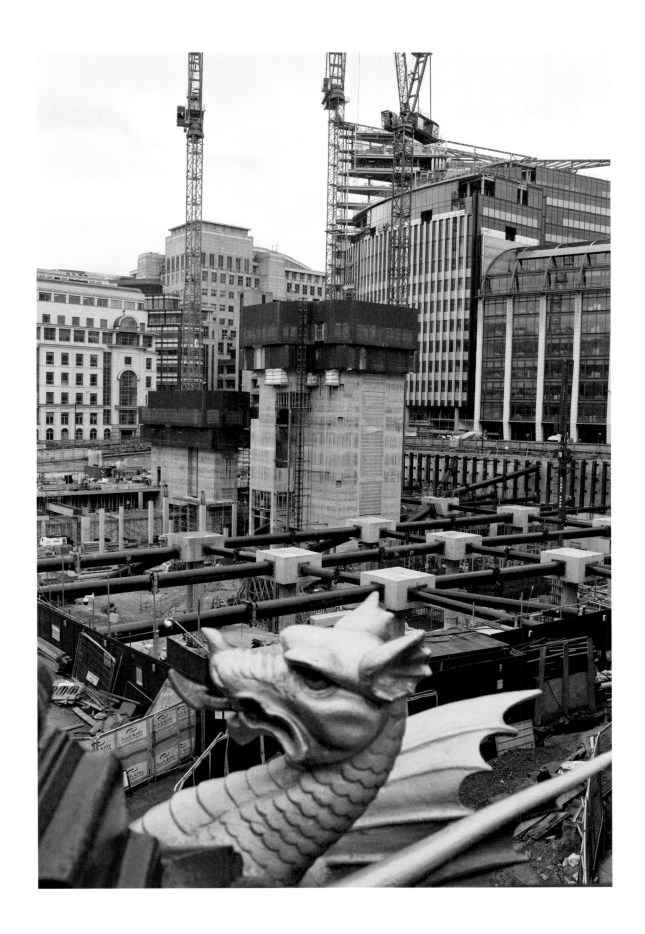

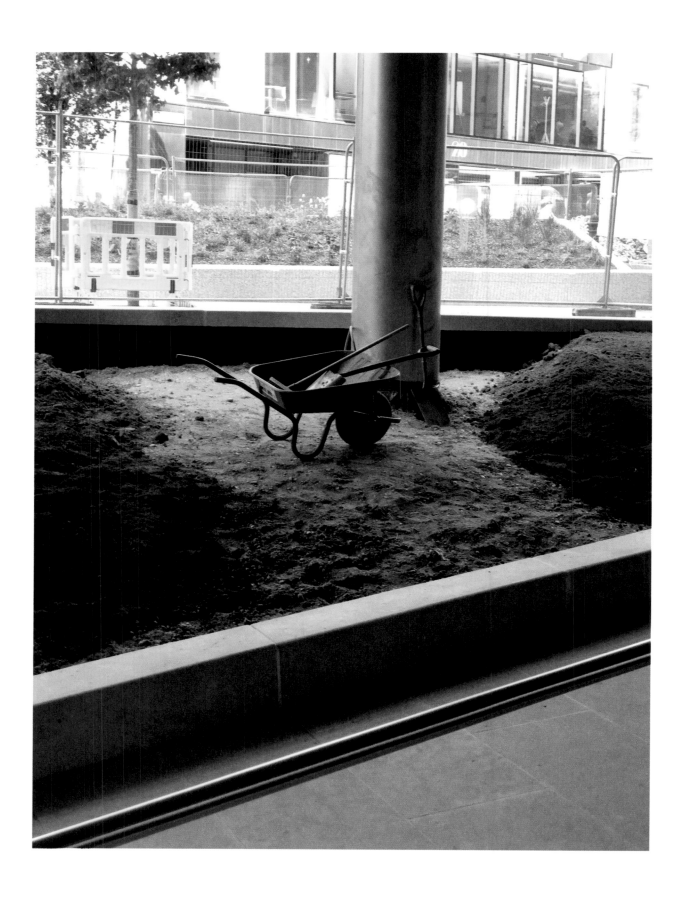

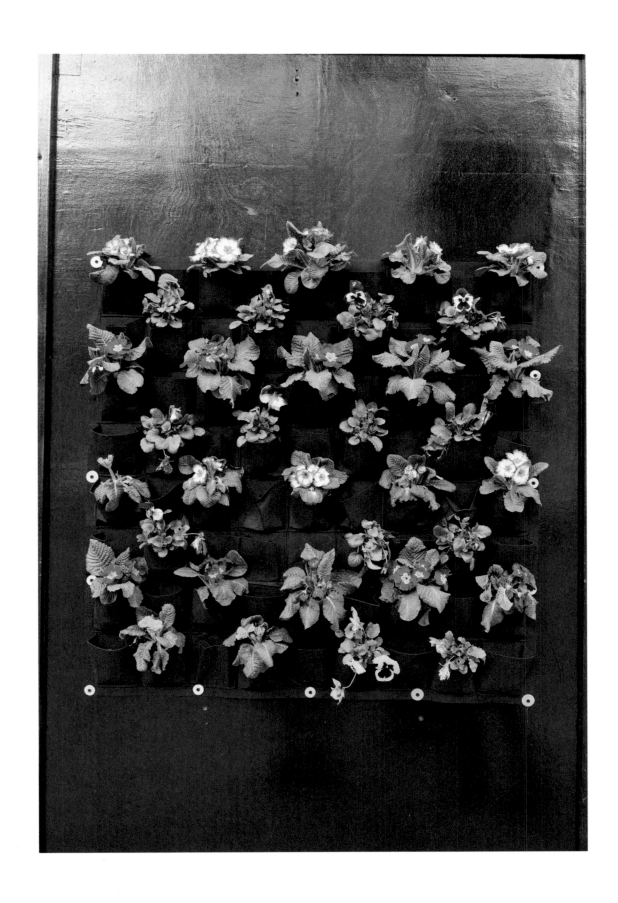

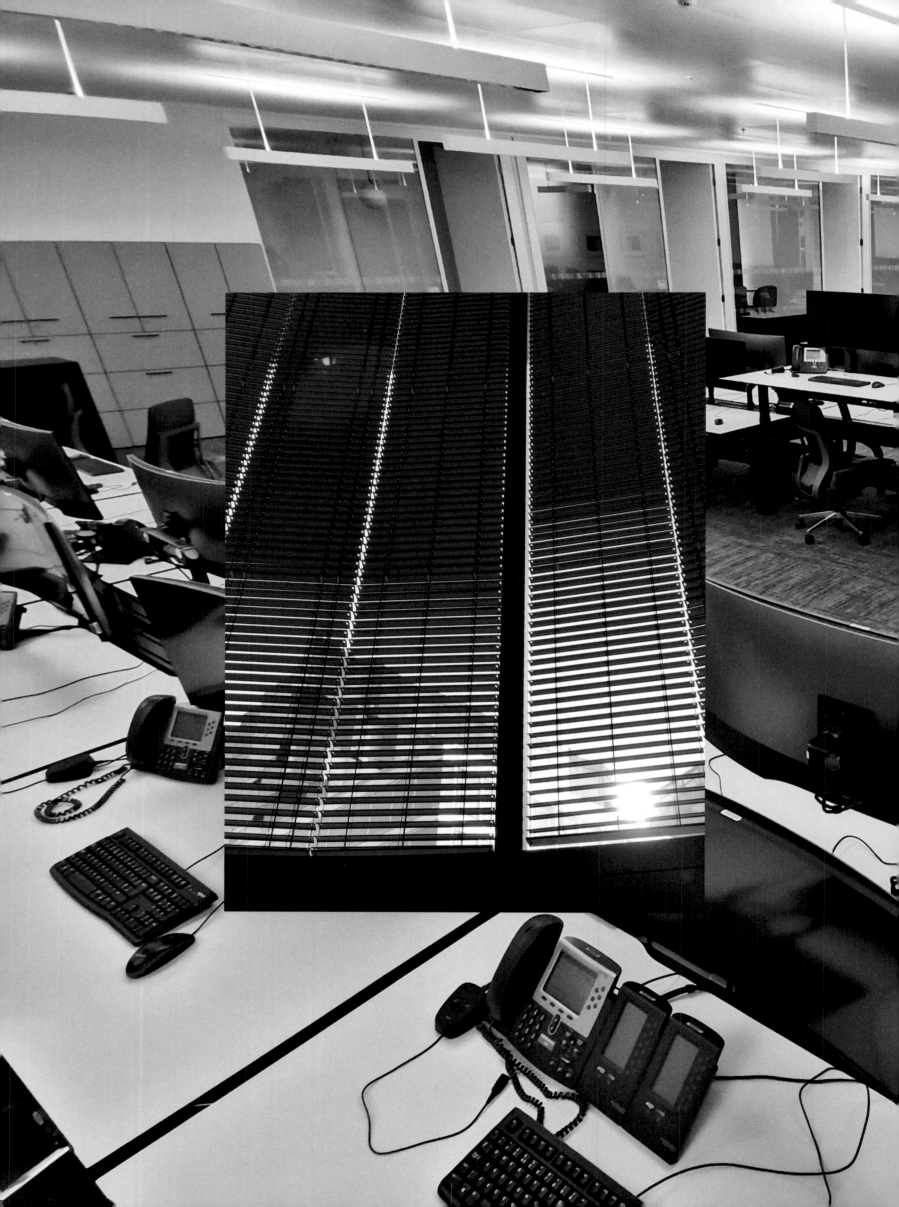

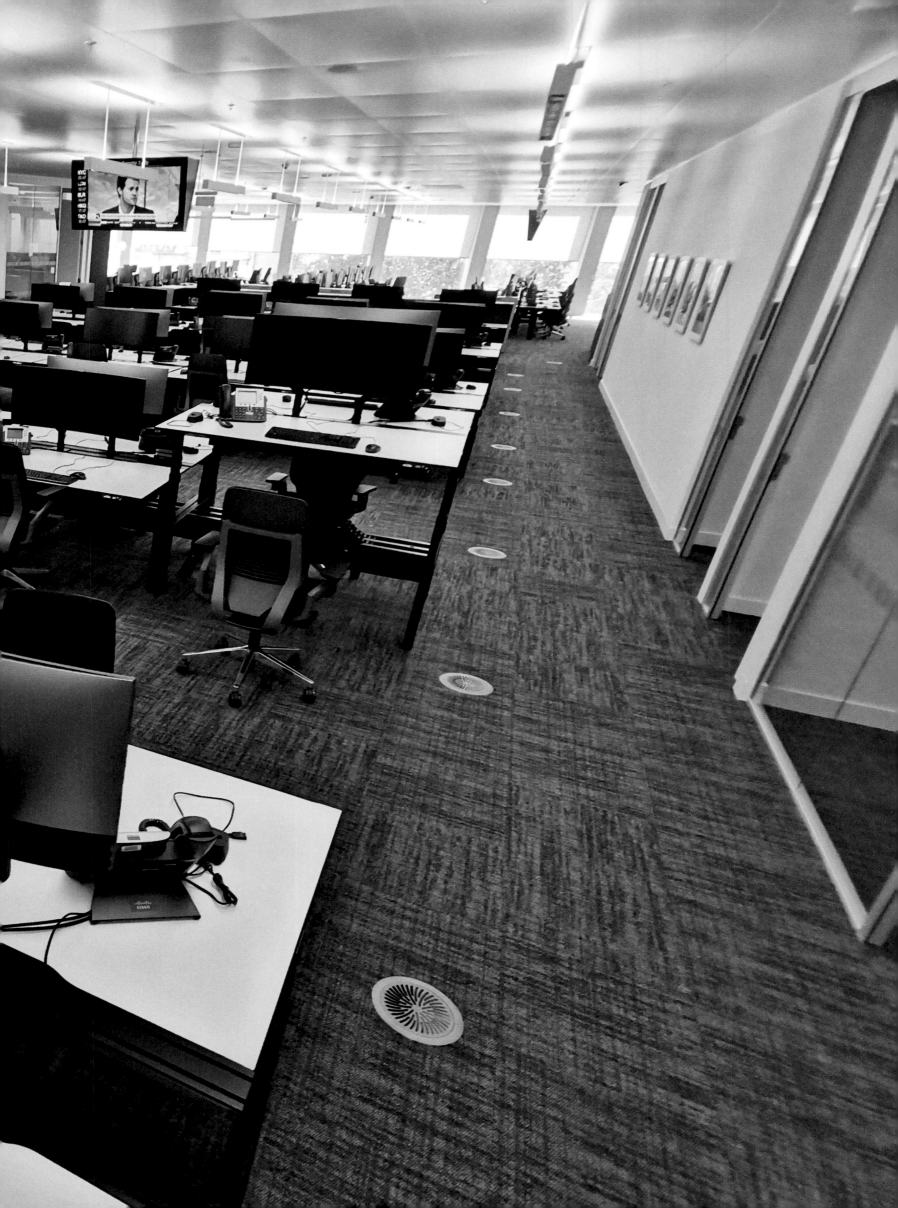

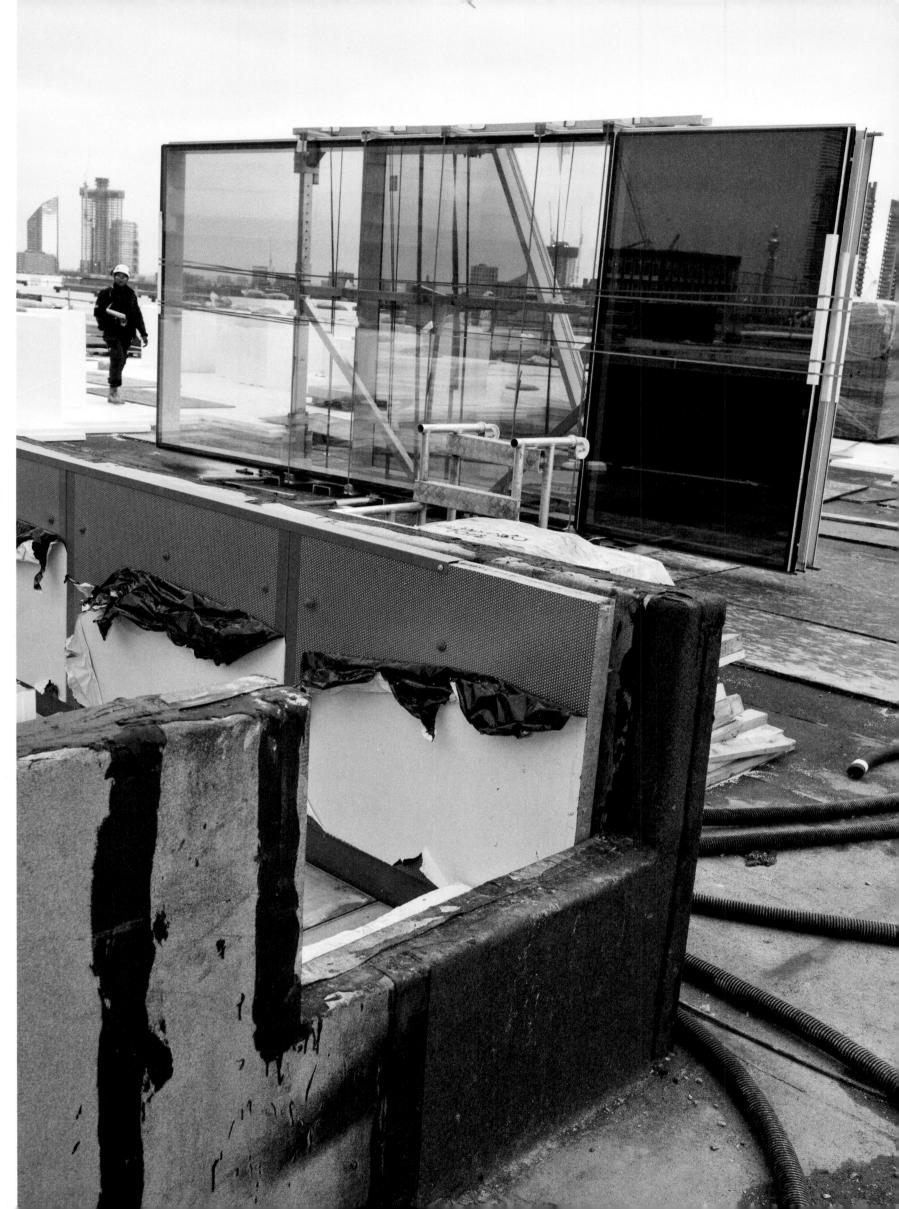

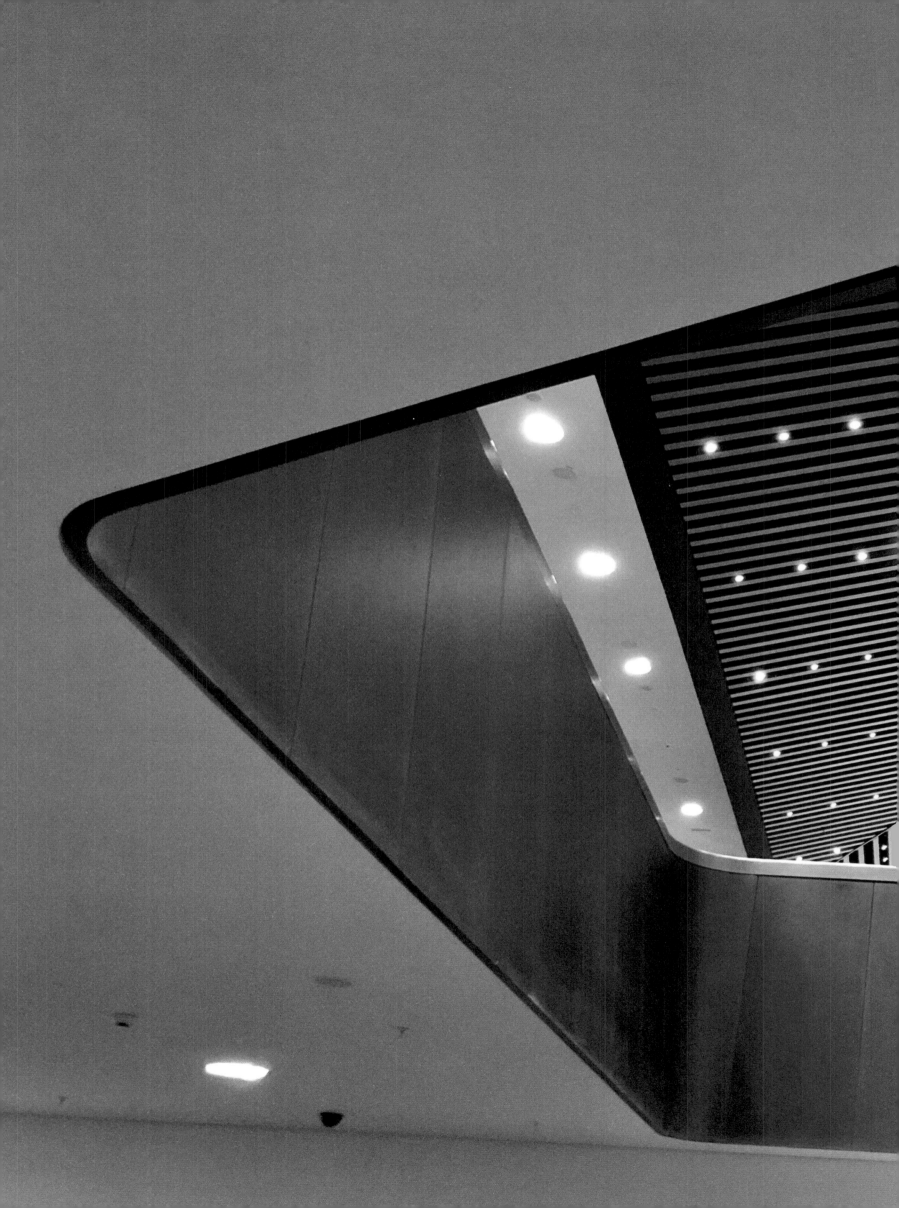

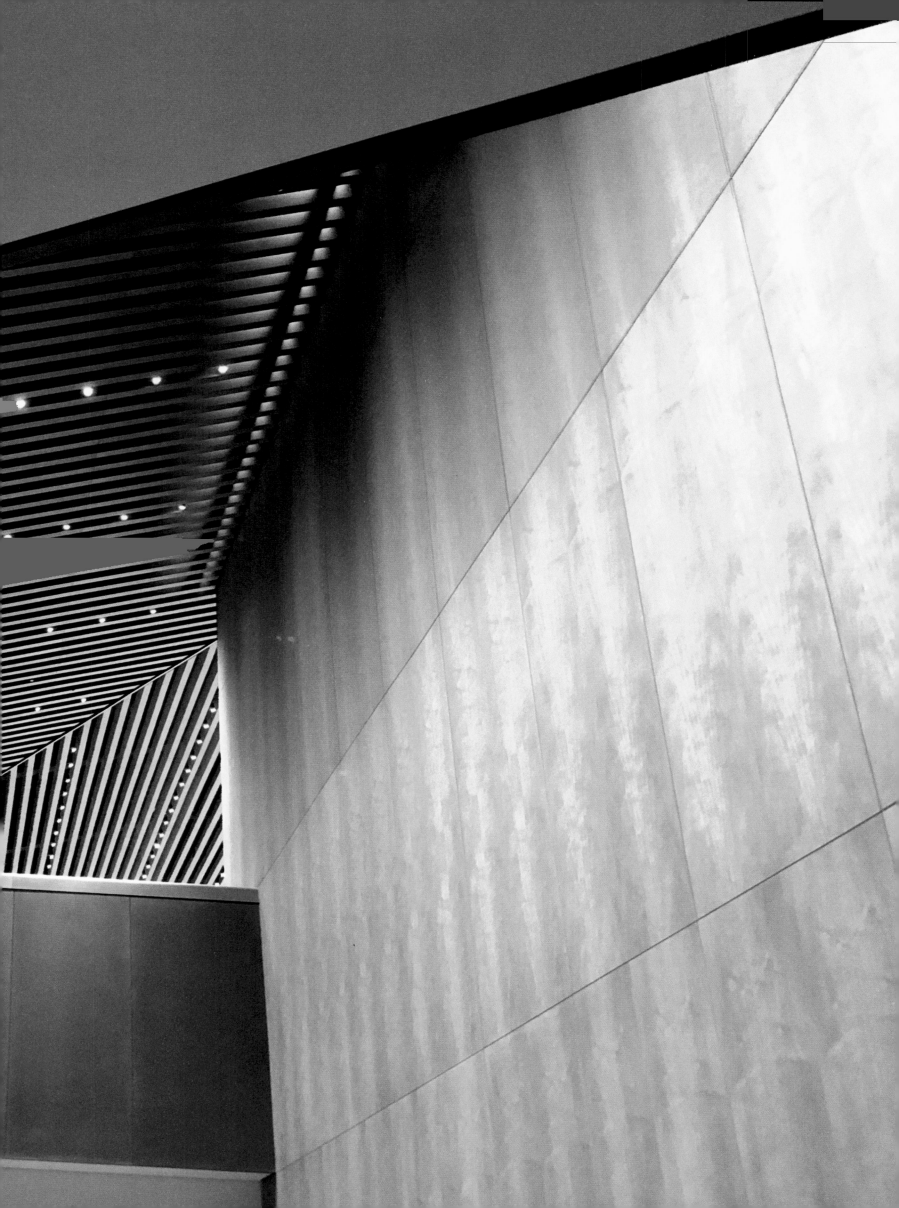

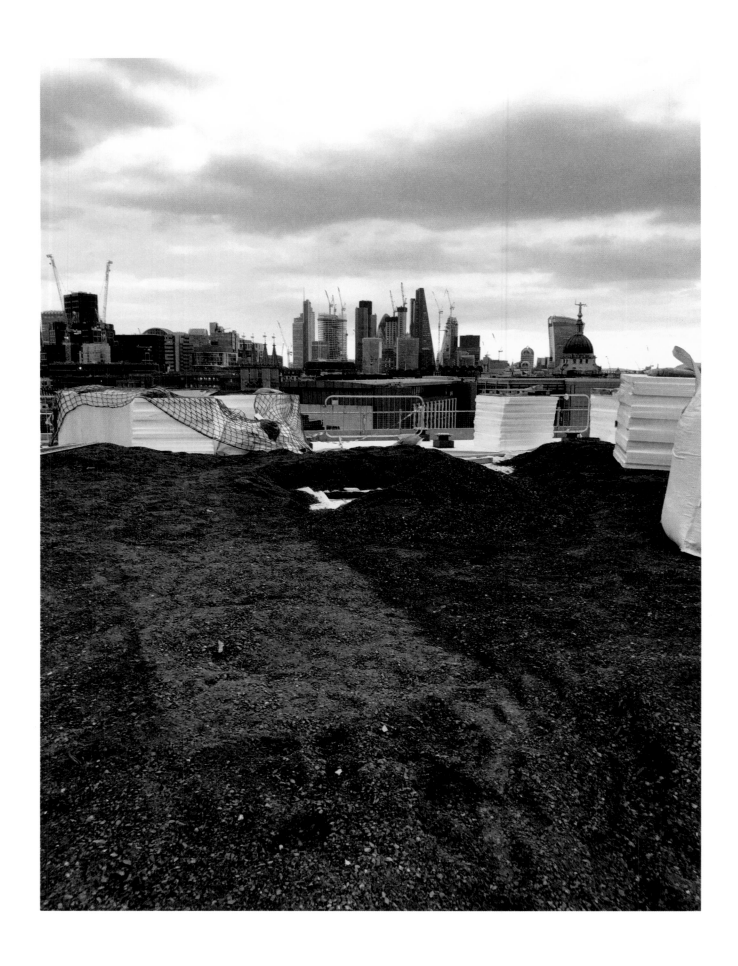

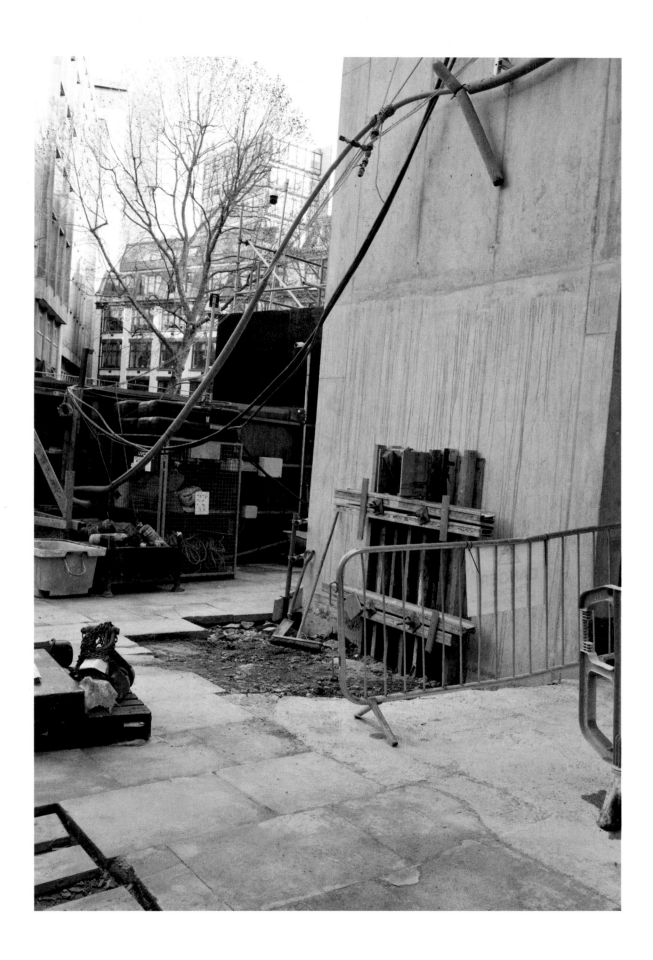

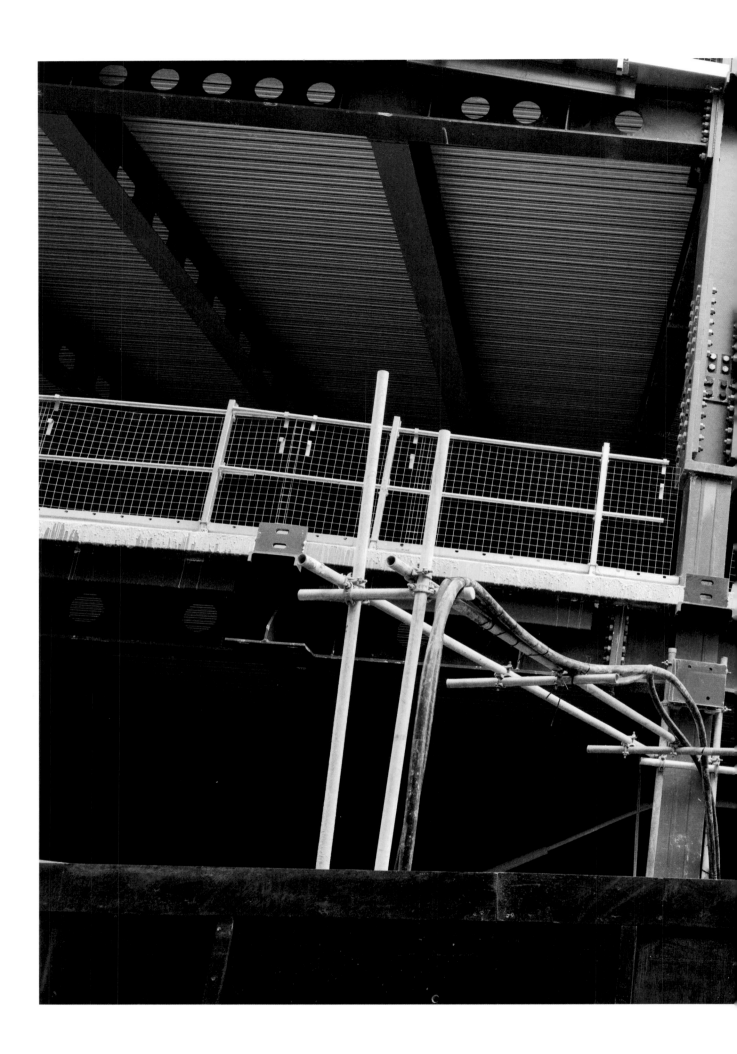

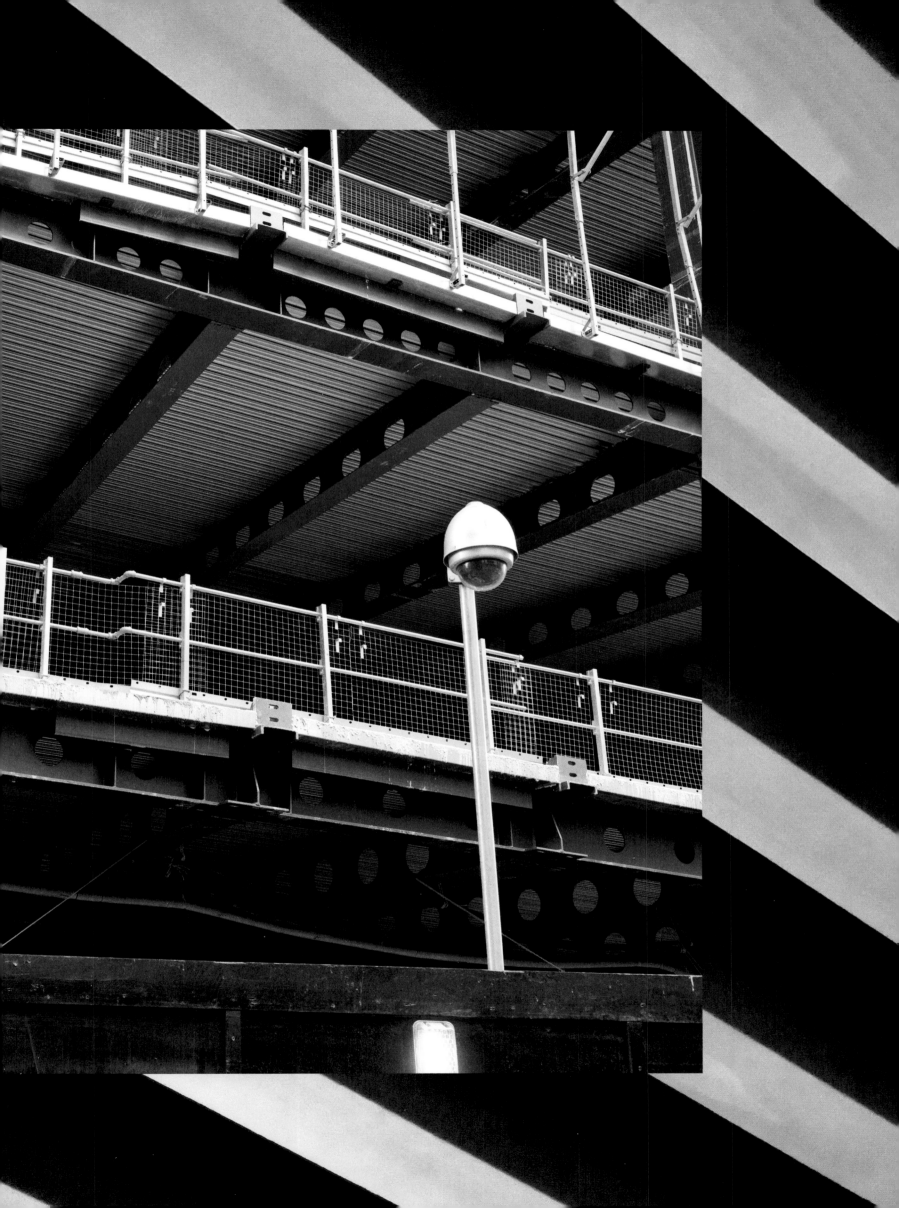

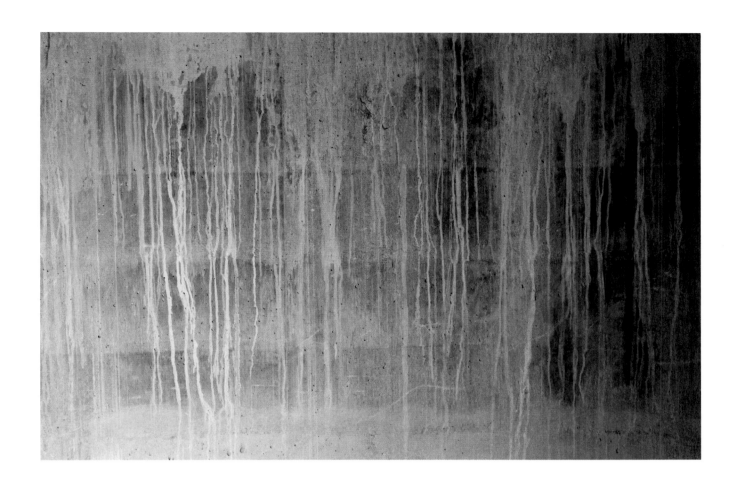

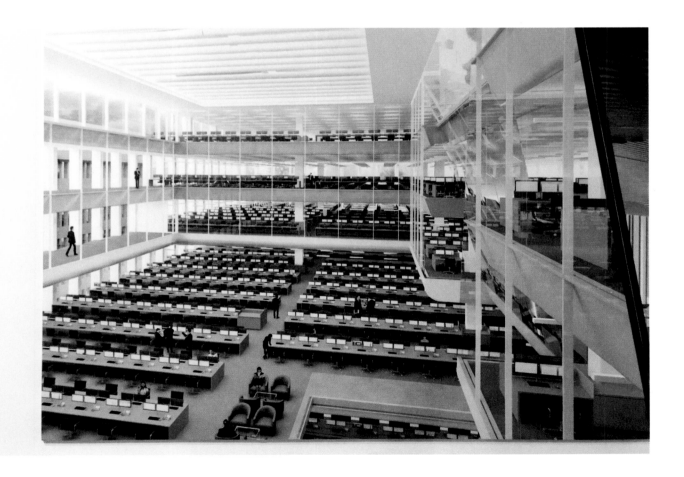

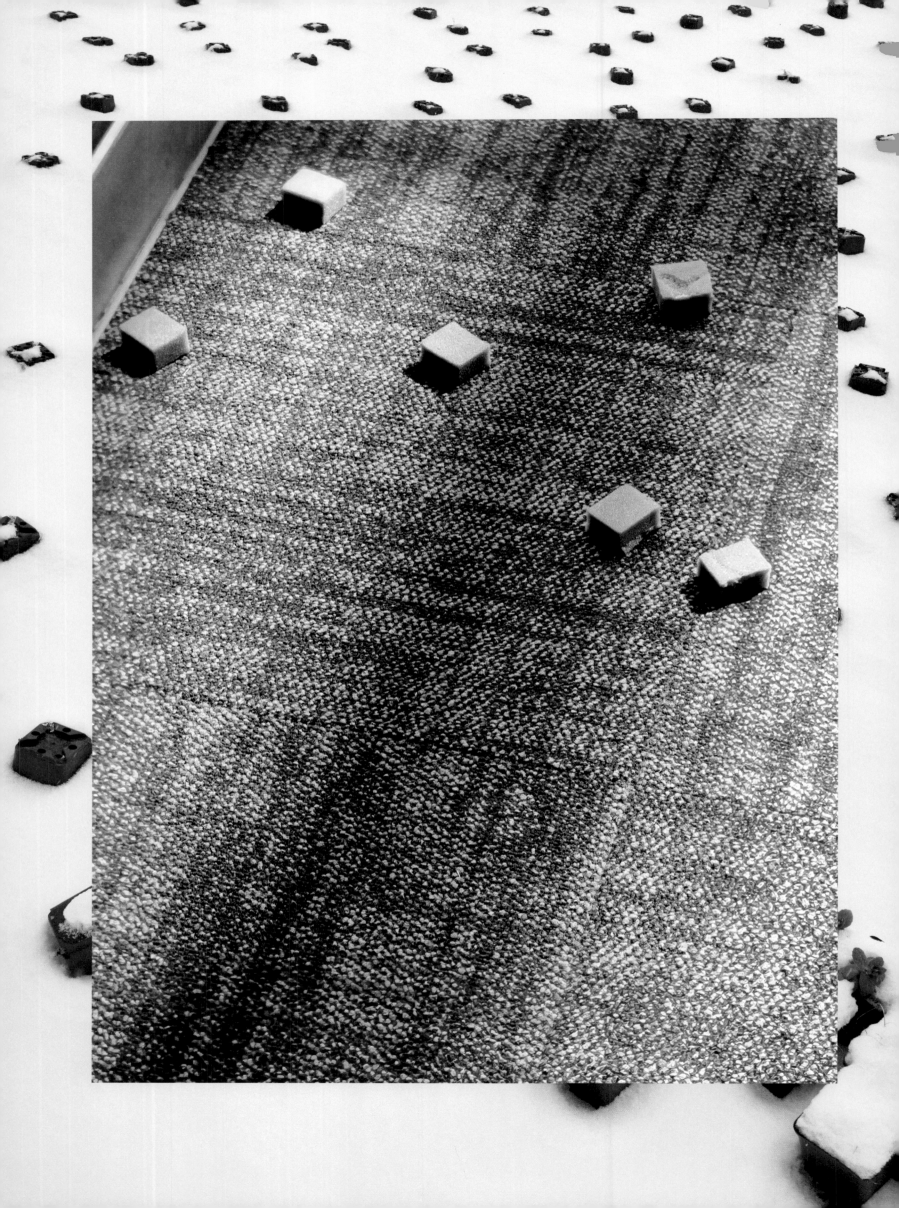

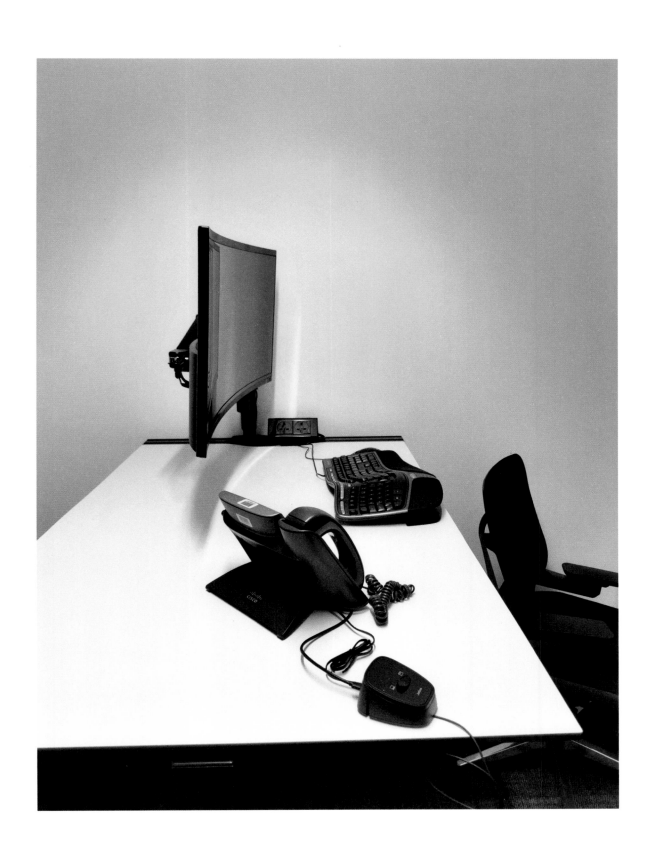

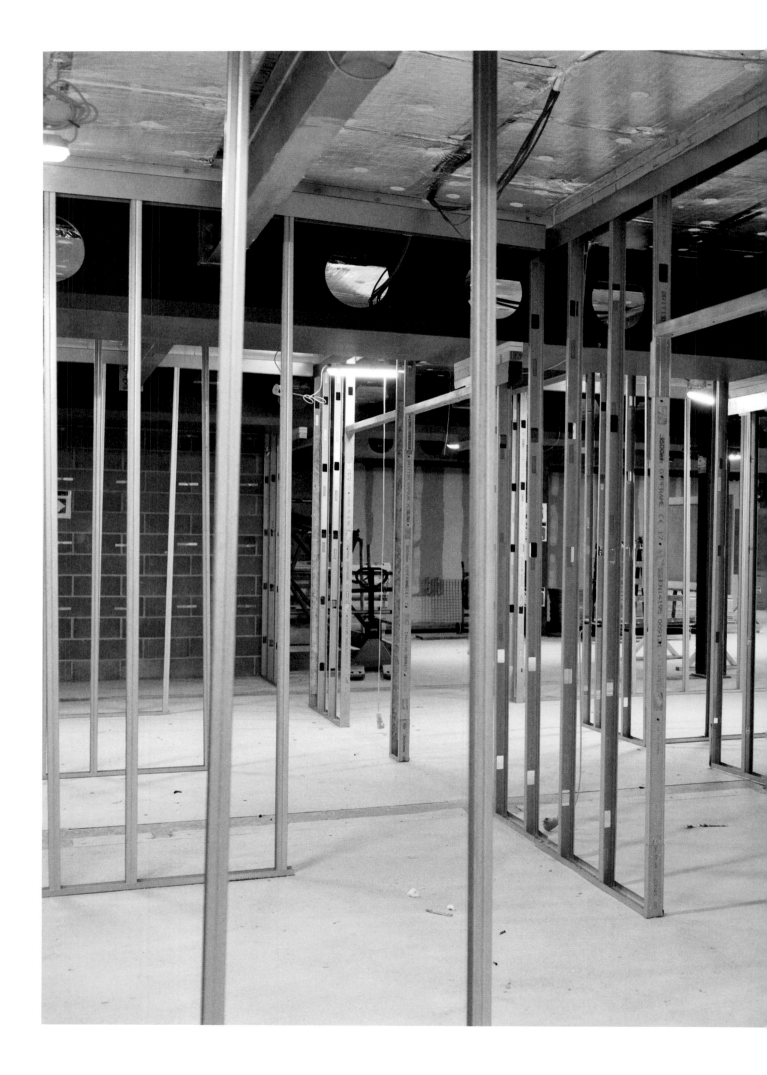

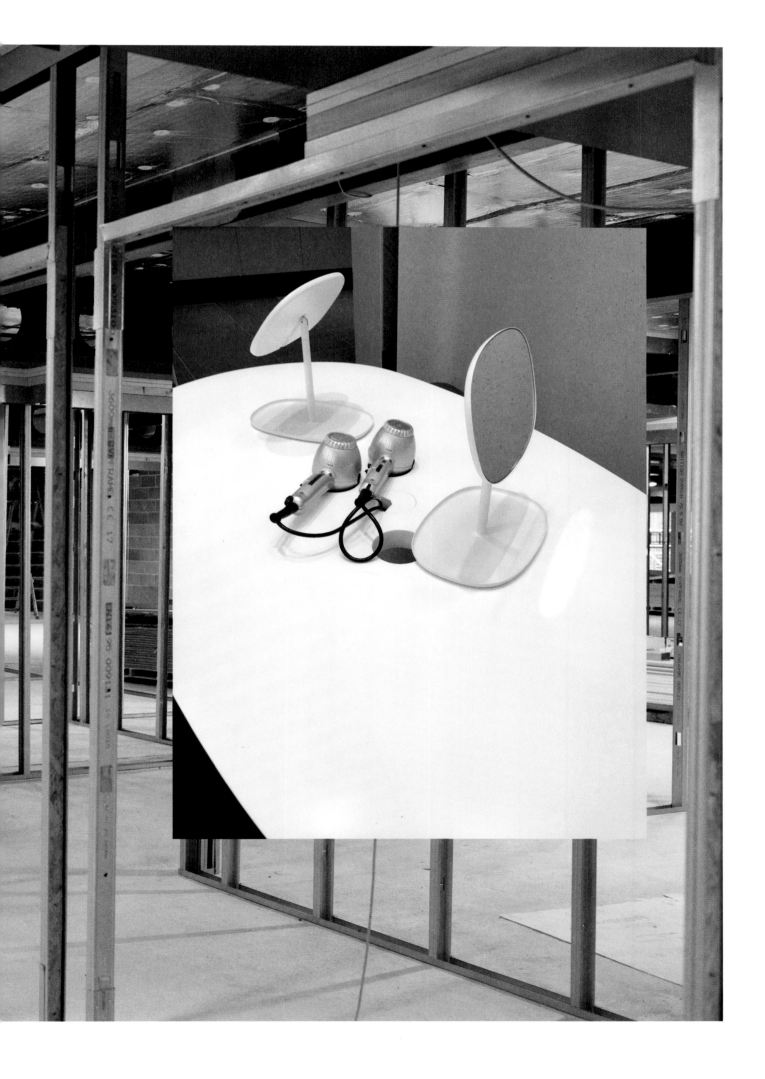

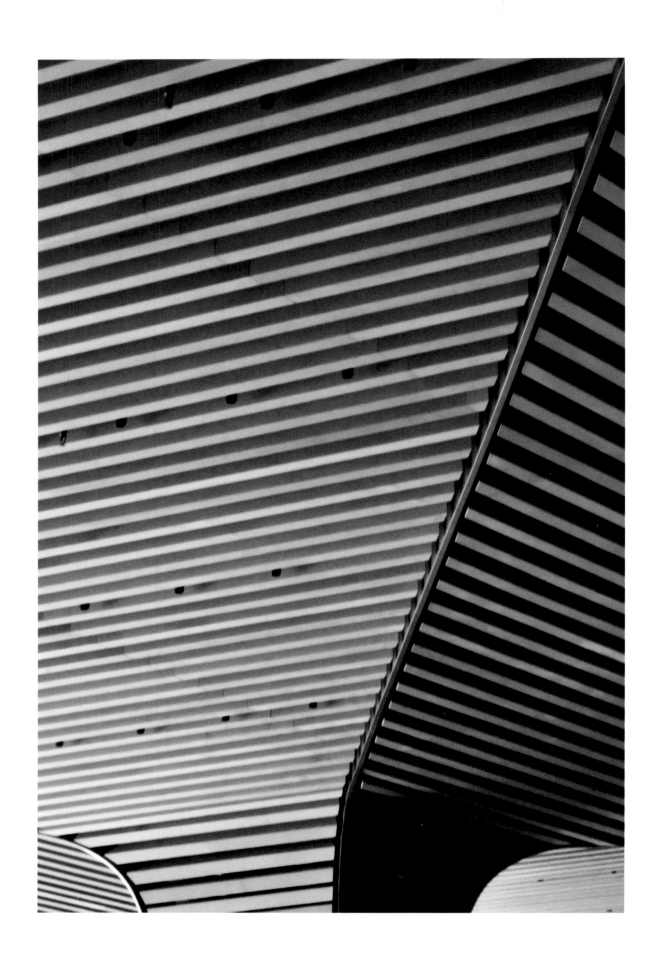

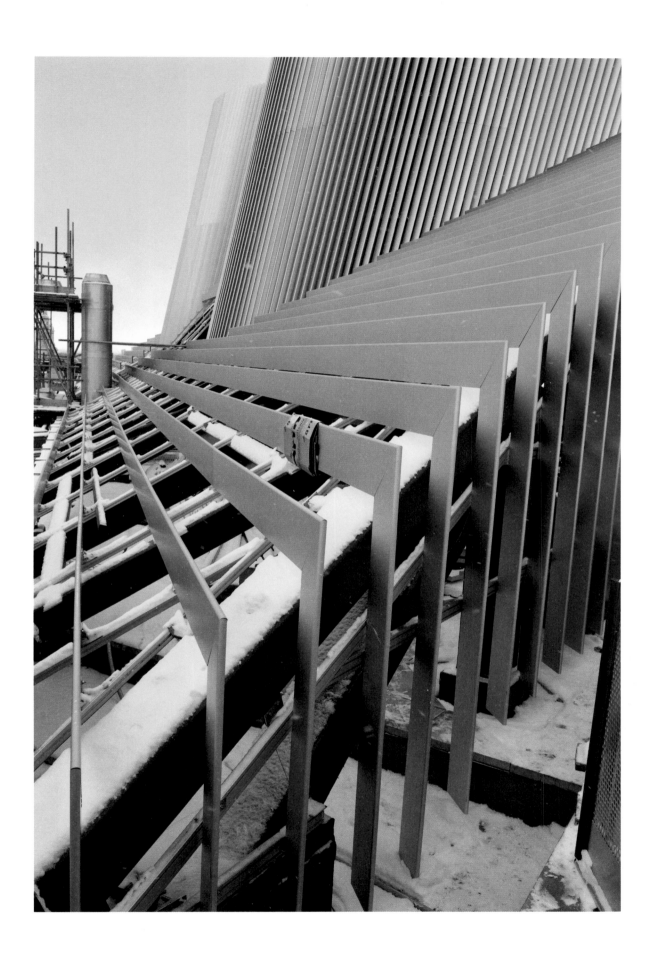

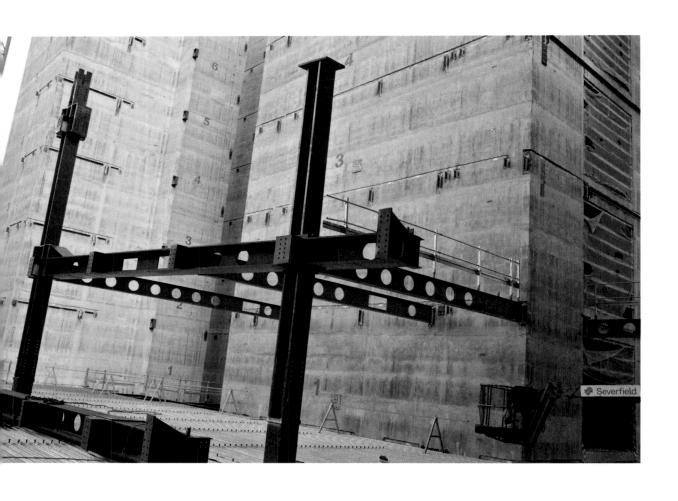

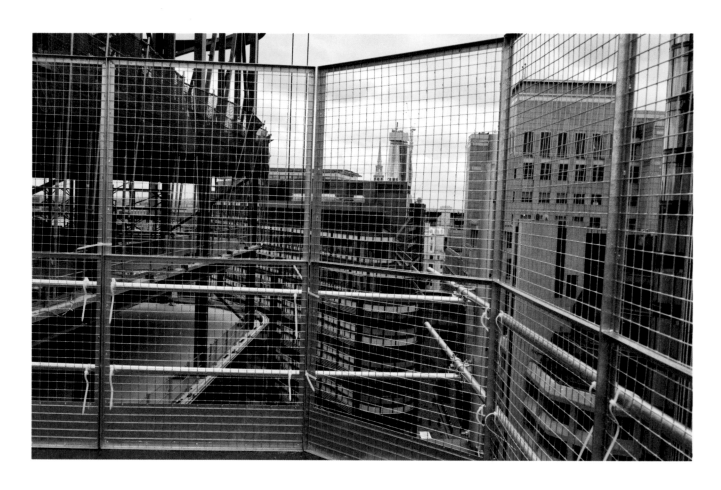

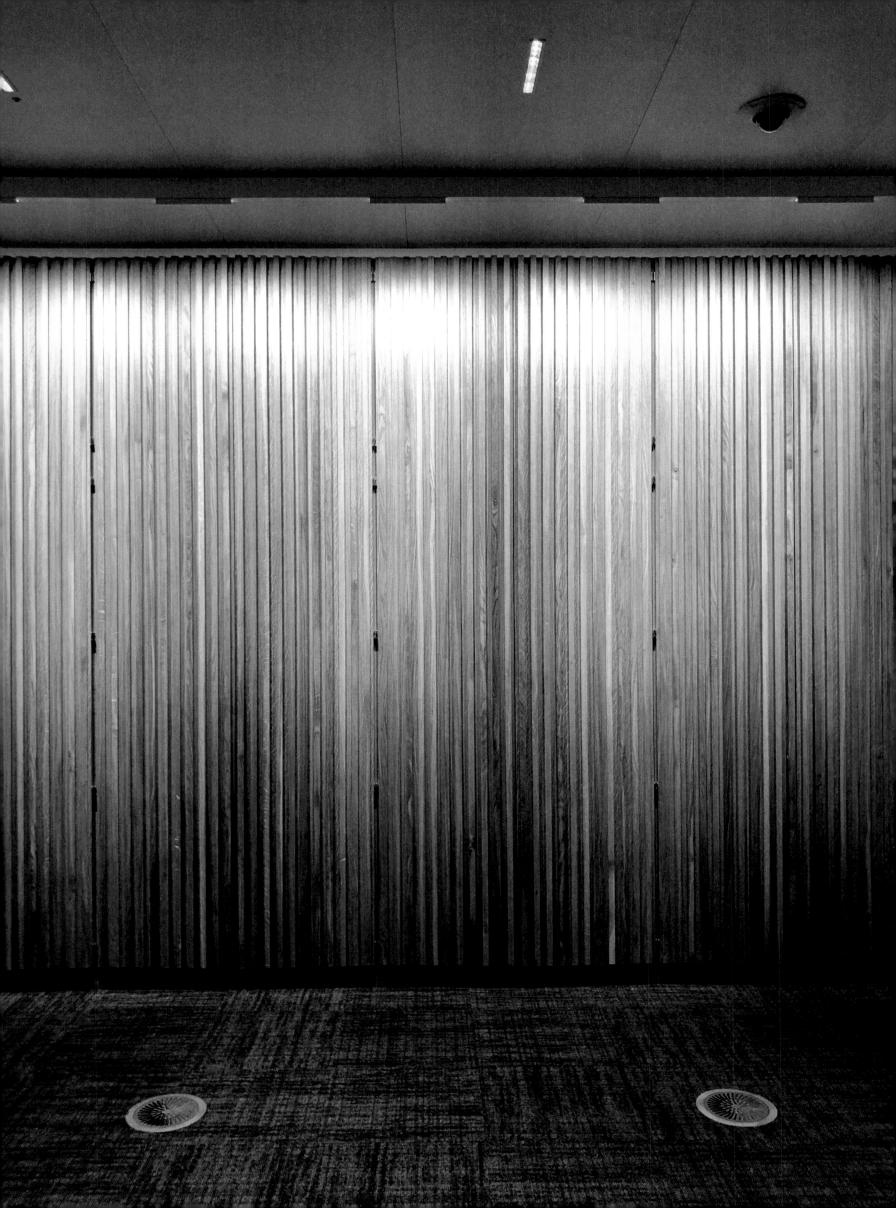

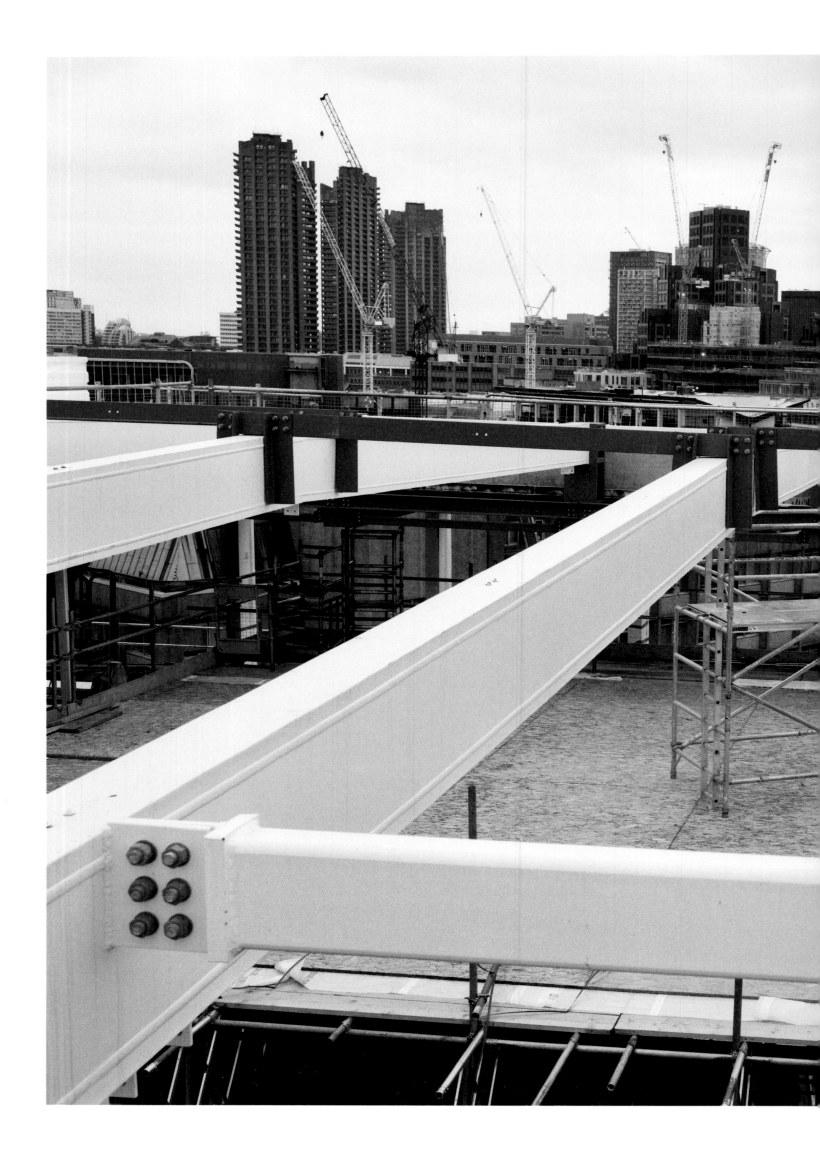

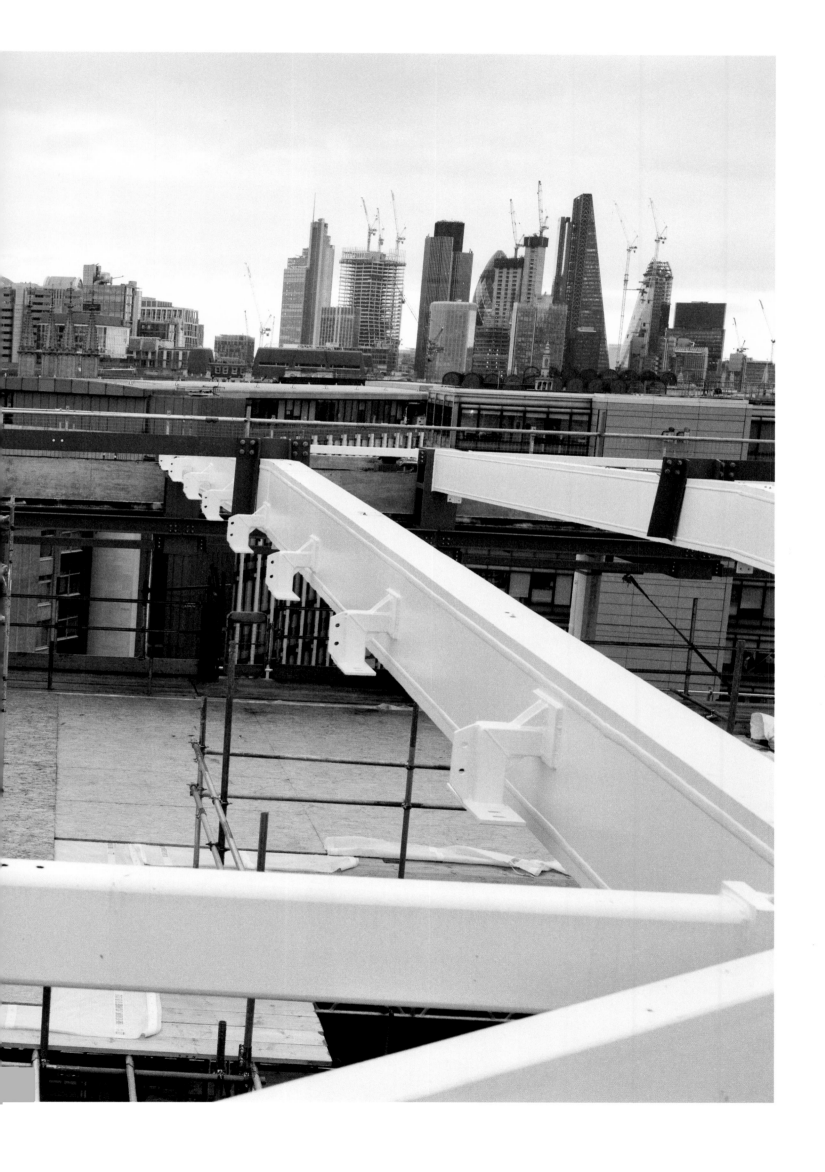

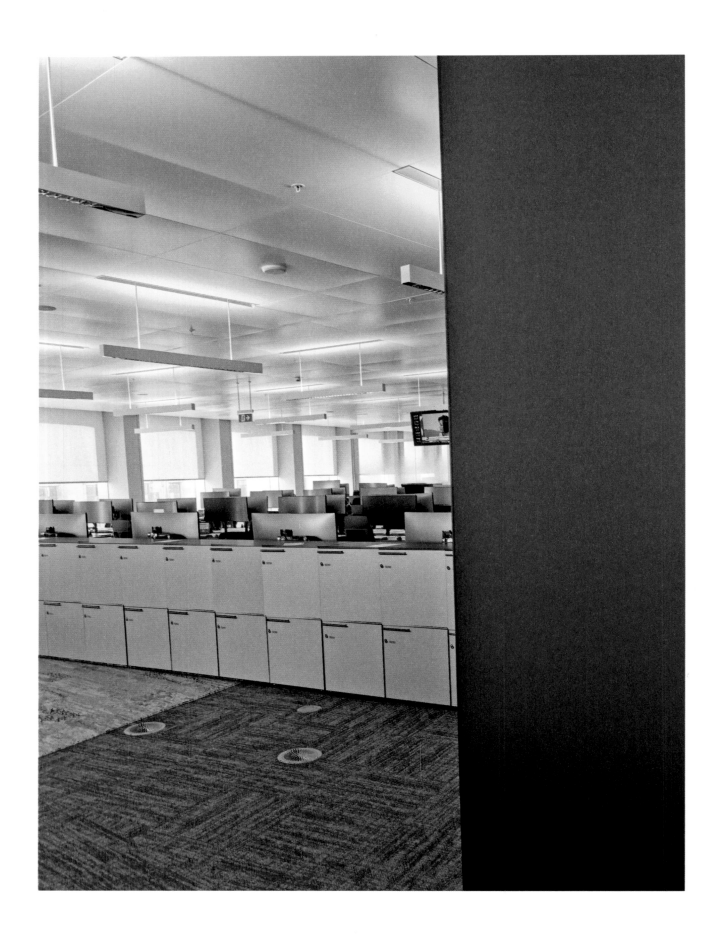

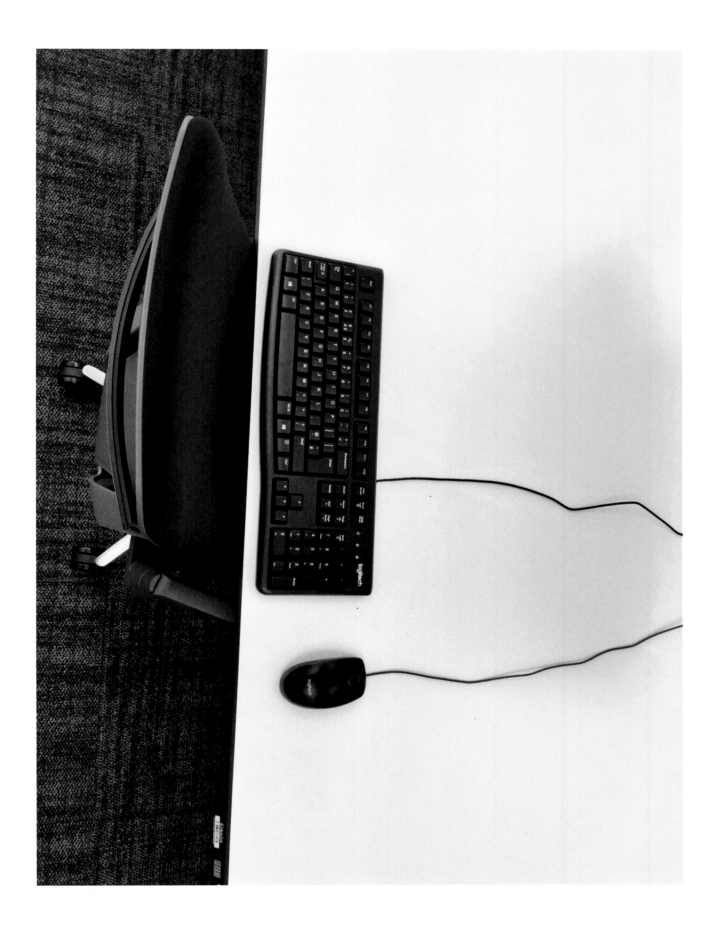

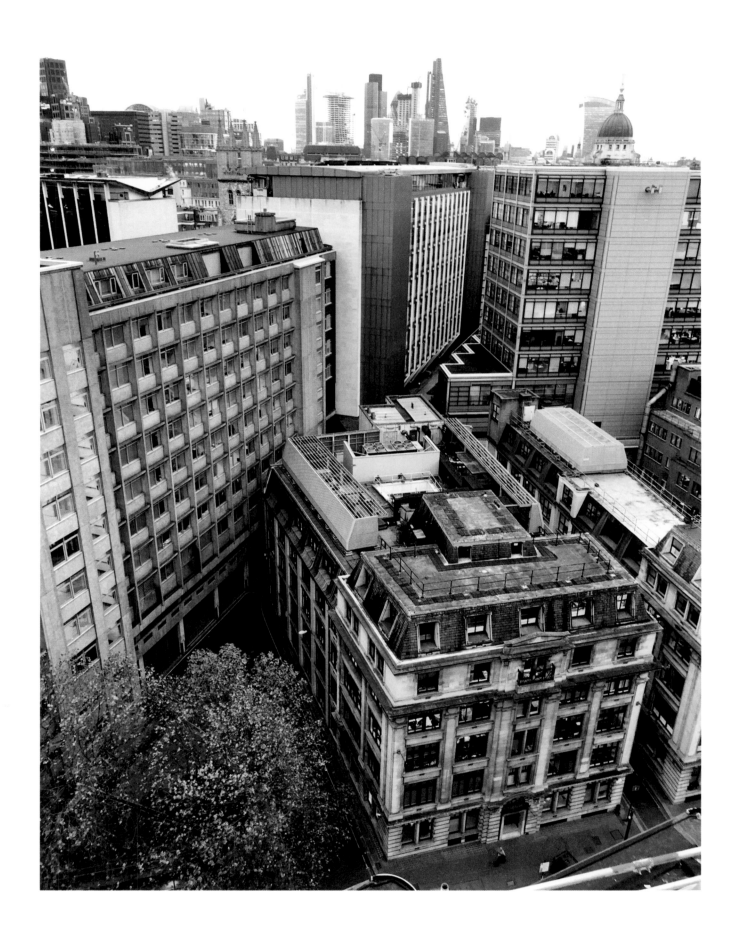

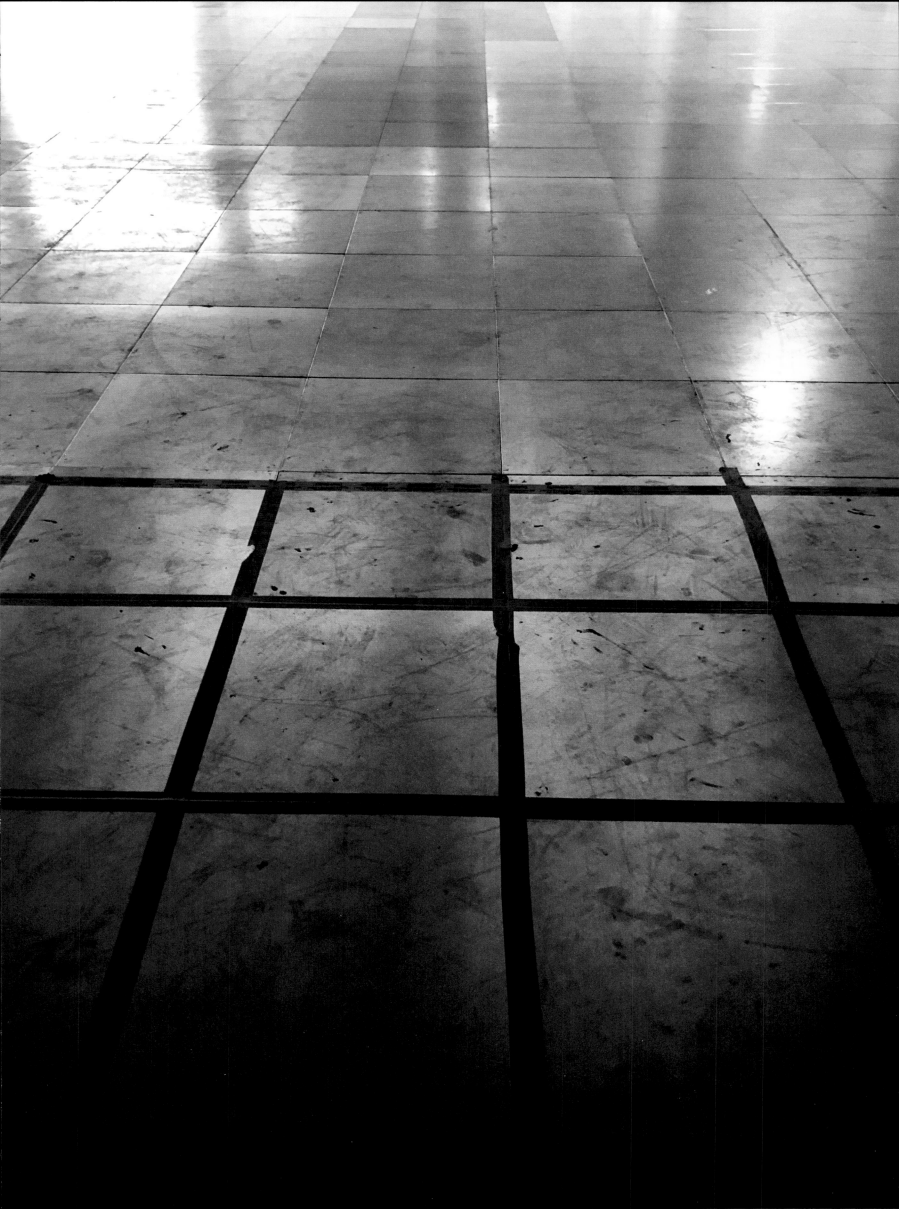

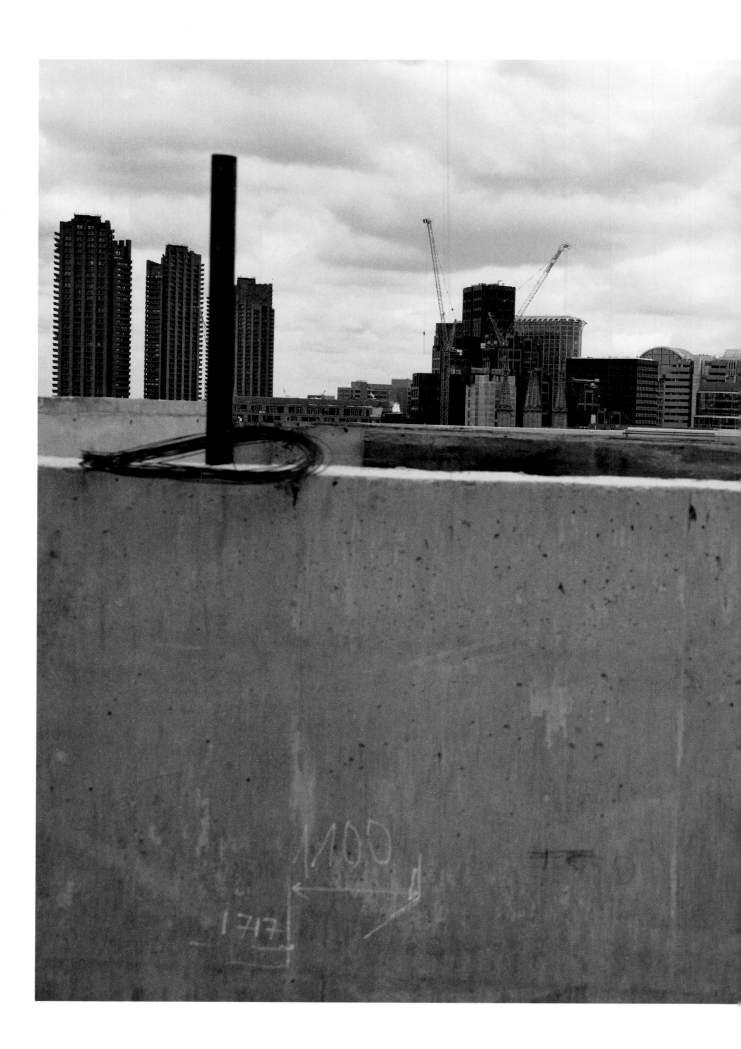

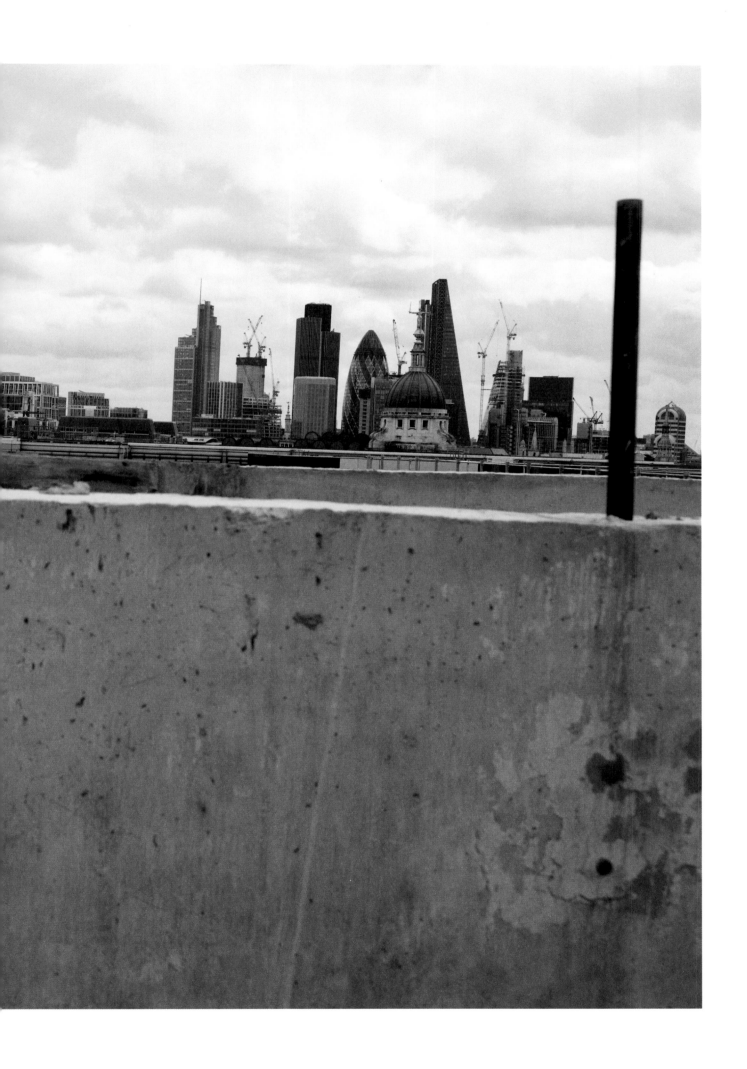

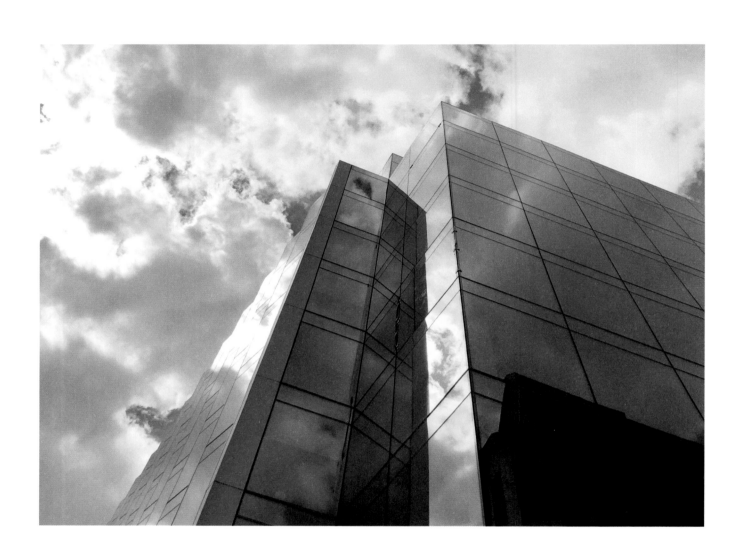

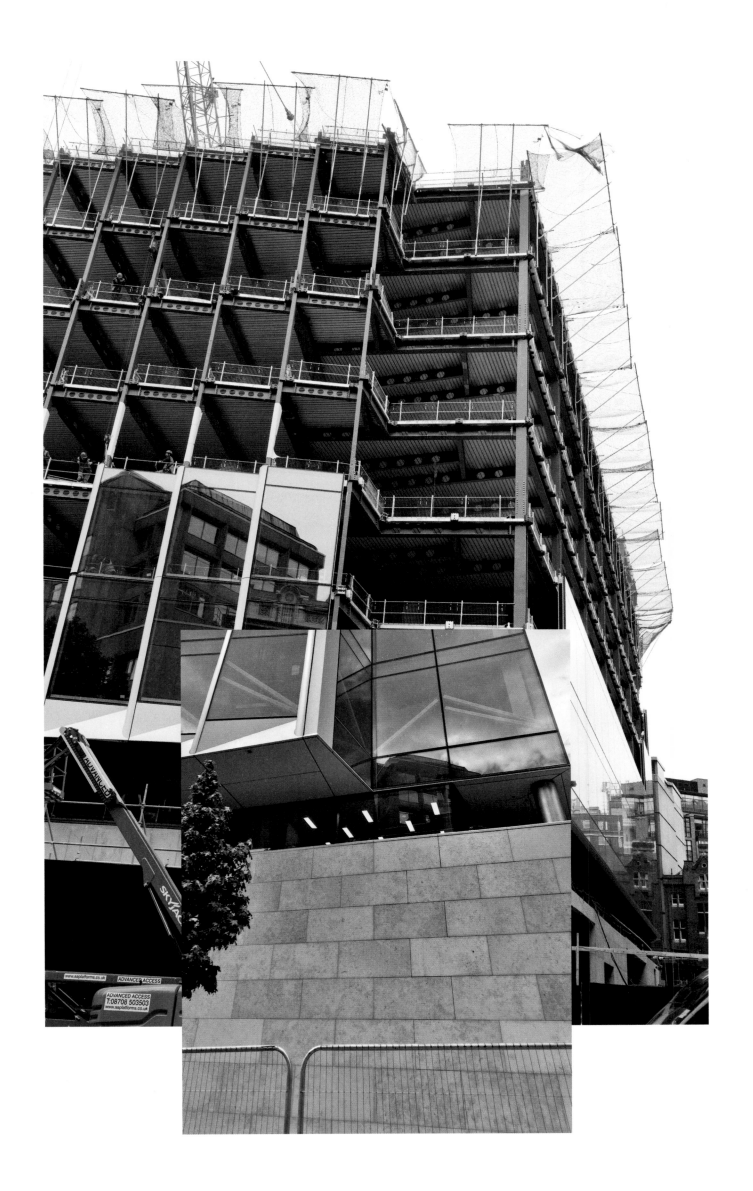

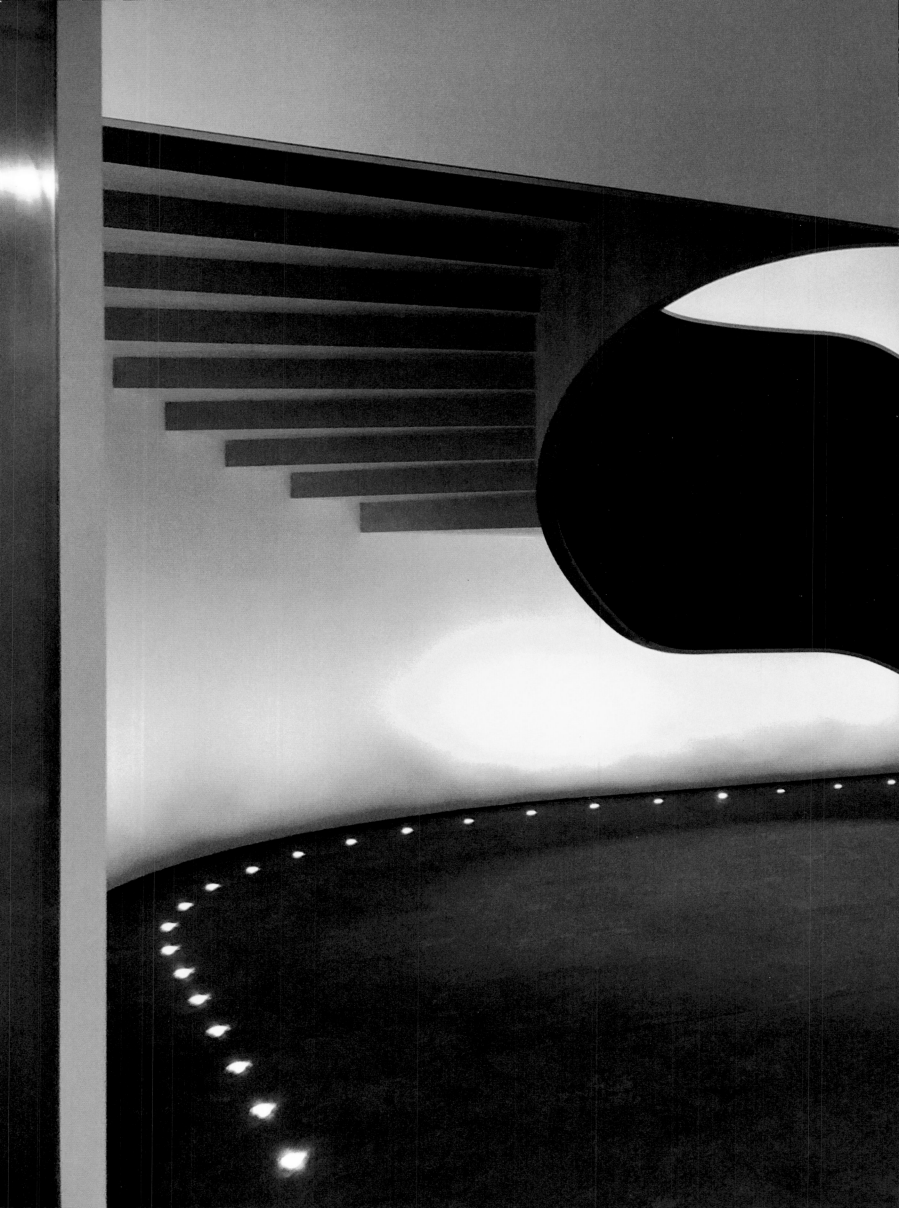

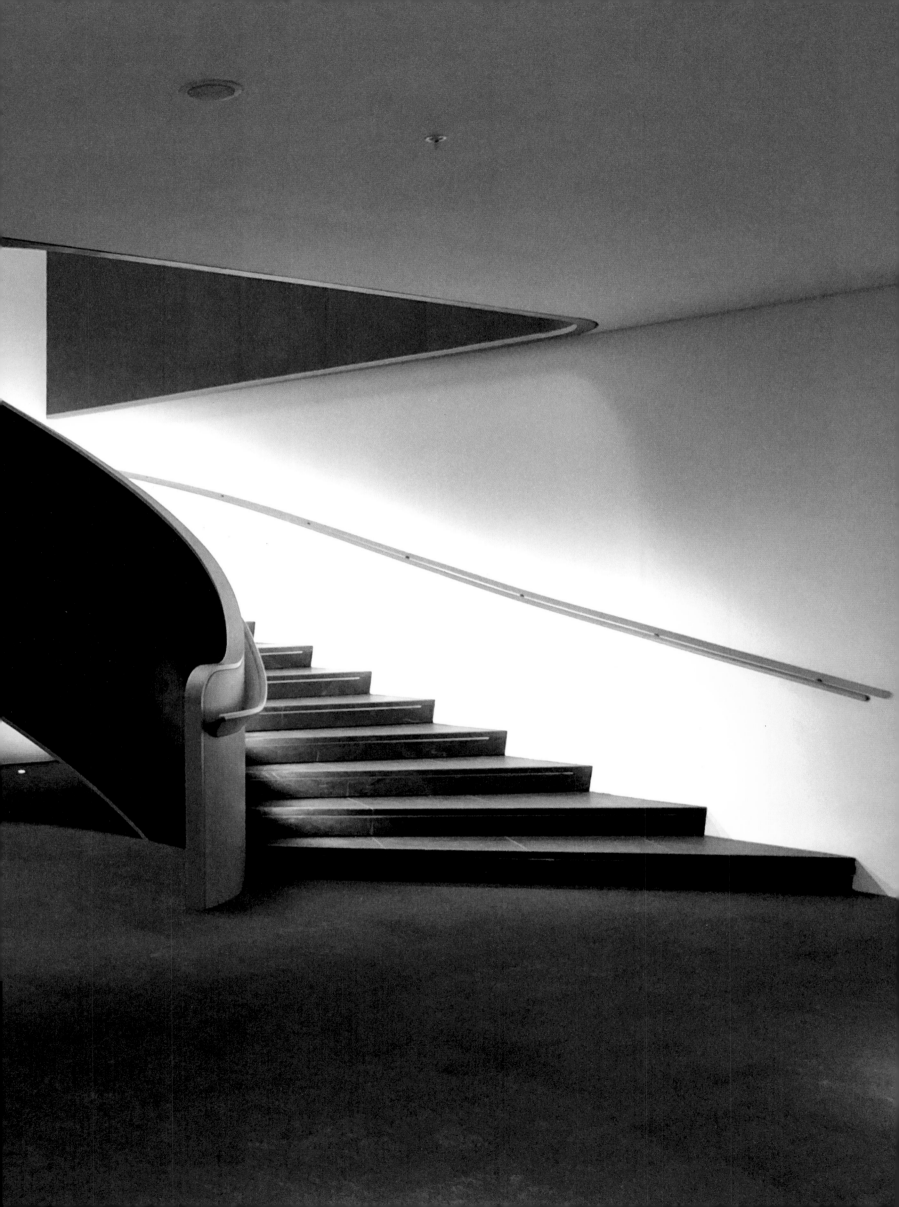

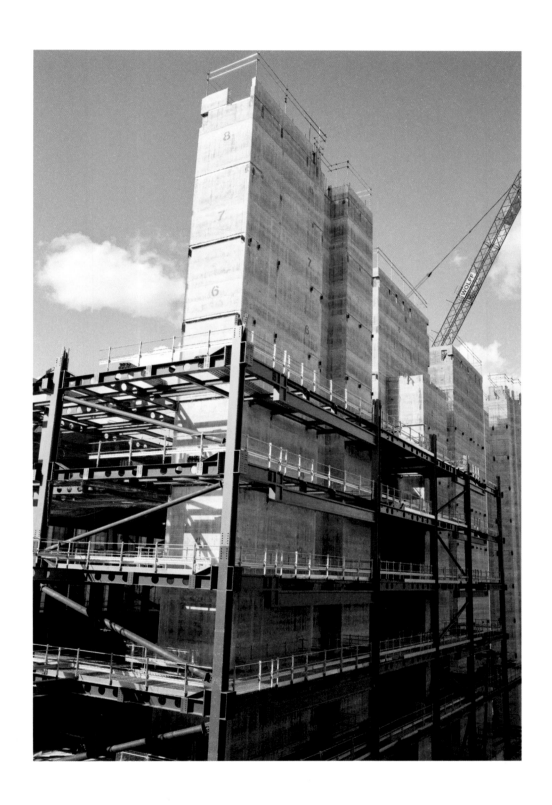

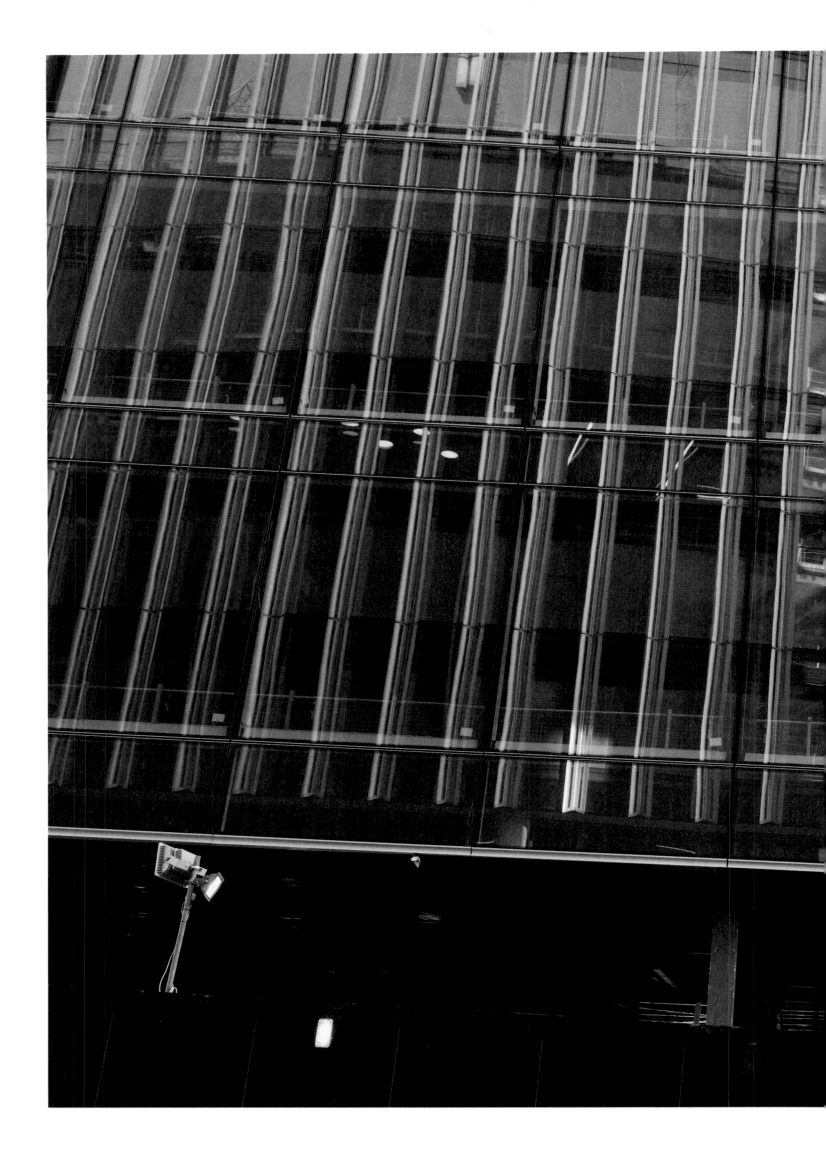

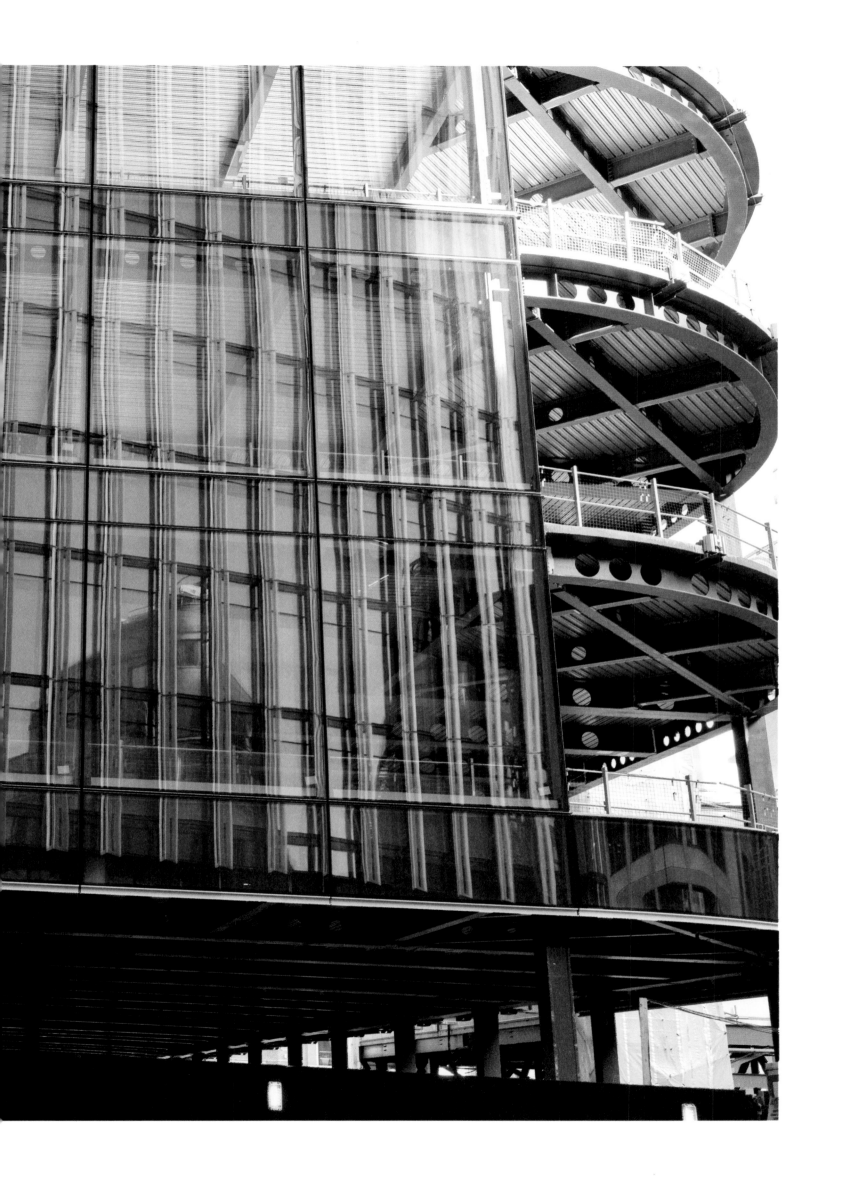

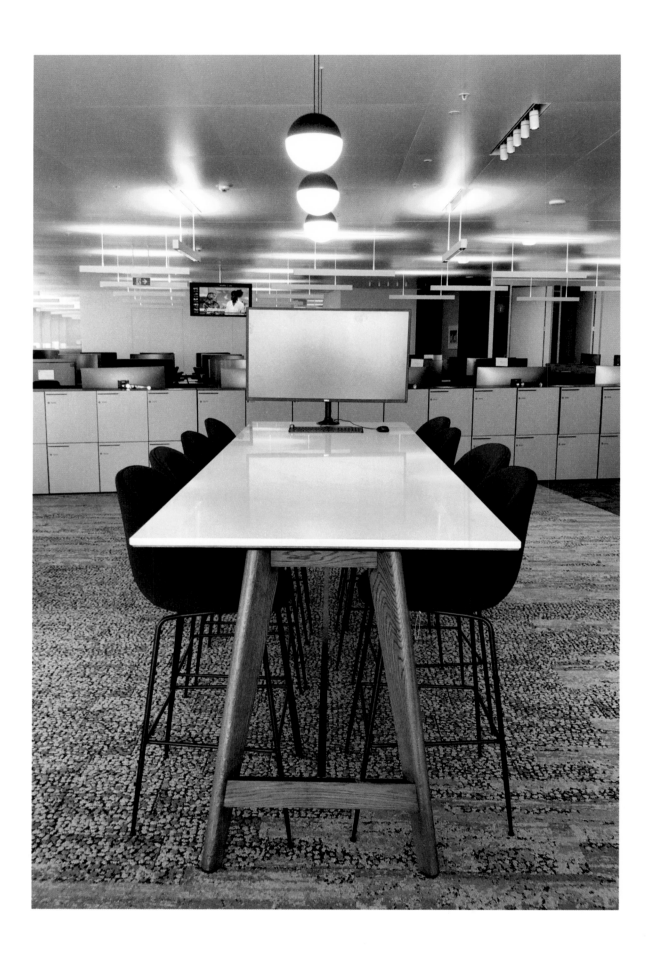

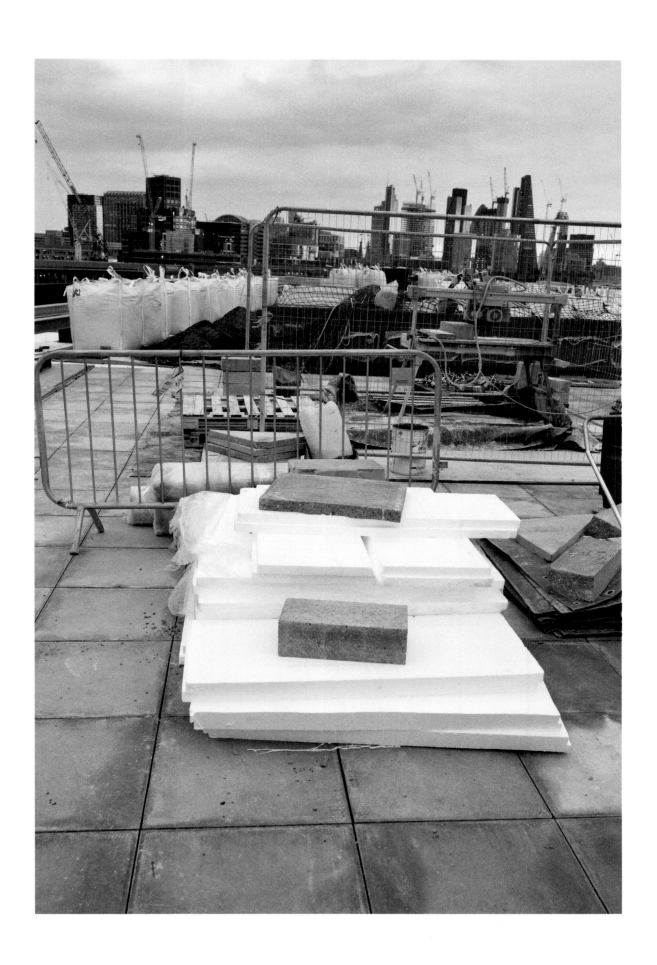

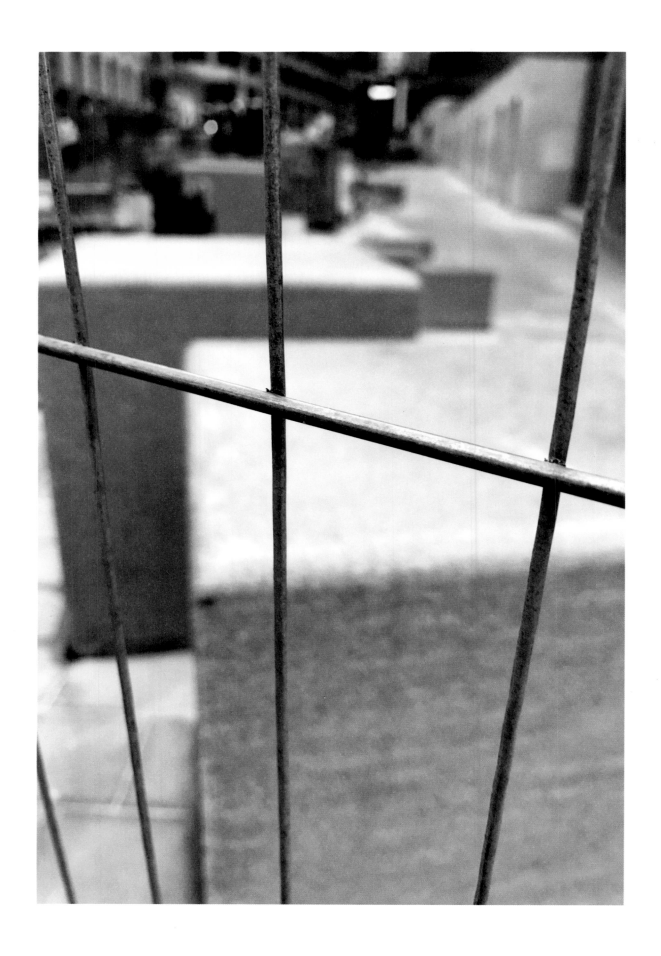

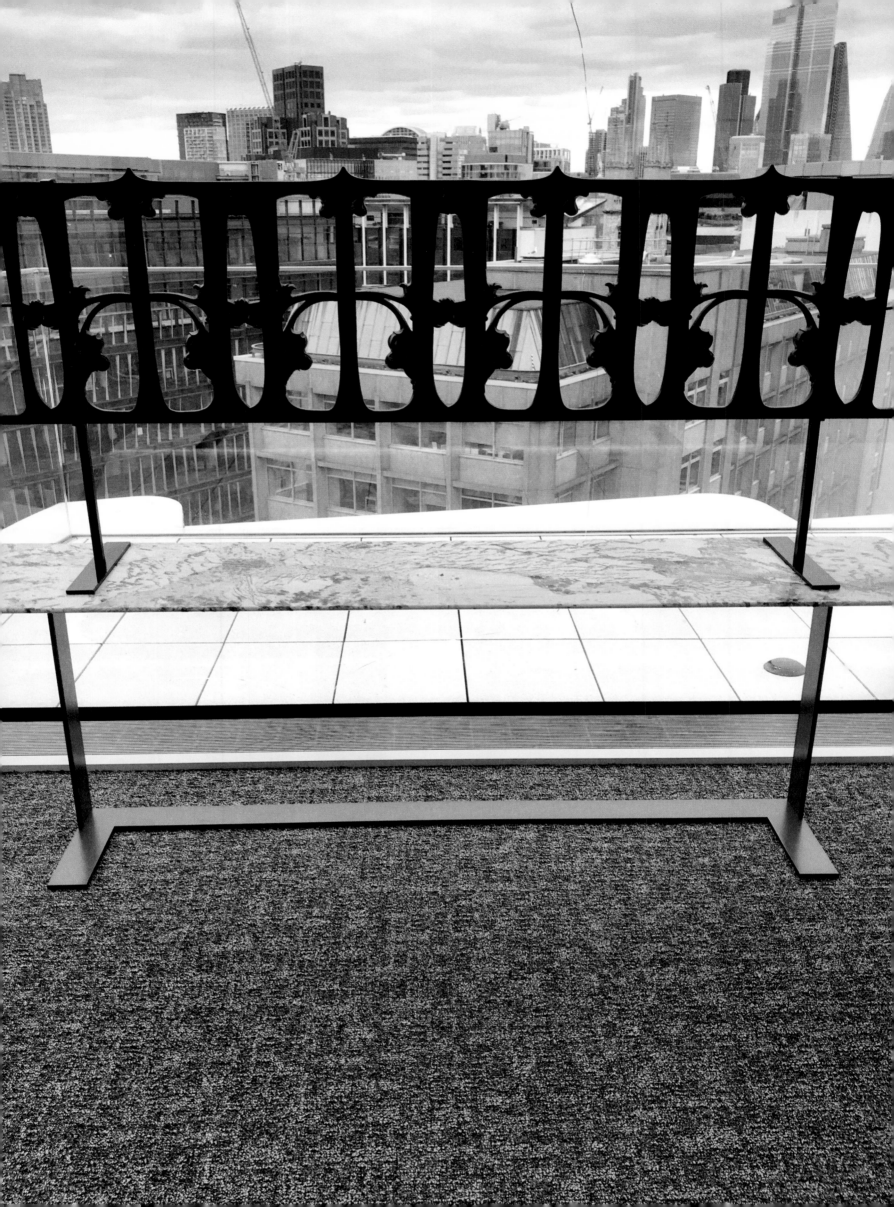

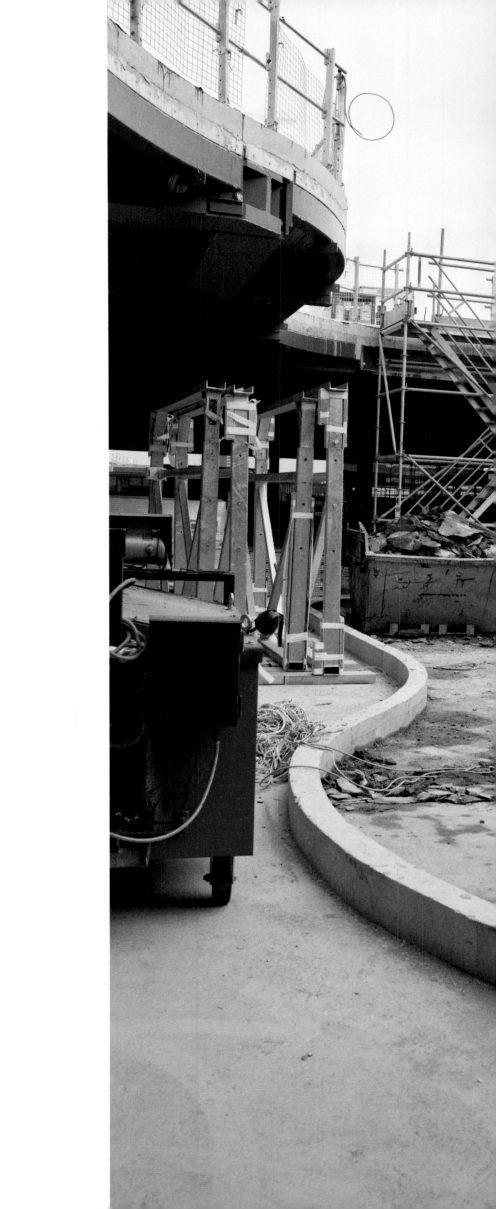

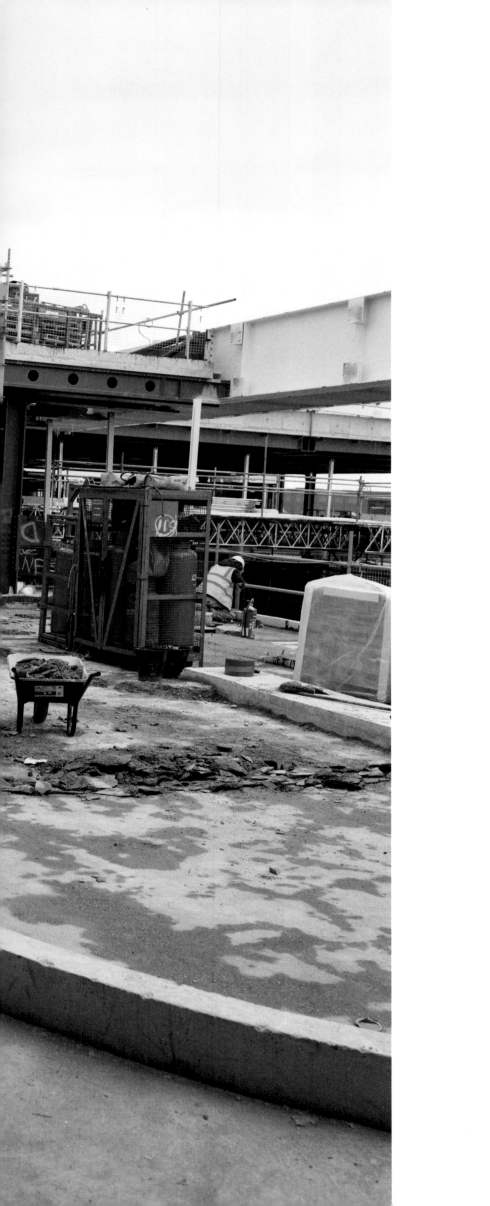

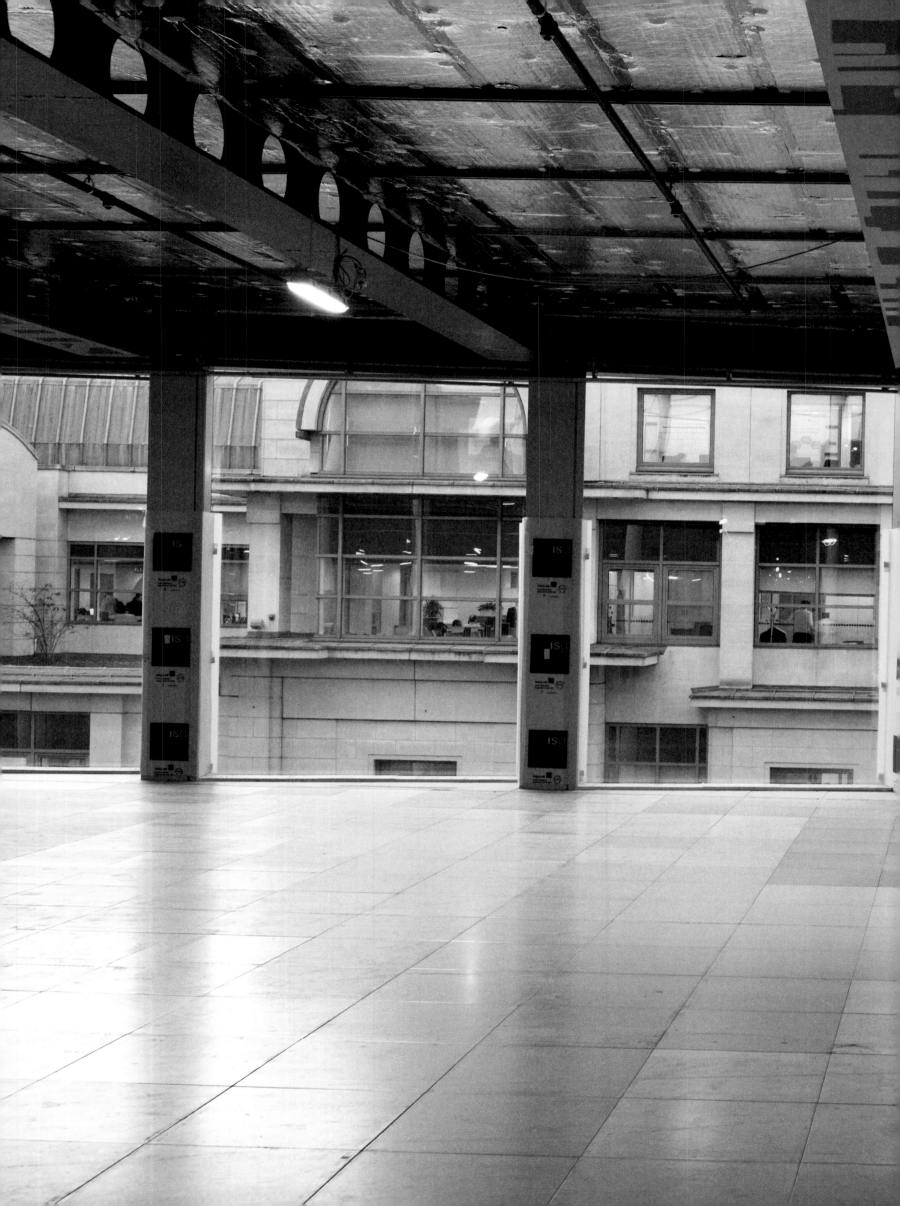

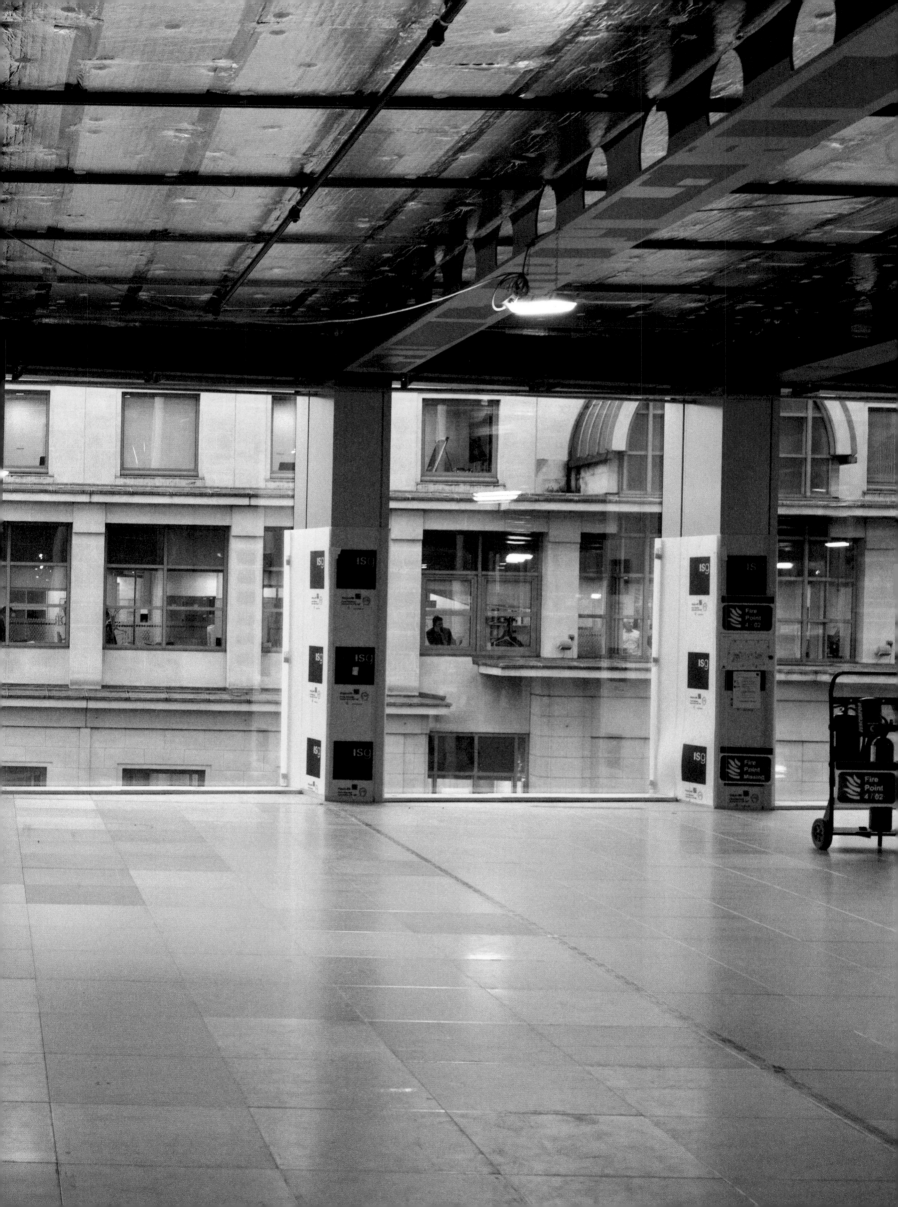

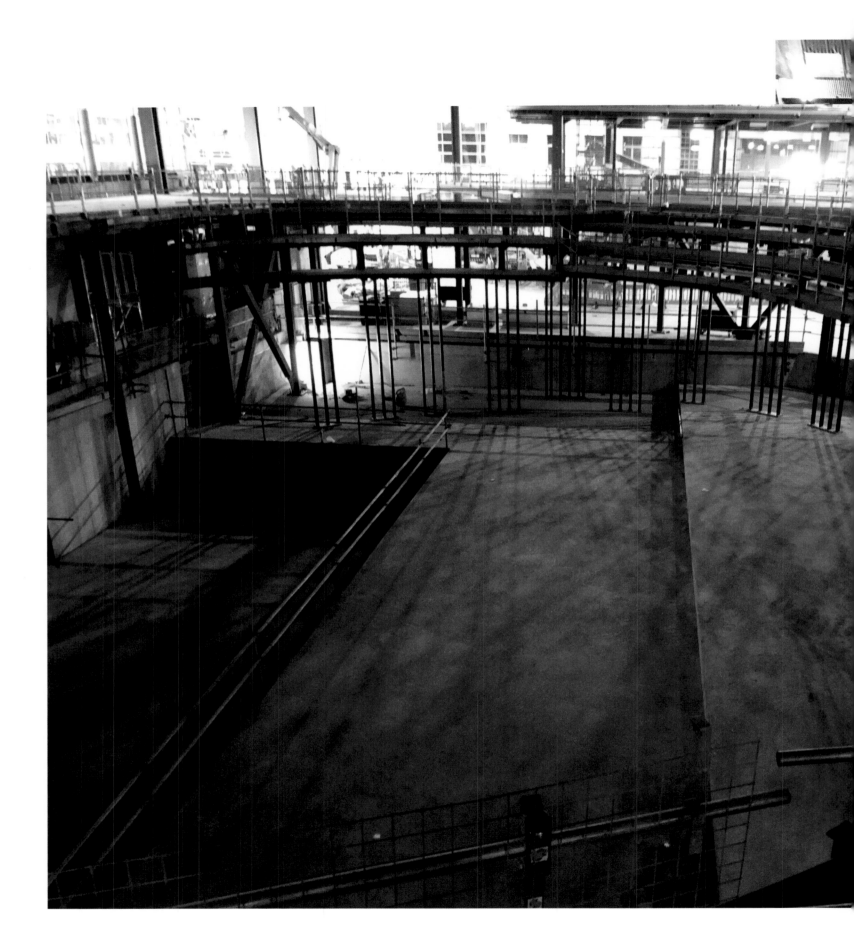

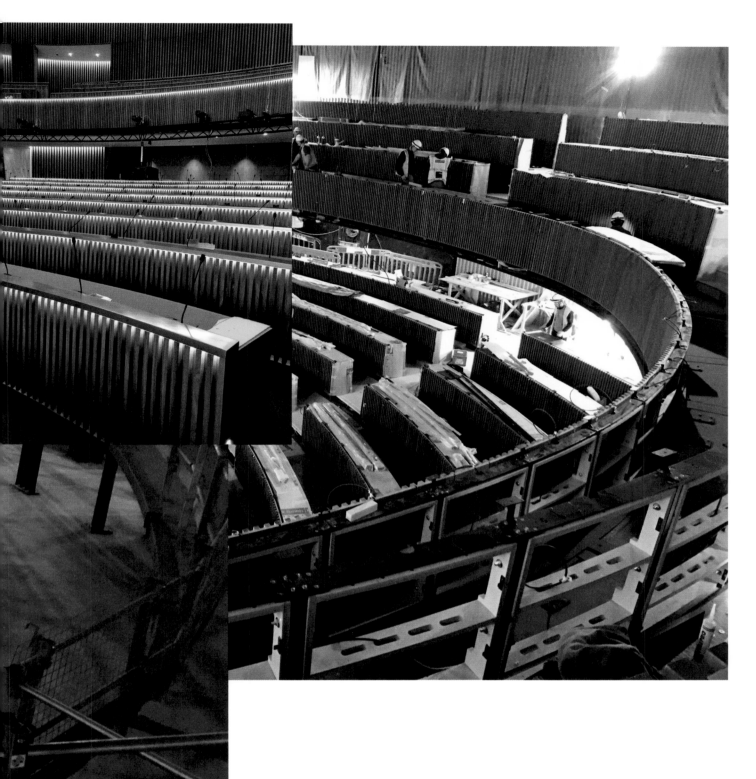

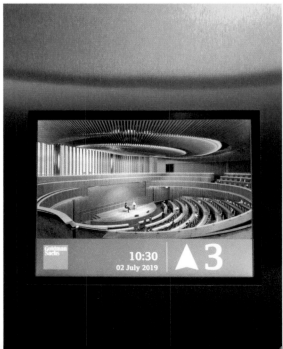

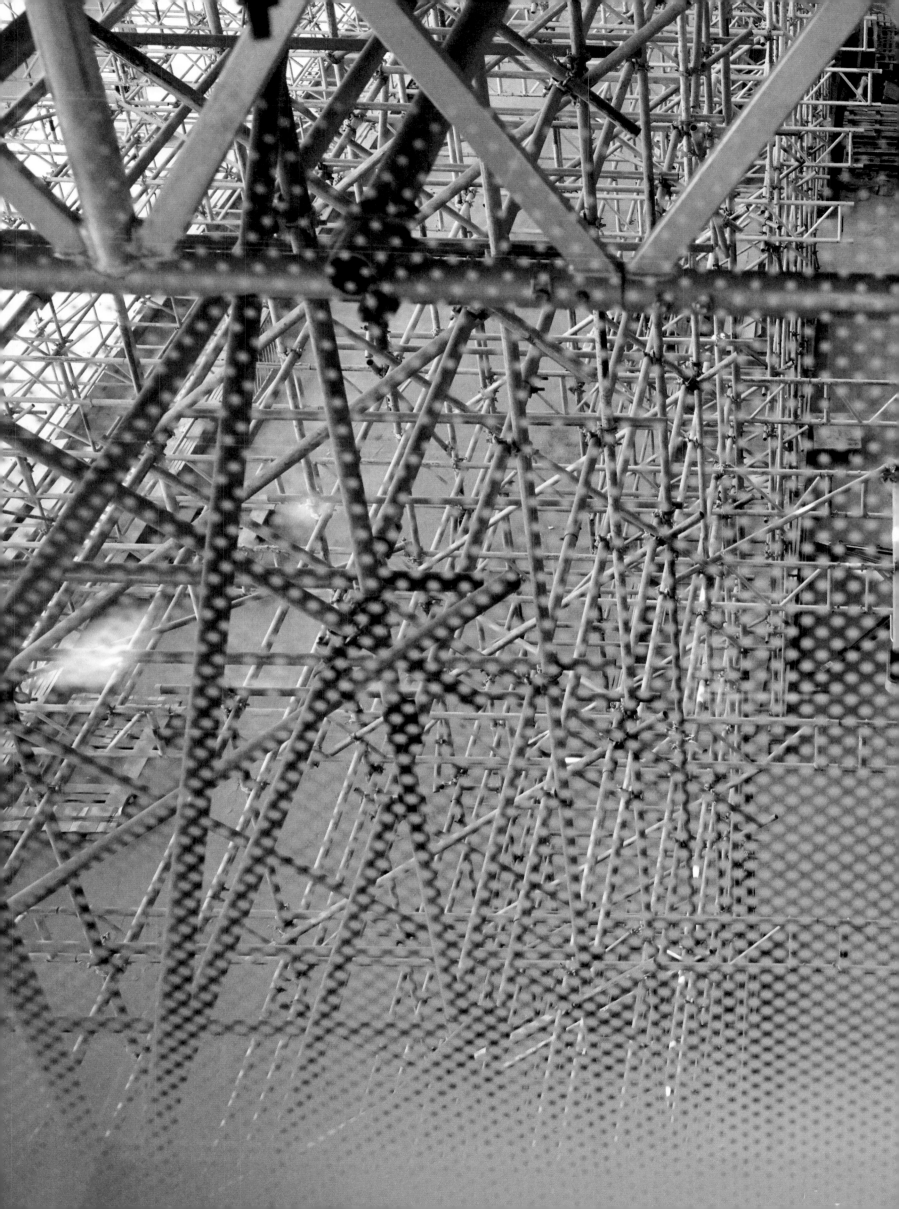

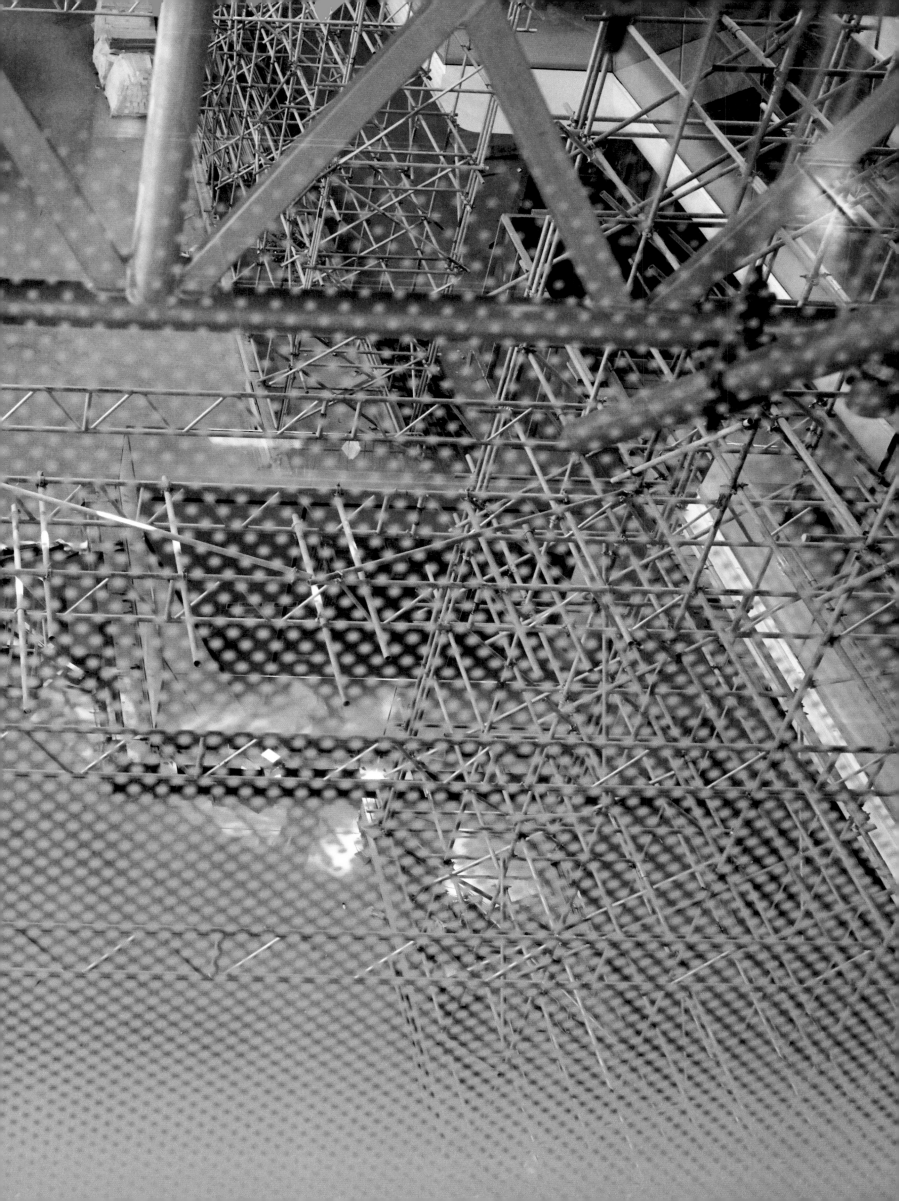

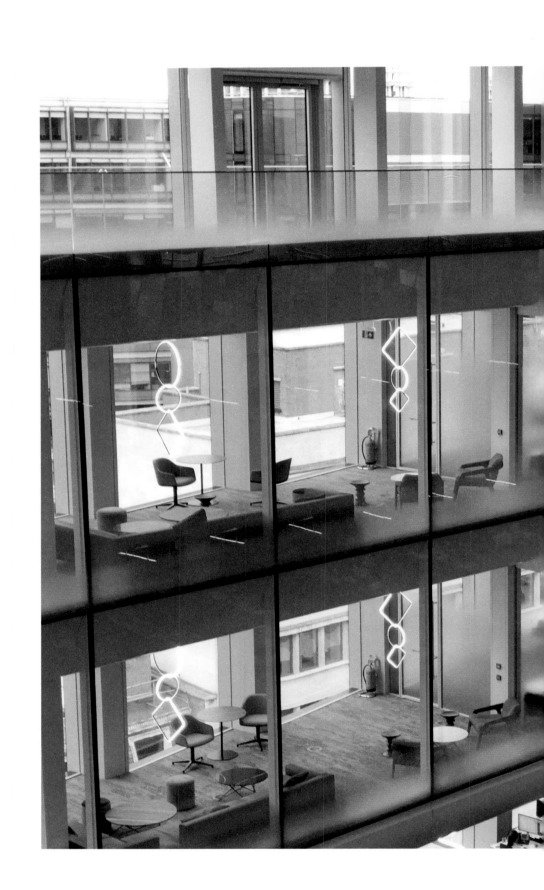

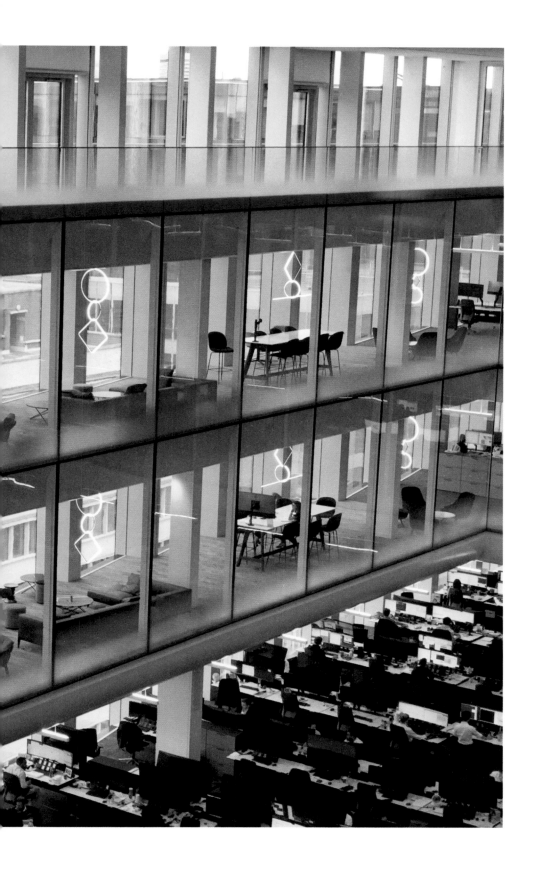

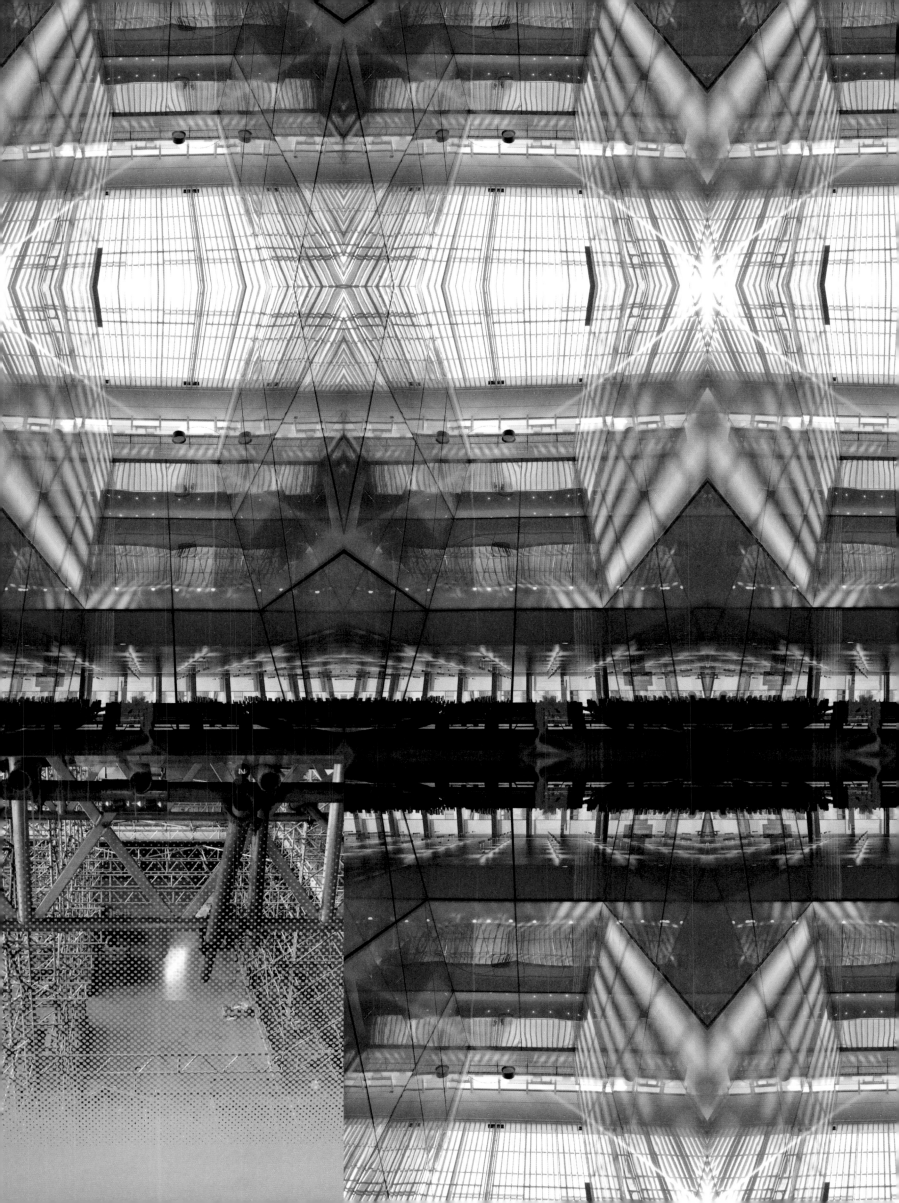

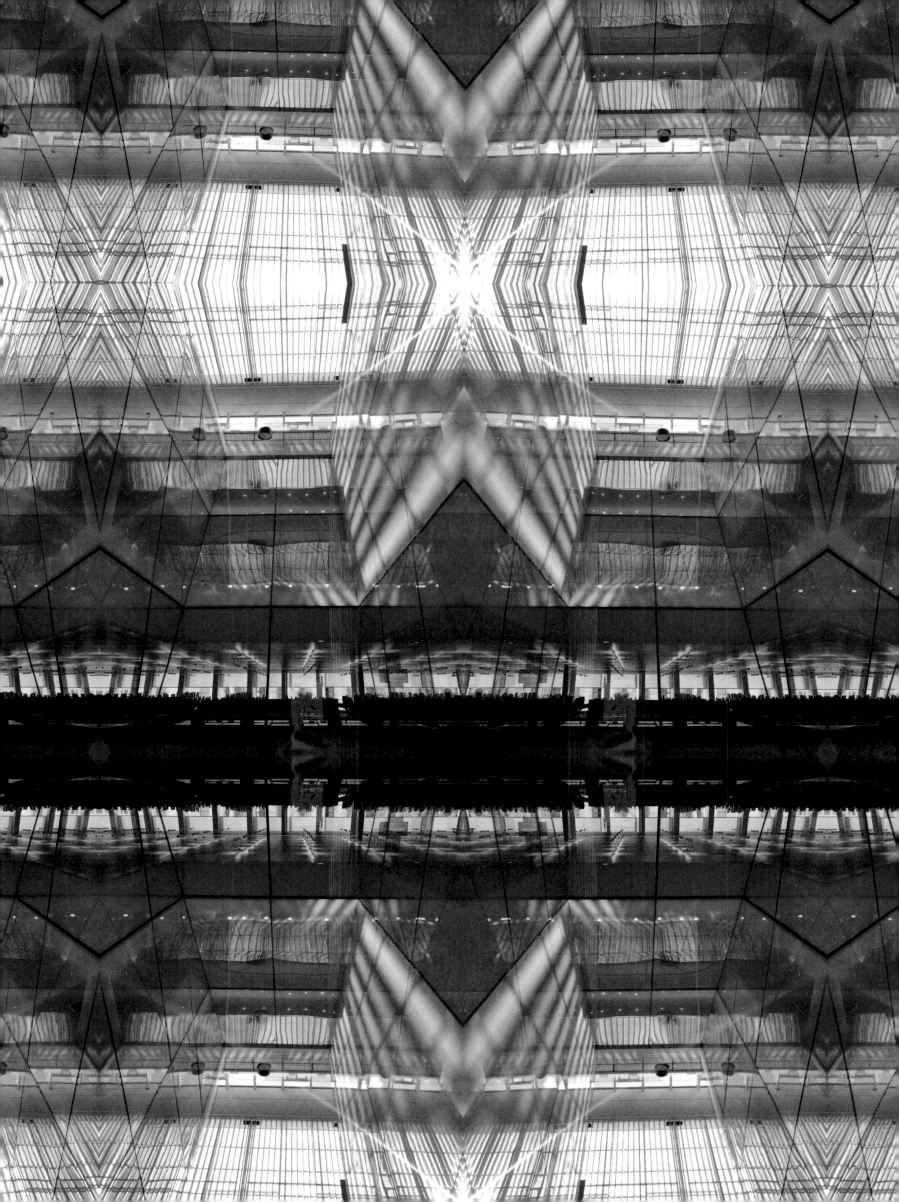

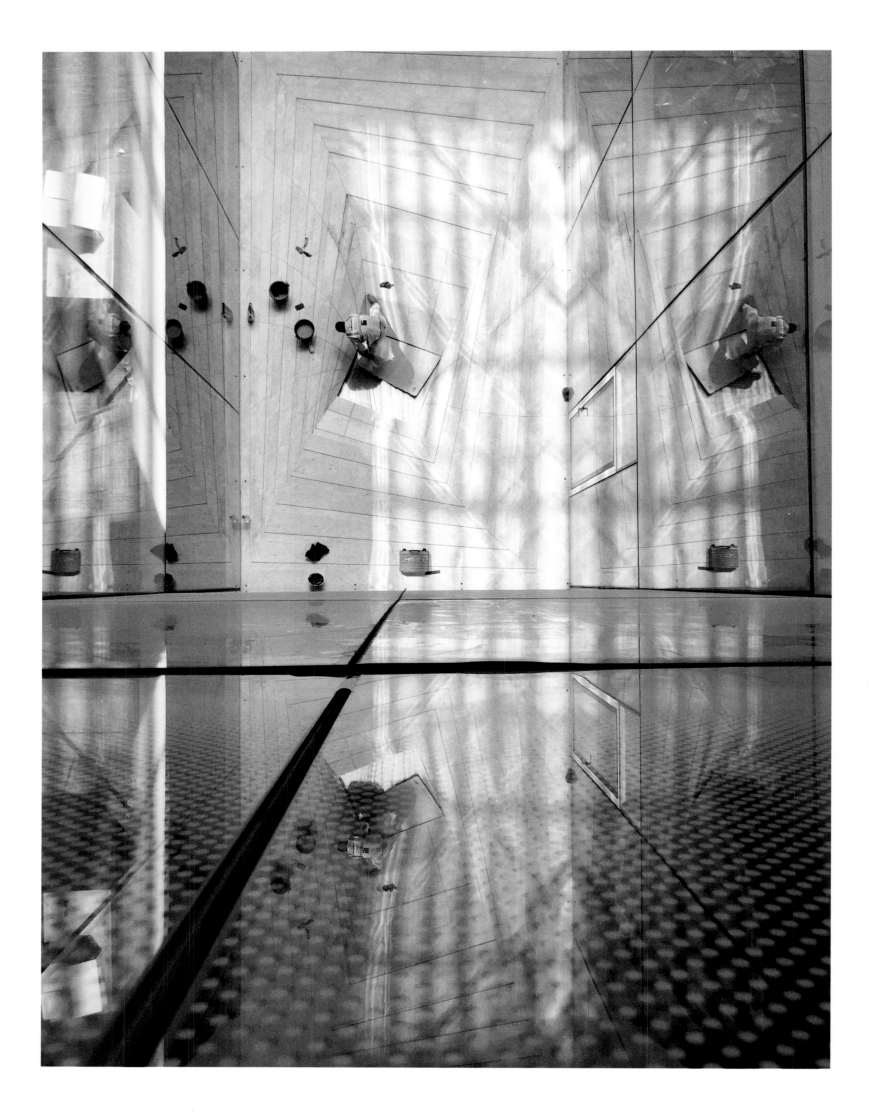

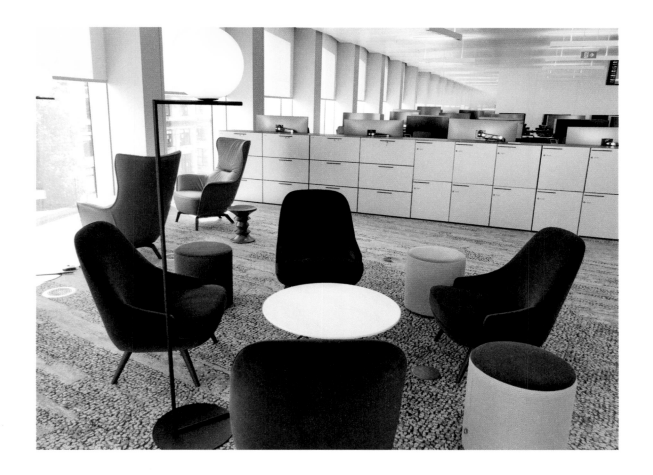

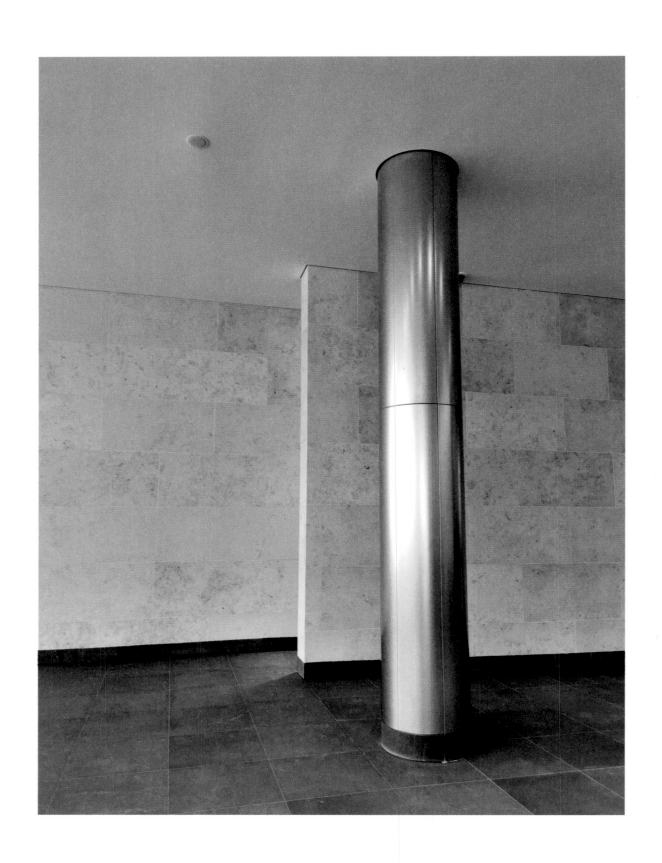

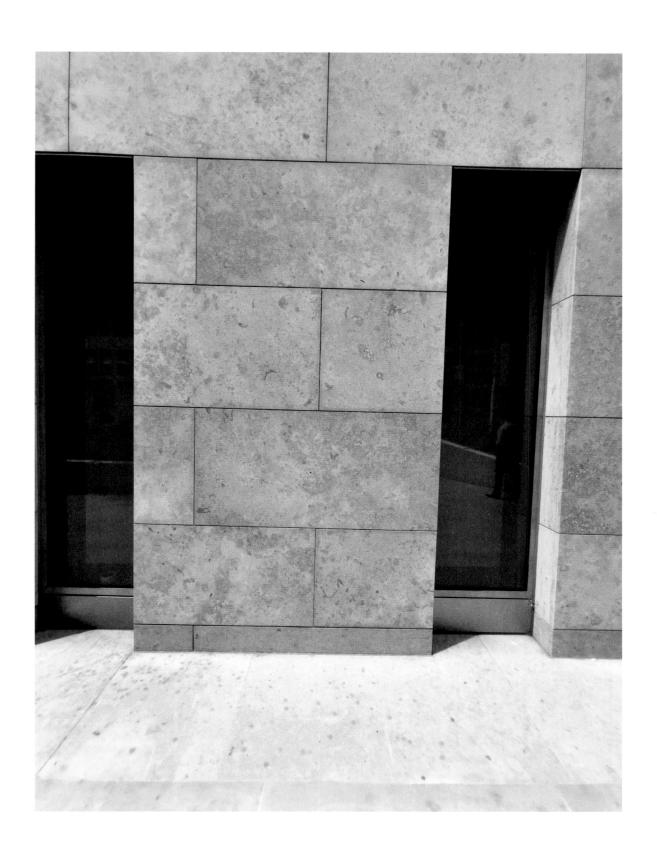

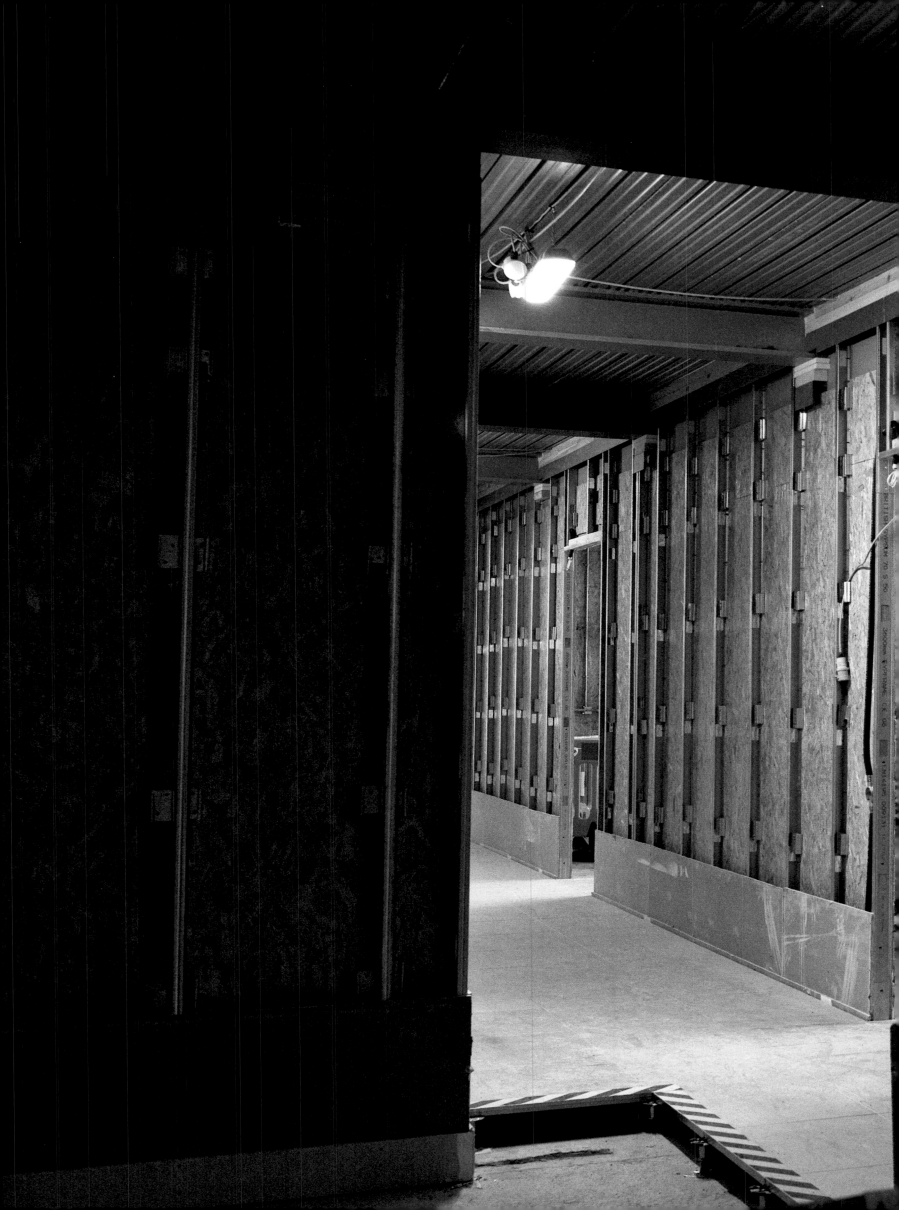

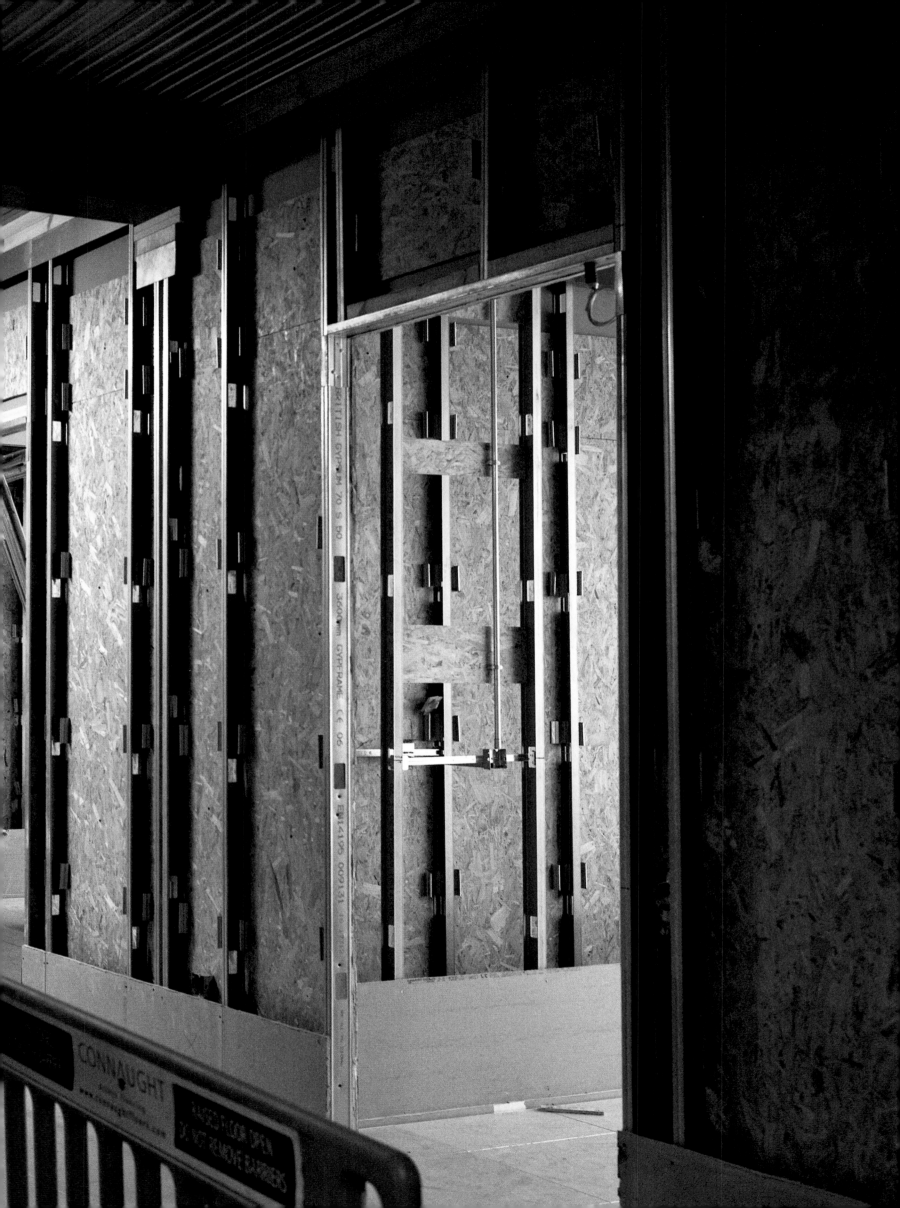

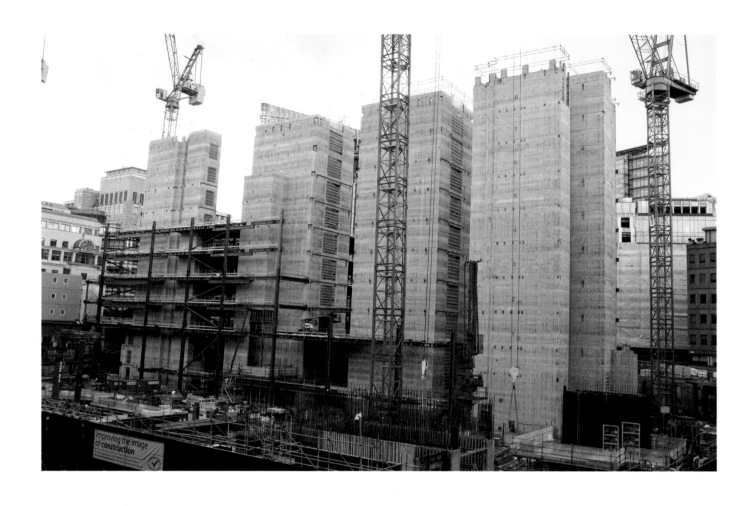

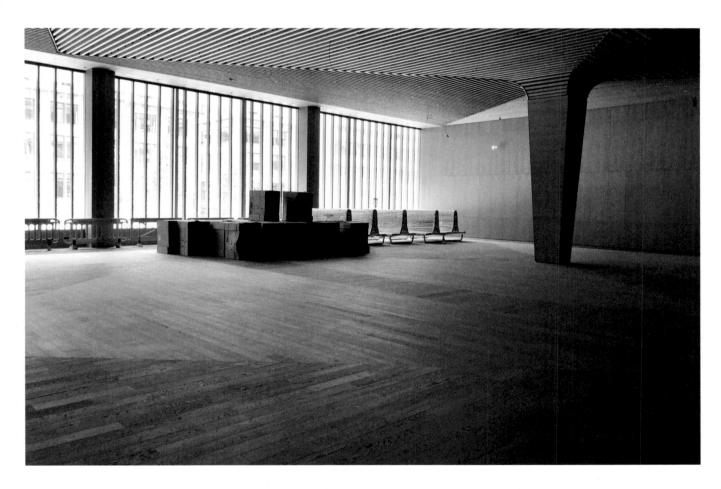

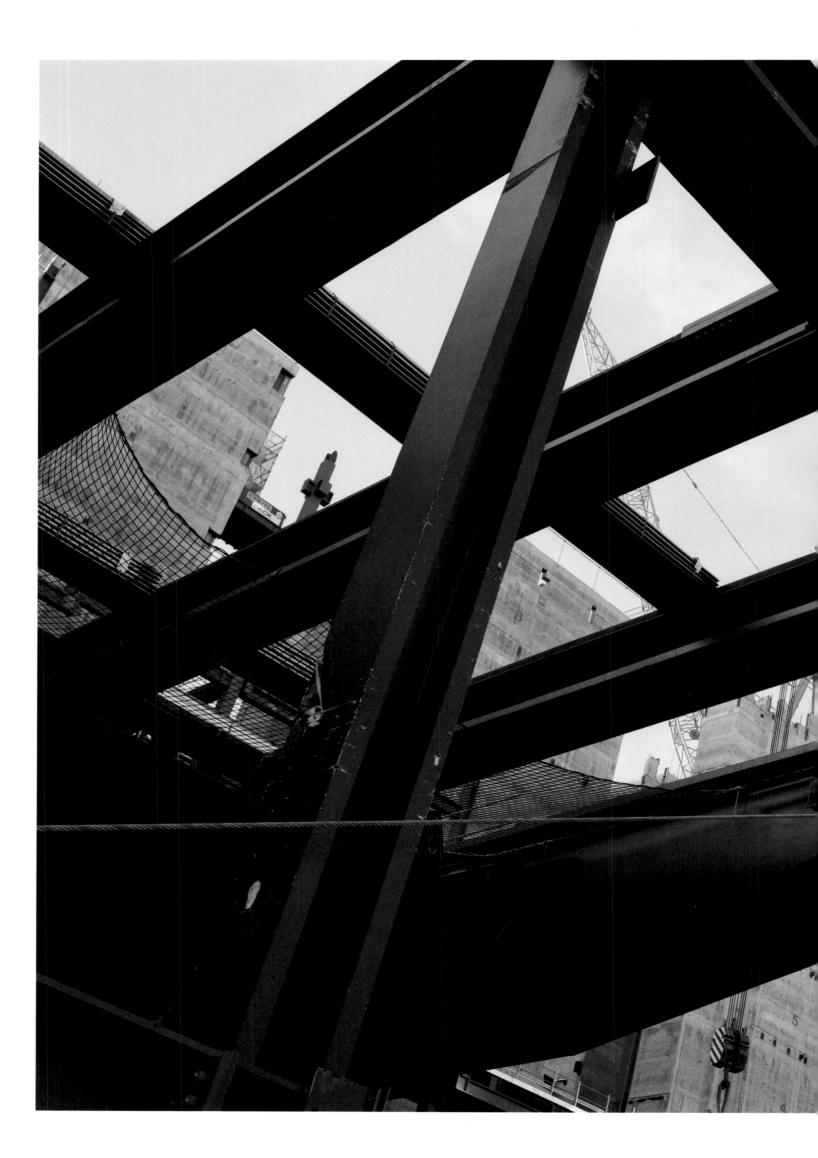

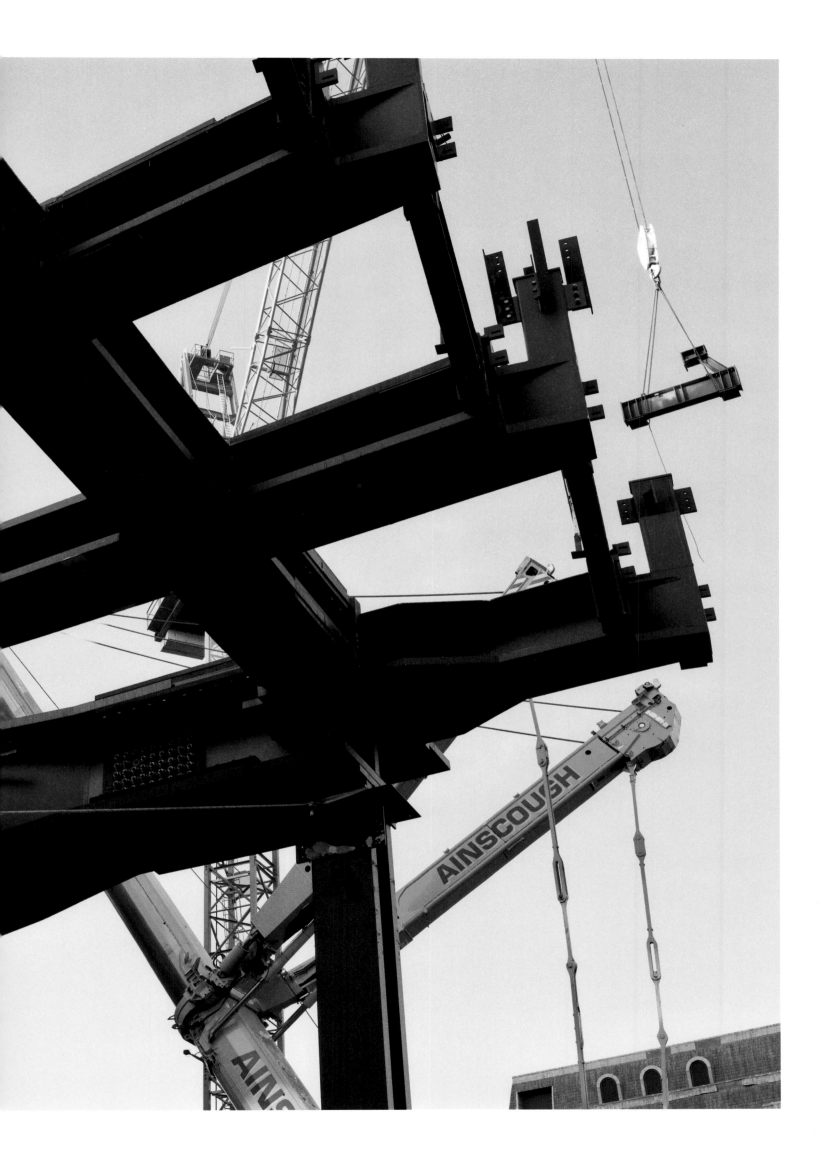

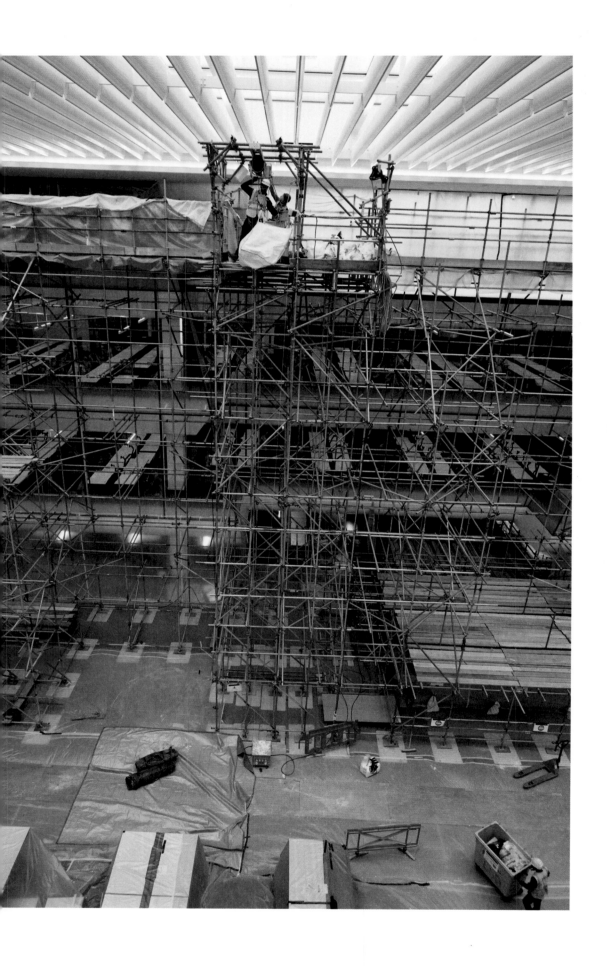

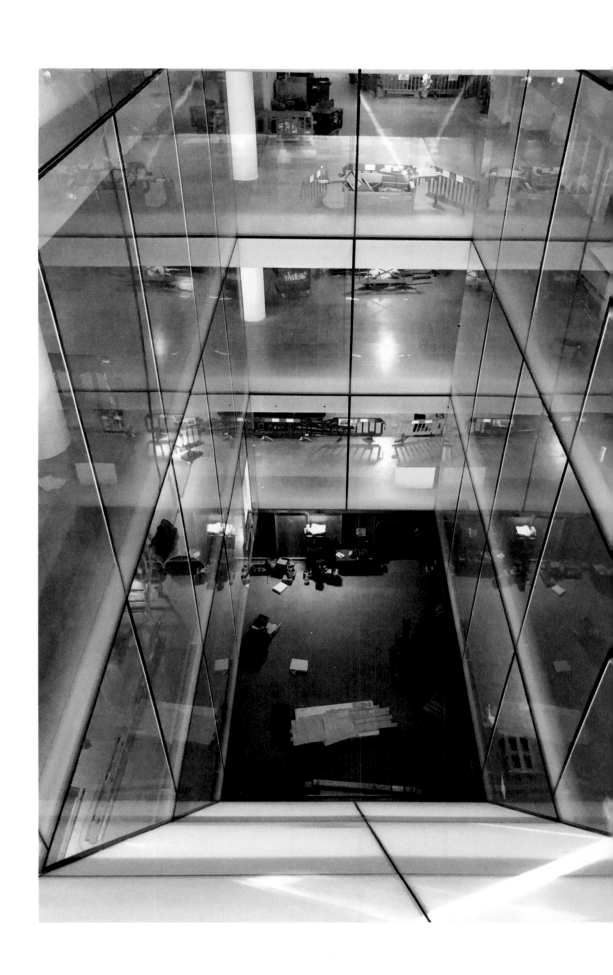

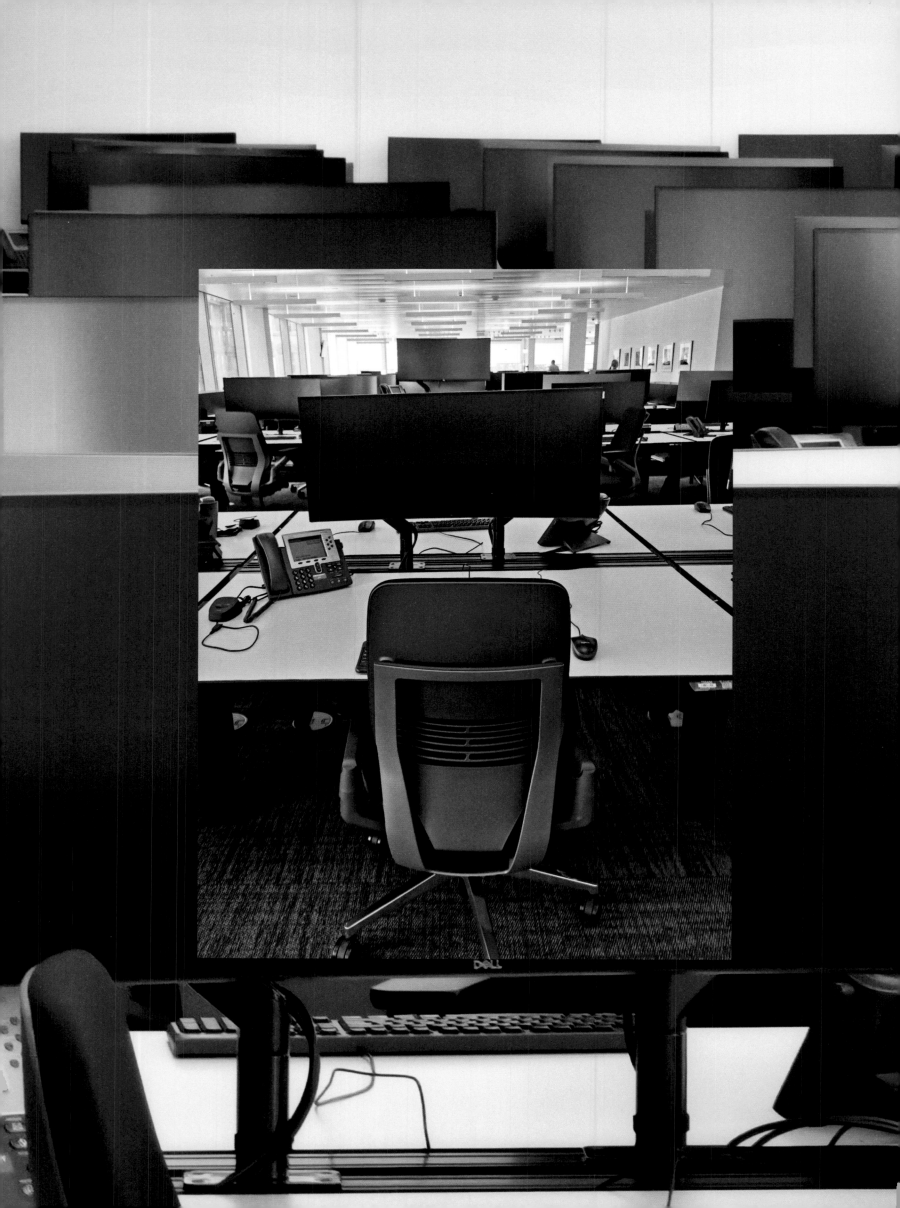

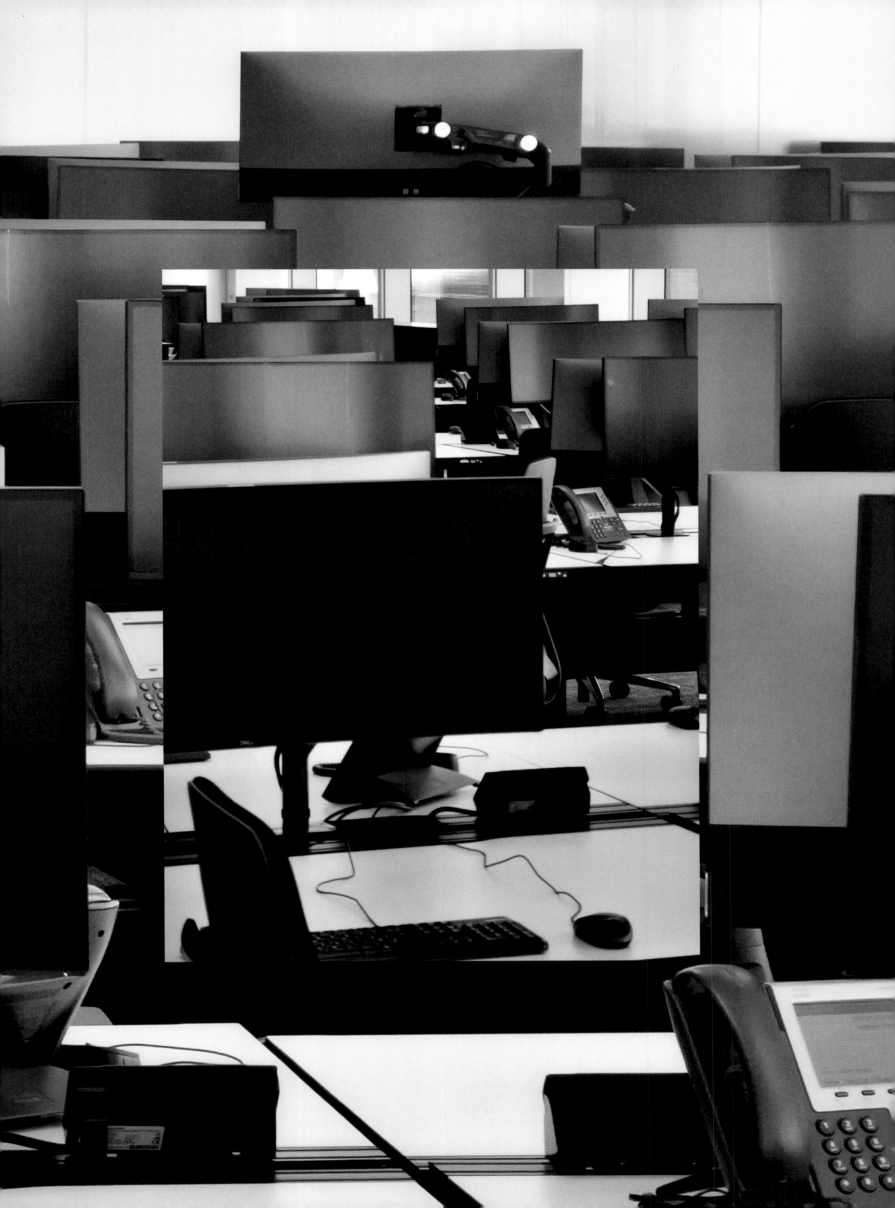

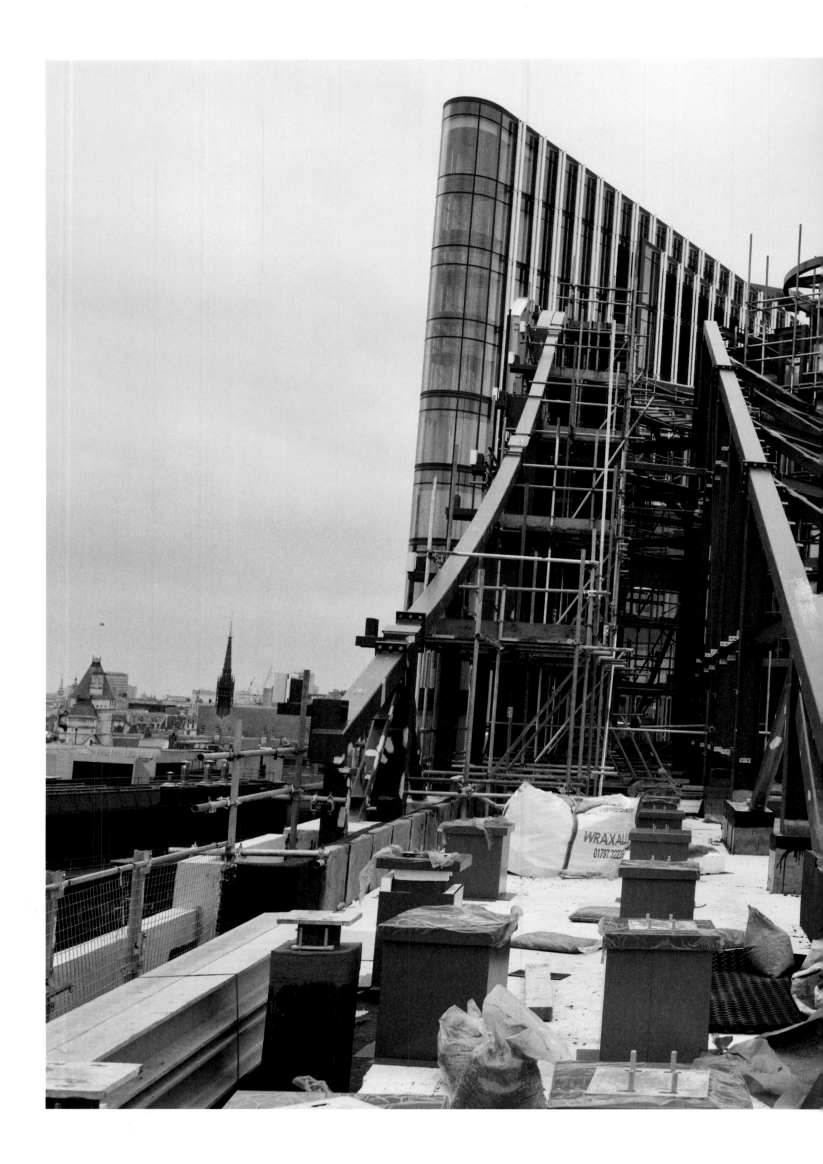

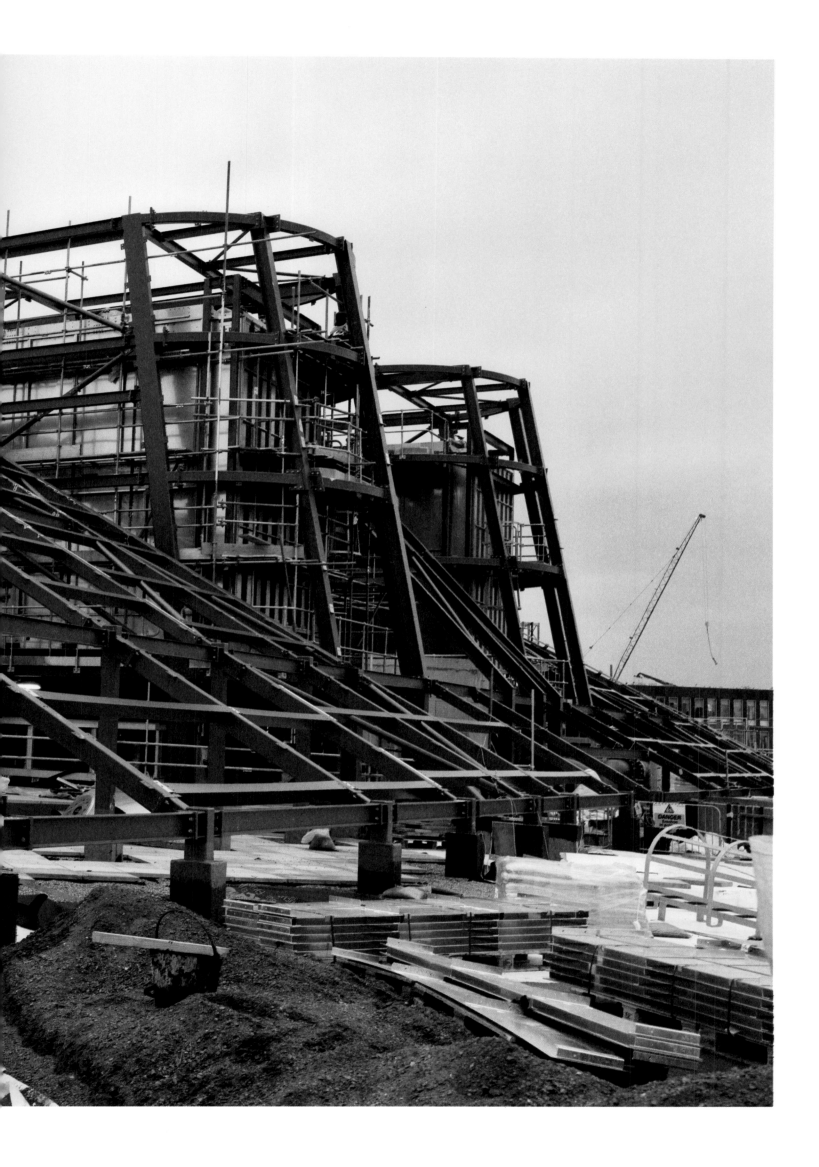

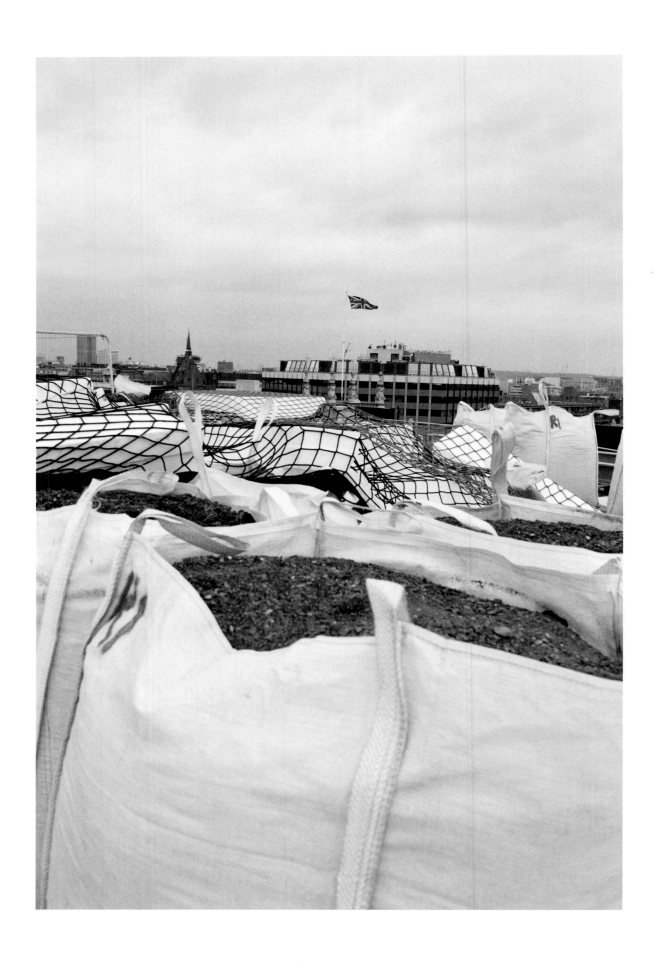

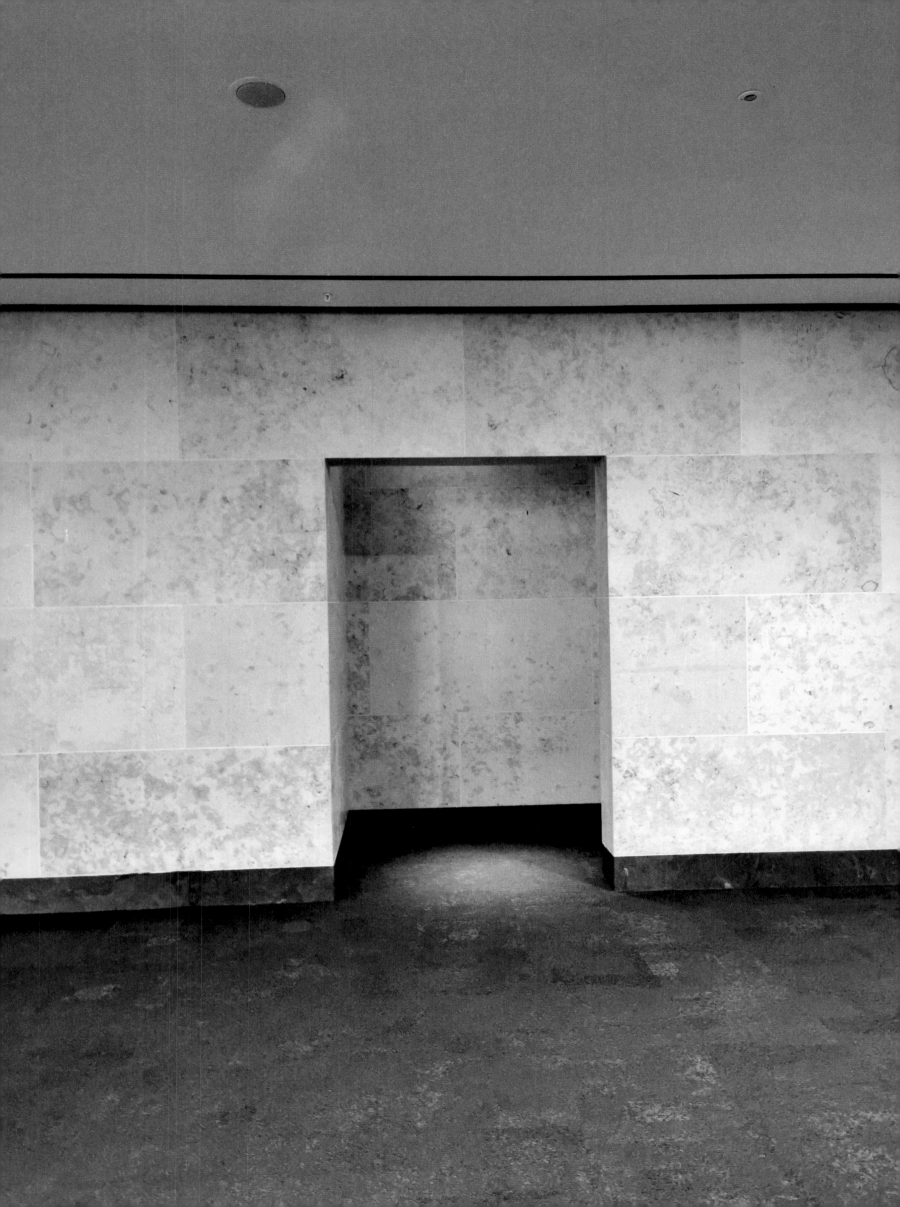

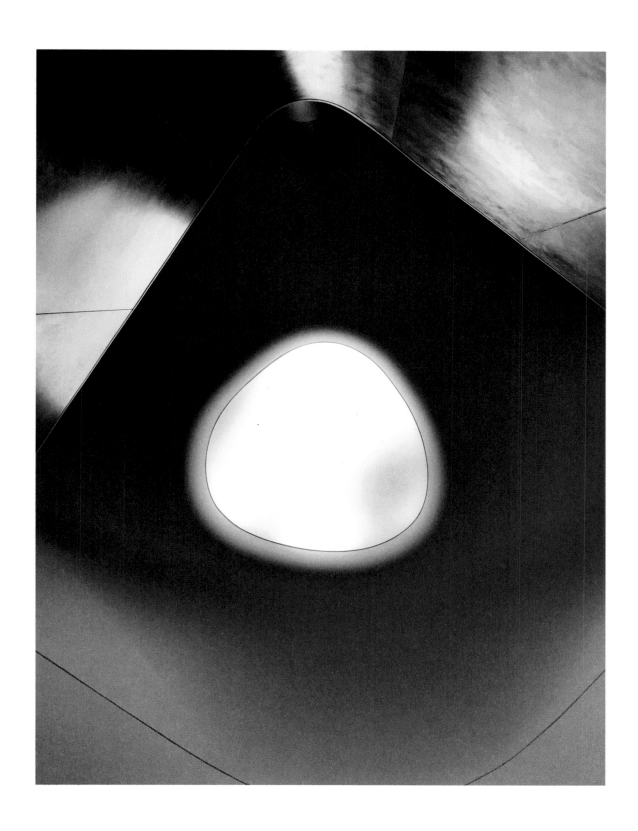

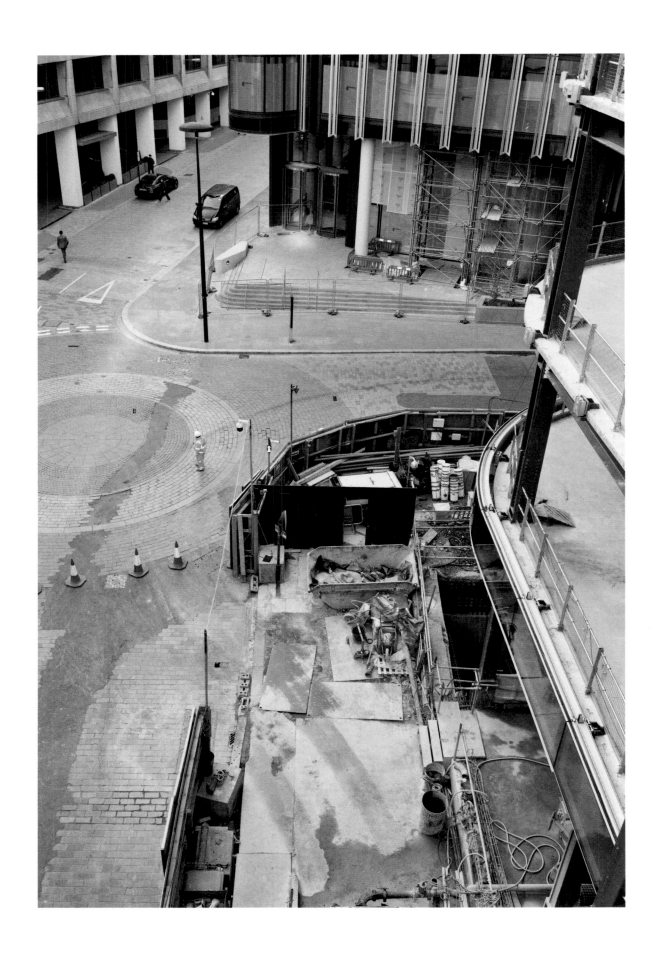

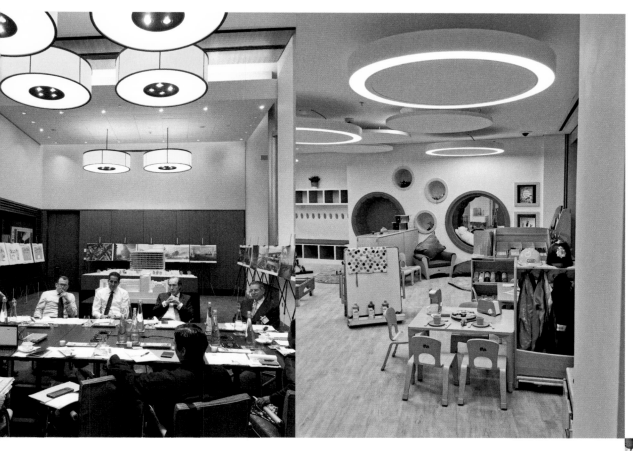

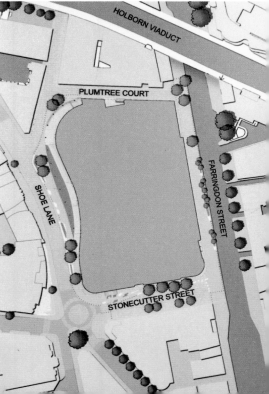

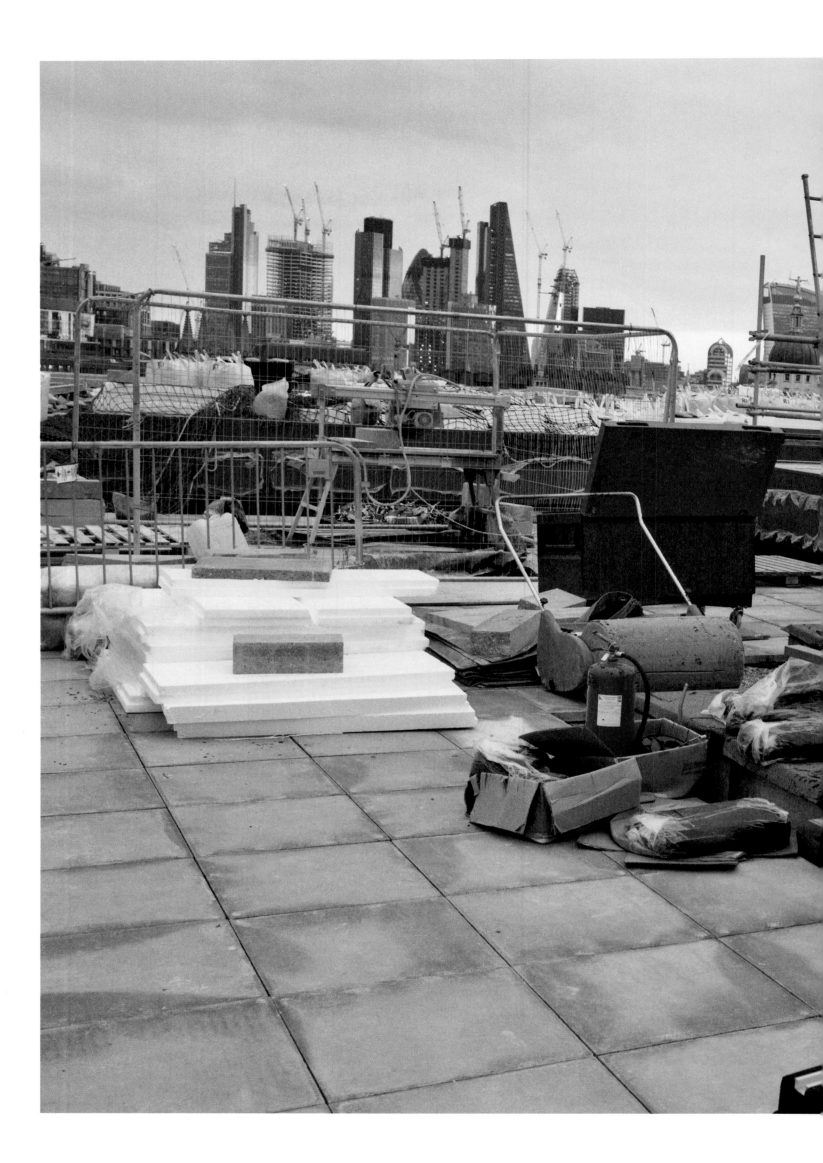

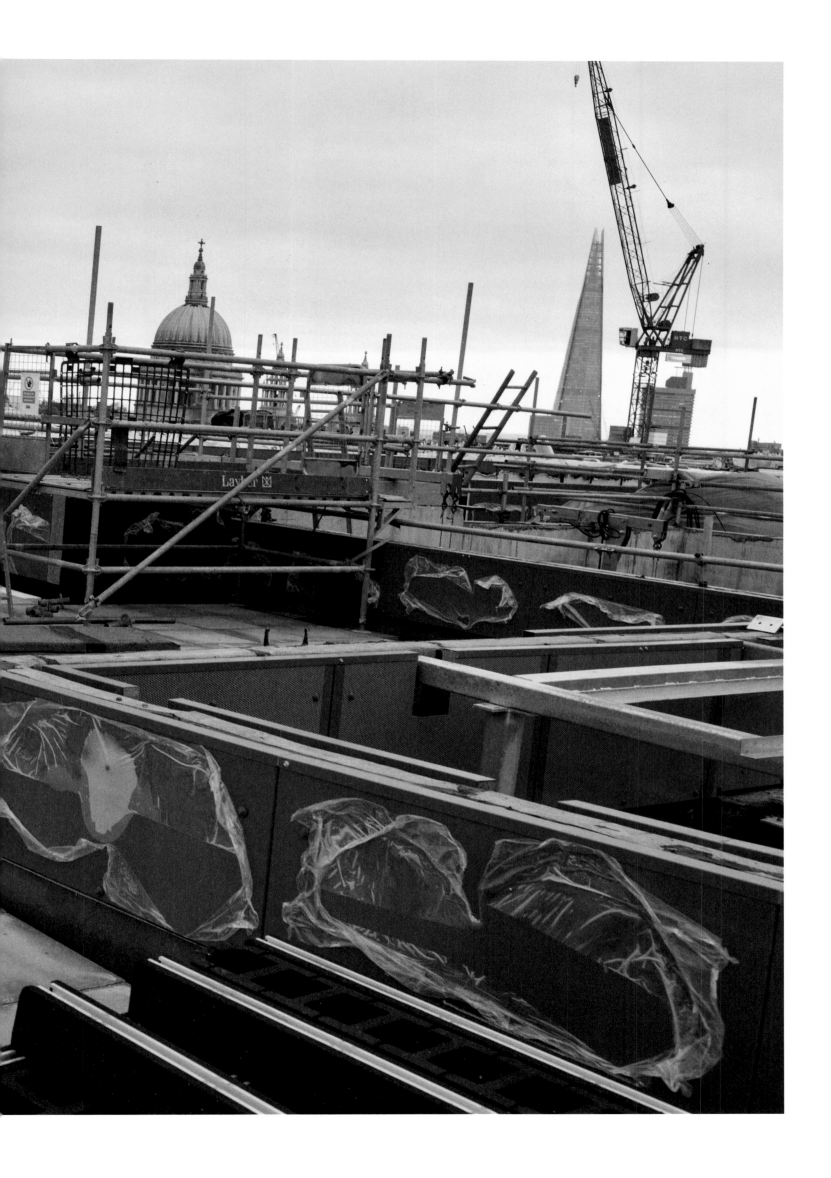

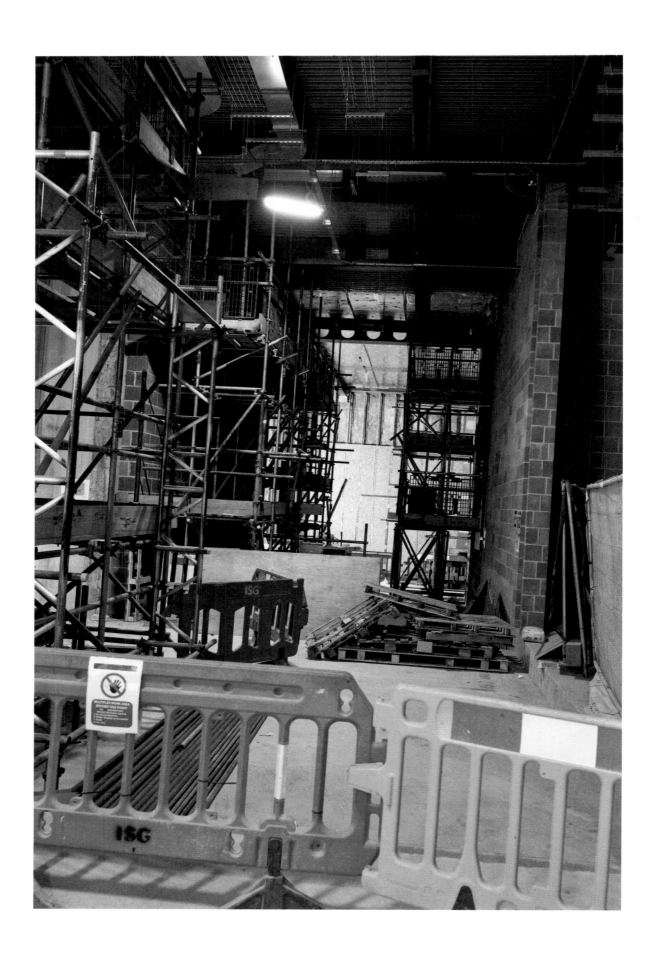

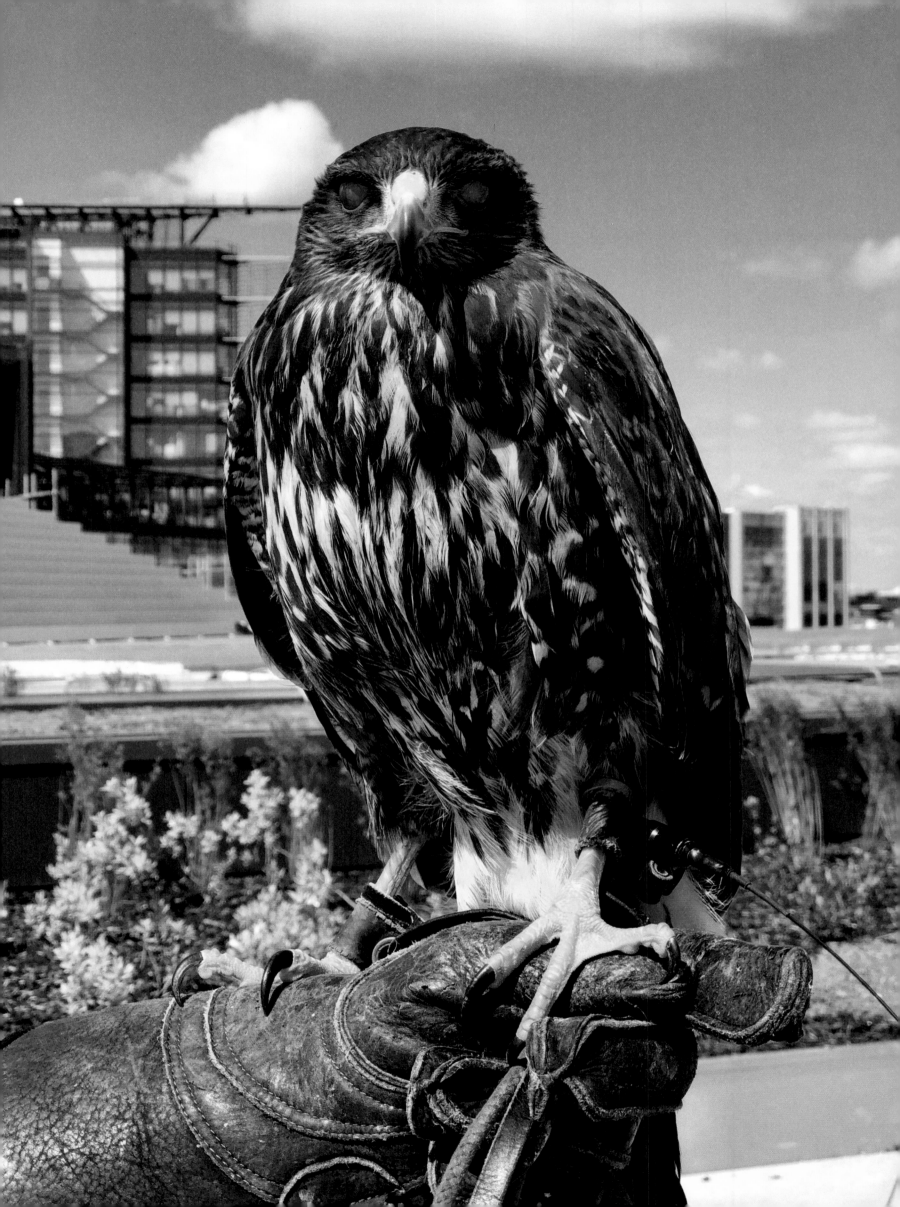

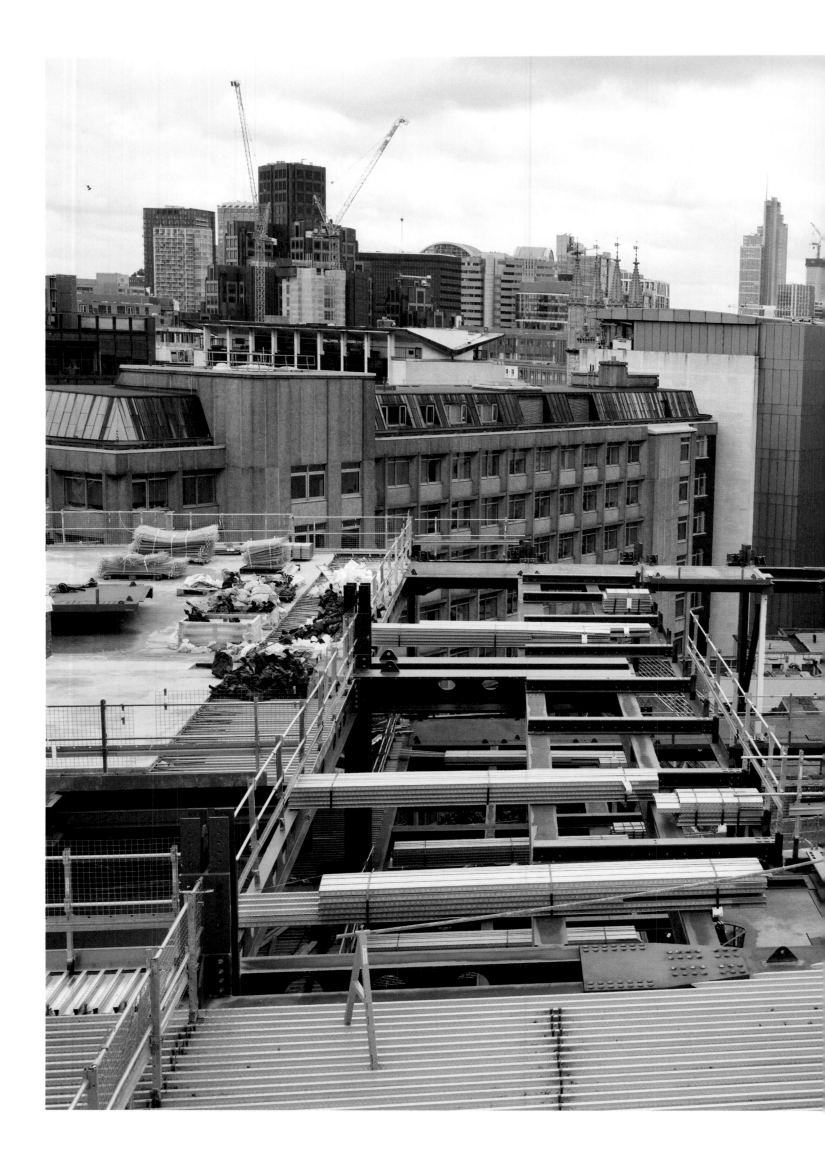

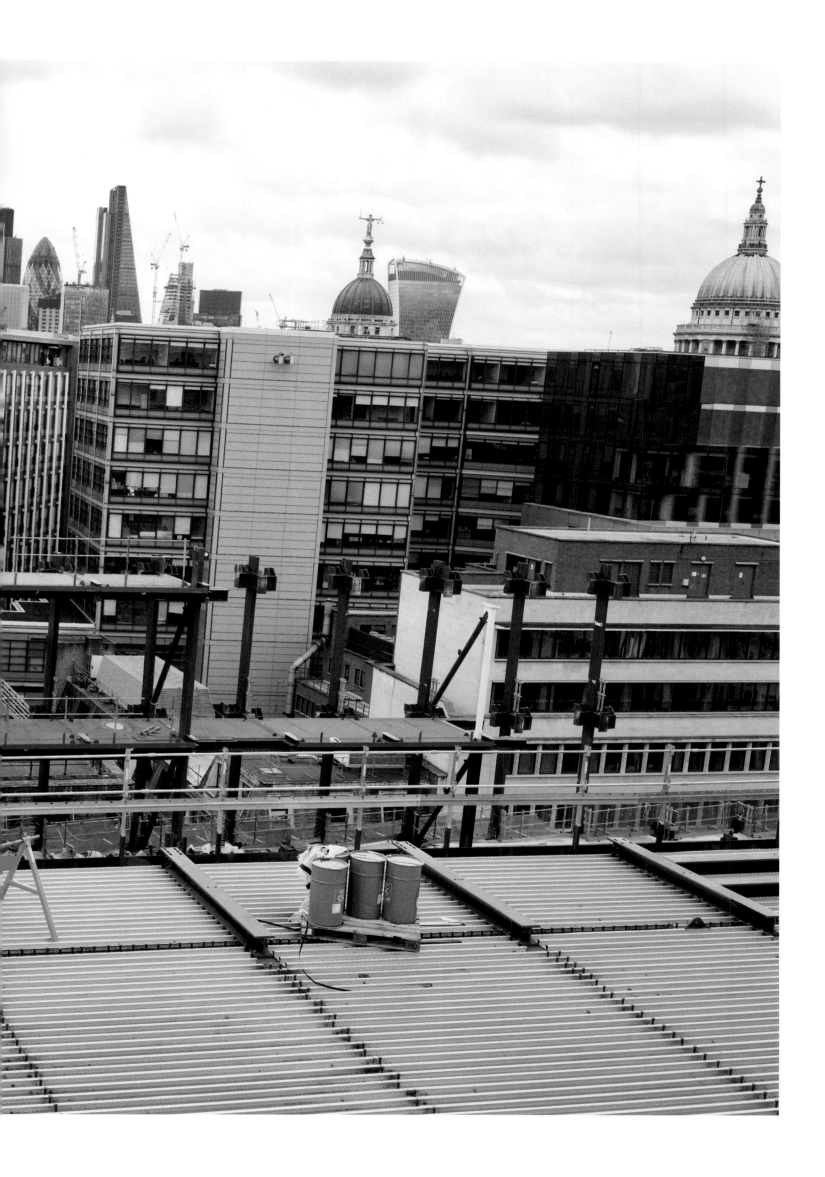

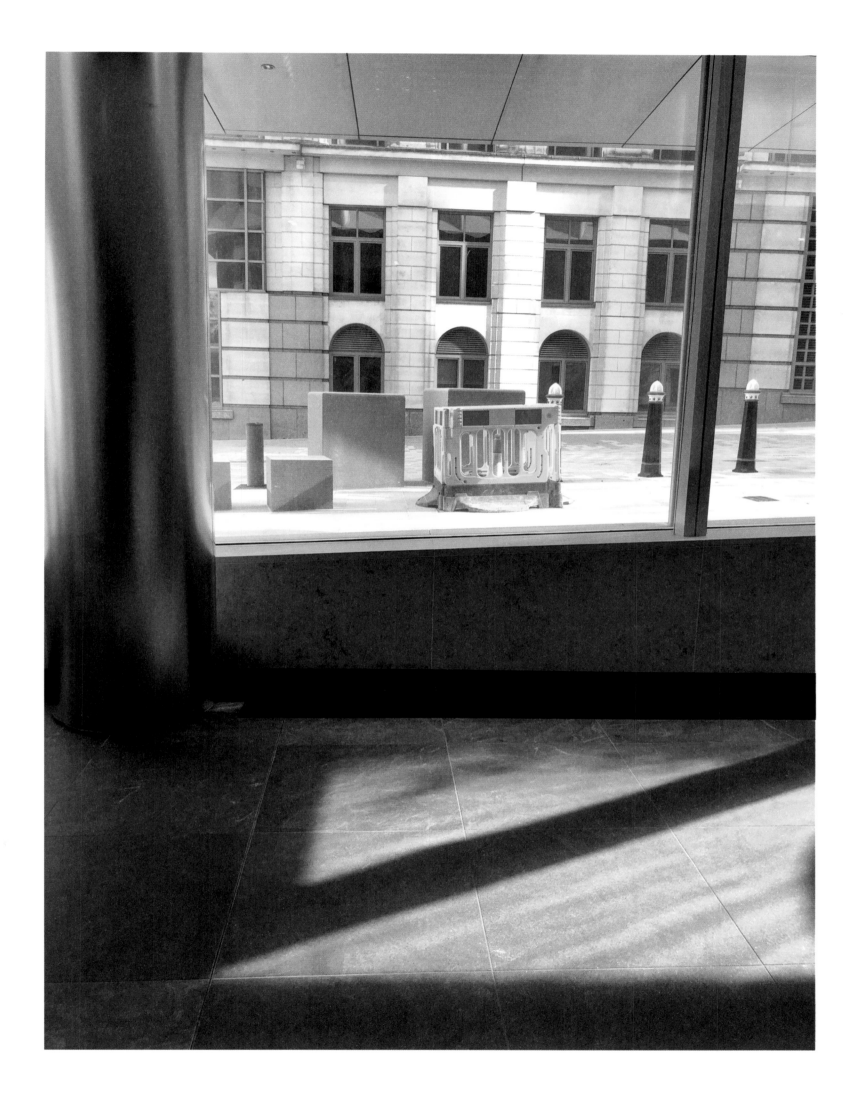

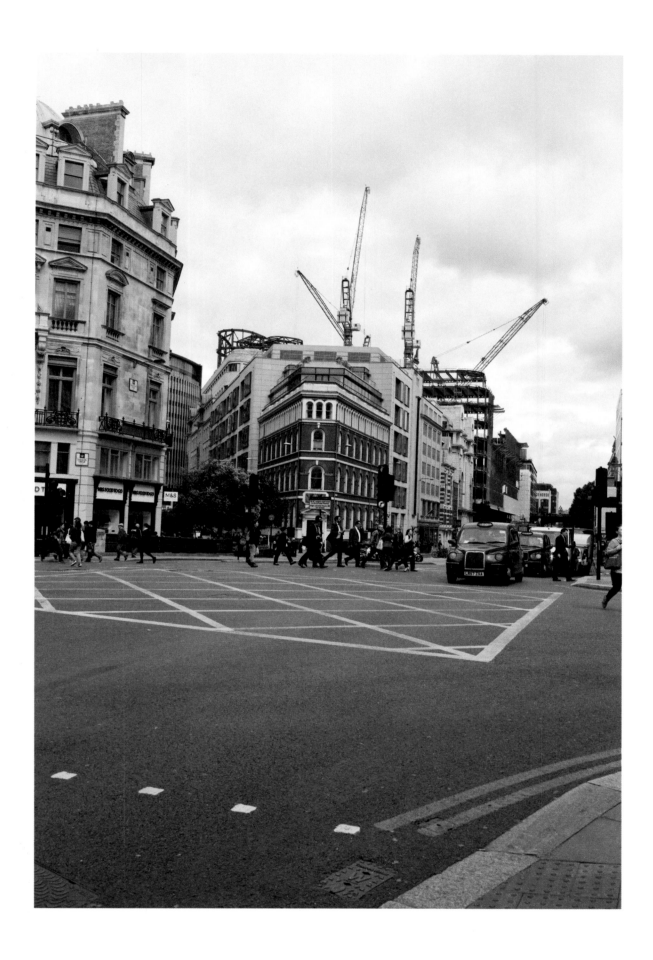

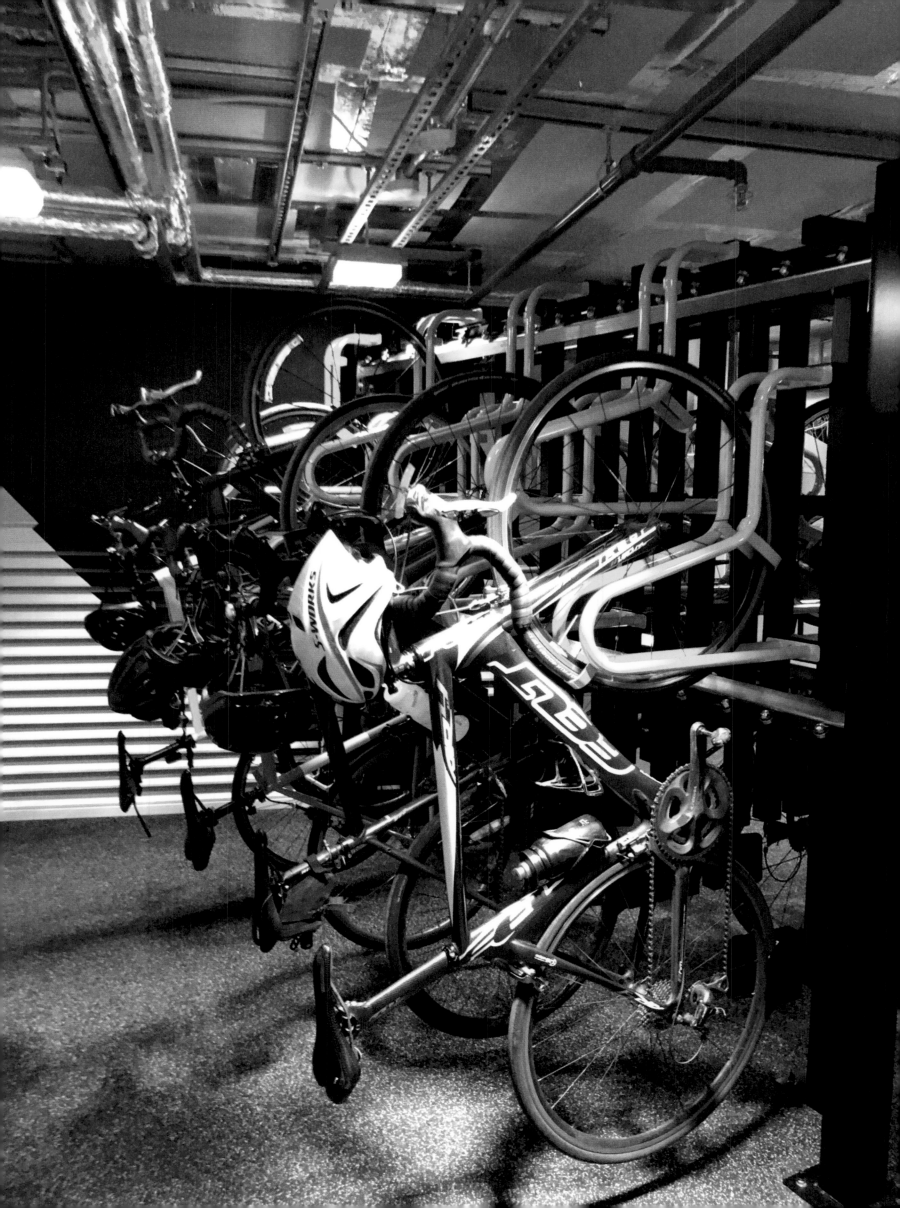

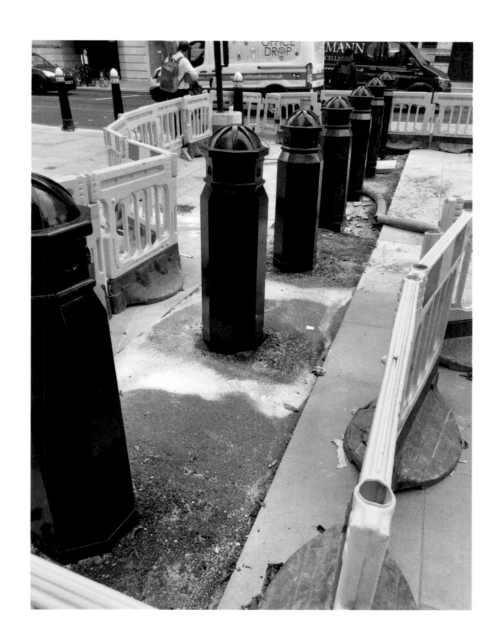

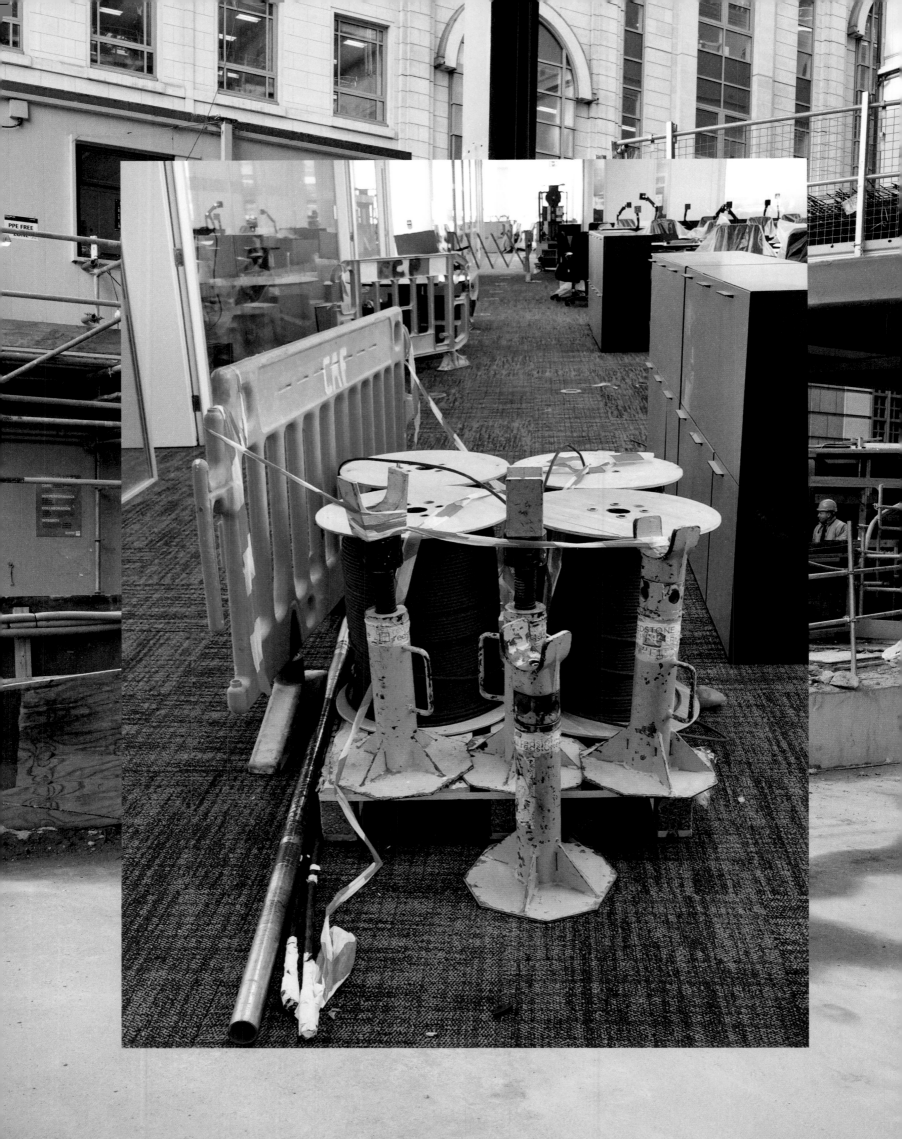

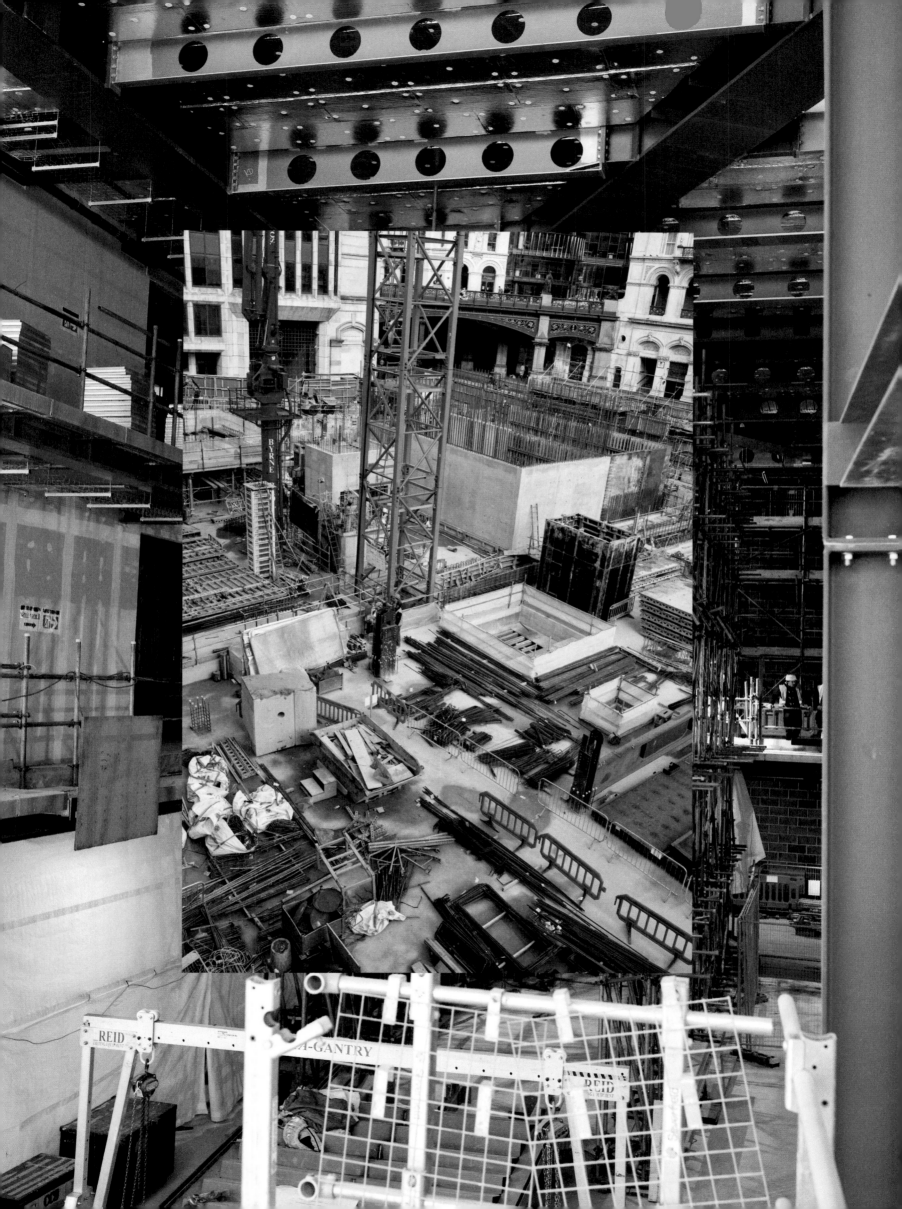

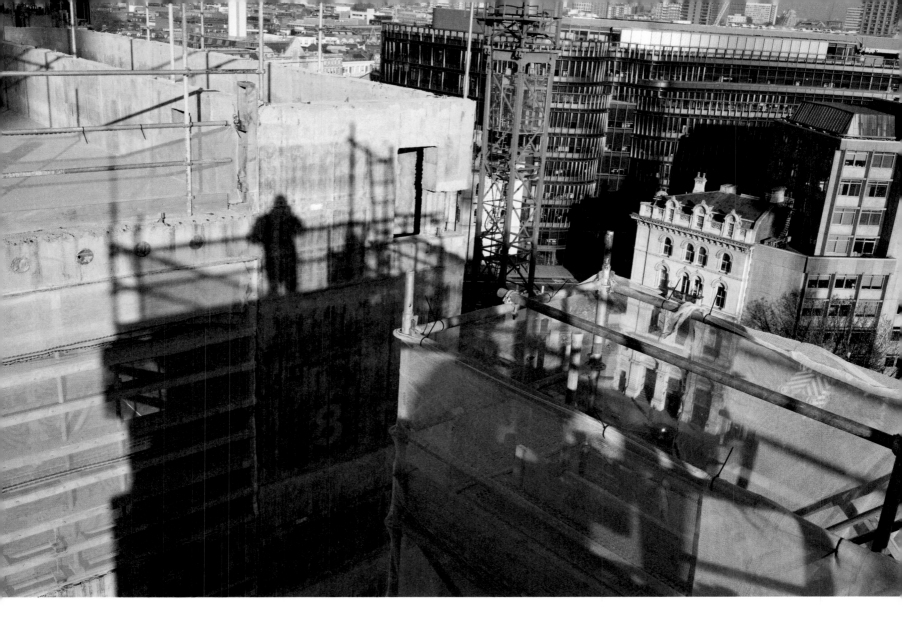

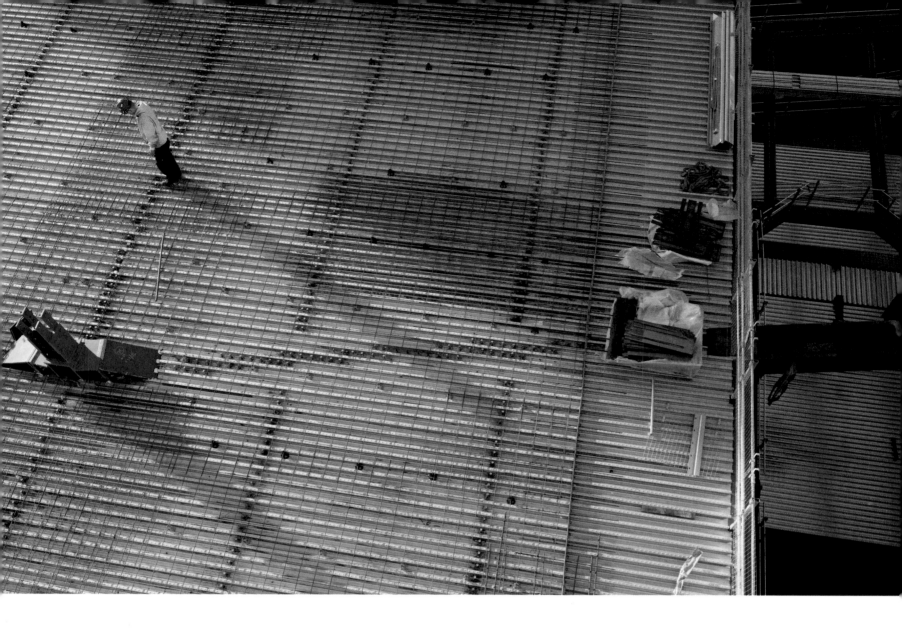

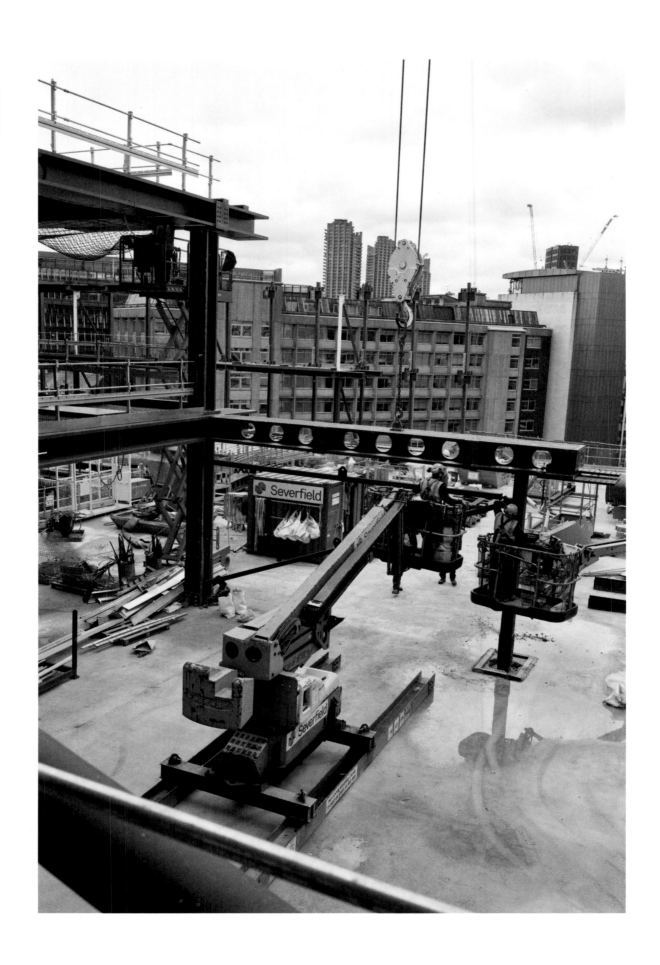

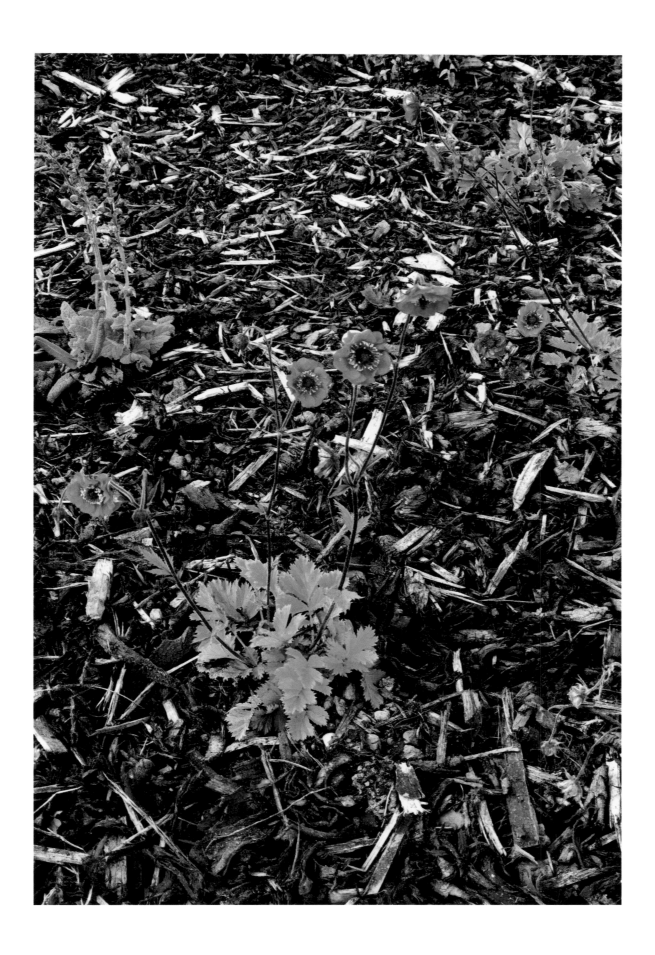

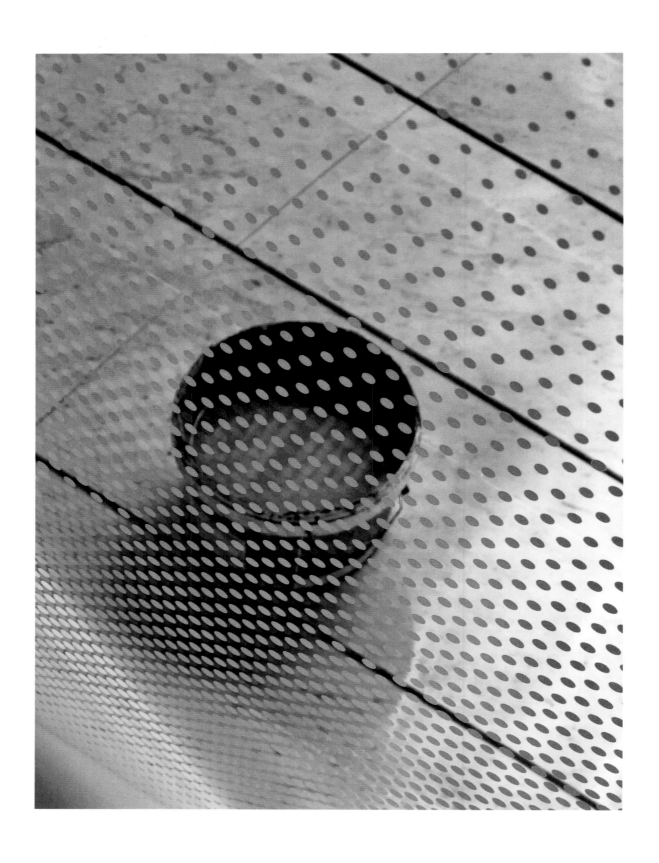

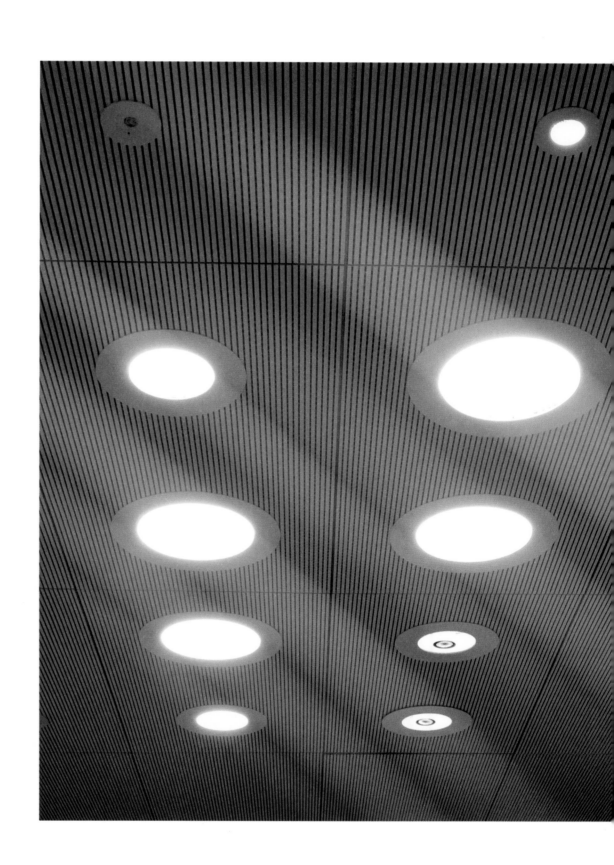

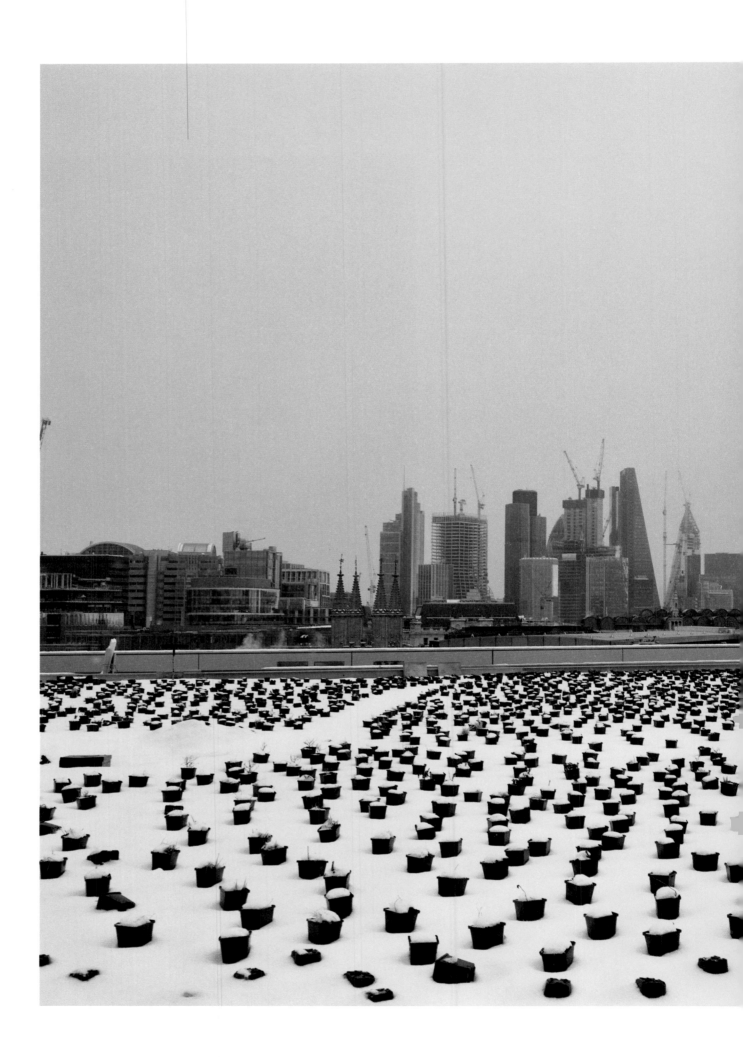

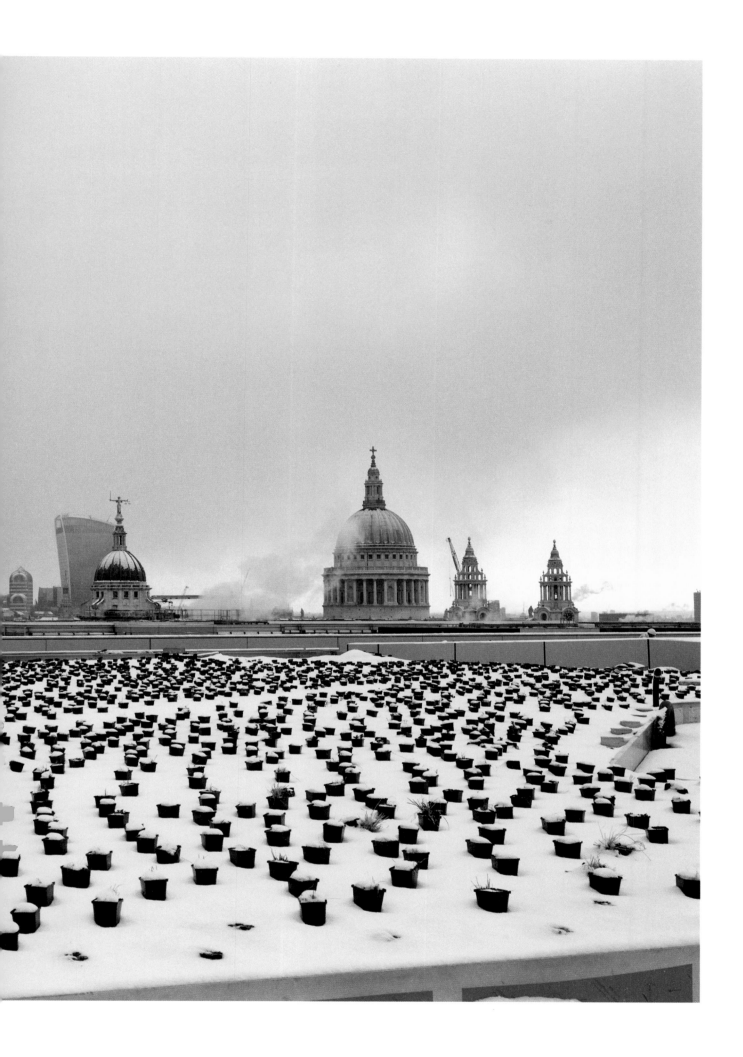

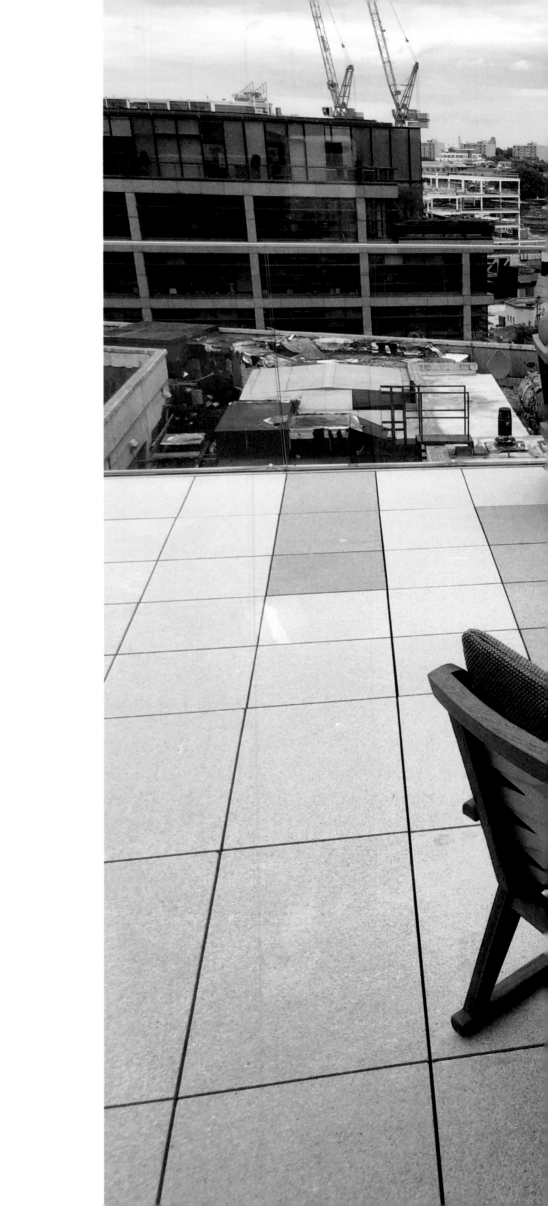

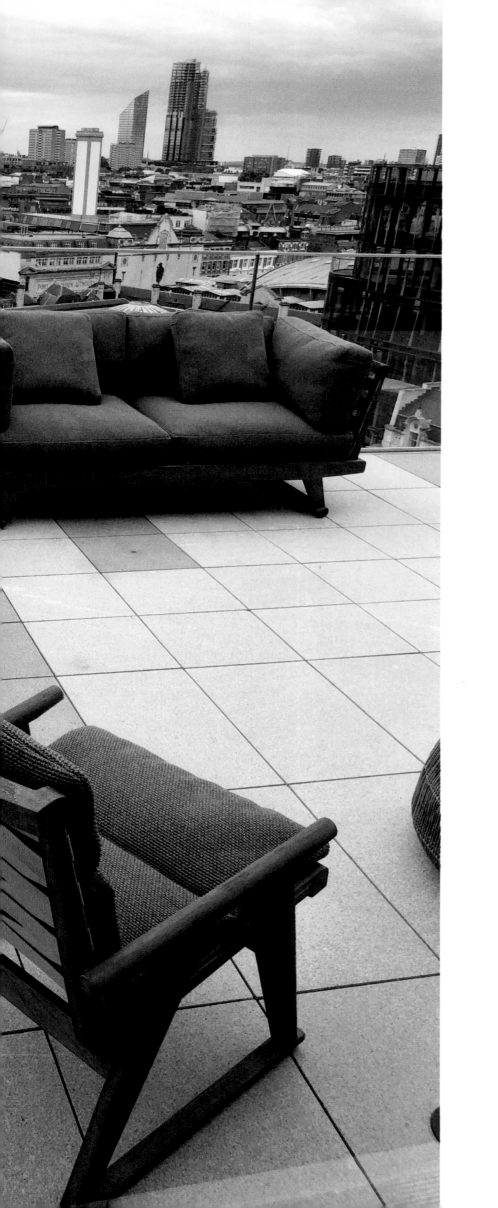

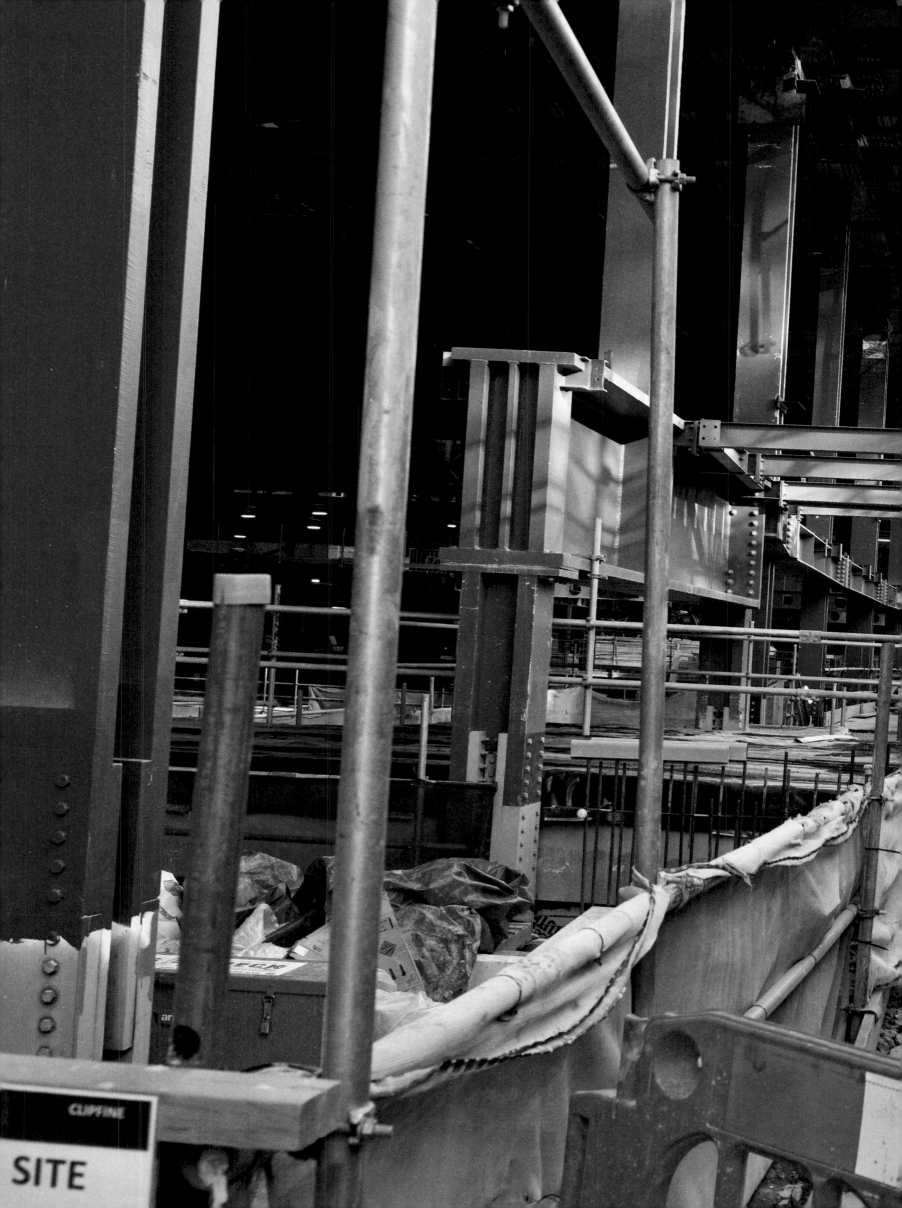

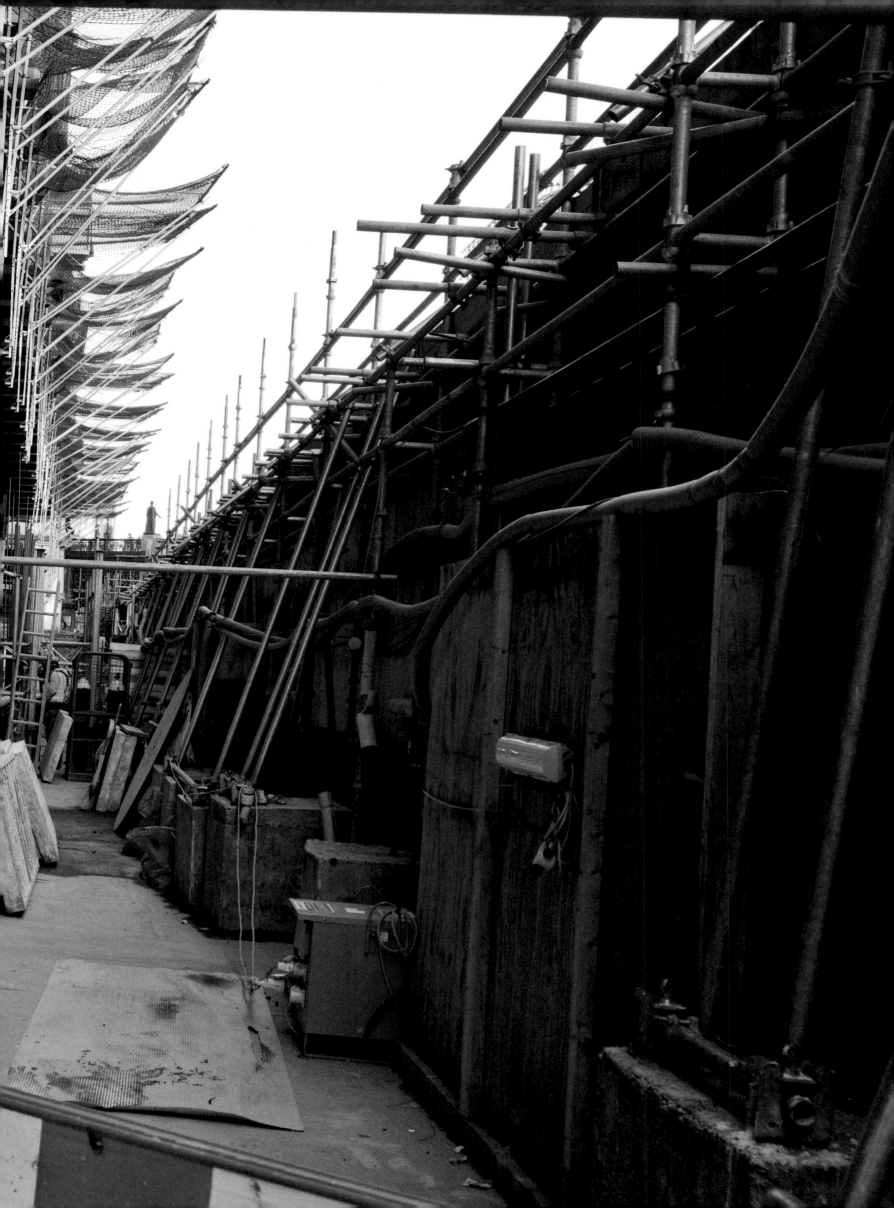

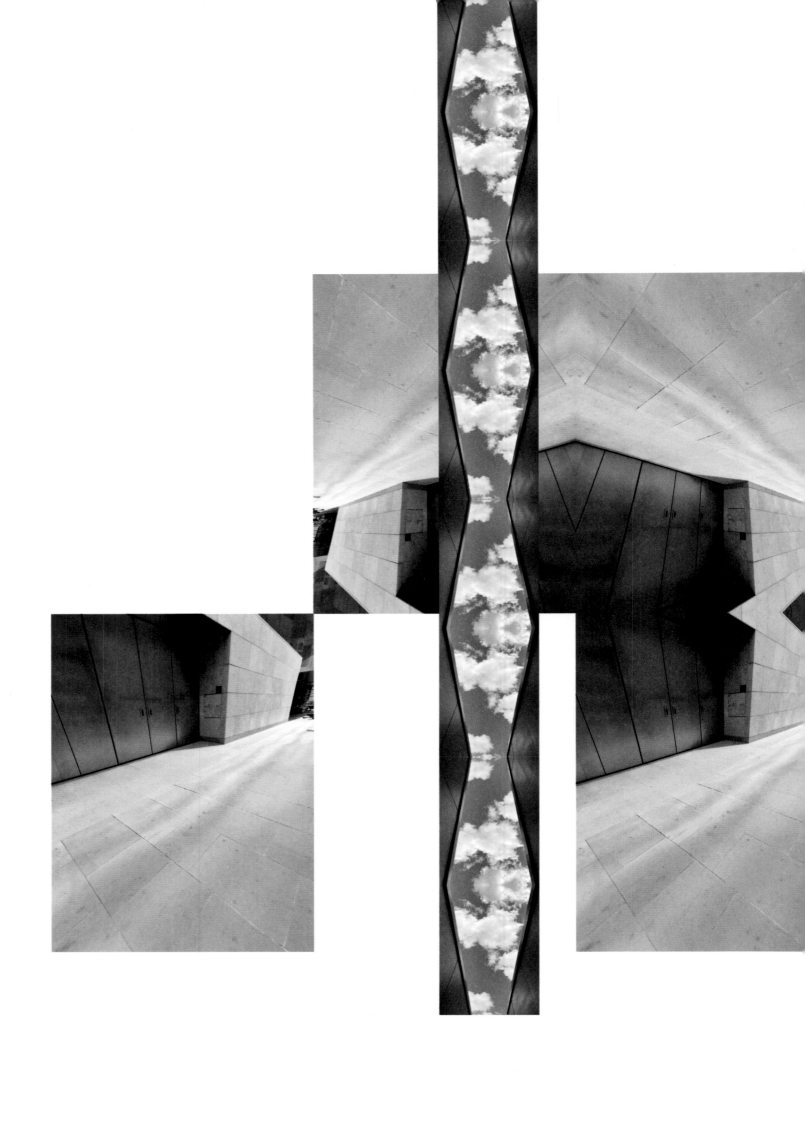

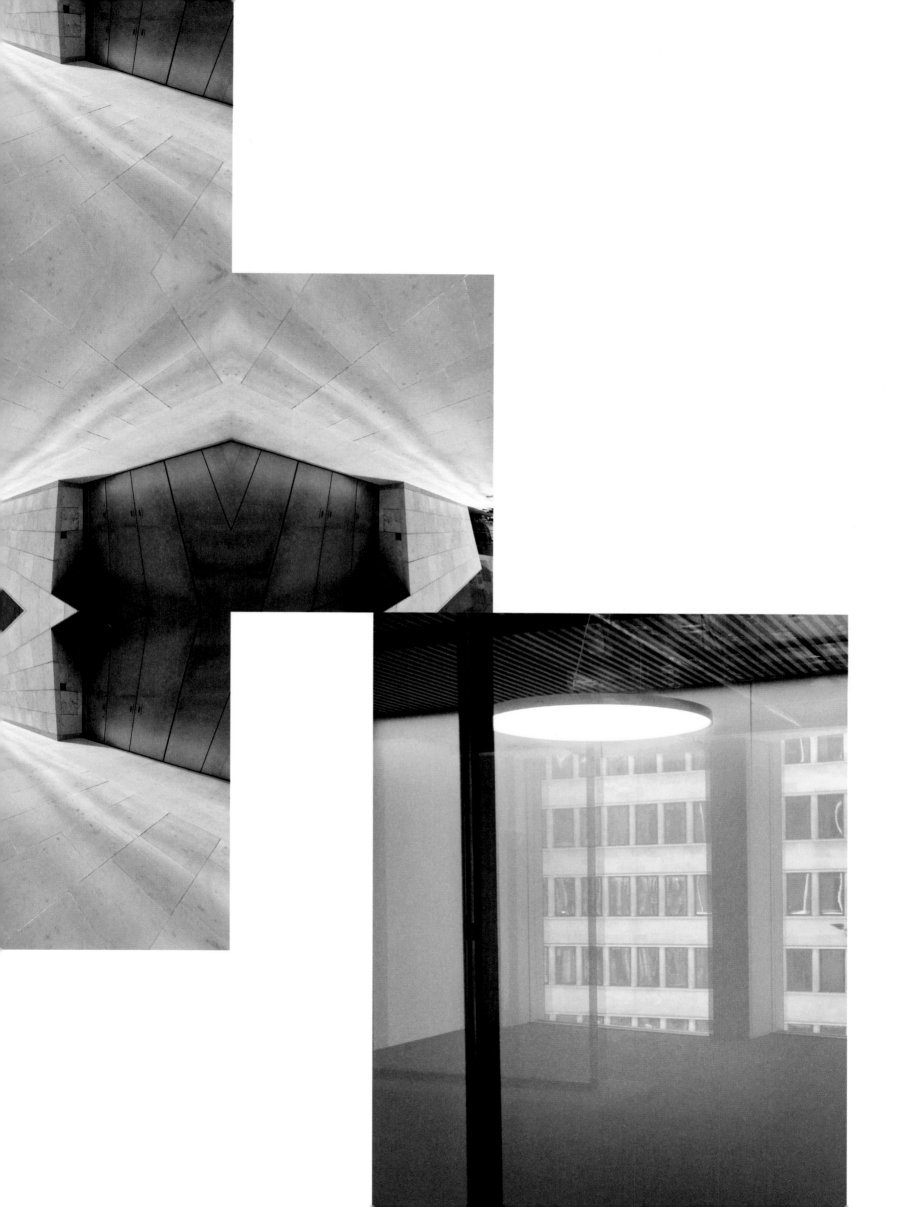

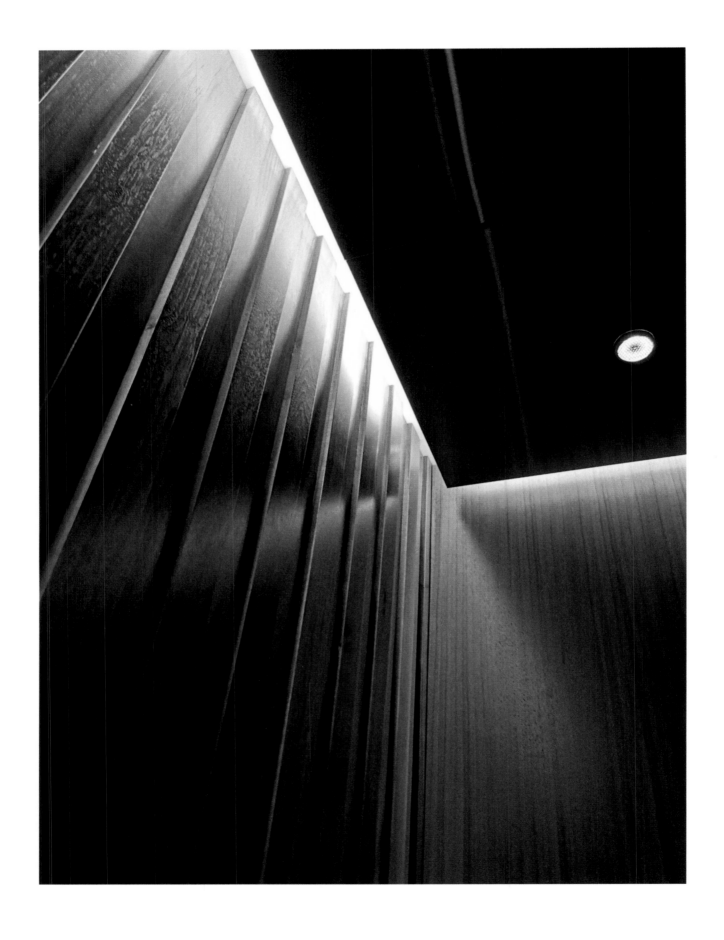

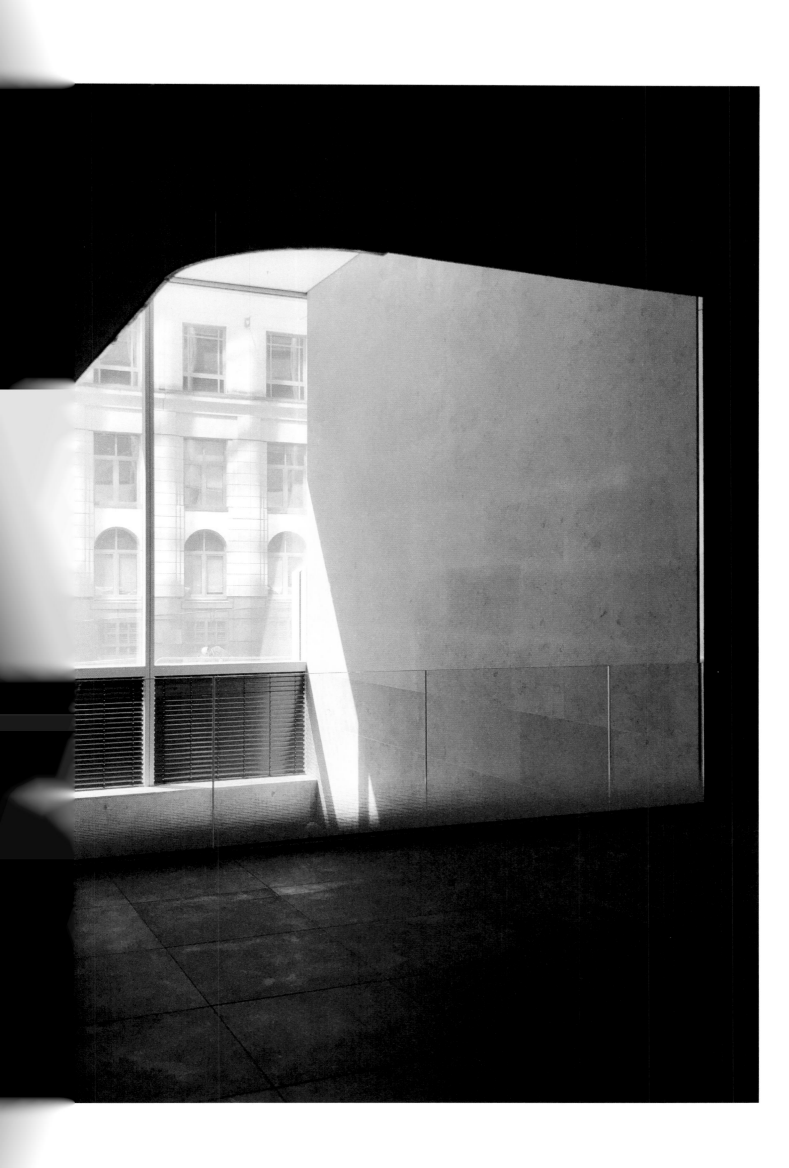

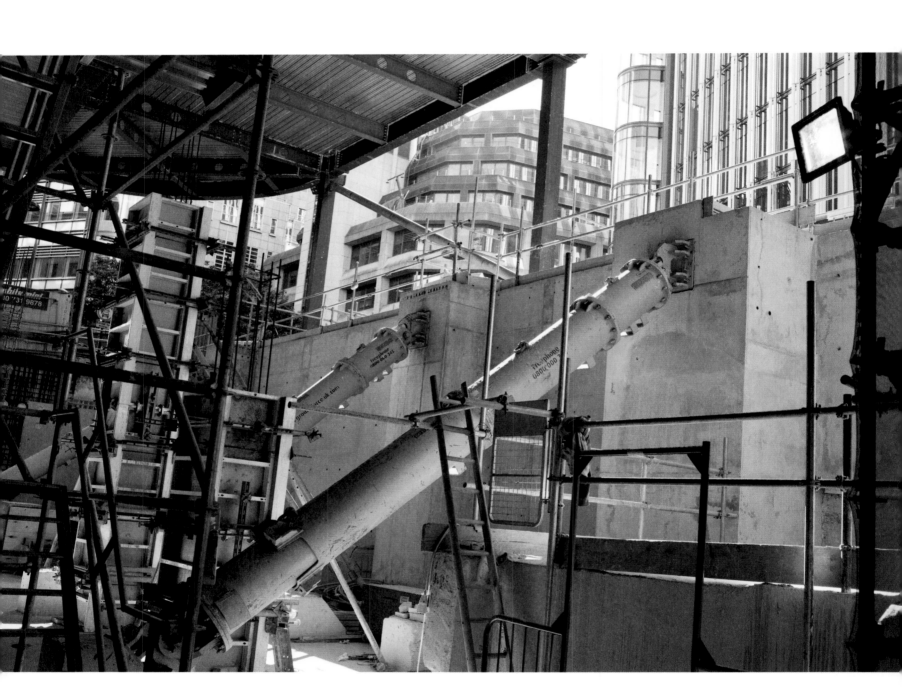

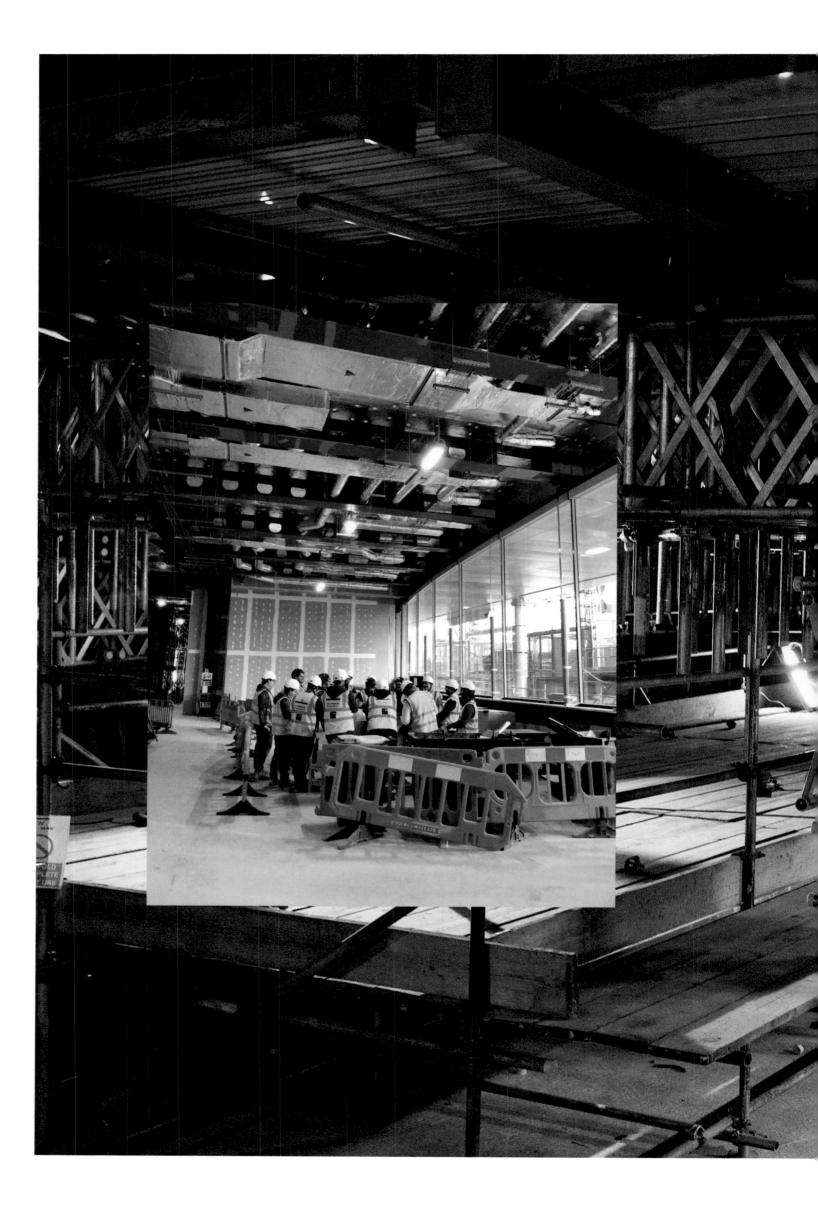

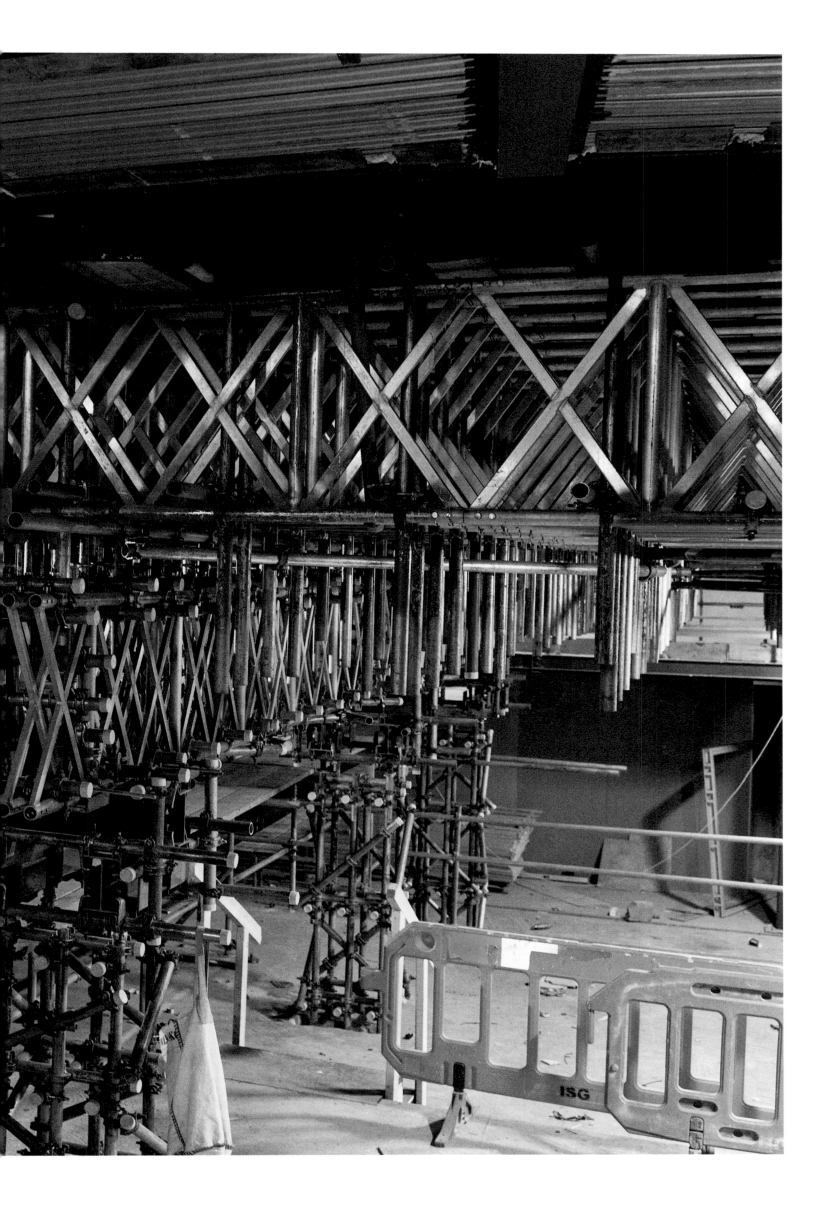

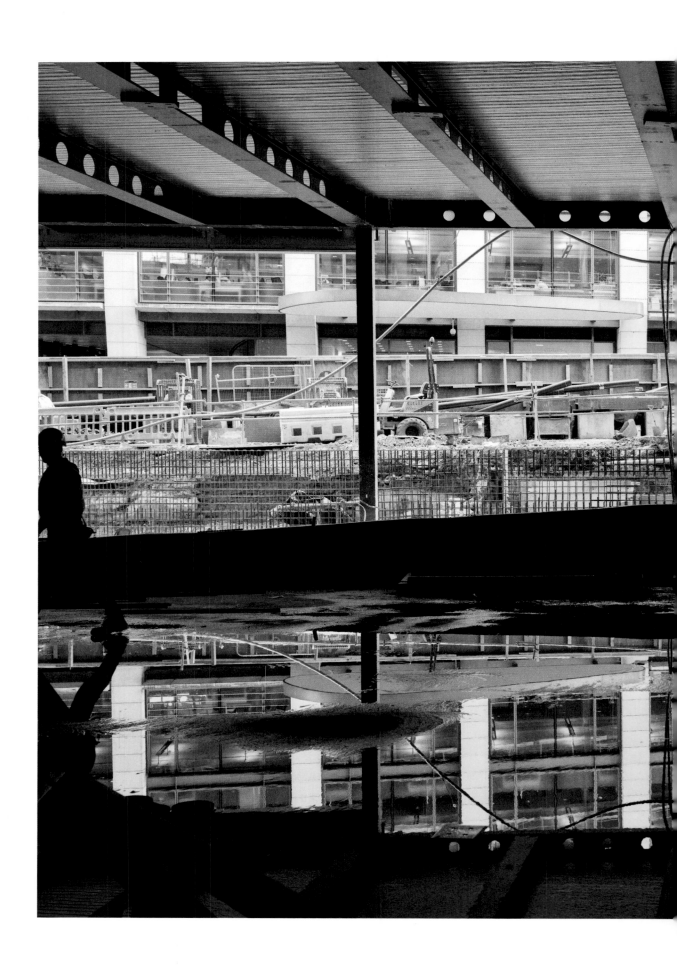

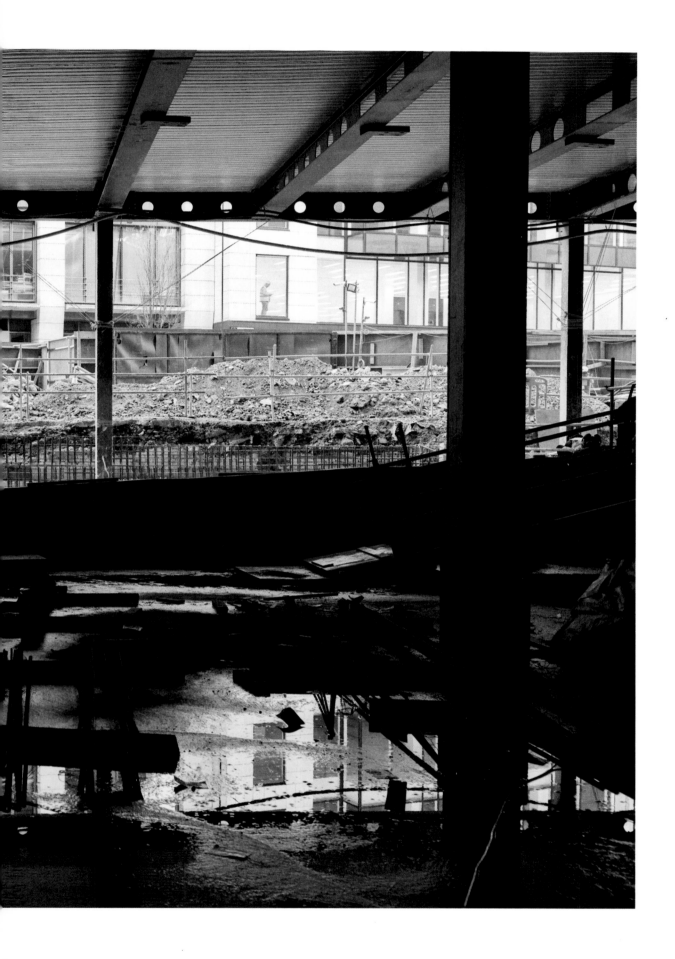

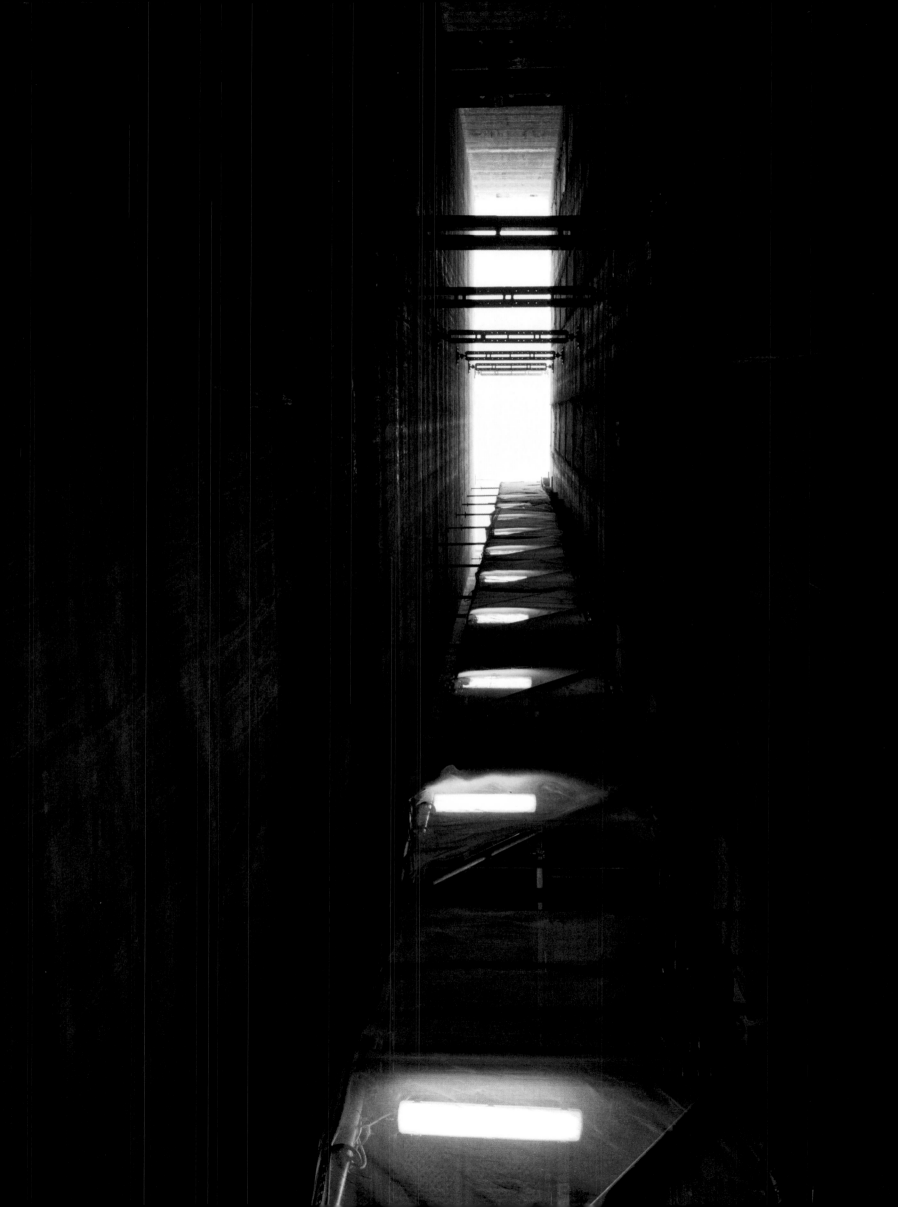

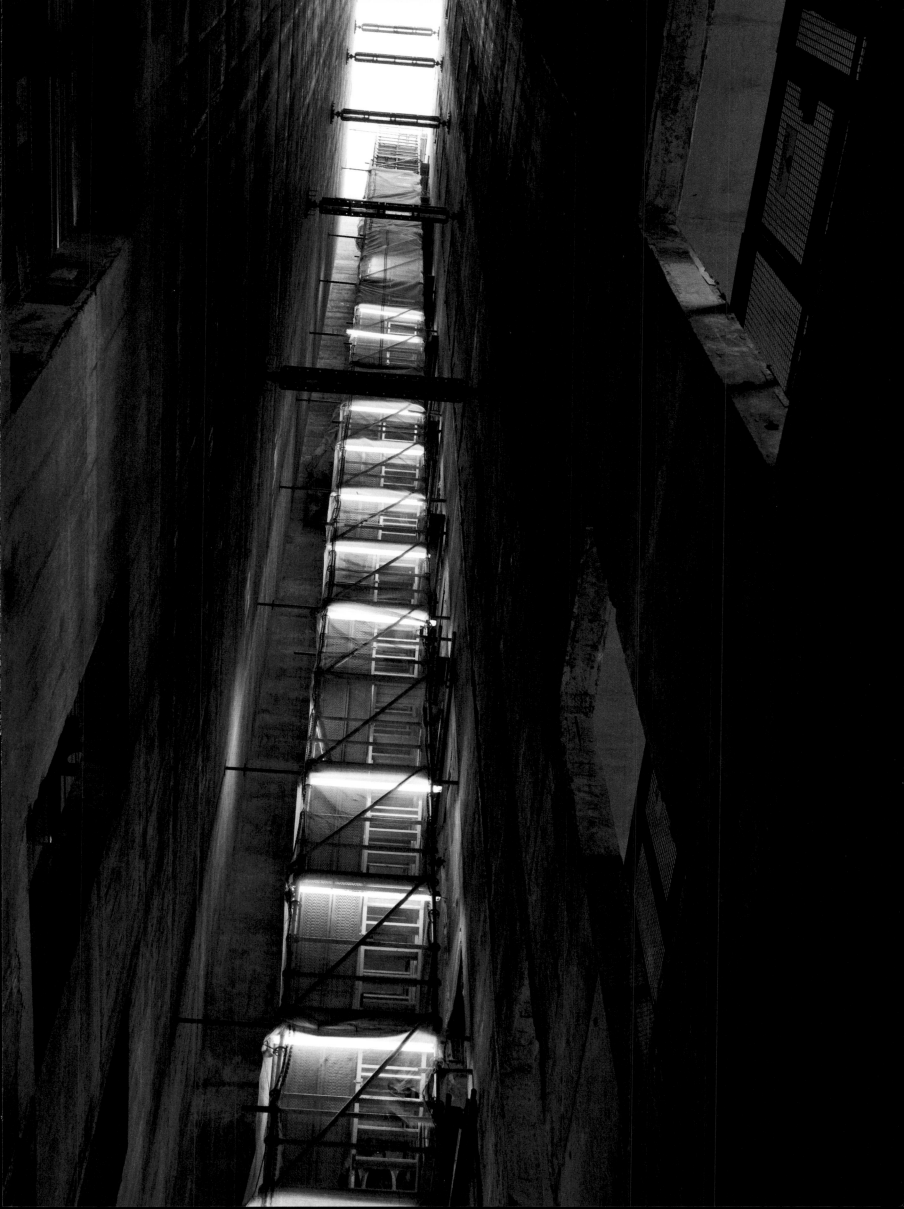

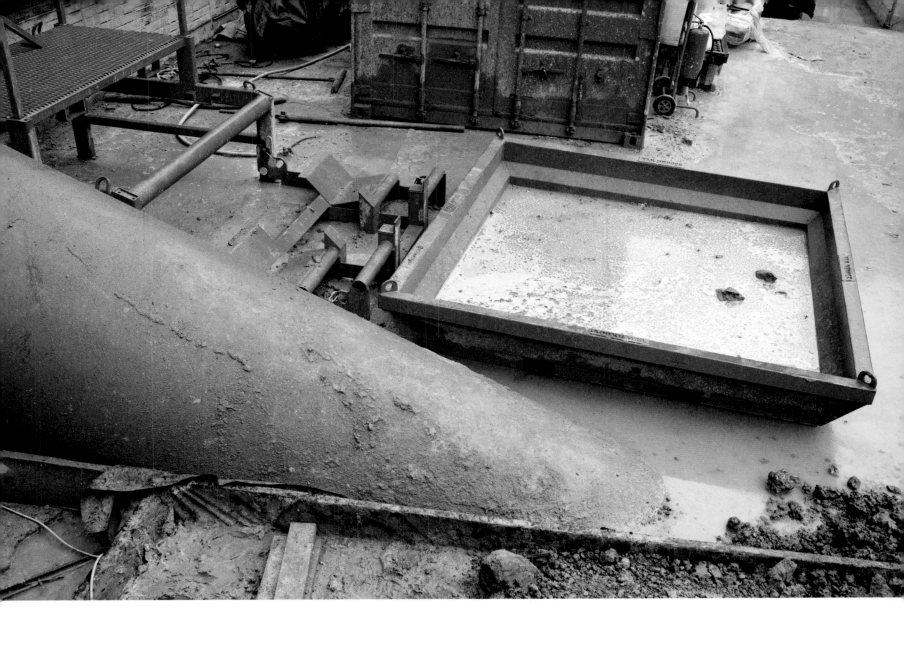

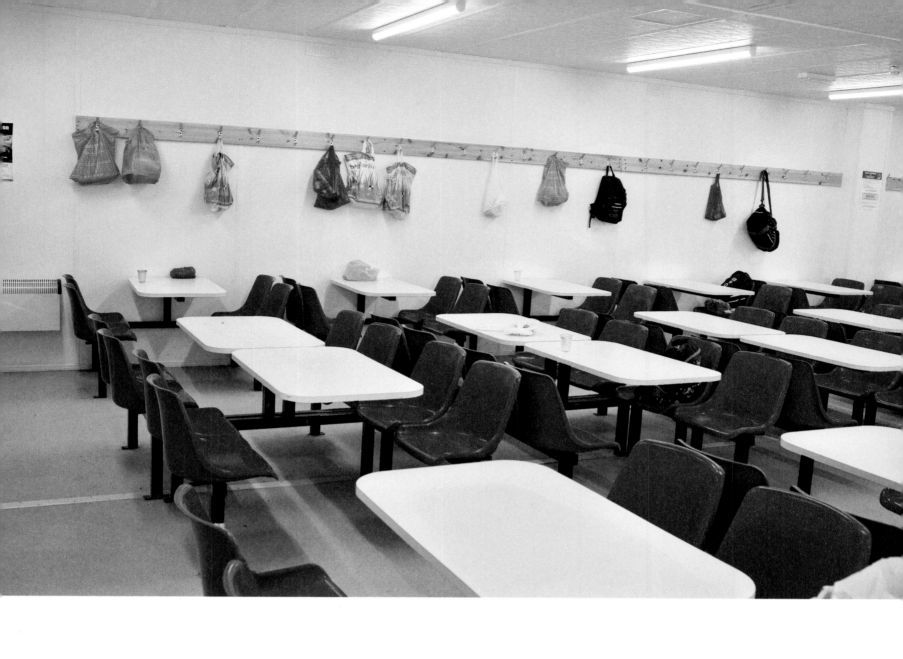

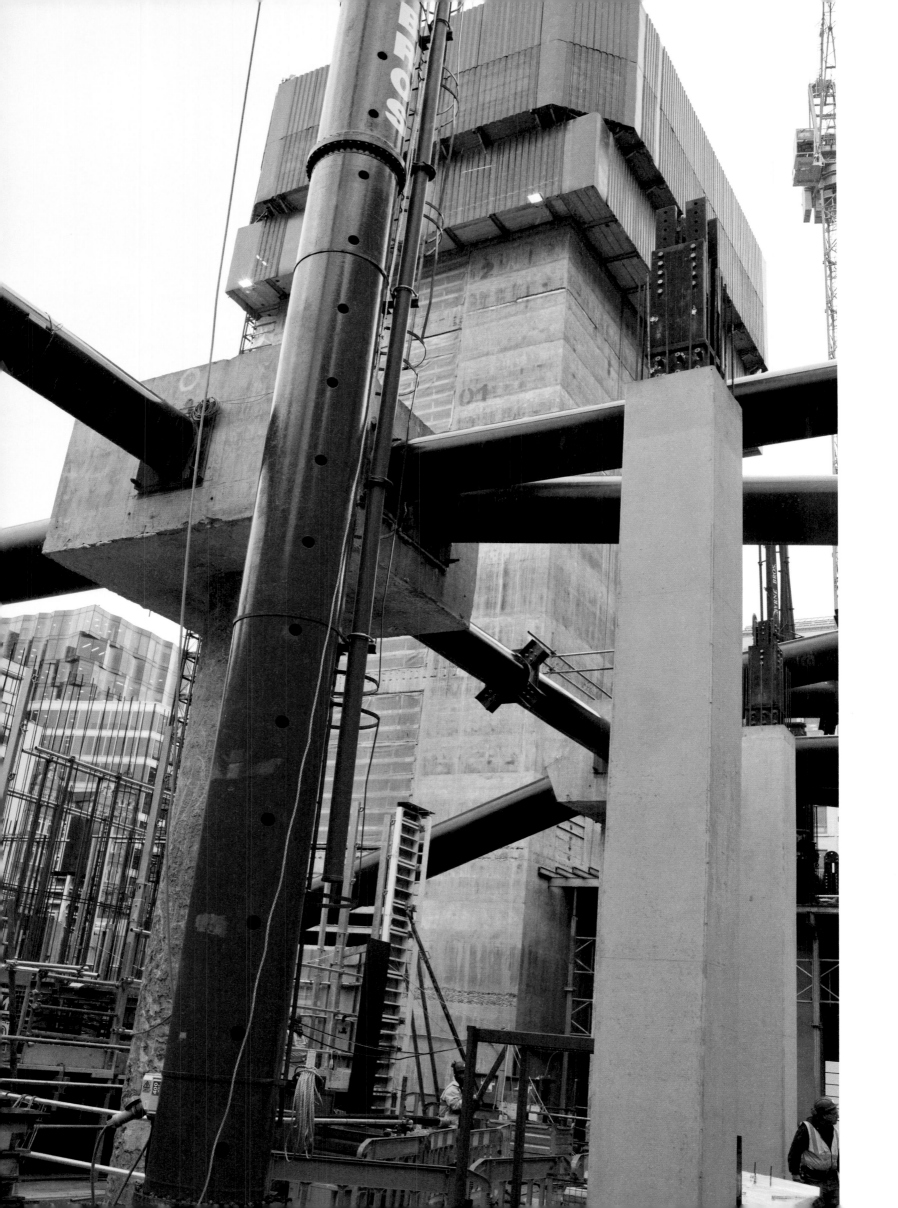

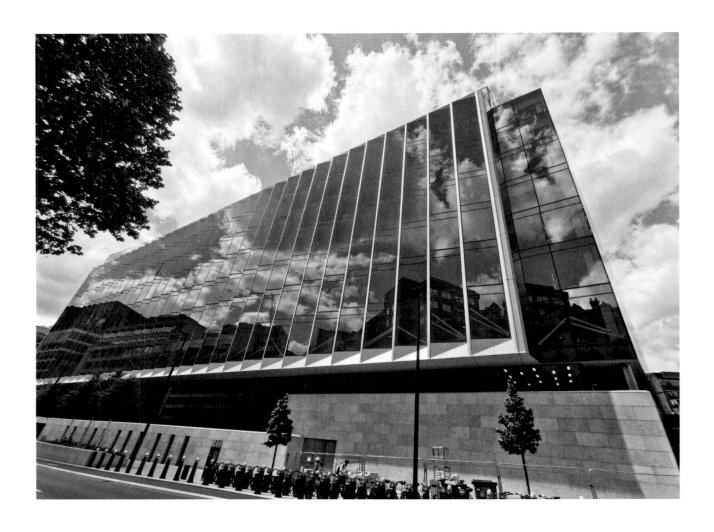

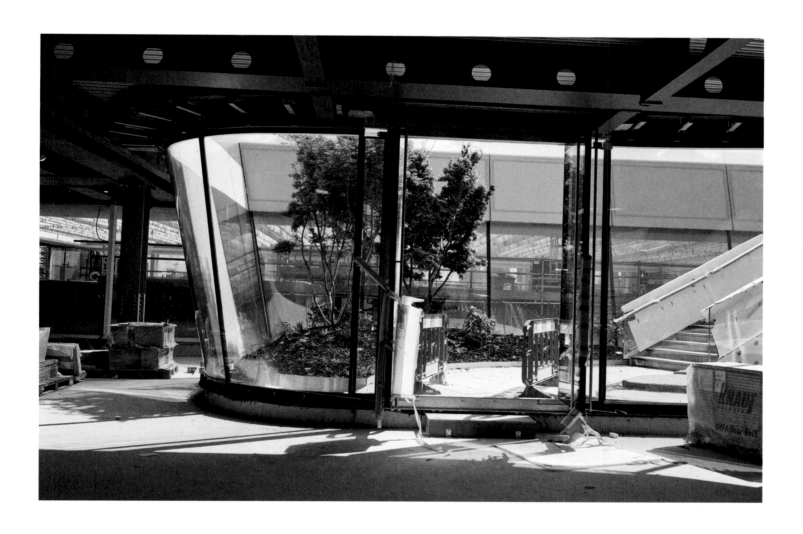

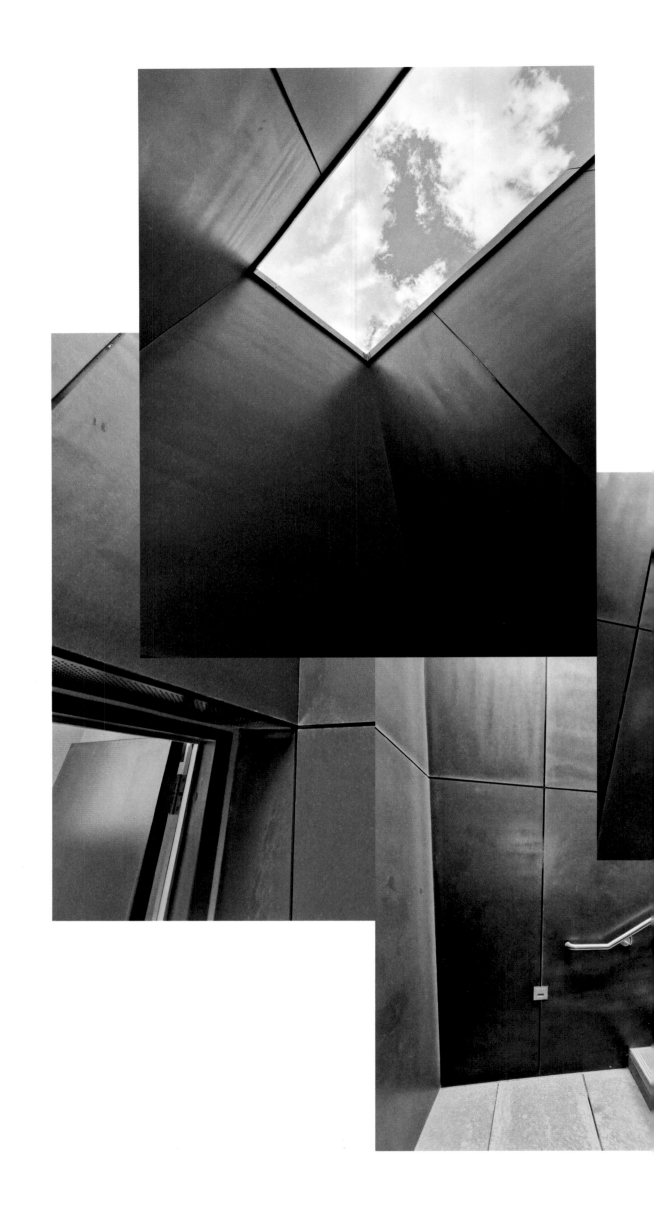

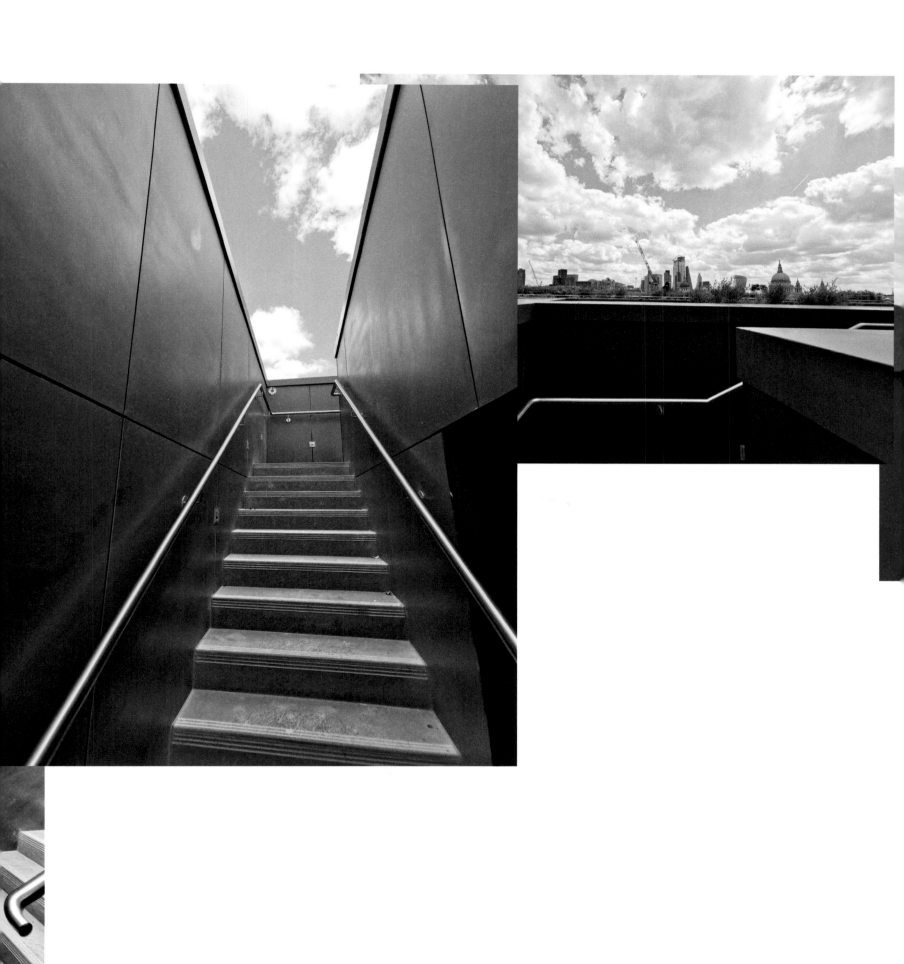

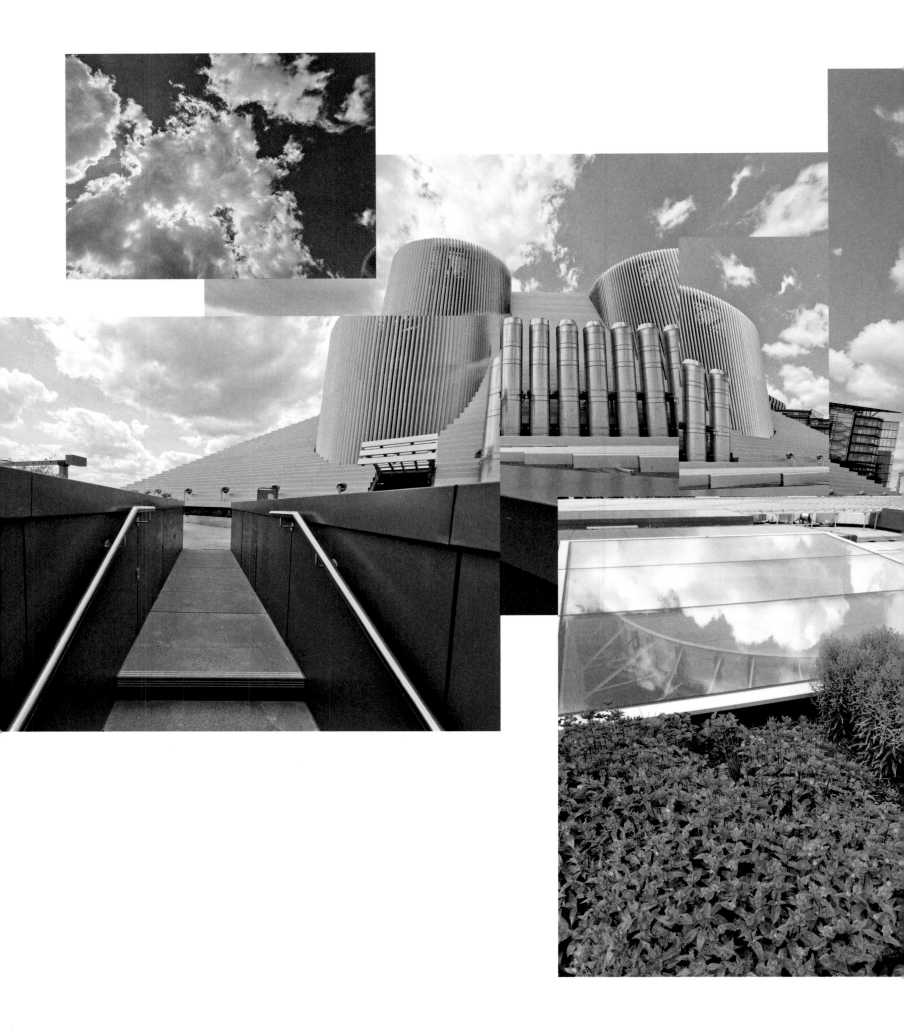

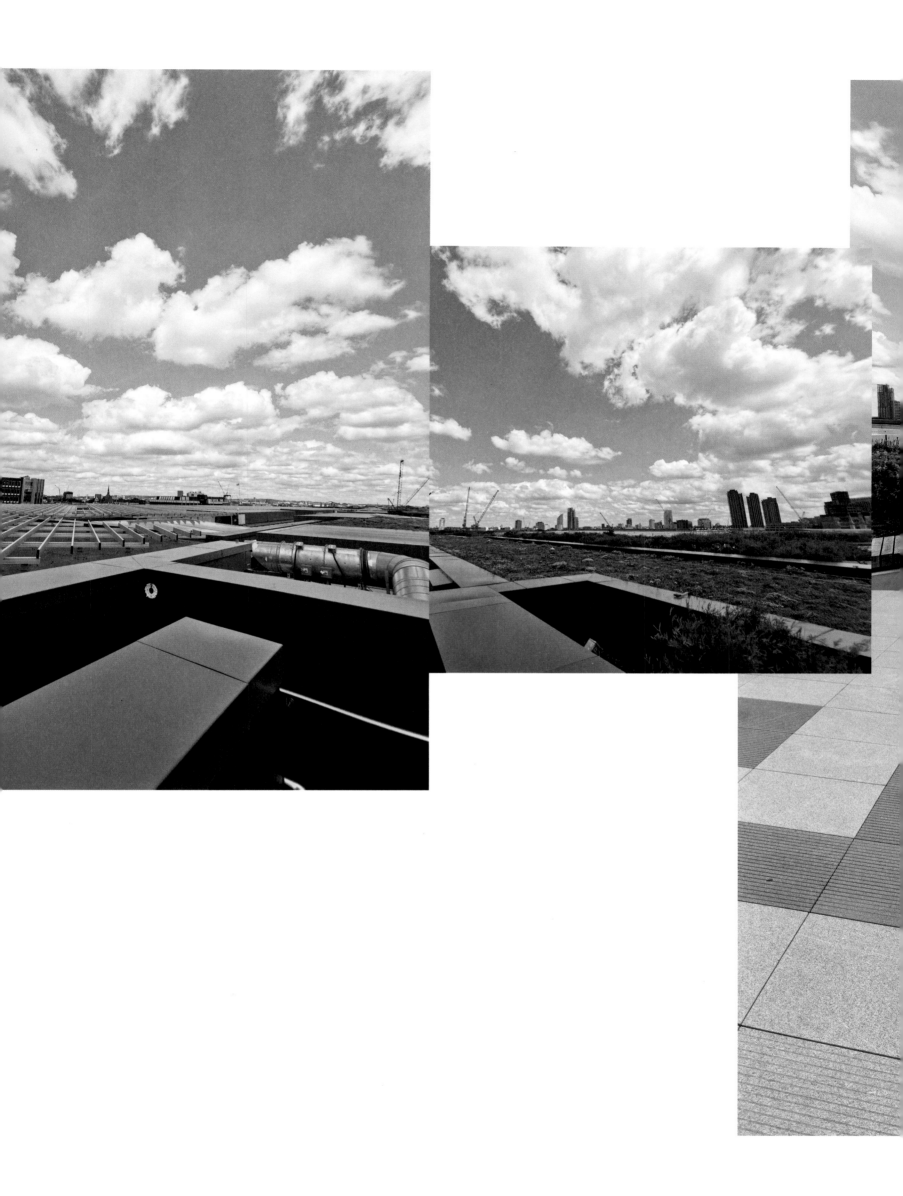

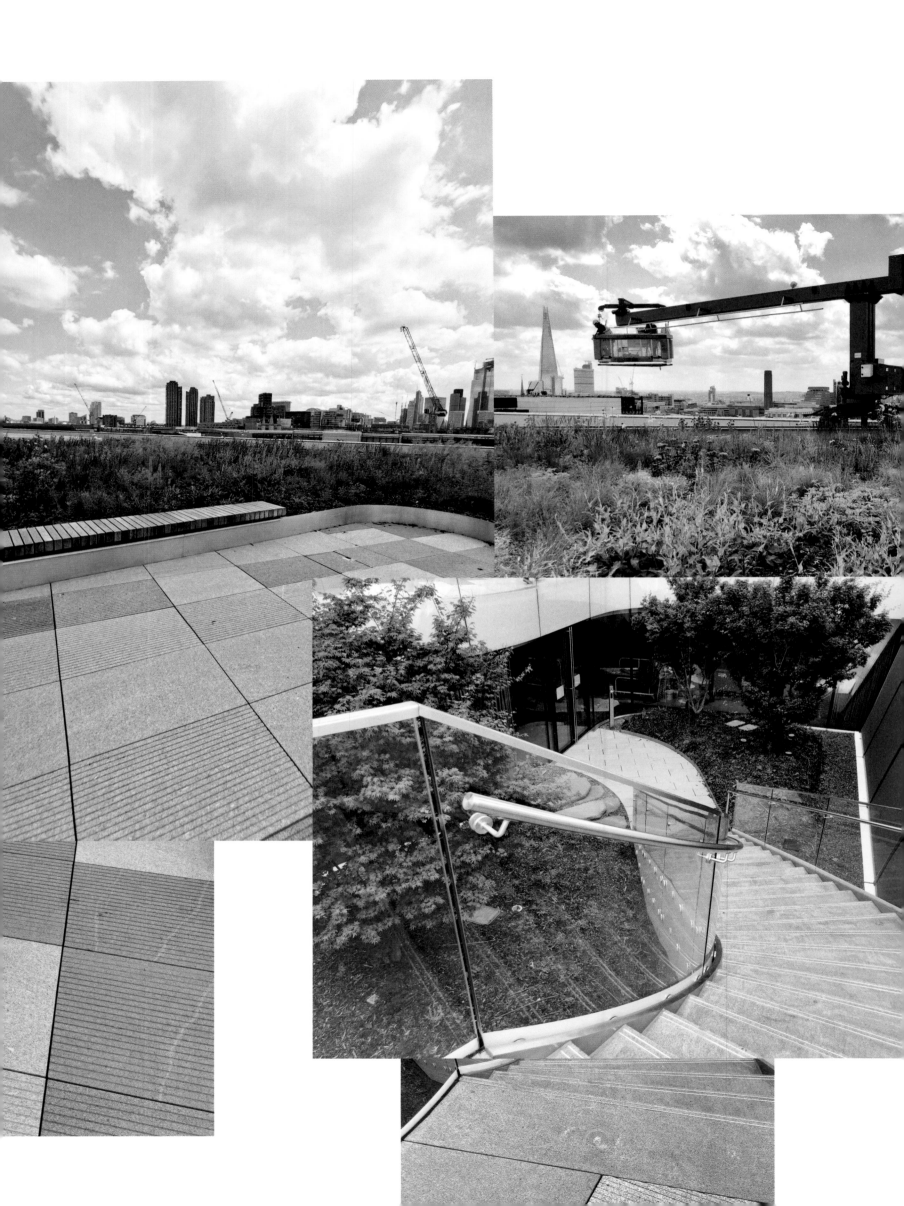

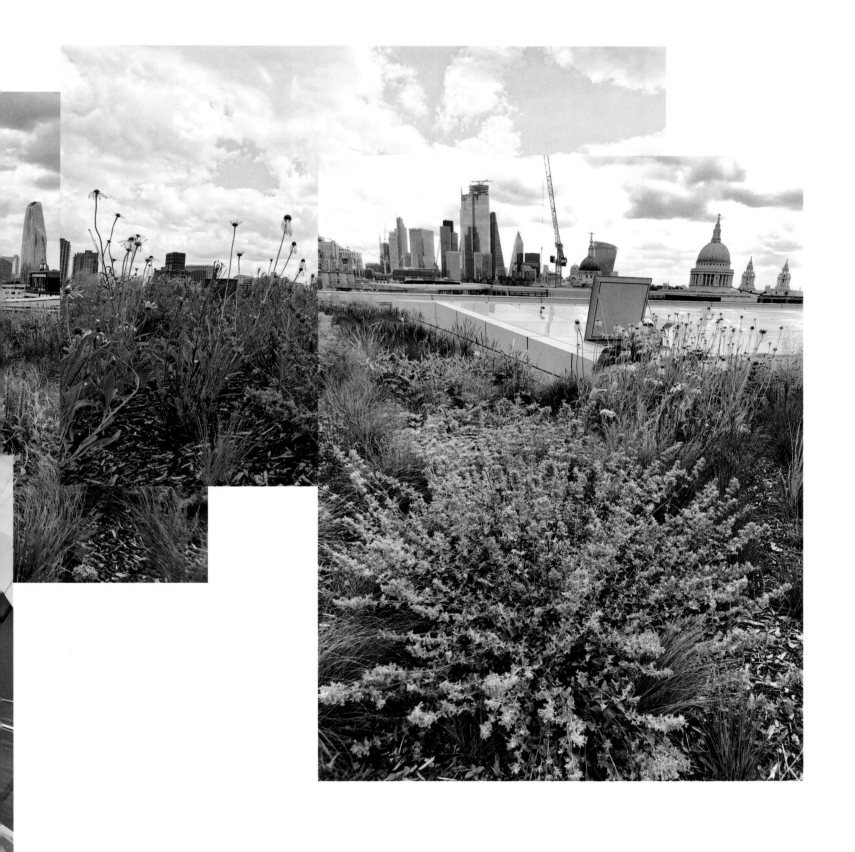

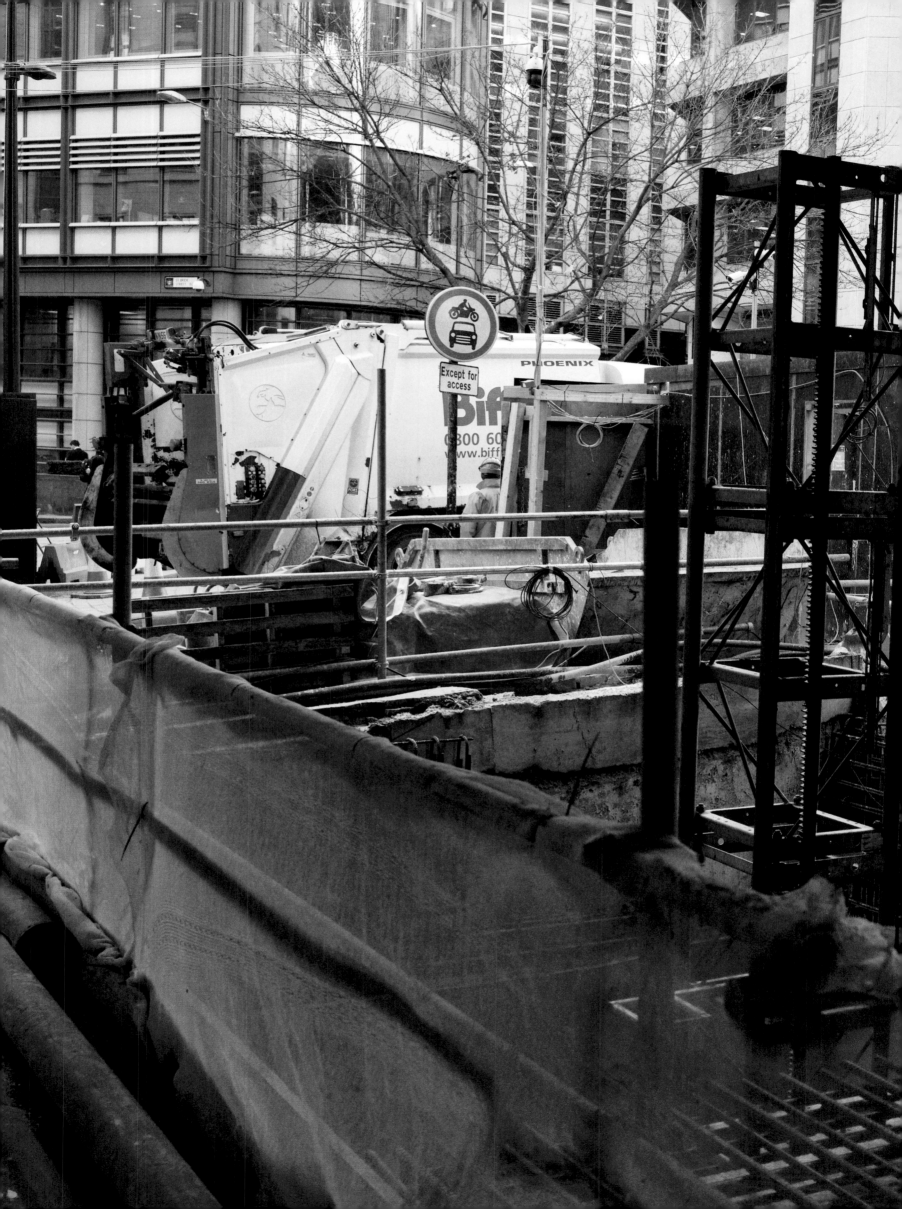

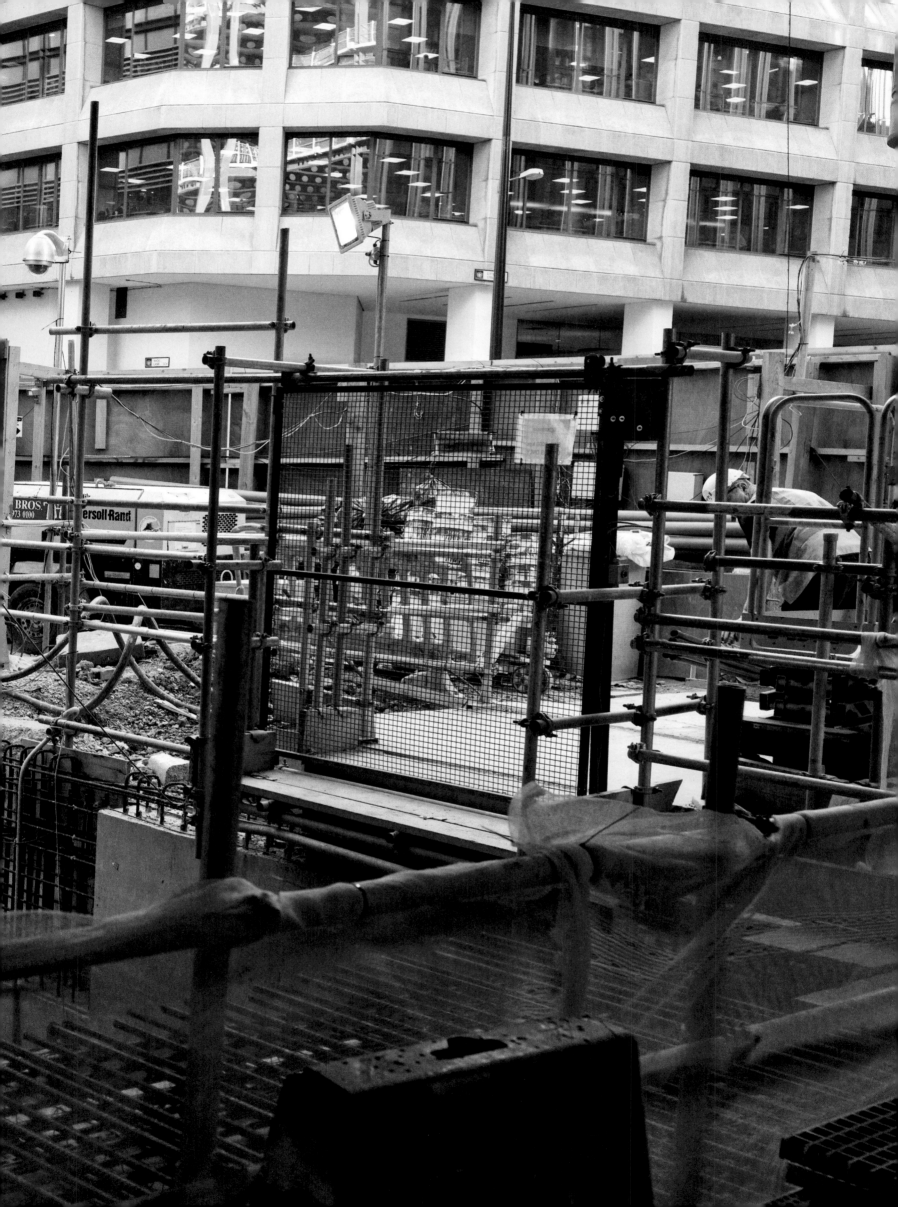

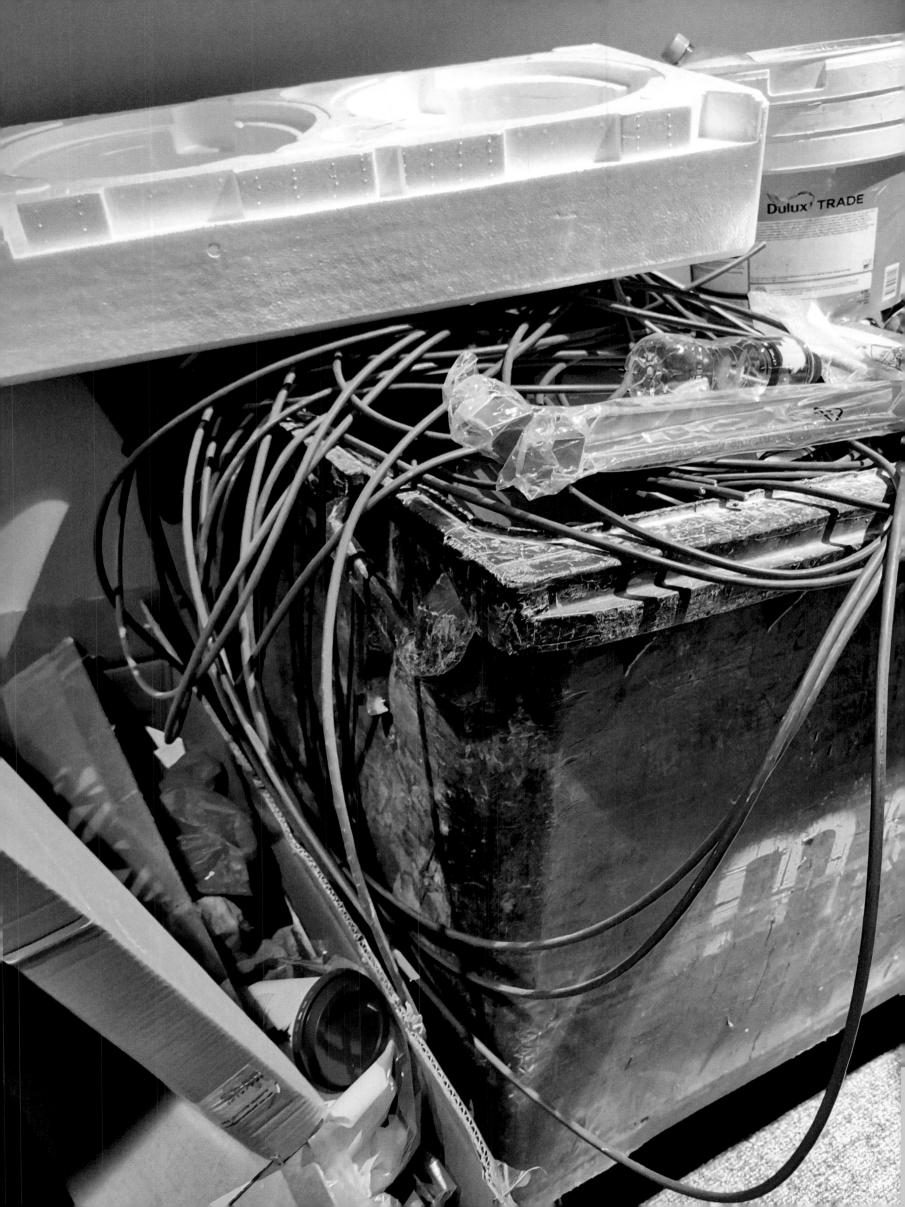

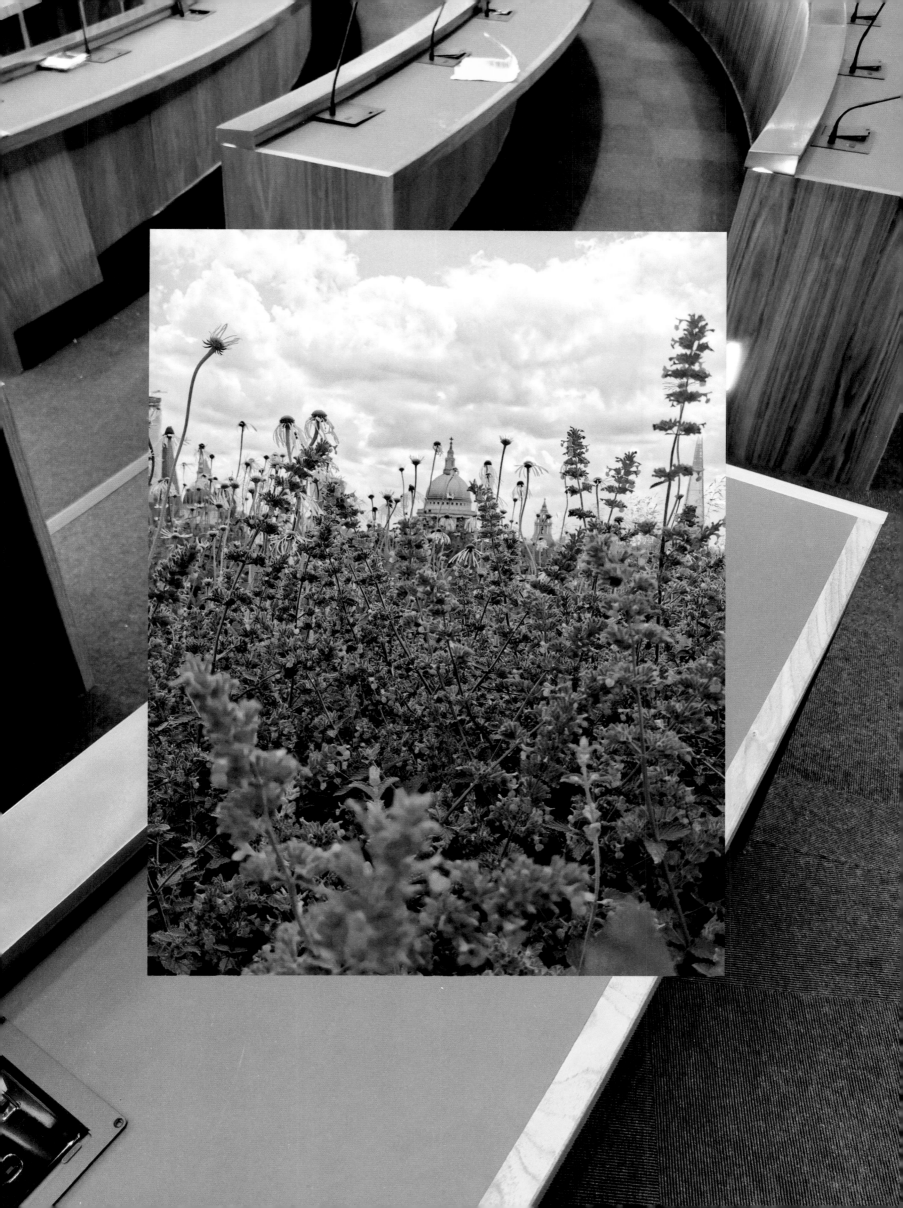

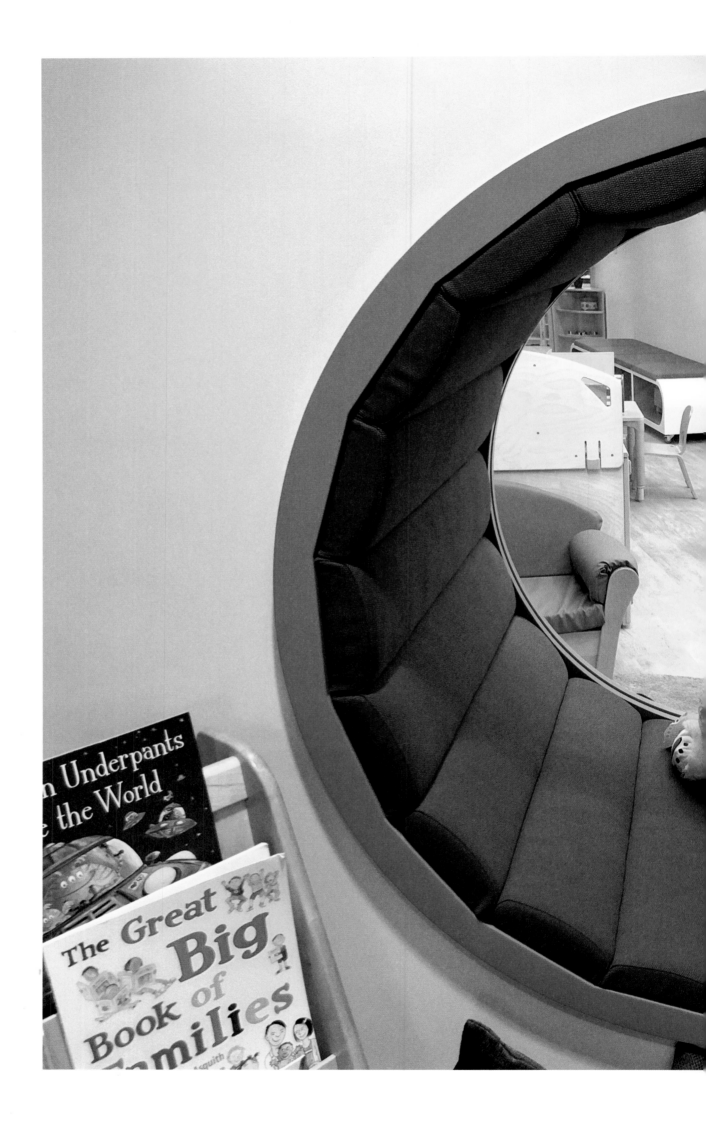

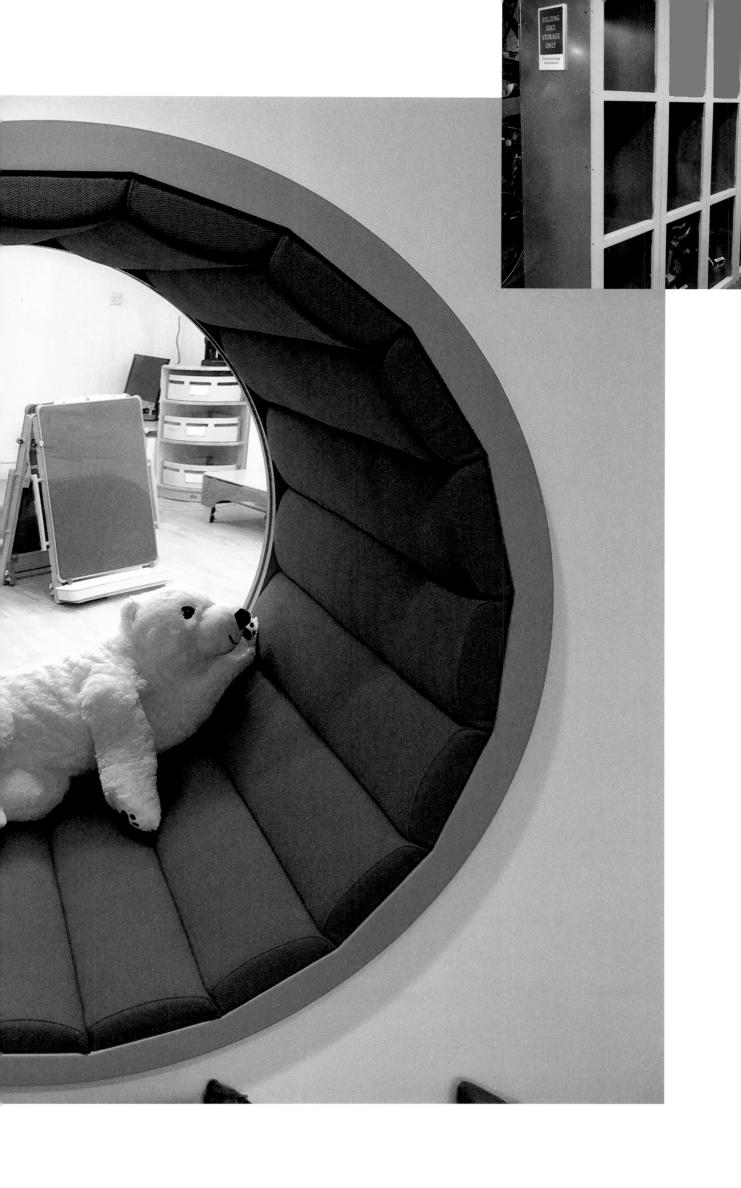

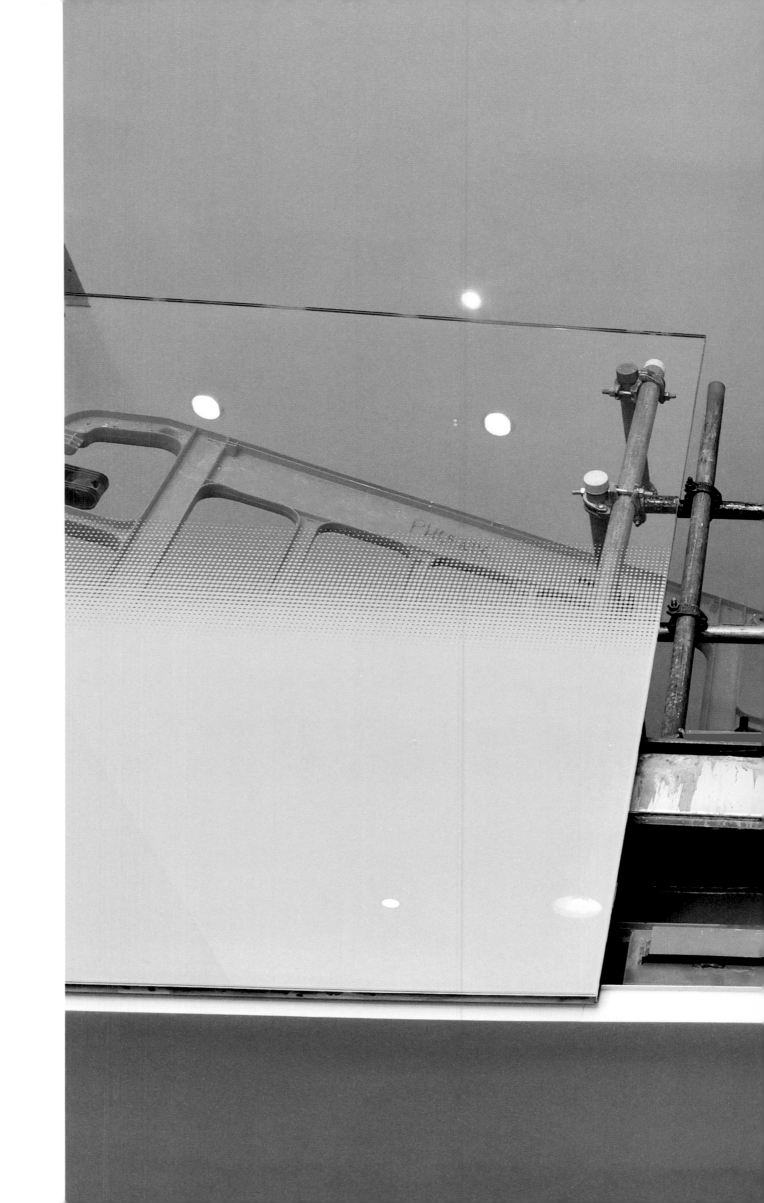

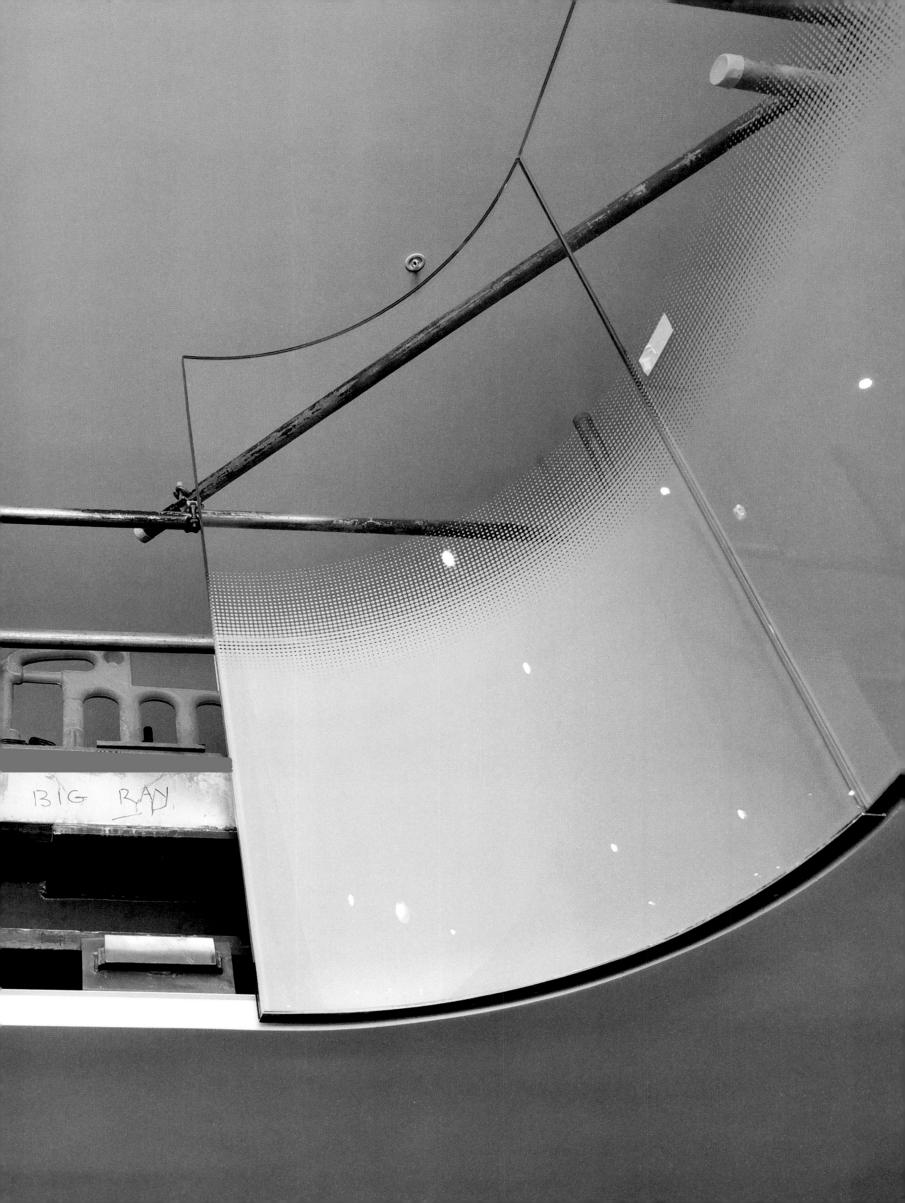

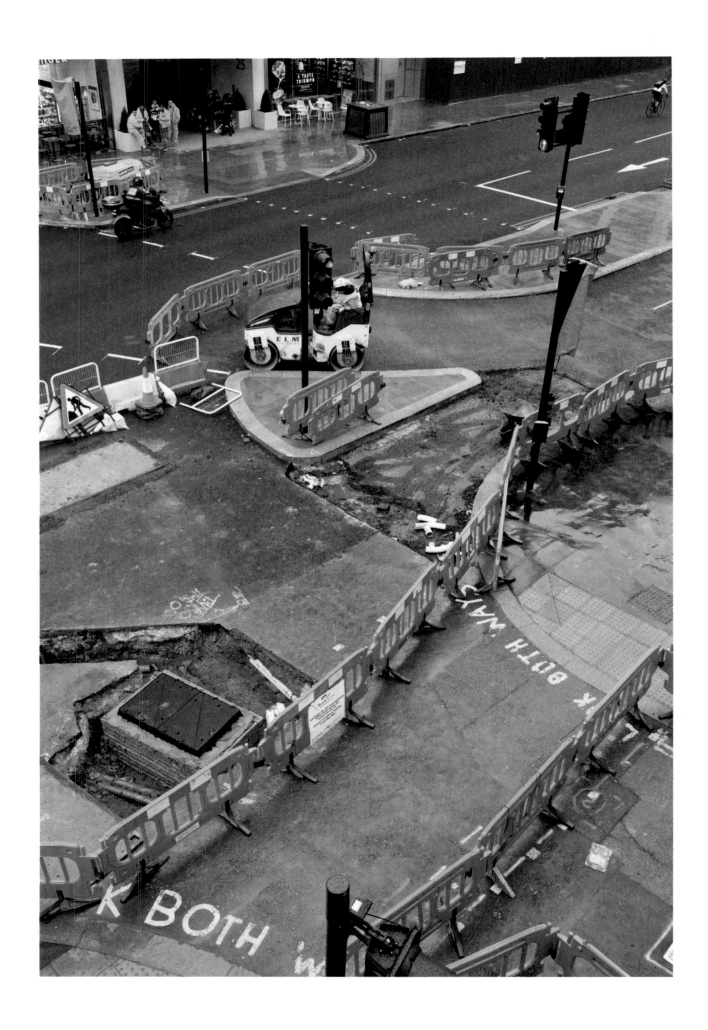

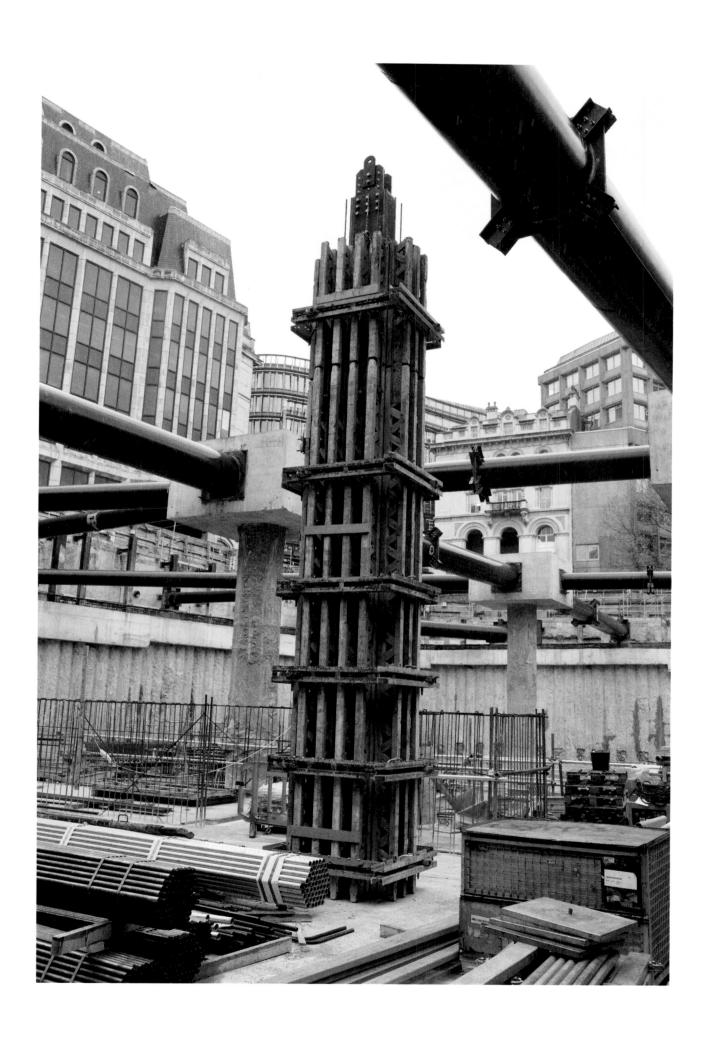

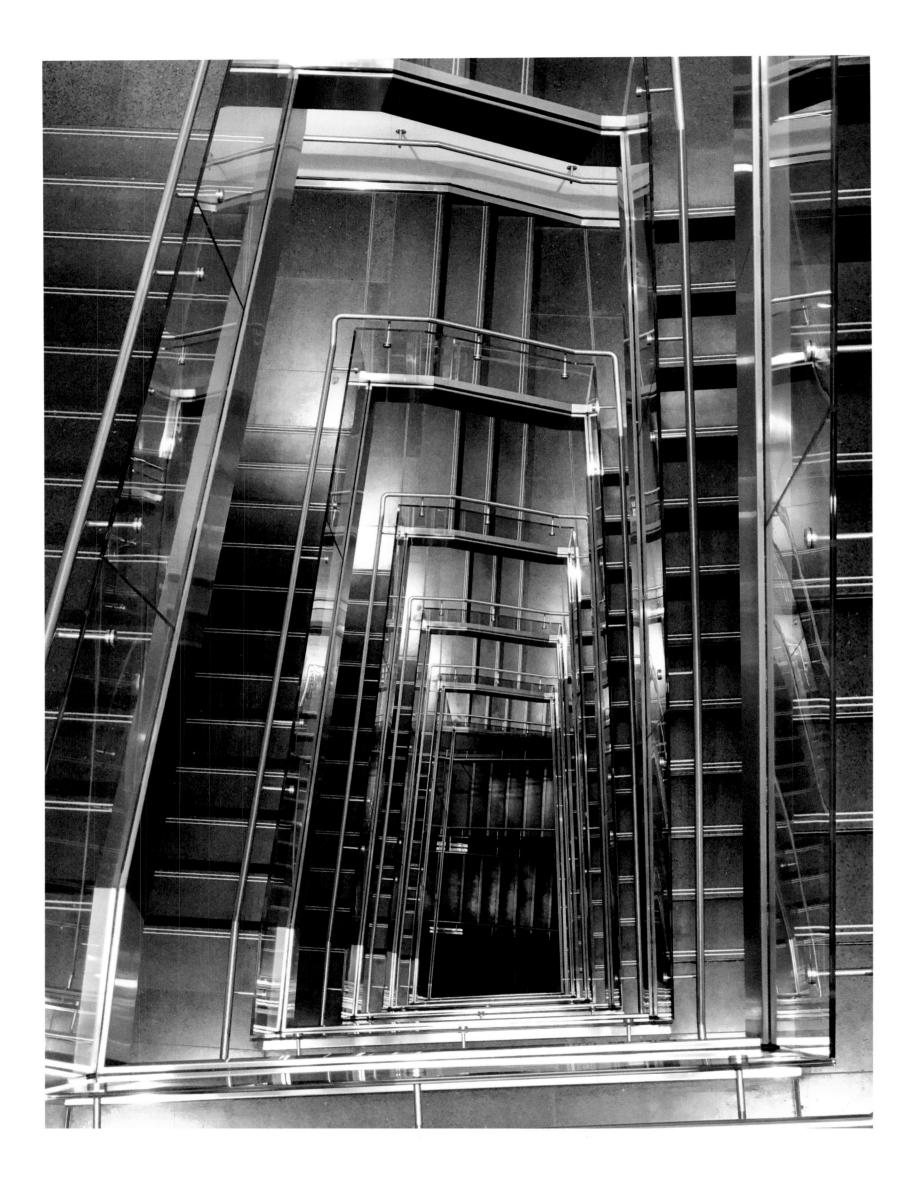

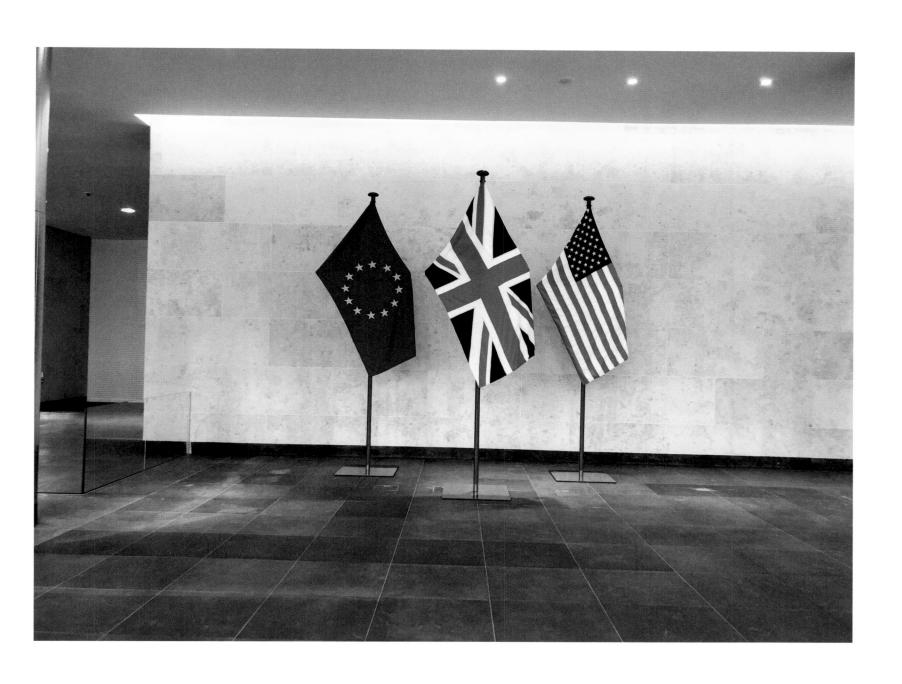

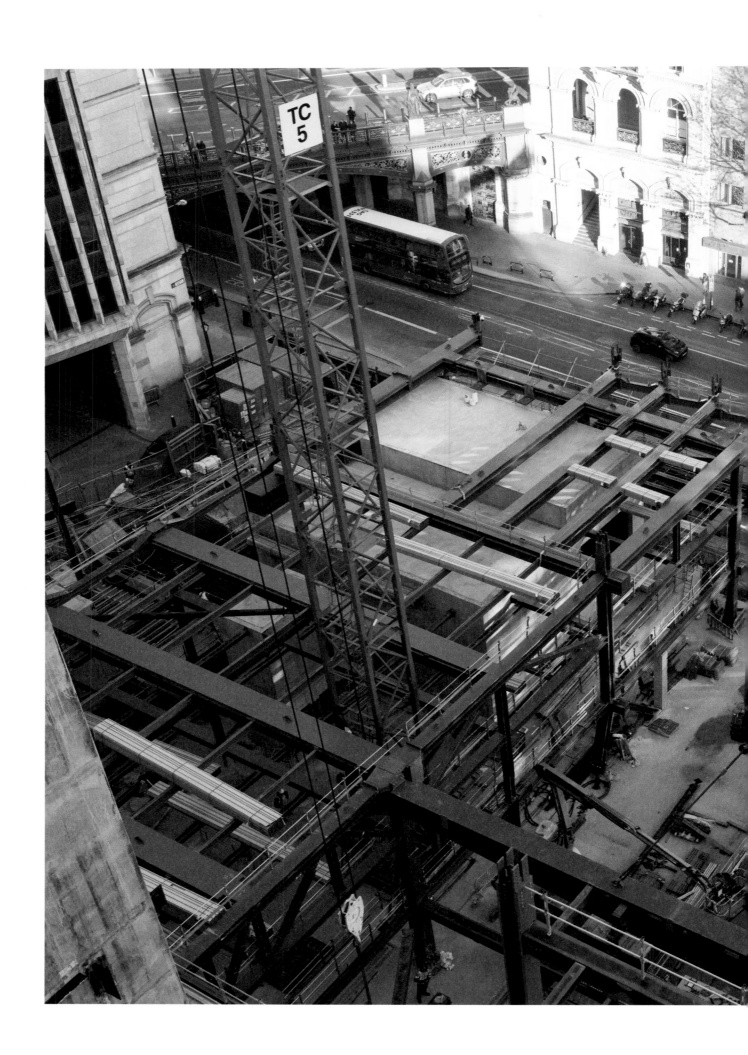

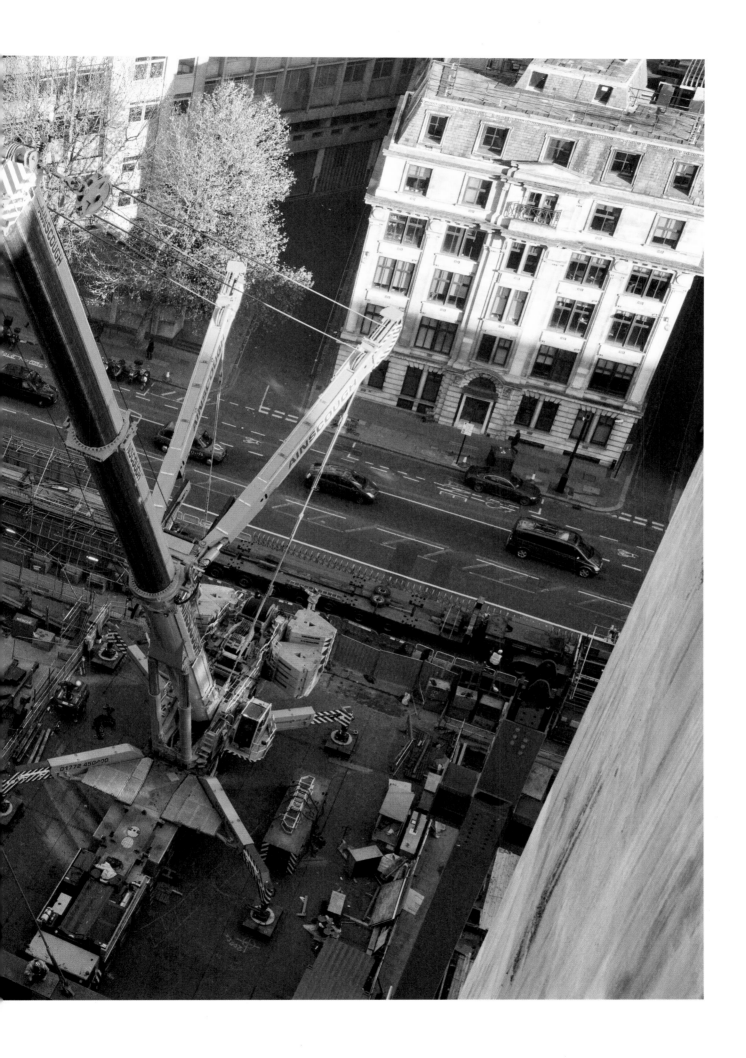

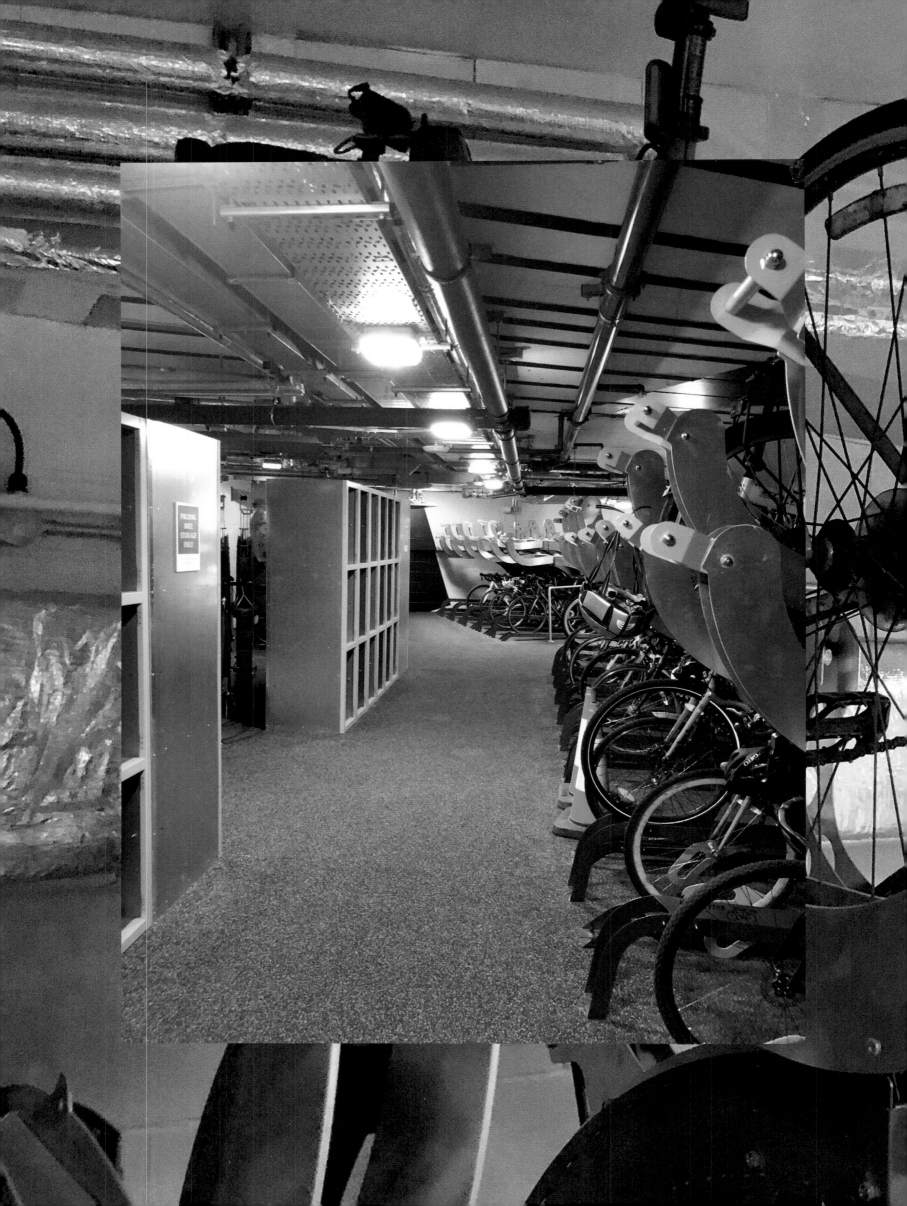

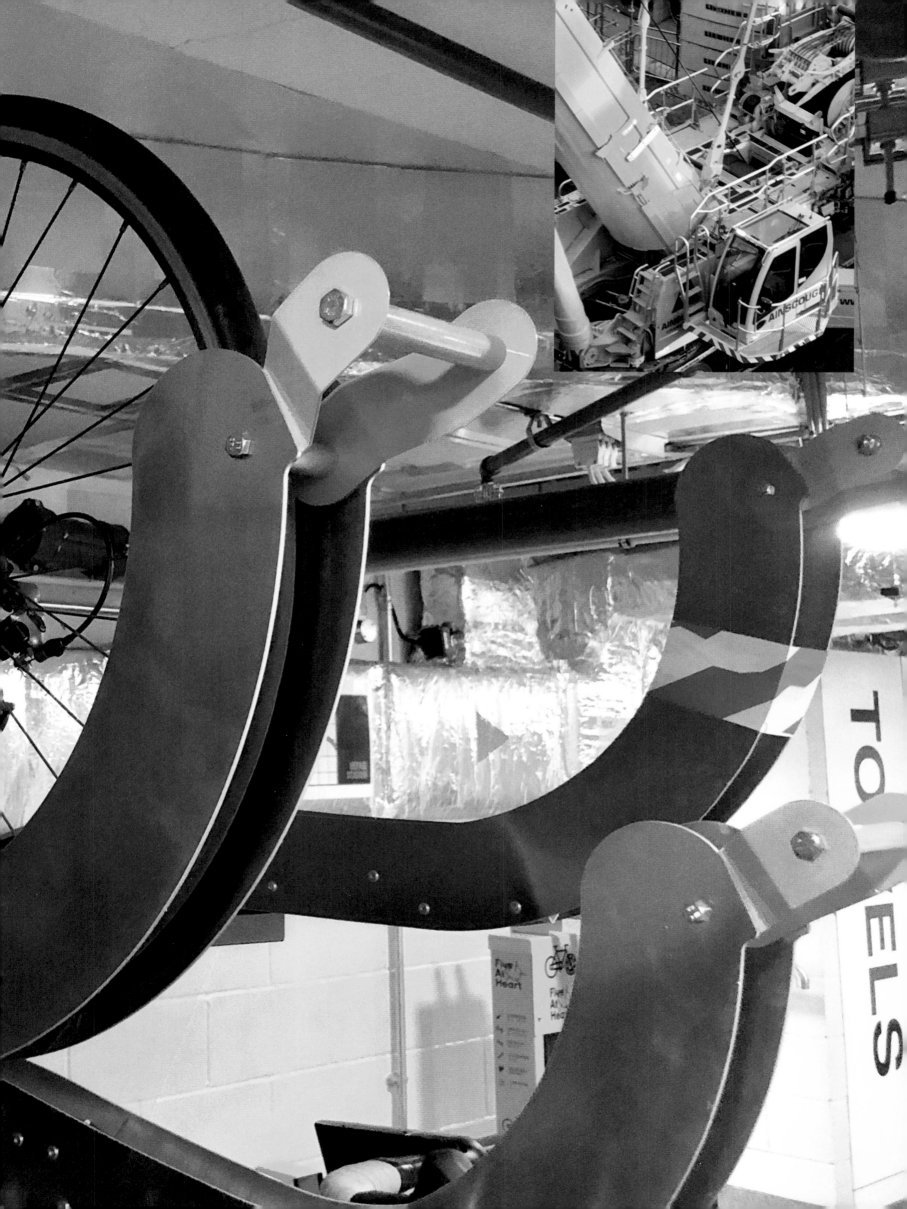

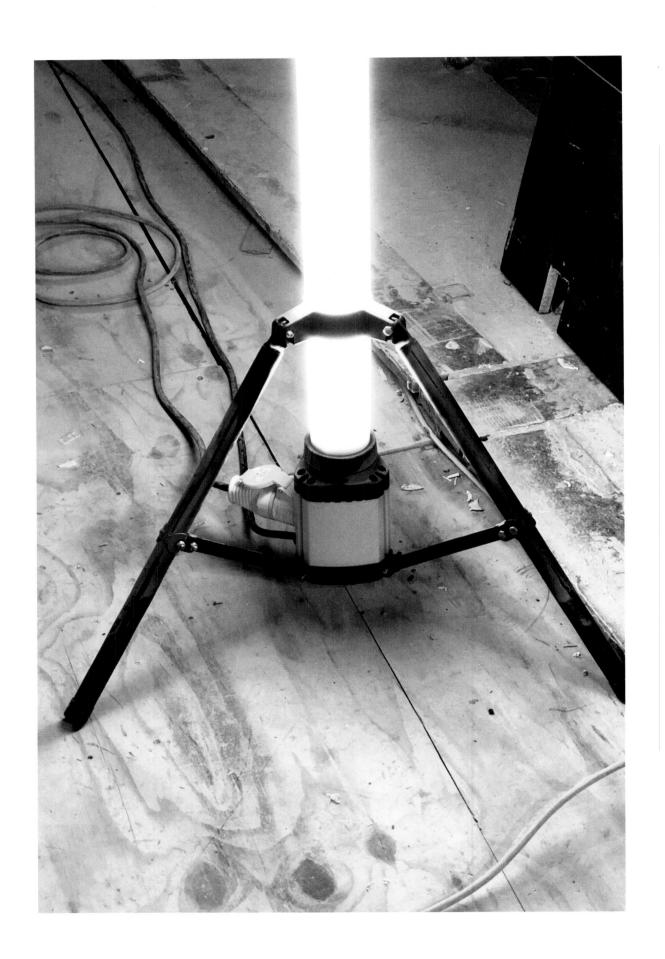

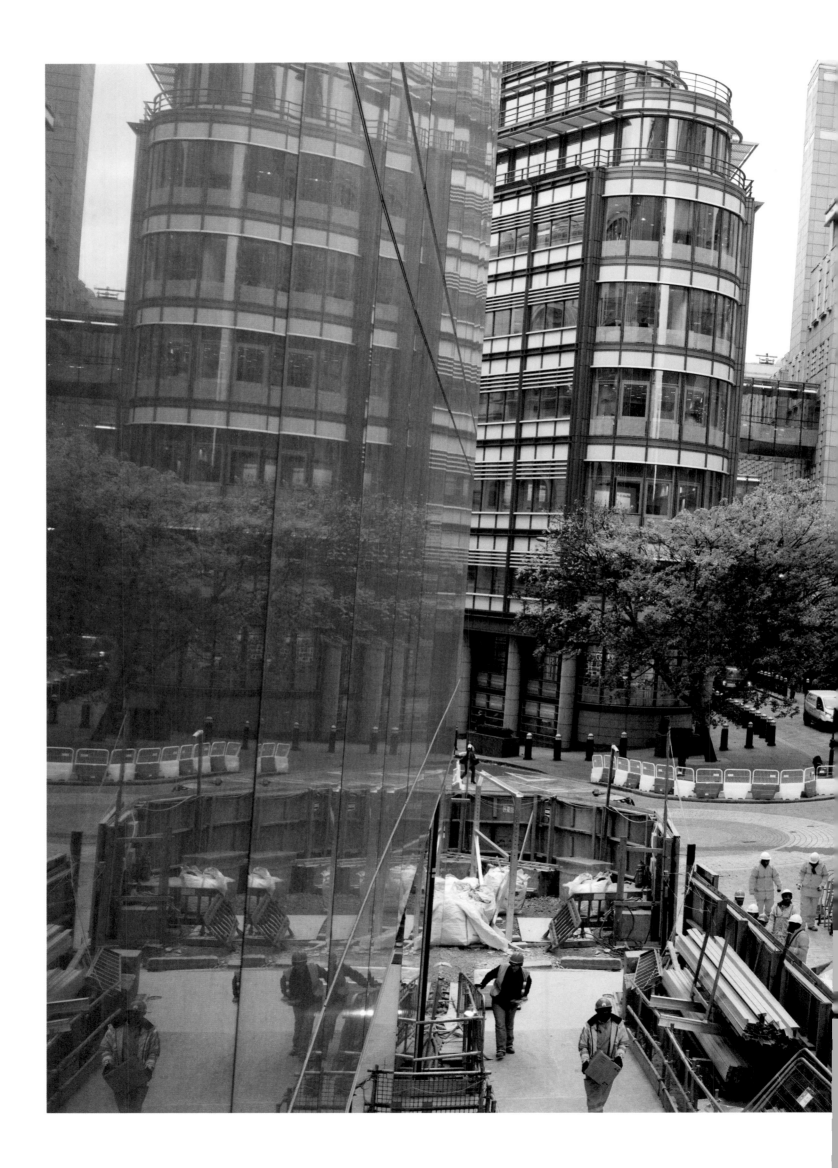

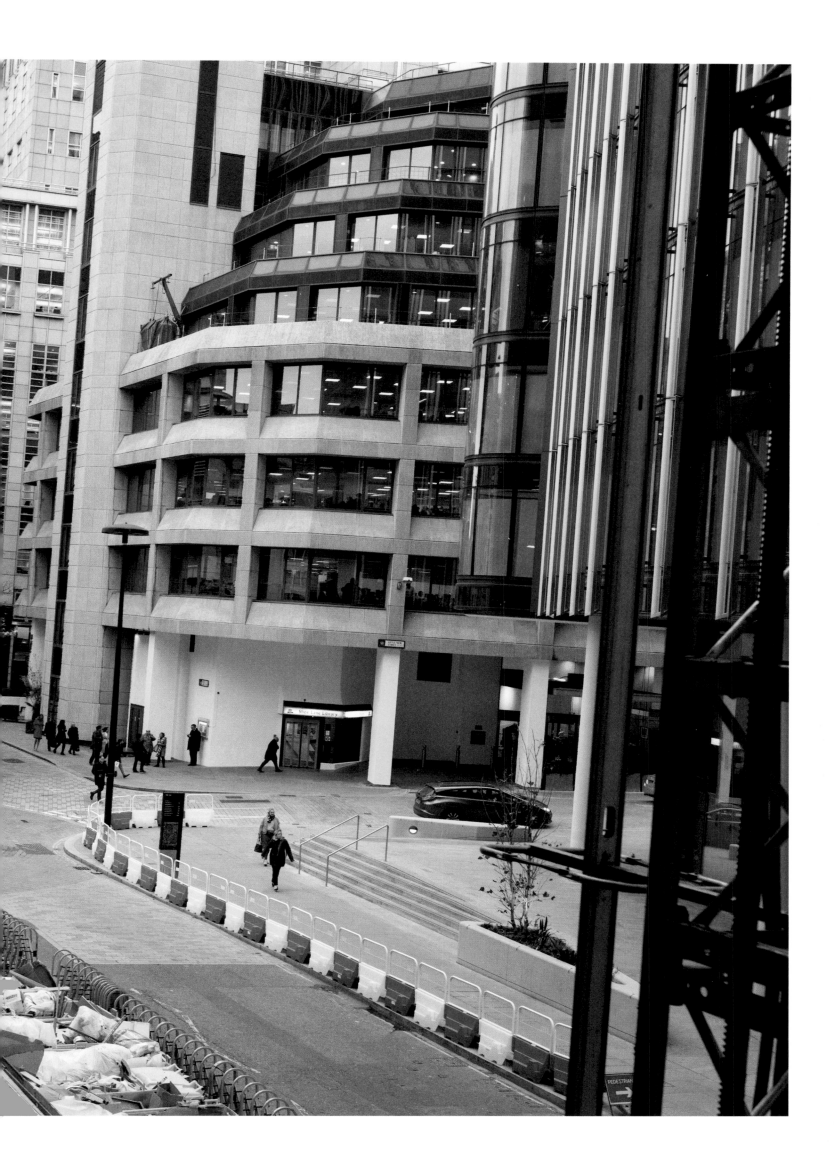

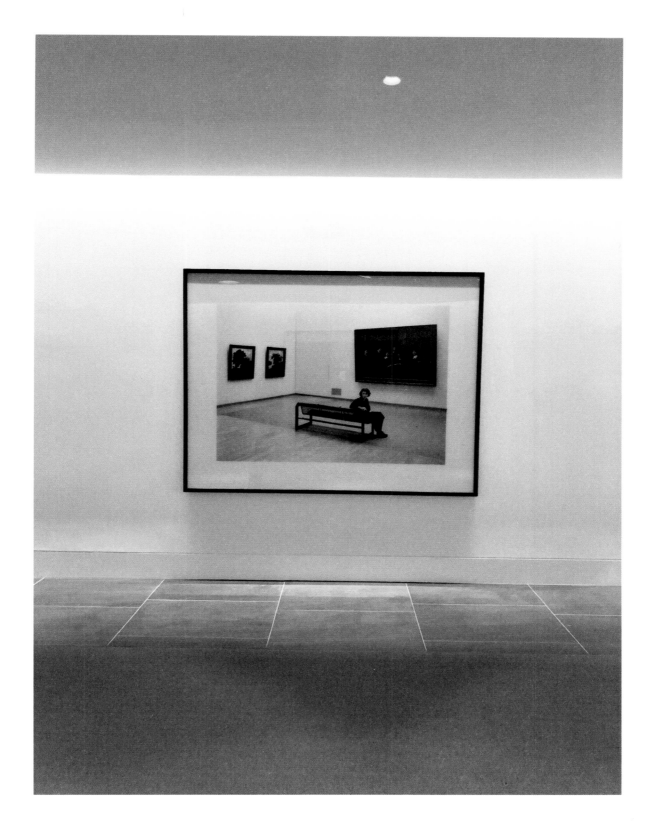

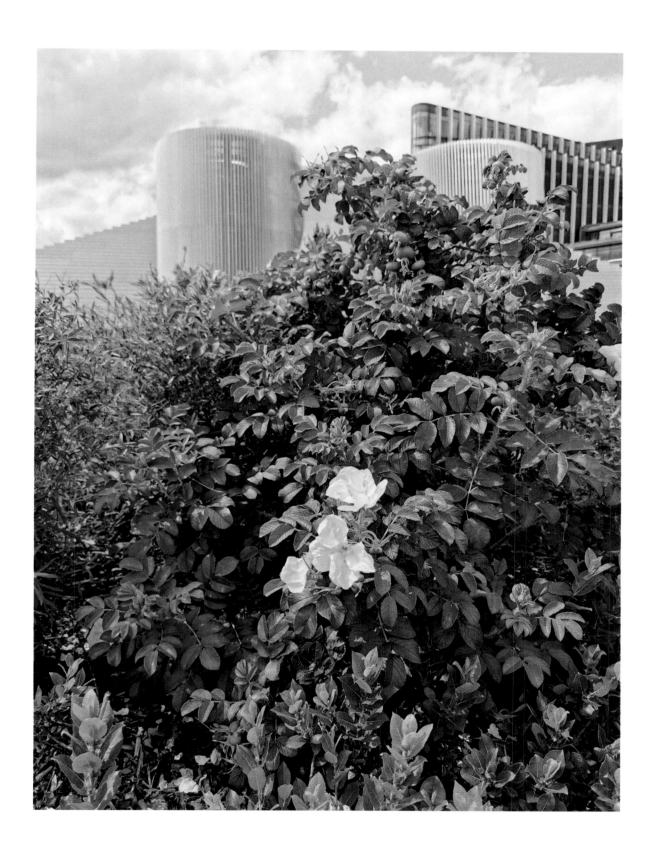

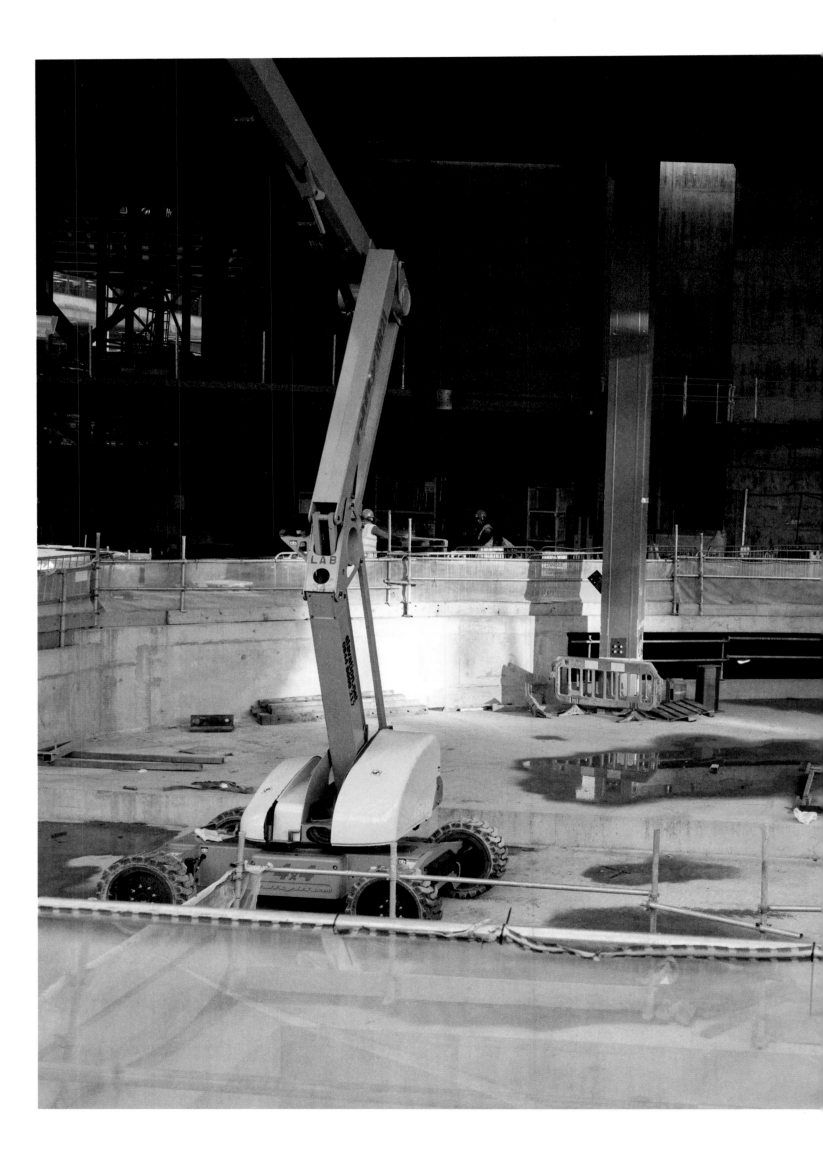

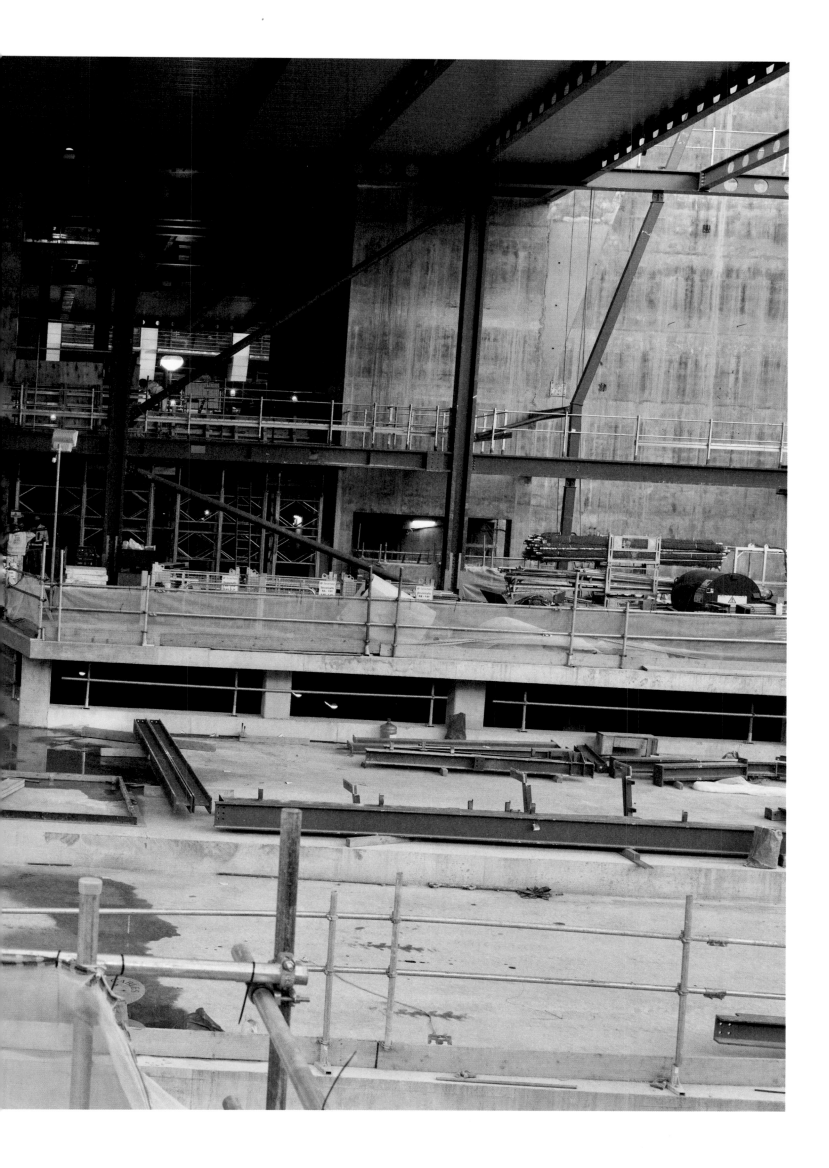

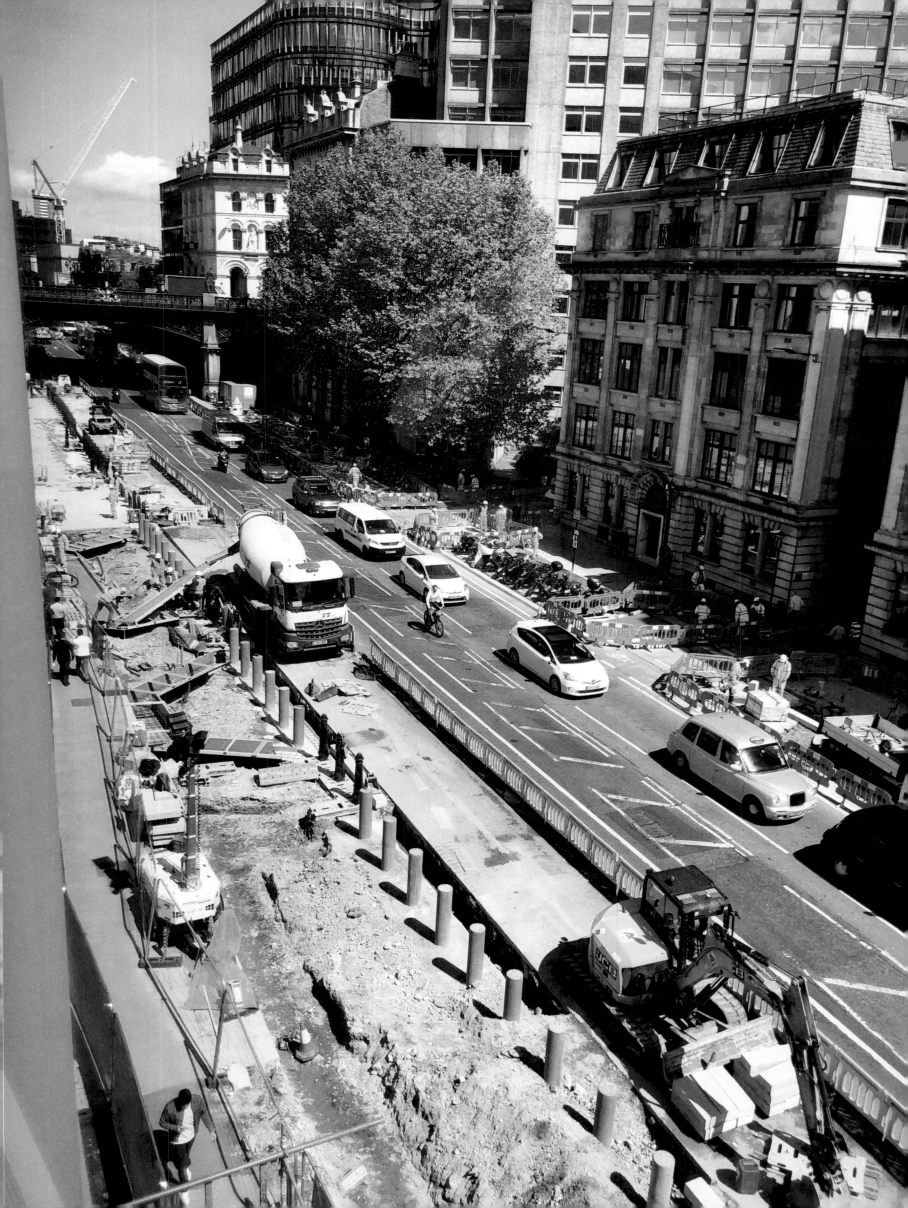